MONSOON

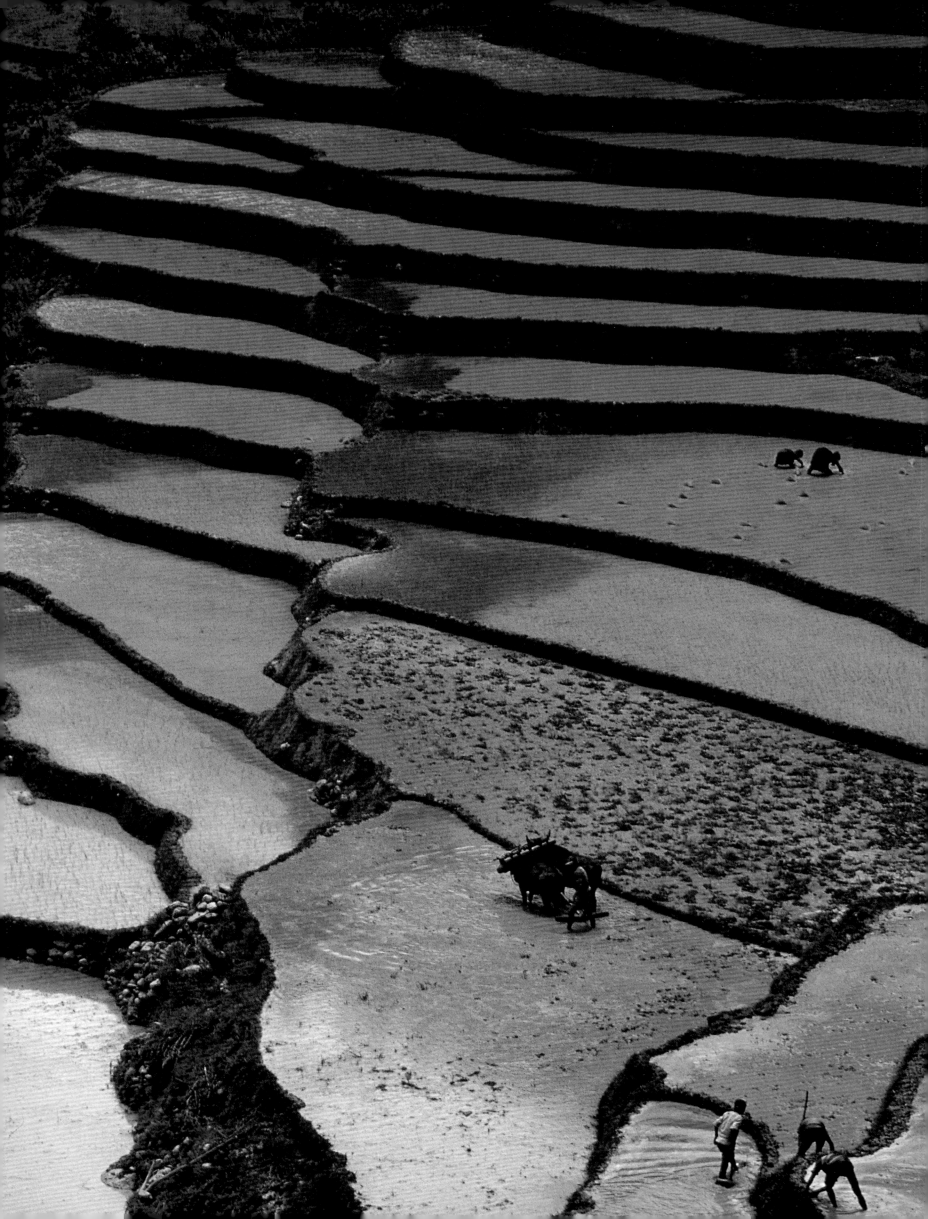

MONSOON

Photographs and texts by Motoi Ichihara

*E*DITION *S*TEMMLE

Zurich New York

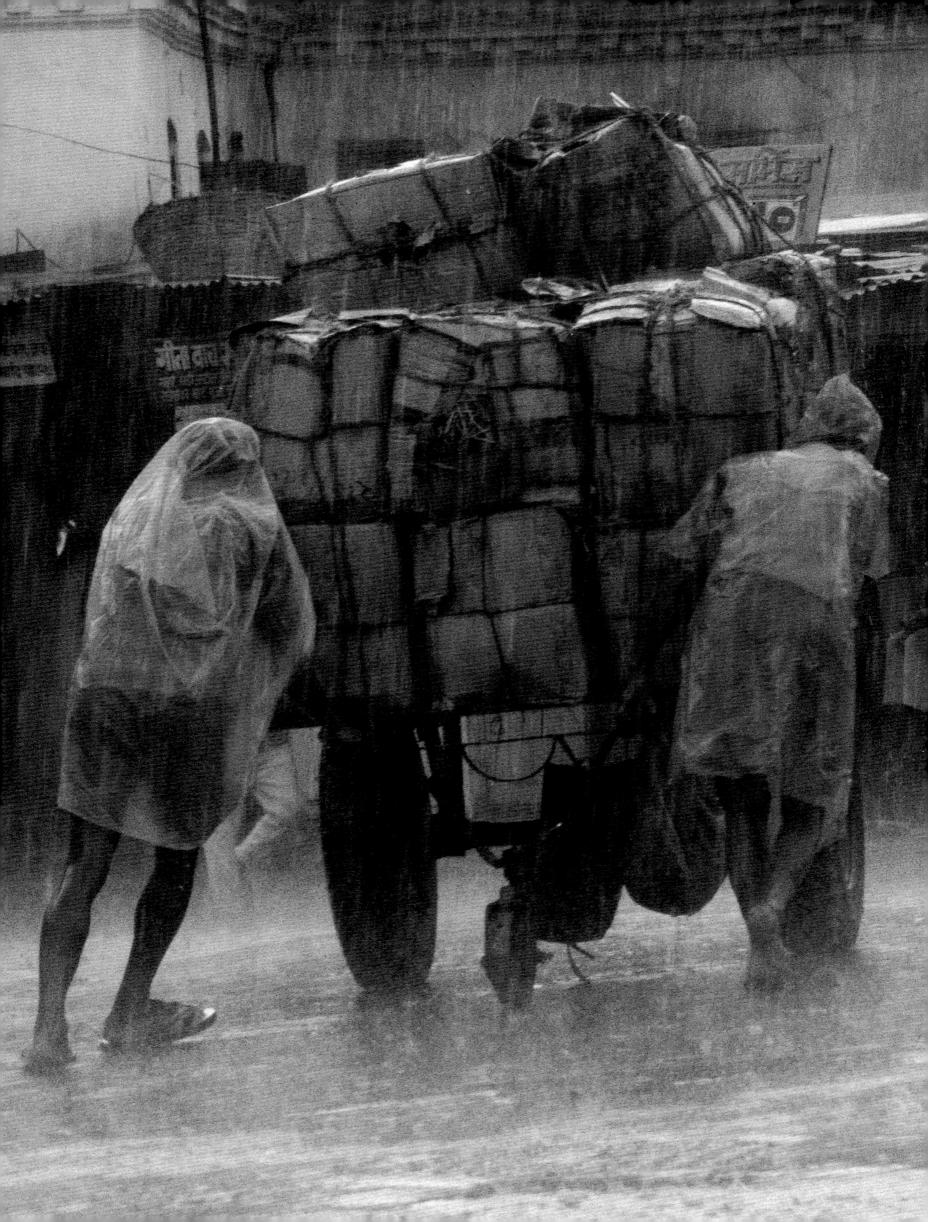

CONTENTS

THE MOTHER WIND

Motoi Ichihara

There is a wondrous wind that has blown across the bounteous Asian continent from time immemorial. Every year, in the same season, it fills the skies with dark clouds. And every year, it brings the rains—a few drops at first, swelling to torrential downpours—heralding the monsoon's arrival. The monsoon is a bringer of life and a shaper of culture. This is the wind, the clouds, and the rain without which this region would not be the same. It is the mother wind, the womb of Asia.

The term itself comes from the Arabic *mausim* meaning "season," and the monsoon seasonal winds divide the year into the dry season and the rainy season as it washes back and forth across the land. Monsoon Asia thus refers to a vast stretch of territory from India across Southeast Asia and up to Japan, and this humid area is home to over half of the world's population.

During the dry season, people, animals, and plants alike suffer from the blazing—sometimes fatal—heat. Thus the rainy season is seen as welcome relief, restoring green to the land and contentment to the people. Yet even this can be too much of a good thing; as the cyclones rage, the typhoons blow, and the falling rains flood the land to inundate crops and wash all away.

This is a harsh environment as people live by the water and die by the water. Yet it has been going on for so long that it is an integral part of life and culture throughout the region. This is nature—*force majeure*—and its impact has been immeasurable. Religions have been spawned and faiths built around the monsoons. Similarly, the waters have been made part of the rites of Buddhism, Christianity, Hinduism, Islamism, and other religions in the region. Interestingly, all have gods linked to and intervening with this force of nature.

The water exists in many forms and colors—looming up as black clouds one day, pouring down gray another day, and wafting from lightly overcast skies yet another day. It is the bringer of death and the giver of life—the water of the gods.

In 1973, I flew back to Japan from Europe on the Southern route, taking me across India, Bangladesh, and Myanmar. This was during the rainy season, and the soggy lands made a profound impression on me. It was the first time I had been consciously aware of the monsoon's overriding importance. Twelve years later, I chanced to meet Professor Asahiko Taira of the University of Tokyo Ocean Research Institute and decided, as a result of our discussion, to try to capture the monsoon's majesty on film.

As Professor Taira explained it, "Making its way north 40 million years ago, the Indian continent encountered Asia's vast land mass, the clash giving birth to the Himalayan range and these towering mountains in turn altering weather patterns to produce the monsoon winds." This was plate tectonics writ large, and it called up the mystery and romance of the earth's evolution.

This was Asia as a living, fluid continent, the Asia of boundless potential, and Asia as a land still in progress. Having myself grown up in Monsoon Asia, I resolved to undertake a 12-year project to track the monsoon. I began by dividing Asia into four areas. Recognizing that administrative boundaries are largely artificial boundaries not respected by the seasons, culture, or other essentials, I demarcated these areas by mountain ranges, rivers, oceans, and other geological borders of significance. Once that was done, I set off in 1987, traveling to all of the four areas: the Bay of Bengal region (Southern and Eastern India, Bangladesh, Sri Lanka, Myanmar, and the Andaman Islands), the Himalayan region (Bhutan, Tibet, Nepal, Northern India, Sikkim, Ladakh, and Yunnan), Southeast Asia (the Philippines, Thailand, Laos, Cambodia, Vietnam, Malaysia, the Indonesian Islands Borneo, Sumatra, Java, and Bali), and the Far East (Taiwan, the Chinese regions Guilin, Sichuan, Shanghai and Chong Qing, Korea, and Japan [except Hokkaido, which has no rainy season]).

For twelve years I journeyed alone in these lands. And in that dozen years I witnessed not just the widely publicized poverty that is so pervasive in much of Asia, but a lush Asia: where time flows like a stately river, nature is awash in a riot of green, and the people have a smile for all the world.

Although much of Asia has been westernized not only in its food, shelter, and clothing but also in its thinking, I came away impressed with the need for all Asian people to recognize anew the grand cultural traditions, the distinctive ecosystems, and the traditional pace of life engendered by the monsoon's annual outpouring. At the same time, I realized that Asia is not alone—that all regions of the globe have venerable traditions and, mores born of their natural circumstances and I came to believe it imperative that all peoples in all regions learn to understand and respect each other's cultures if we are to survive the 21st century.

This book is an effort to depict the daily lives of Asian peoples in the face of global weathers patterns. It is an attempt to convey some of the personal drama of these people caught between heaven and earth, between the sea and the sky. As such, I hope it might contribute in some small way to a better understanding of Asian realities.

While many people helped in large ways and small to facilitate this book, I would like especially to thank Japan Red Cross Society Vice President Tadateru Konoe, former International Federation of Red Cross and Red Crescent Societies Deputy Secretary General Kouichi Watanabe, and Marubeni Corporation Senior Vice President Hideya Taida for their generous support. Likewise, I would be remiss were I not to thank, my wife, Midori, who has long and uncomplainingly served as my interface with the non-camera world and has been invaluable in bringing this project to fruition. It feels good to be able to share the joy of completion with her. Finally, of course, I would like to express my profound appreciation to all of my many Asian friends who made me feel so welcome as I photographed their lives.

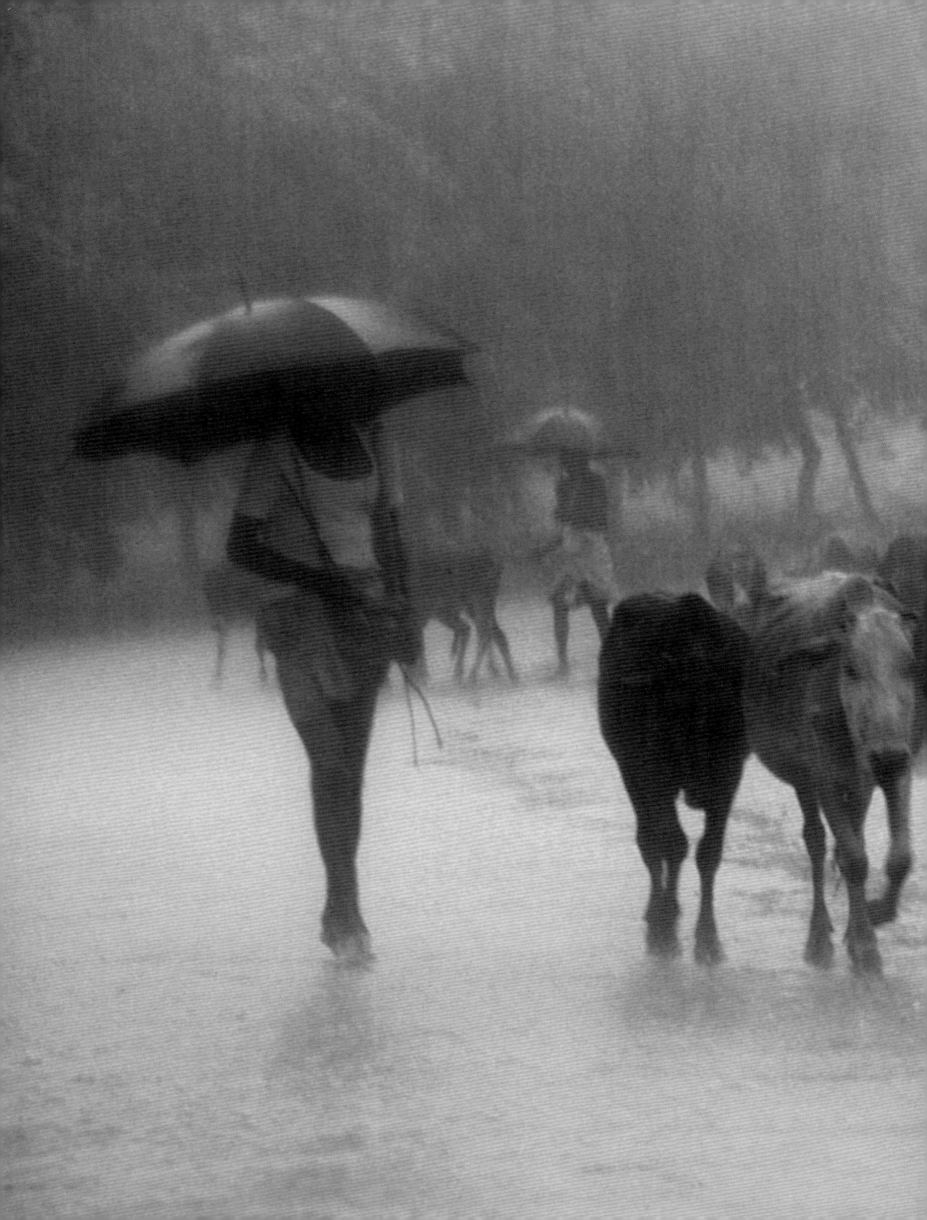

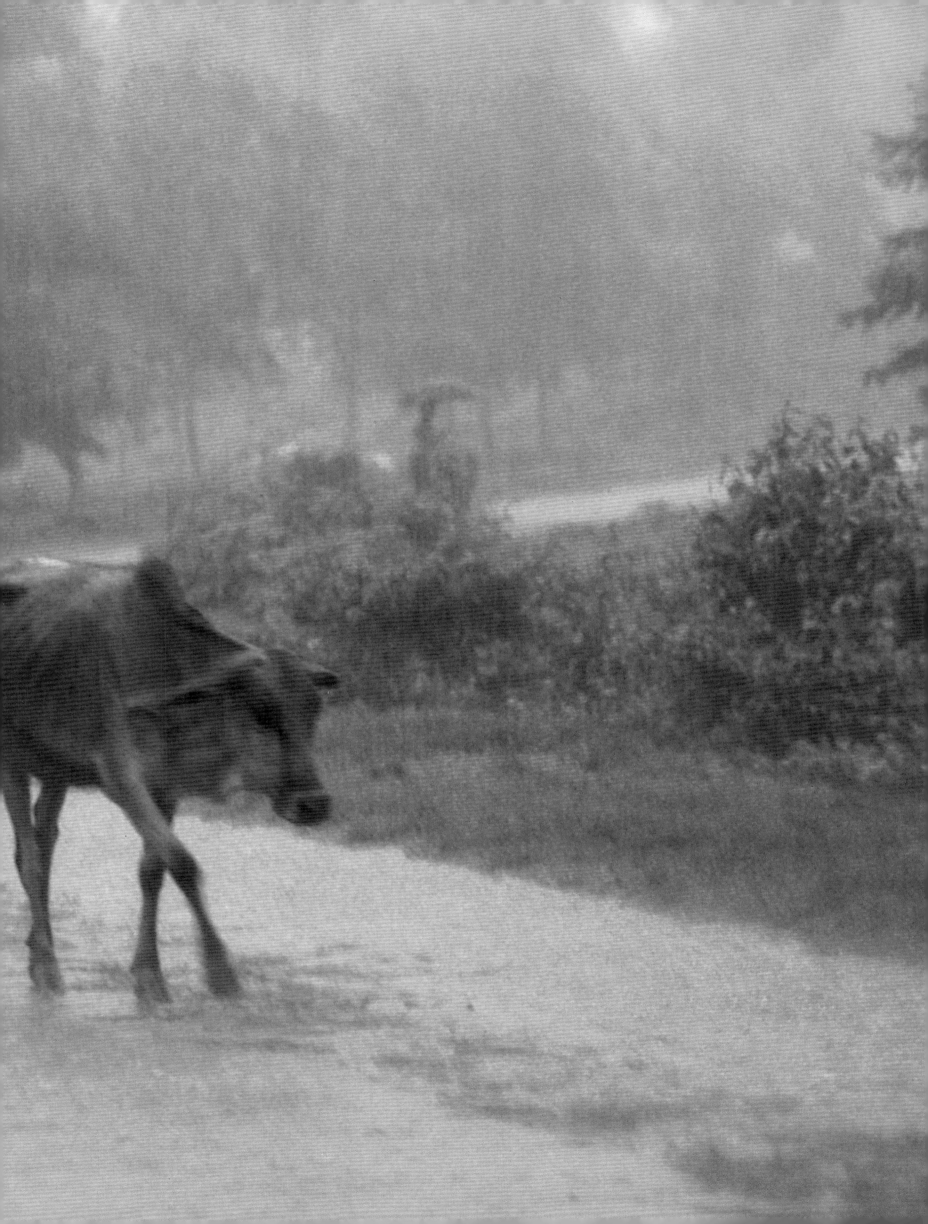

THE BAY OF BENGAL

India
Bangladesh
Sri Lanka
Myanmar

Giving myself over to the eternal Ganges, lying in a boat drifting with the flow, I gaze up and try to read the clouds. As they move across the heavens, these clouds seem to tell of the people's history and my own today. Living on the Indian sub-continent, one develops a languid outlook on life. Time flows at a more stately pace here, and the people are unknowingly drawn into the wonders of philosophy.

This is the part of Asia where the monsoon's impact is more pronounced. This is where the dry season and rainy season are most distinct. In the rainy season, the land is beset with sudden onslaughts of squalls, cyclones, and flooding that take countless lives. During the dry season, there is no rain and the tropical sun beats down unrelentingly, parching the land and taking countless more lives. These extremes of climate wreak havoc on farming and fishing alike, producing food shortages and the threat of starvation. While this region has long been heavily populated, the people are no match for nature, and their lives remain at the mercy of this merciless climate. In resignation, people recognized the folly of considering humankind supreme and sought to come to terms with life as it is. Little wonder this region is the birthplace of Buddhism, Hinduism, and many other religious philosophies.

There is, however, a gentle rain that falls in this region called "the mango shower." This rain typically falls when the delicate-green mango fruit is just forming on the trees, and it is a welcome rain that waters the roots and grows the fruit. Brought by the monsoon winds, this rain nourishes more than the mango. It also revives the people, the livestock, the insects, and all other life after a long and droughtful season. As epitomized by this gentle blessing, the monsoon is not all harshness, and it is often a gentle, even maternal wind.

Gathering this water of life and flowing majestically through the land, the Ganges is regarded by many as a sacred river. Rather than fight the flow of nature, it is far better to give yourself over to the tides of time. Such is the wisdom of Asia nurtured over the ages.

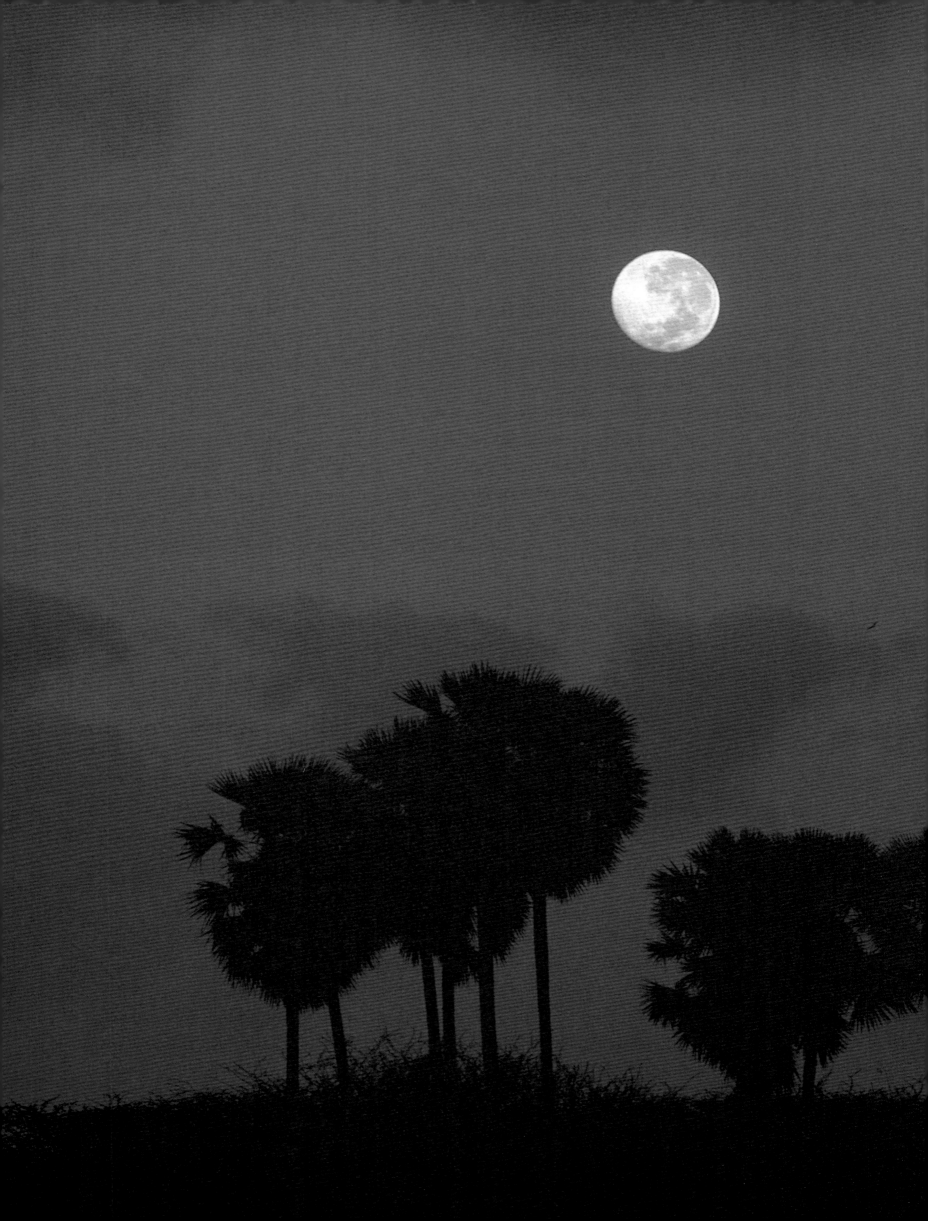

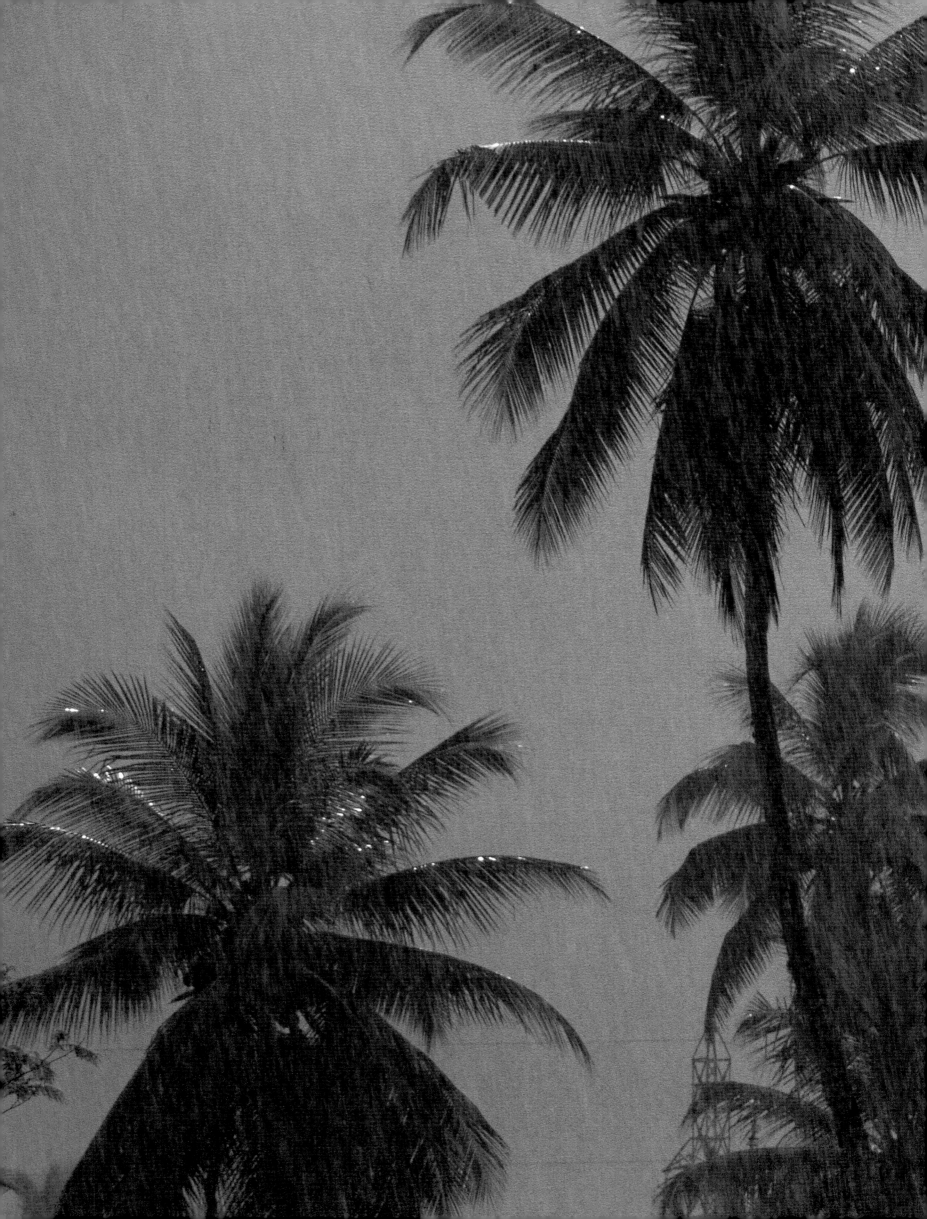

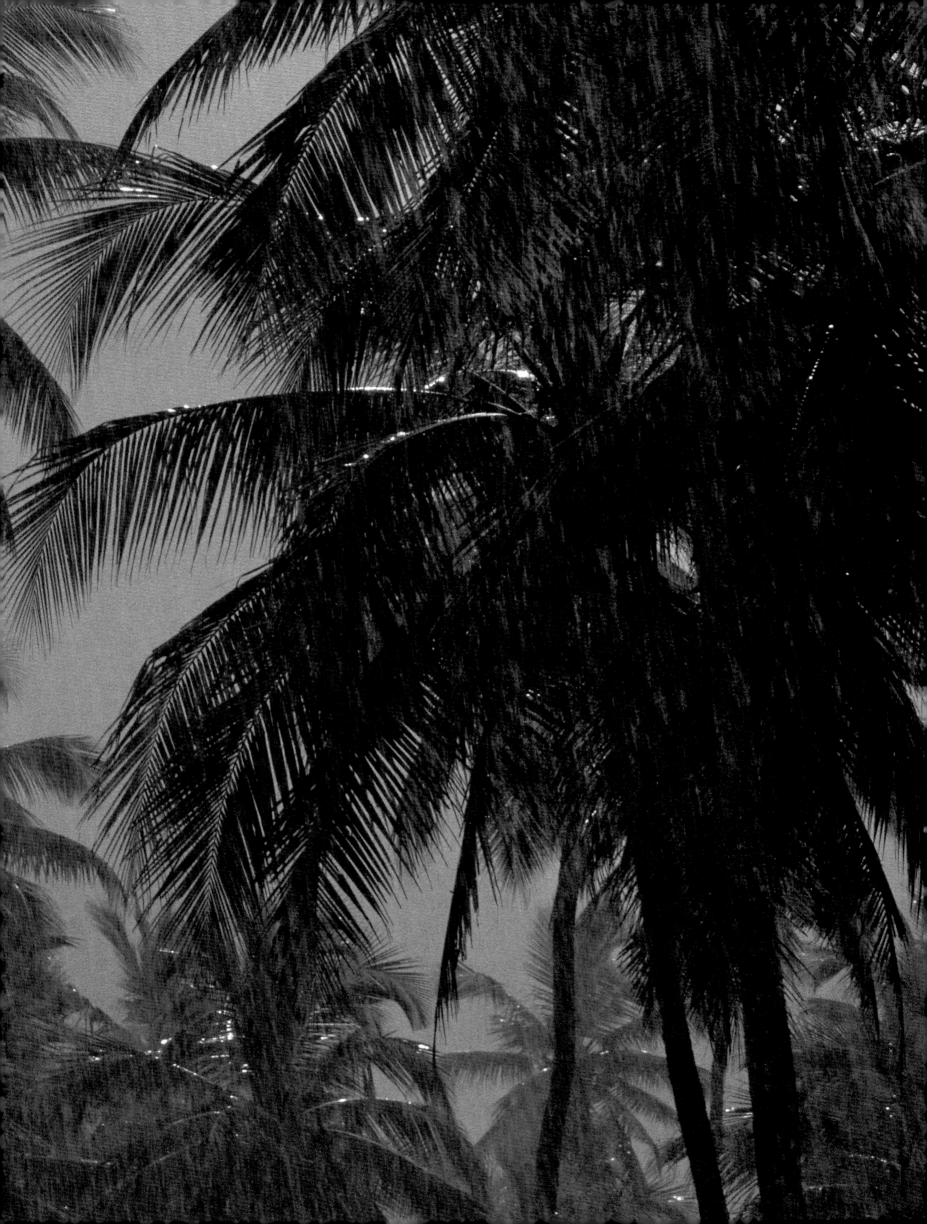

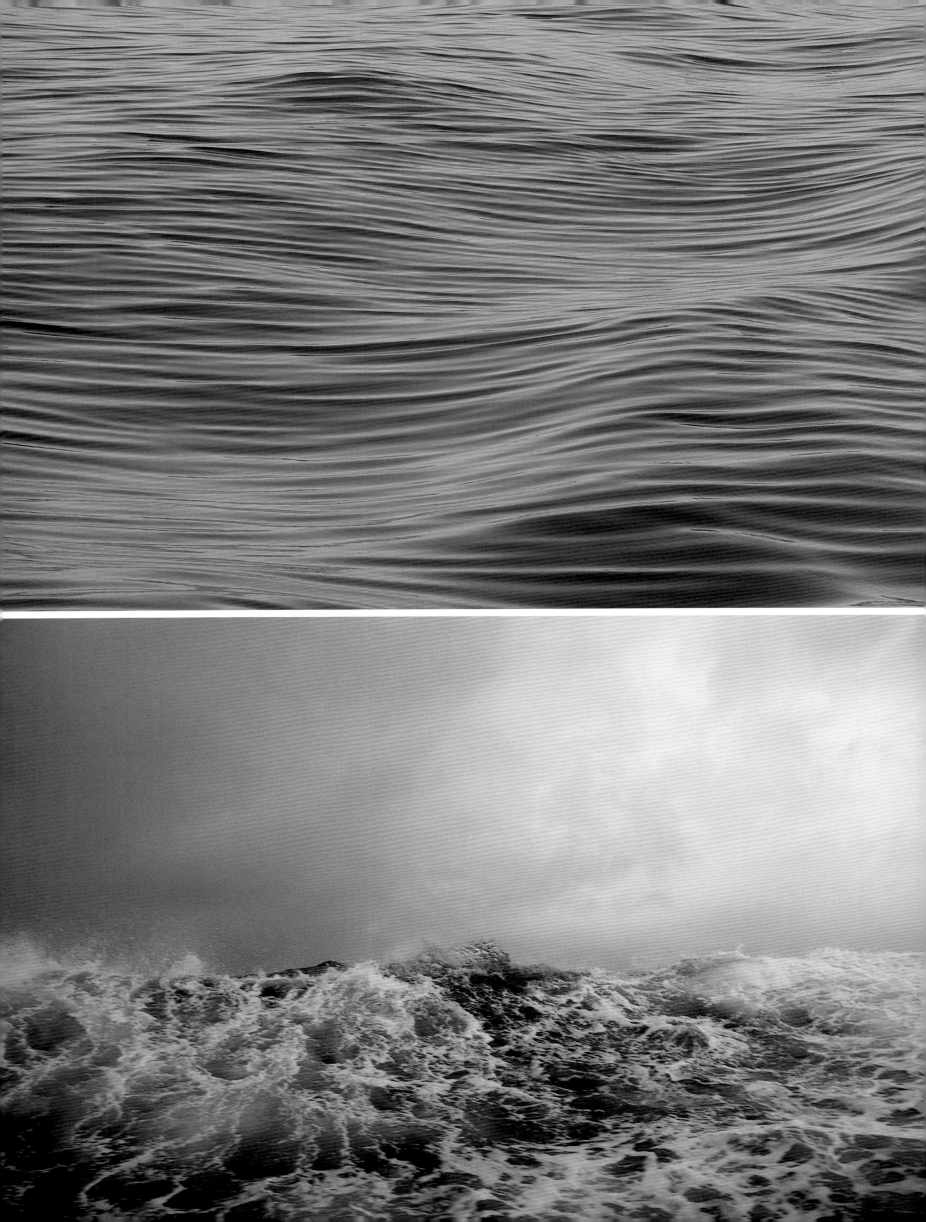

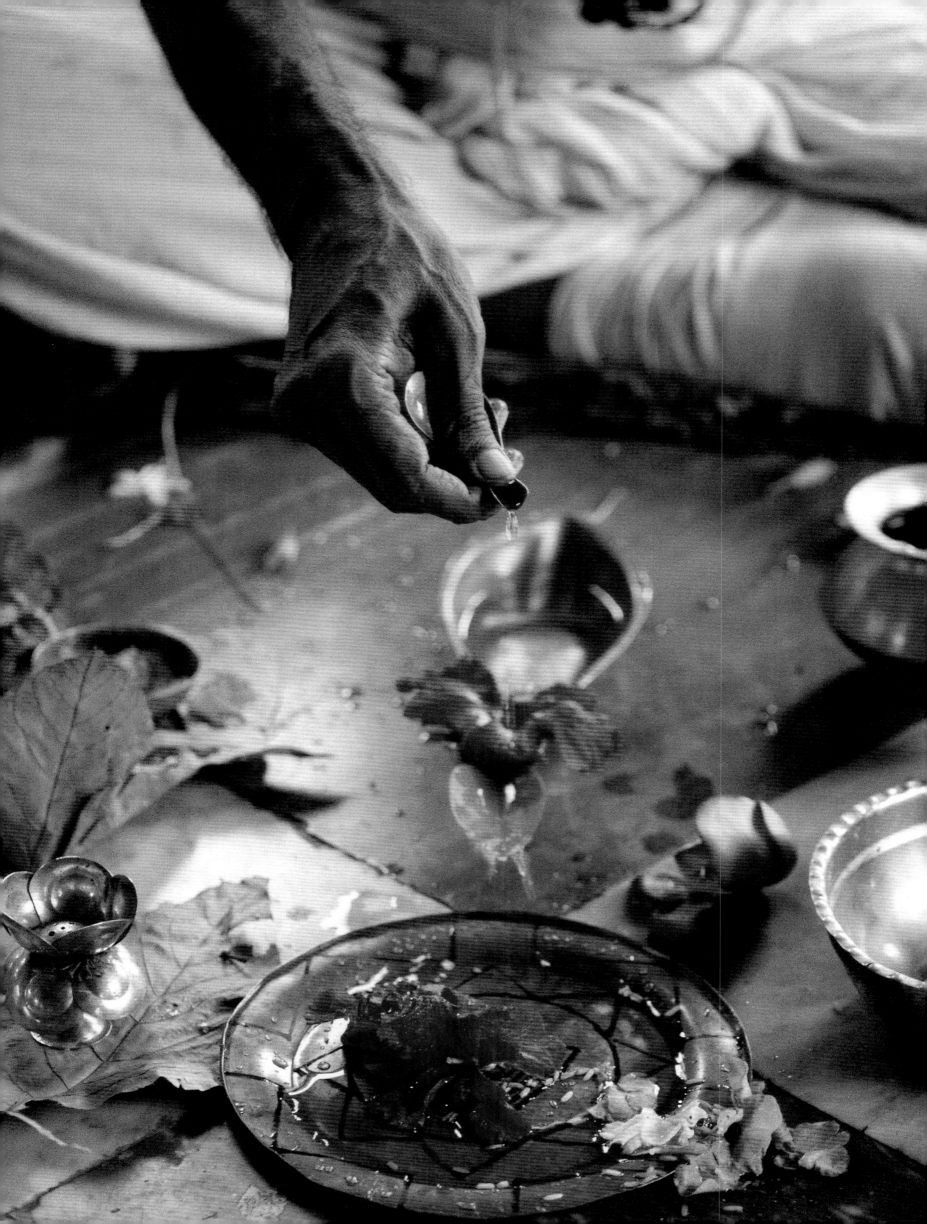

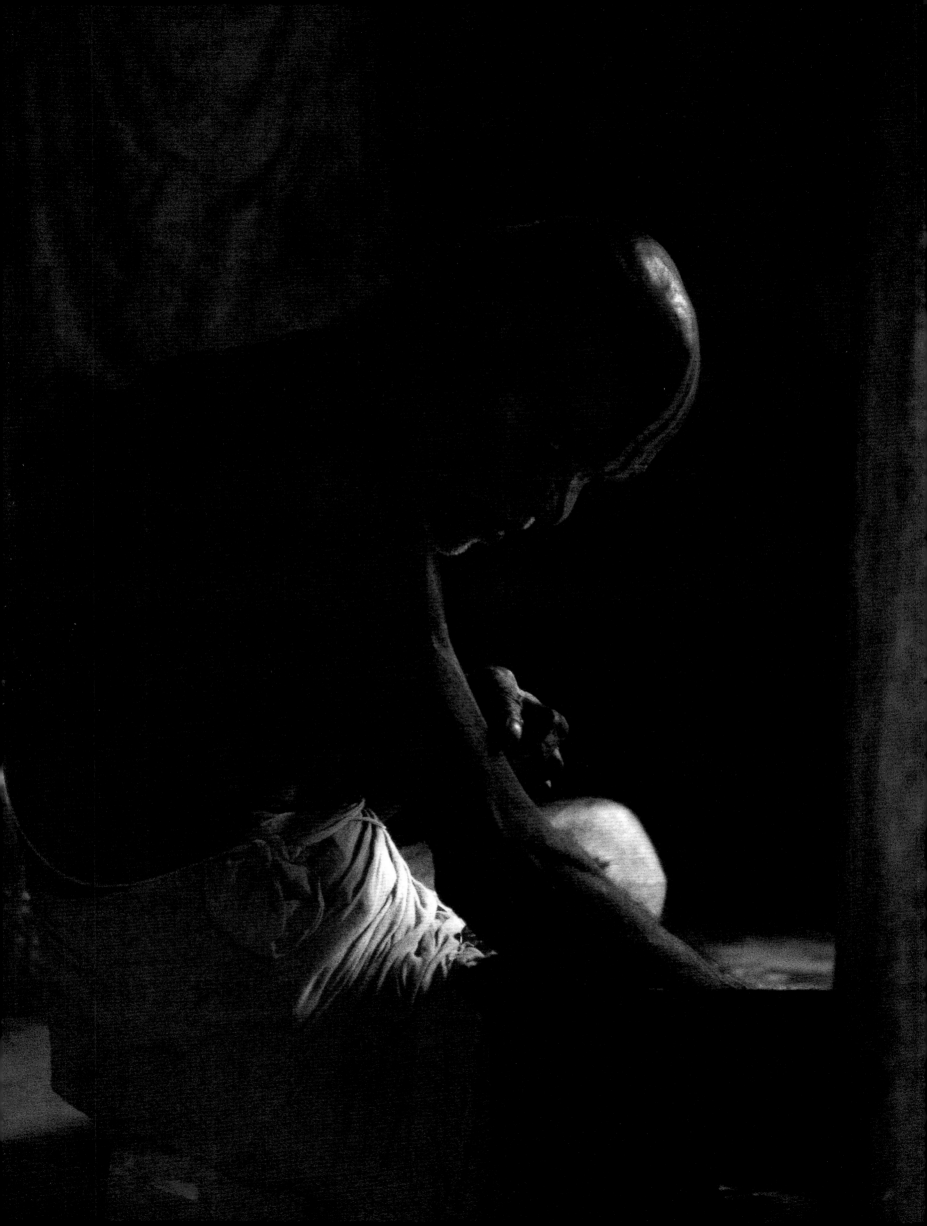

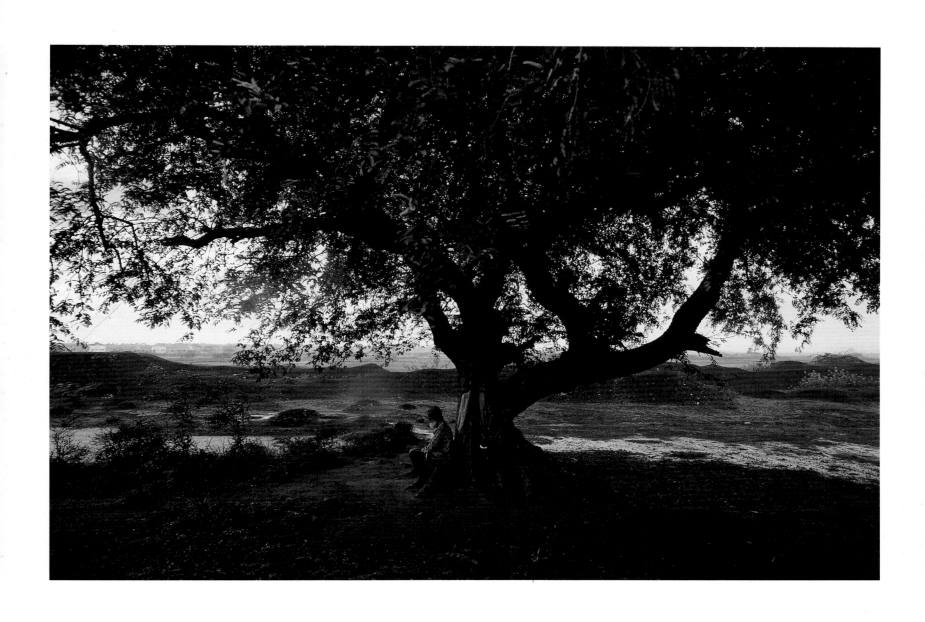

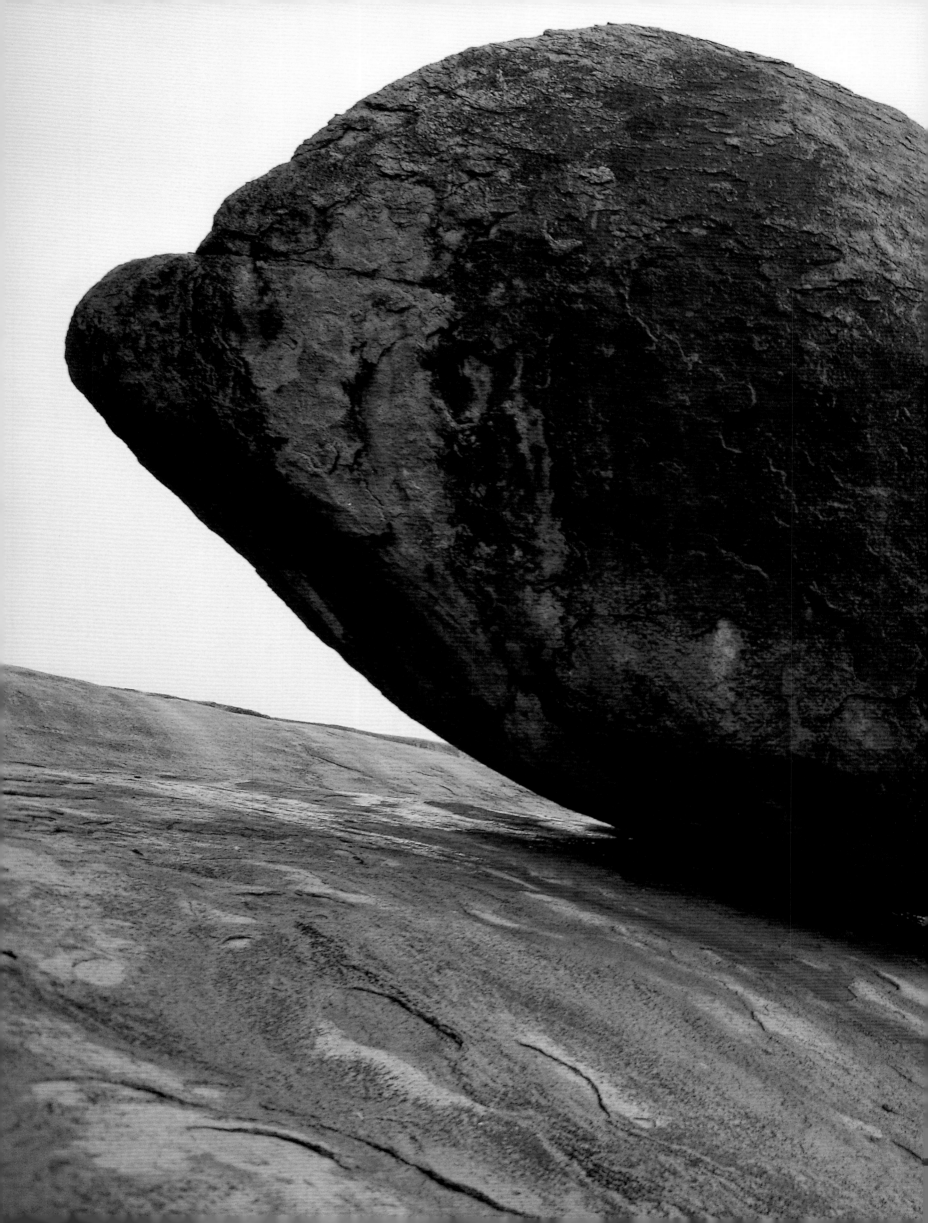

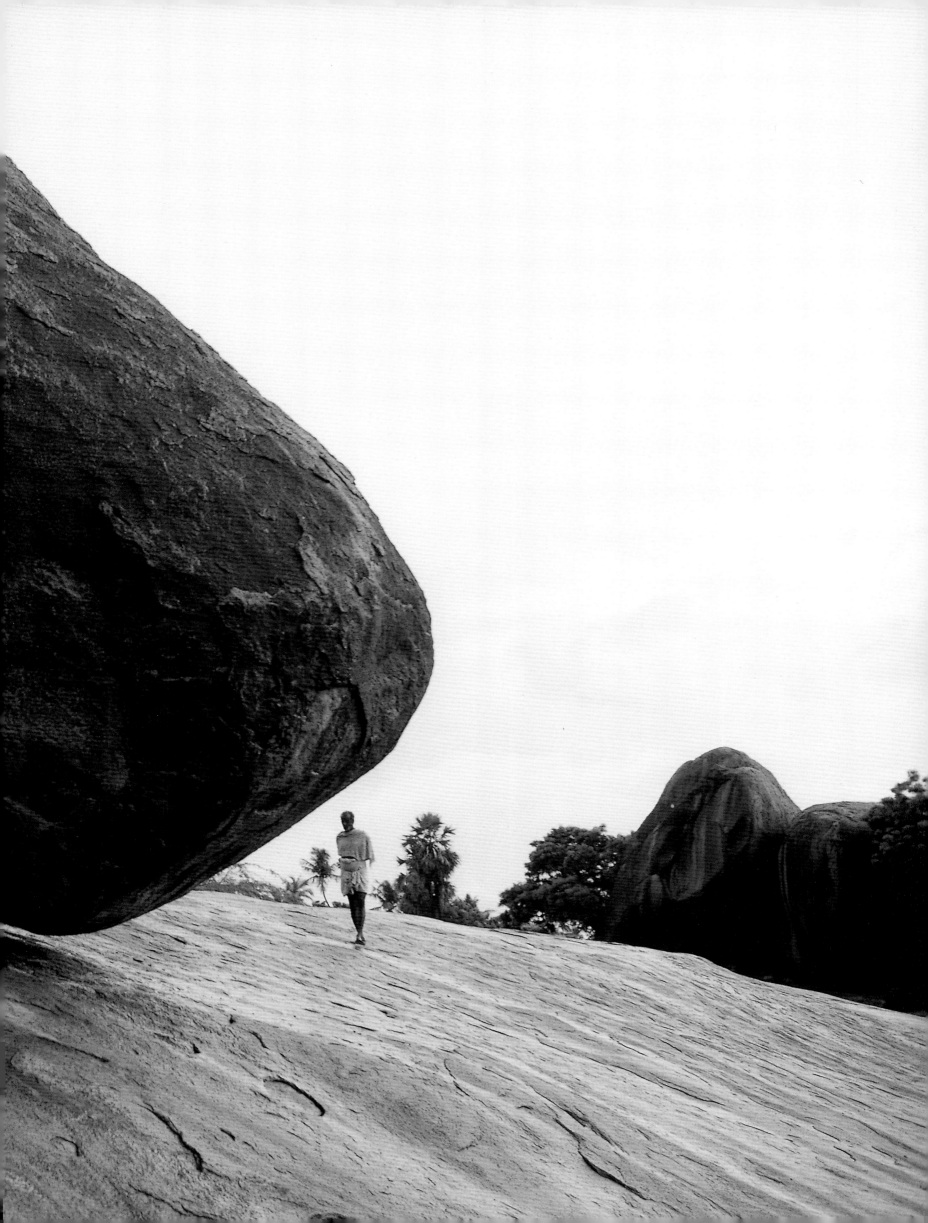

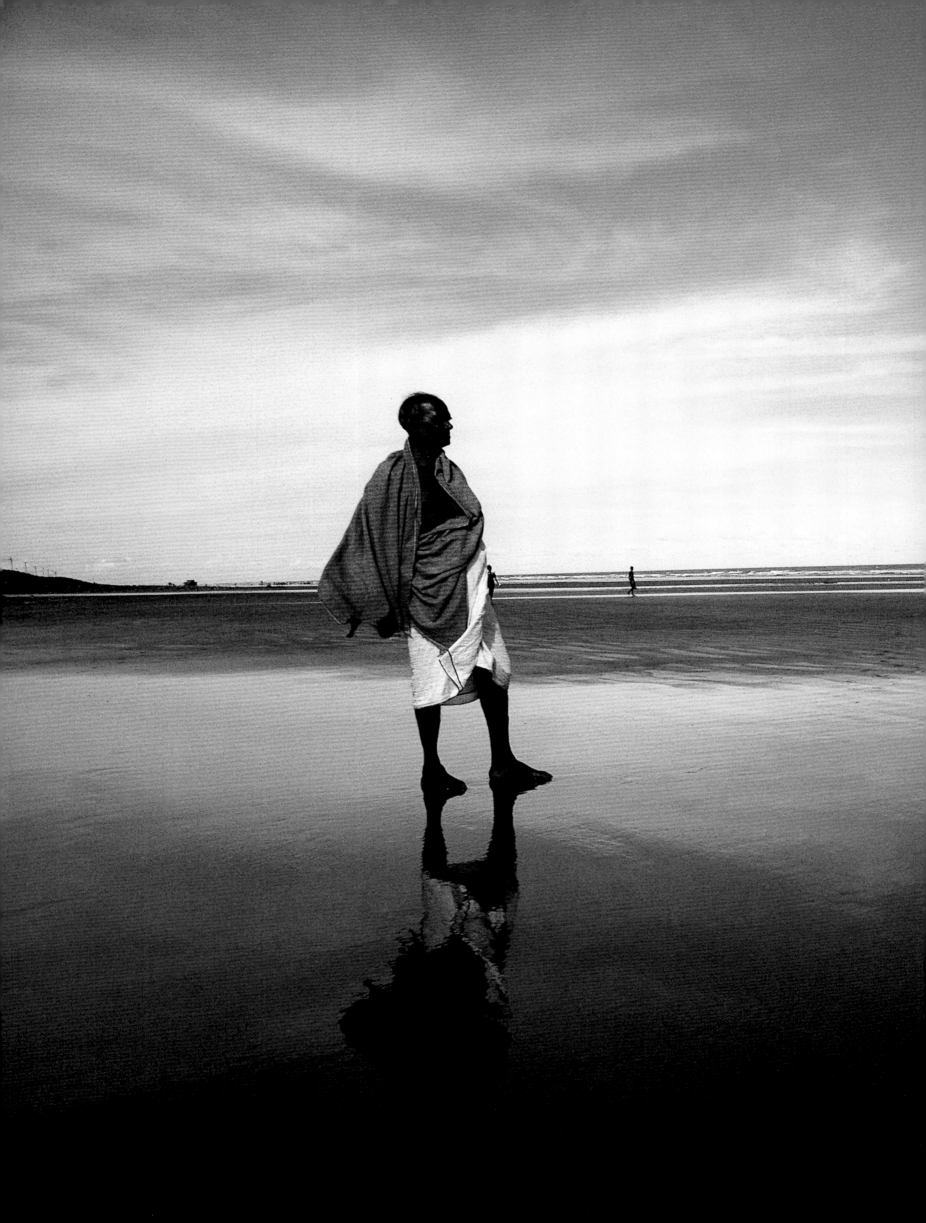

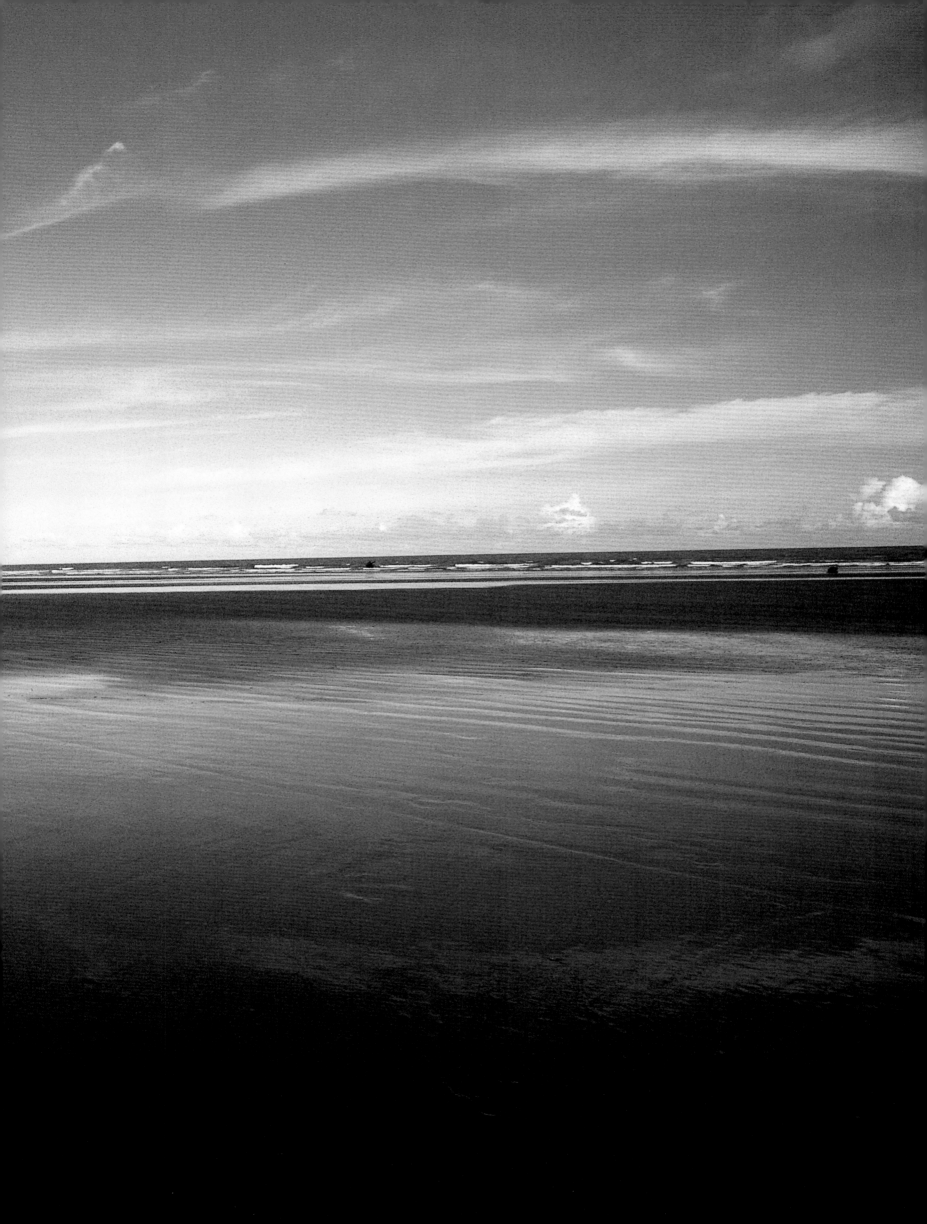

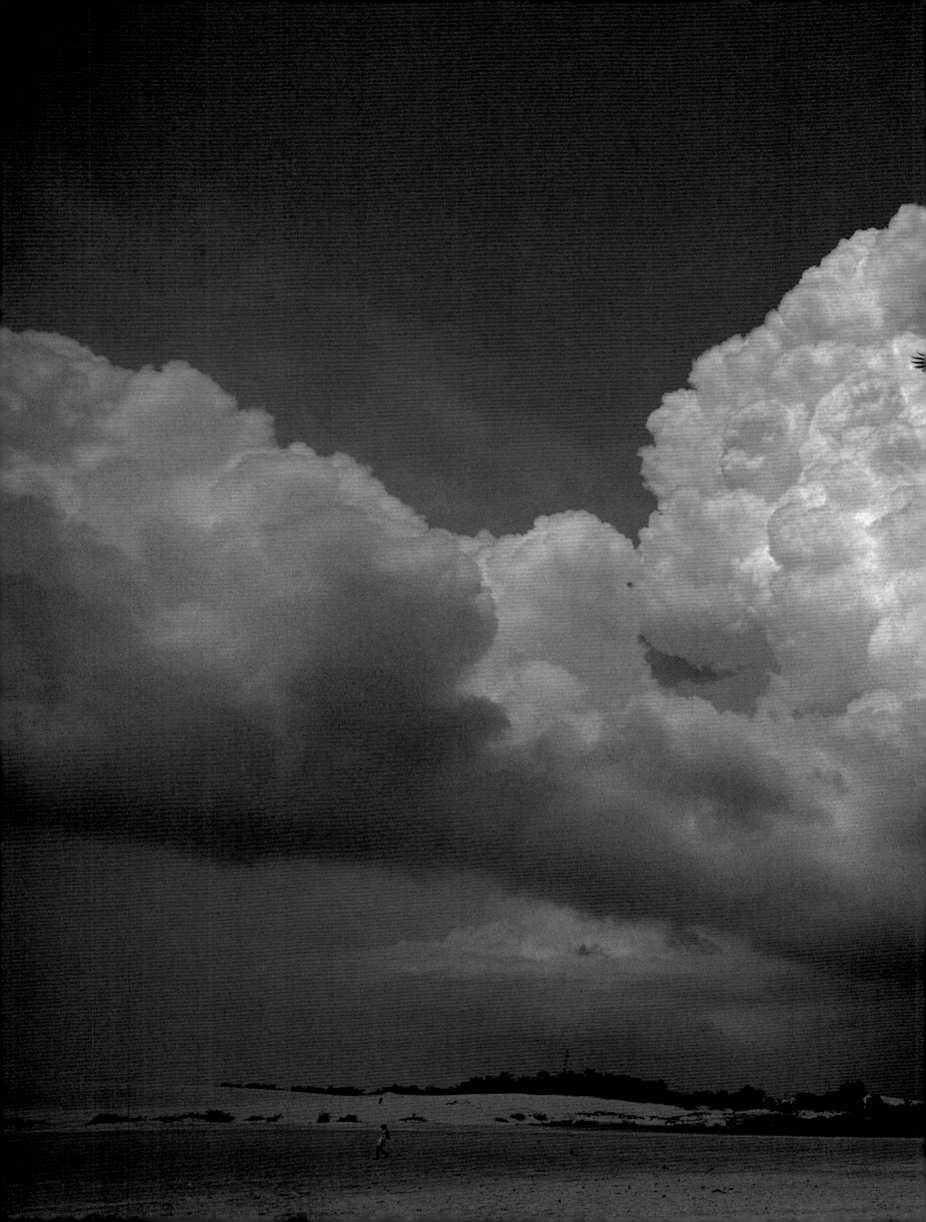

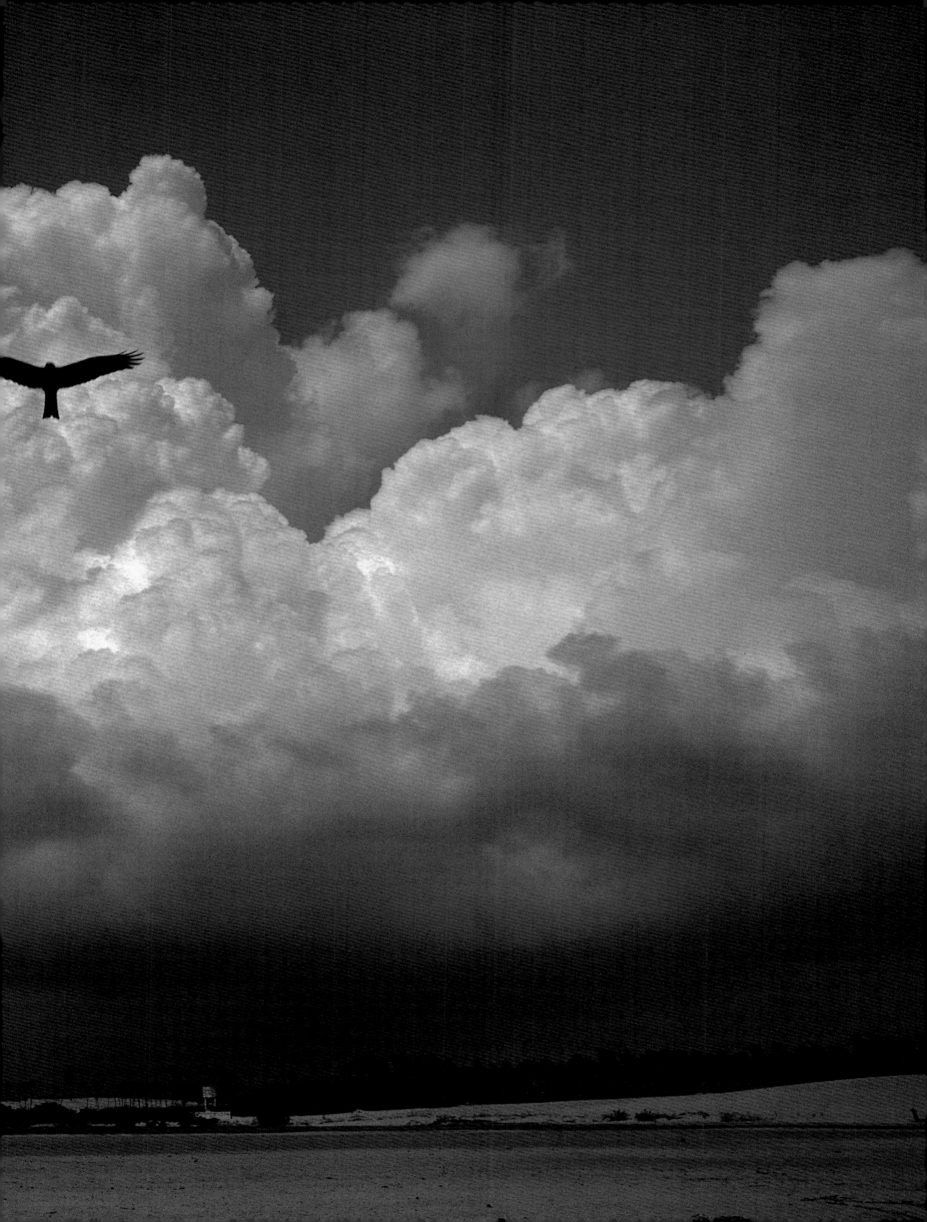

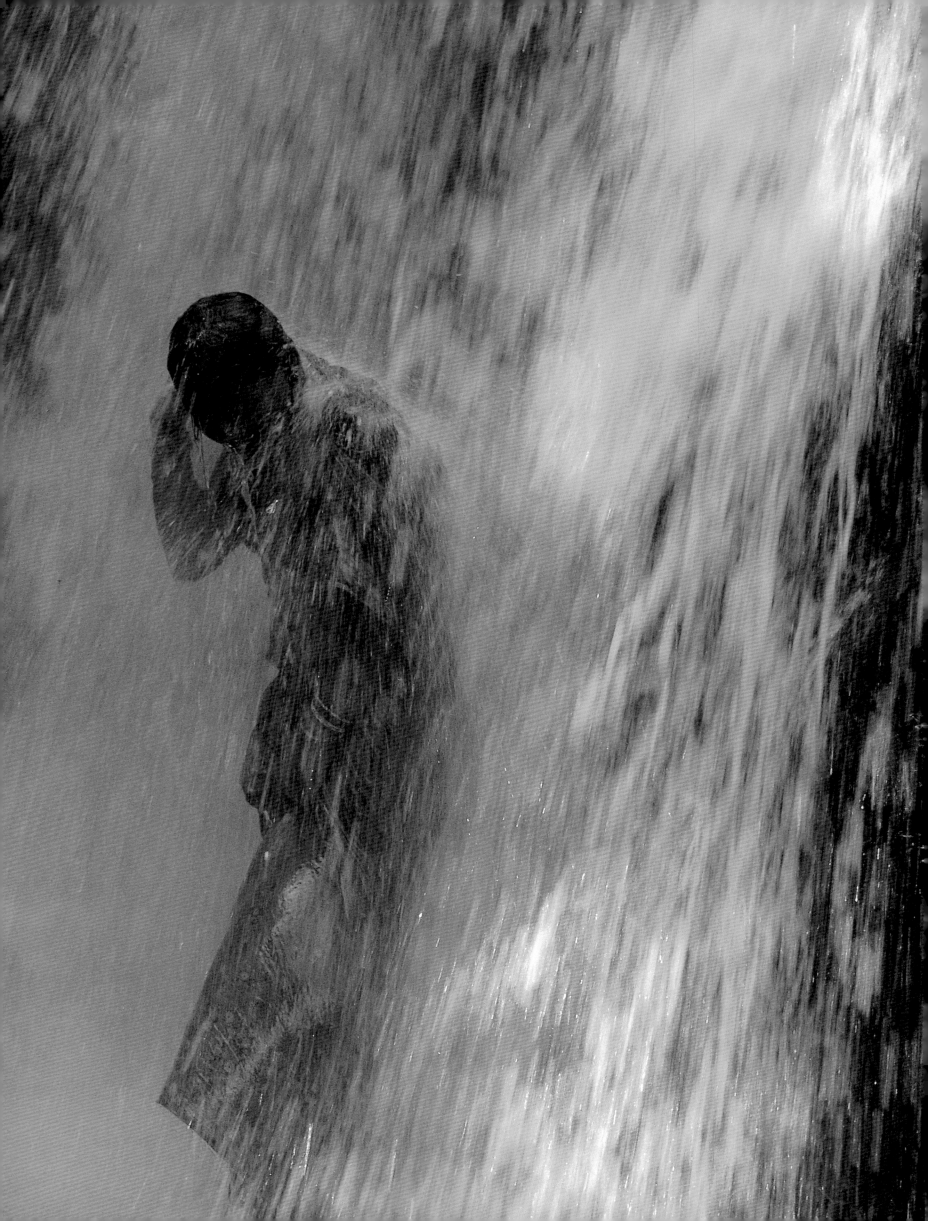

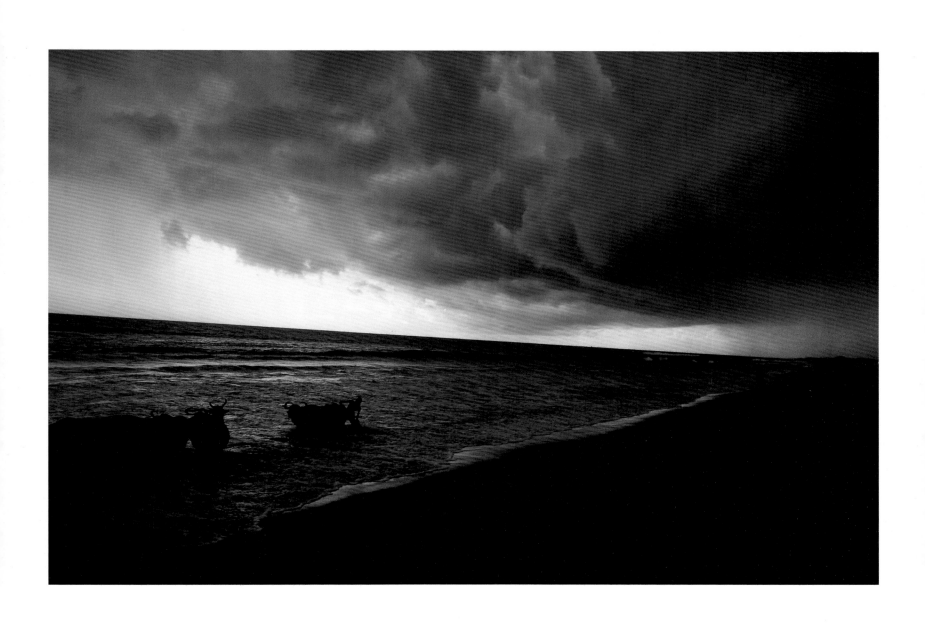

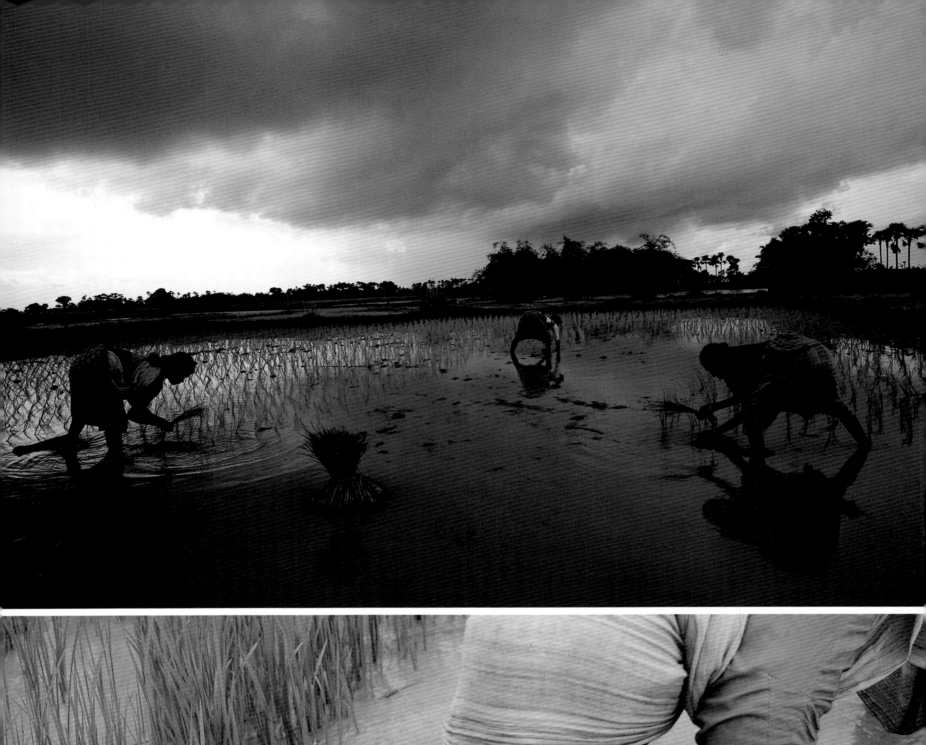
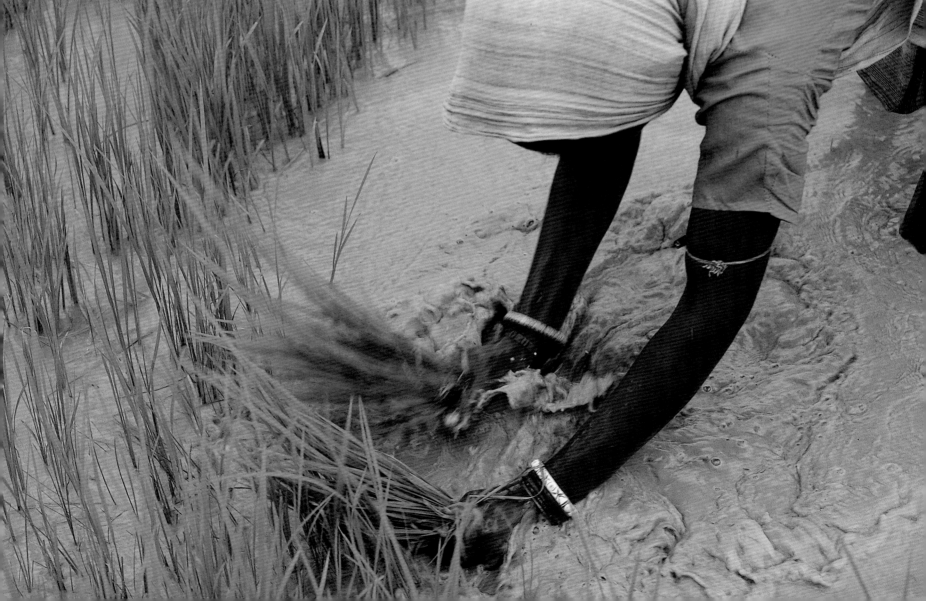

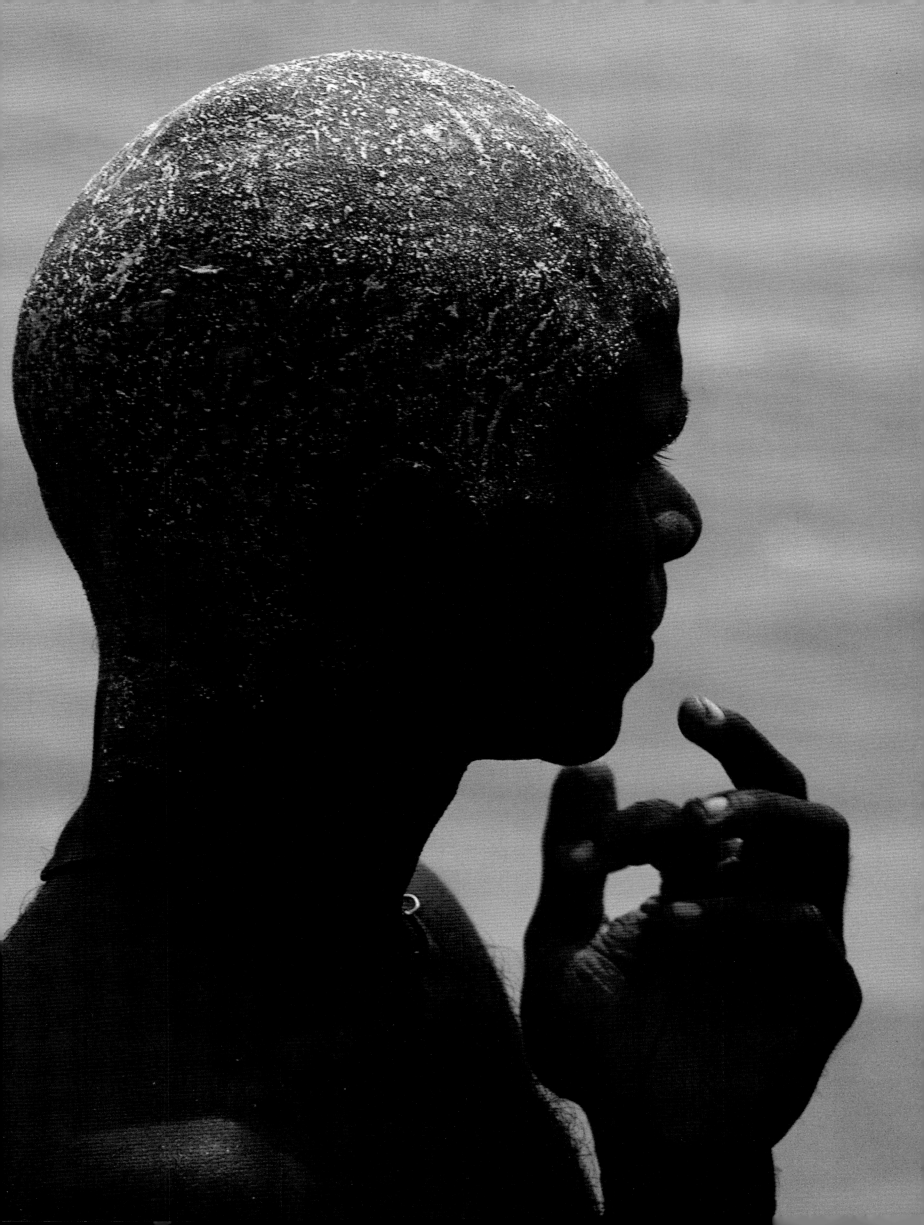

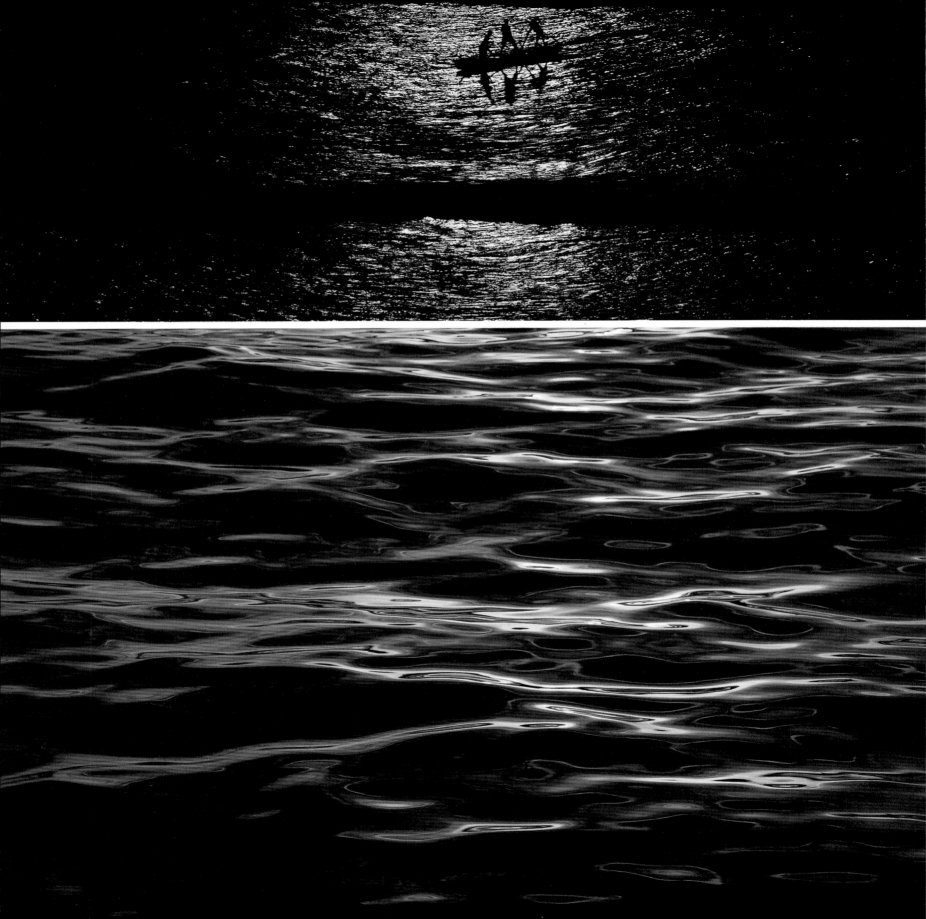

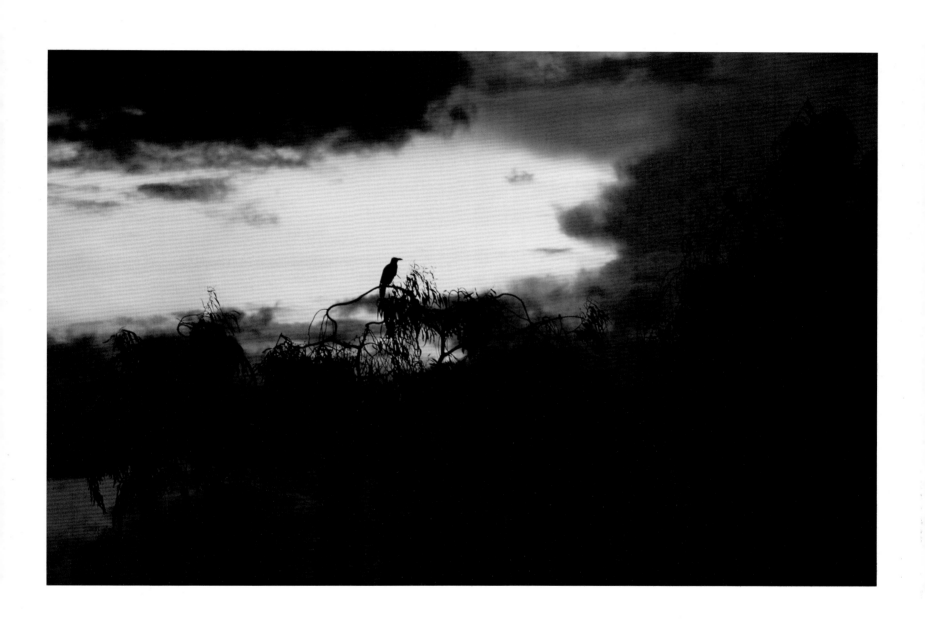

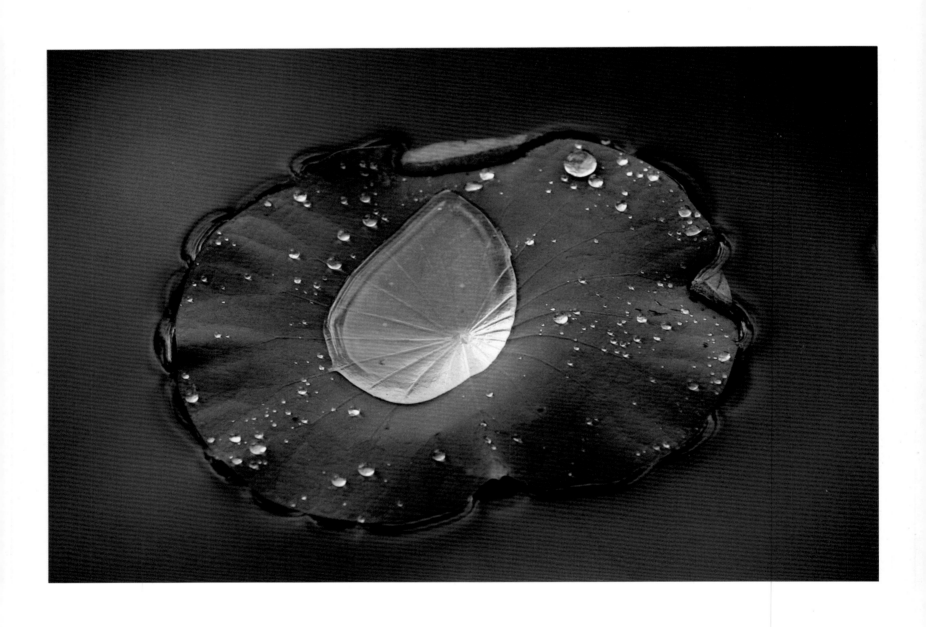

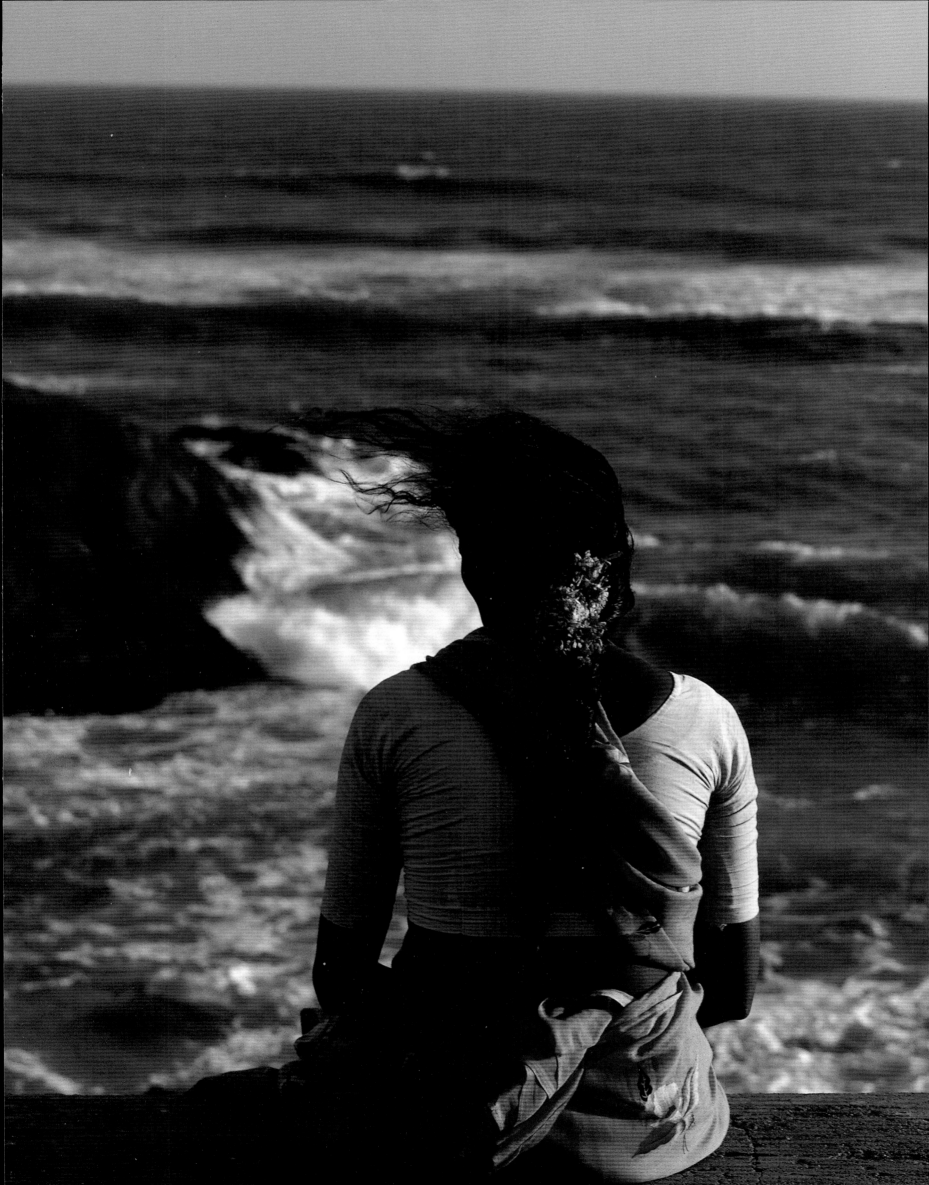

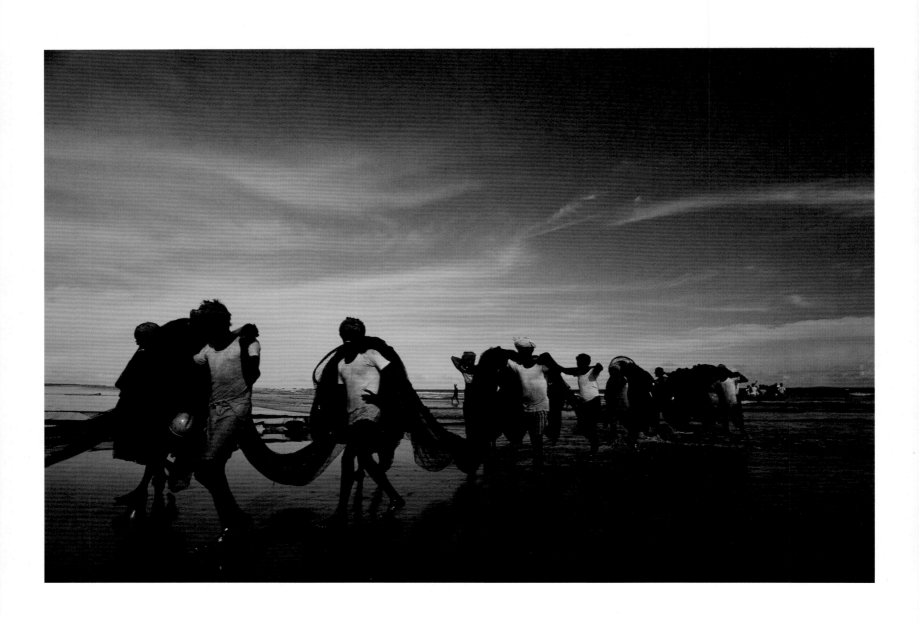

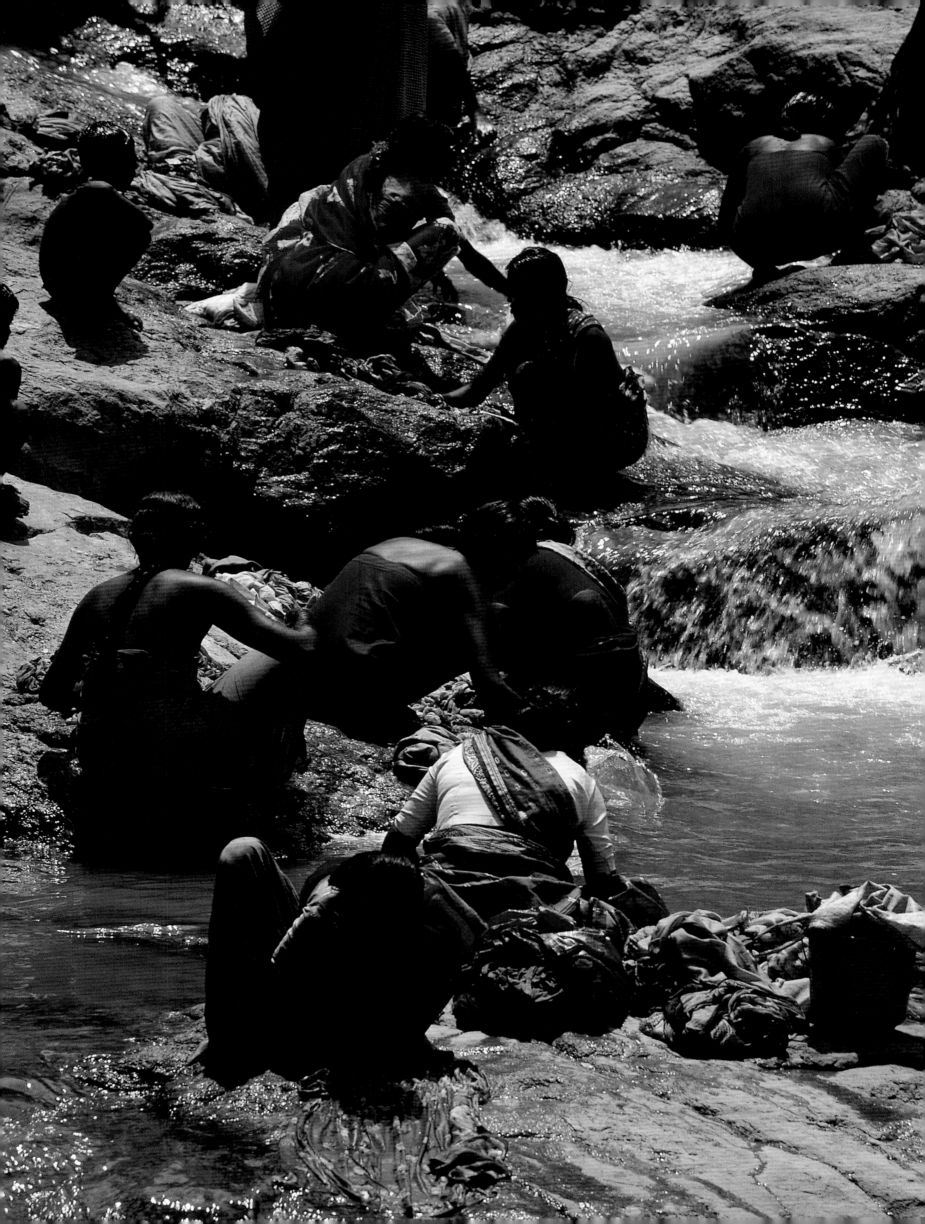

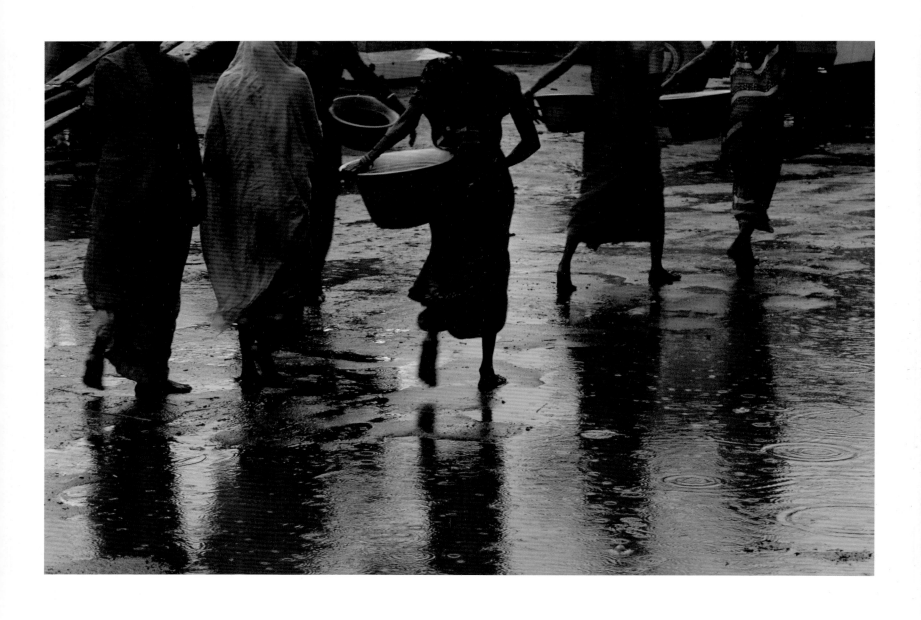

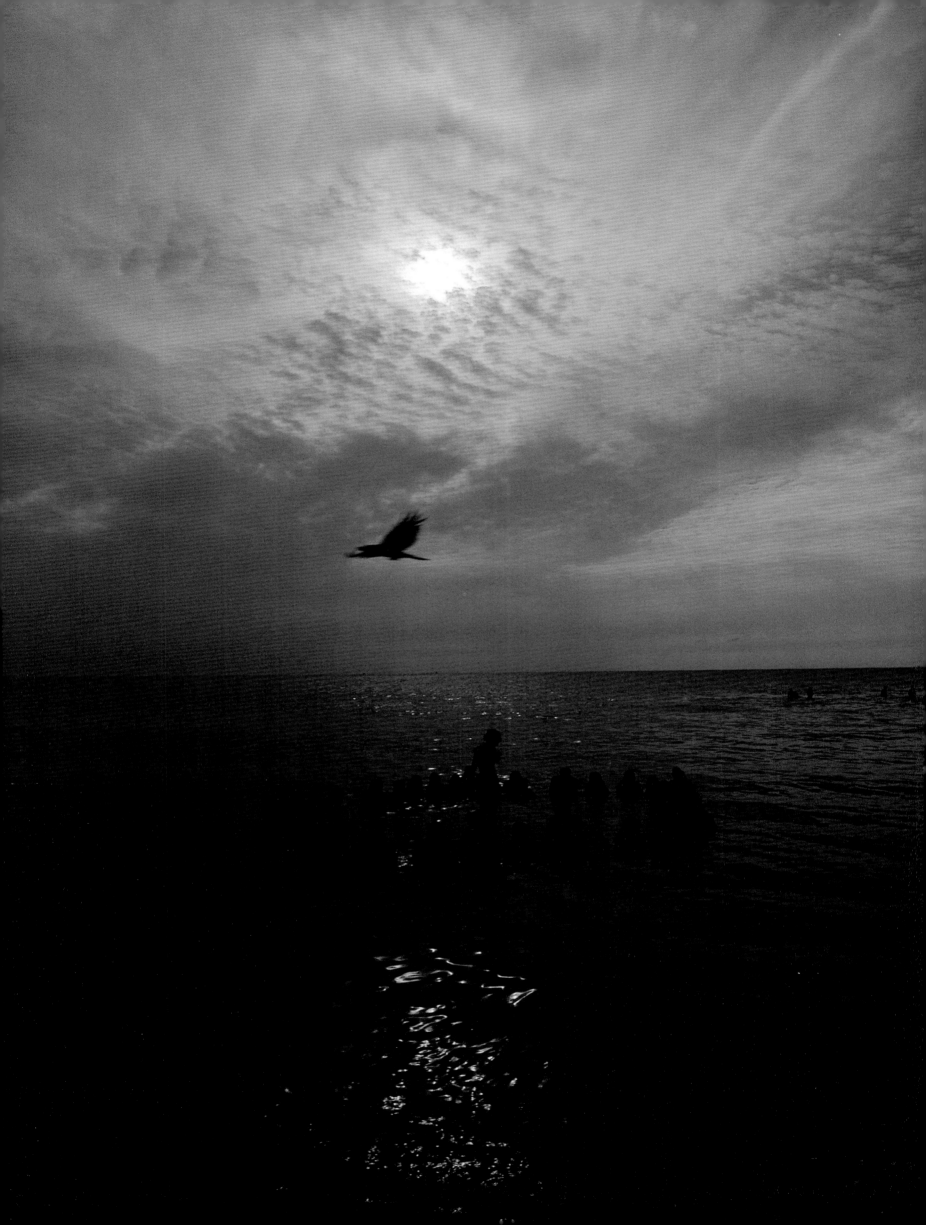

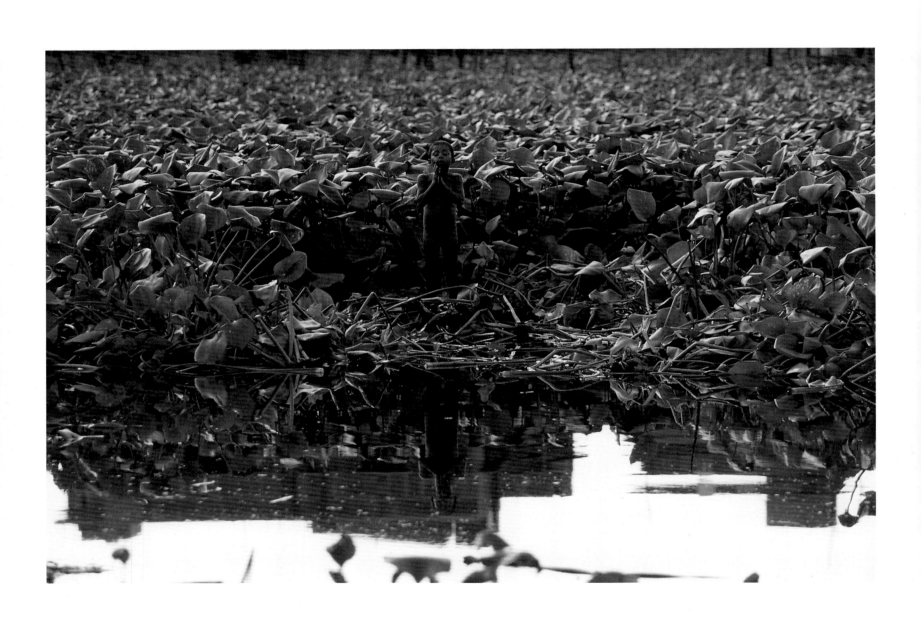

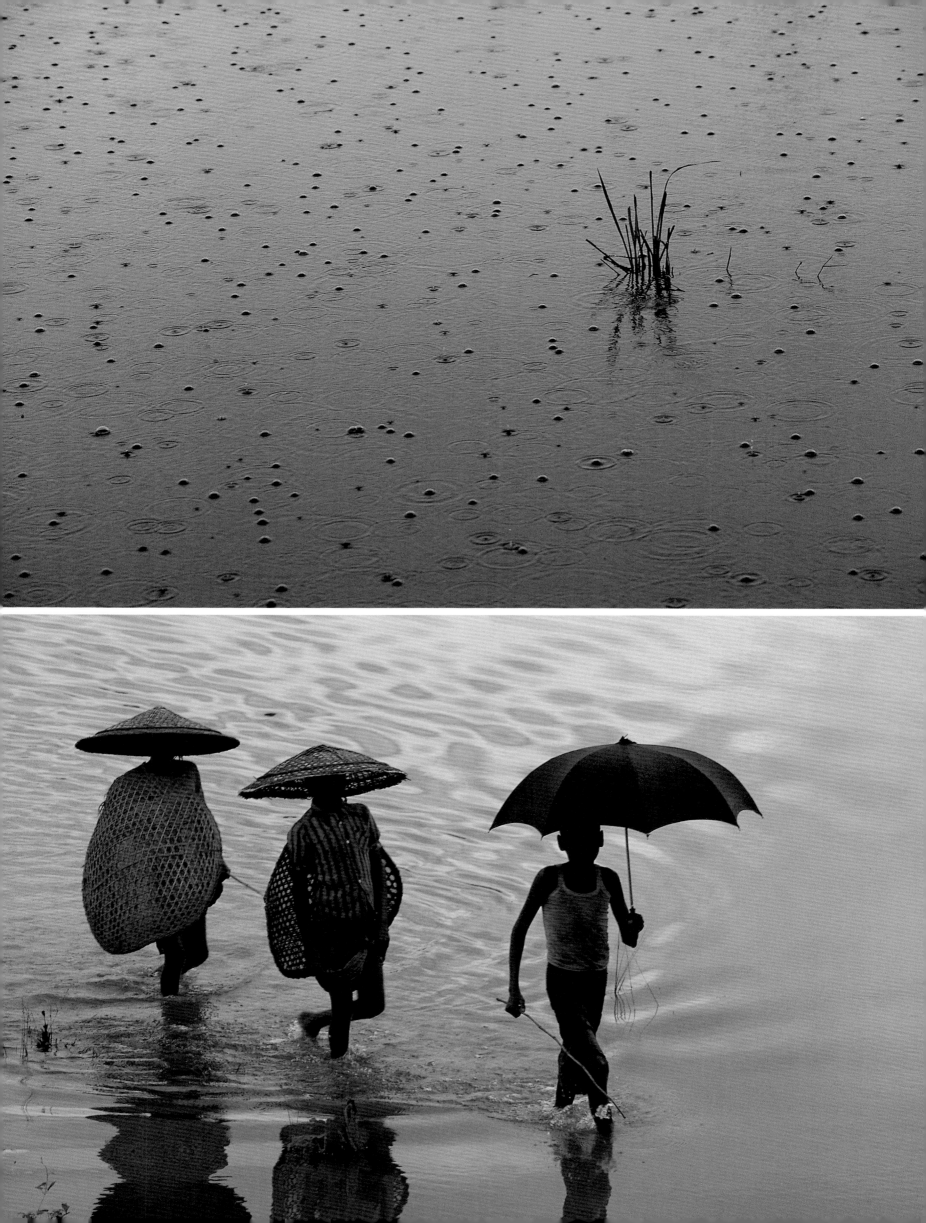

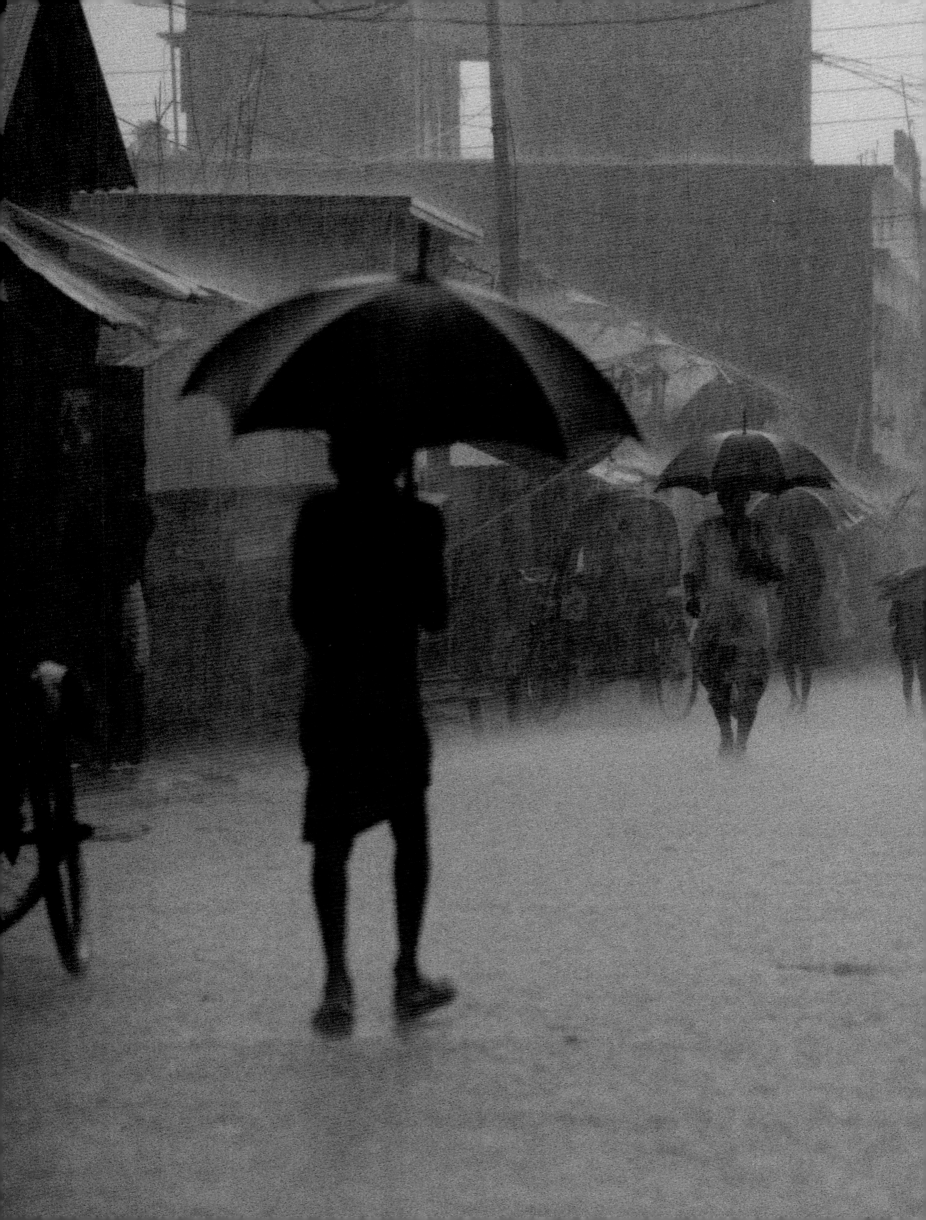

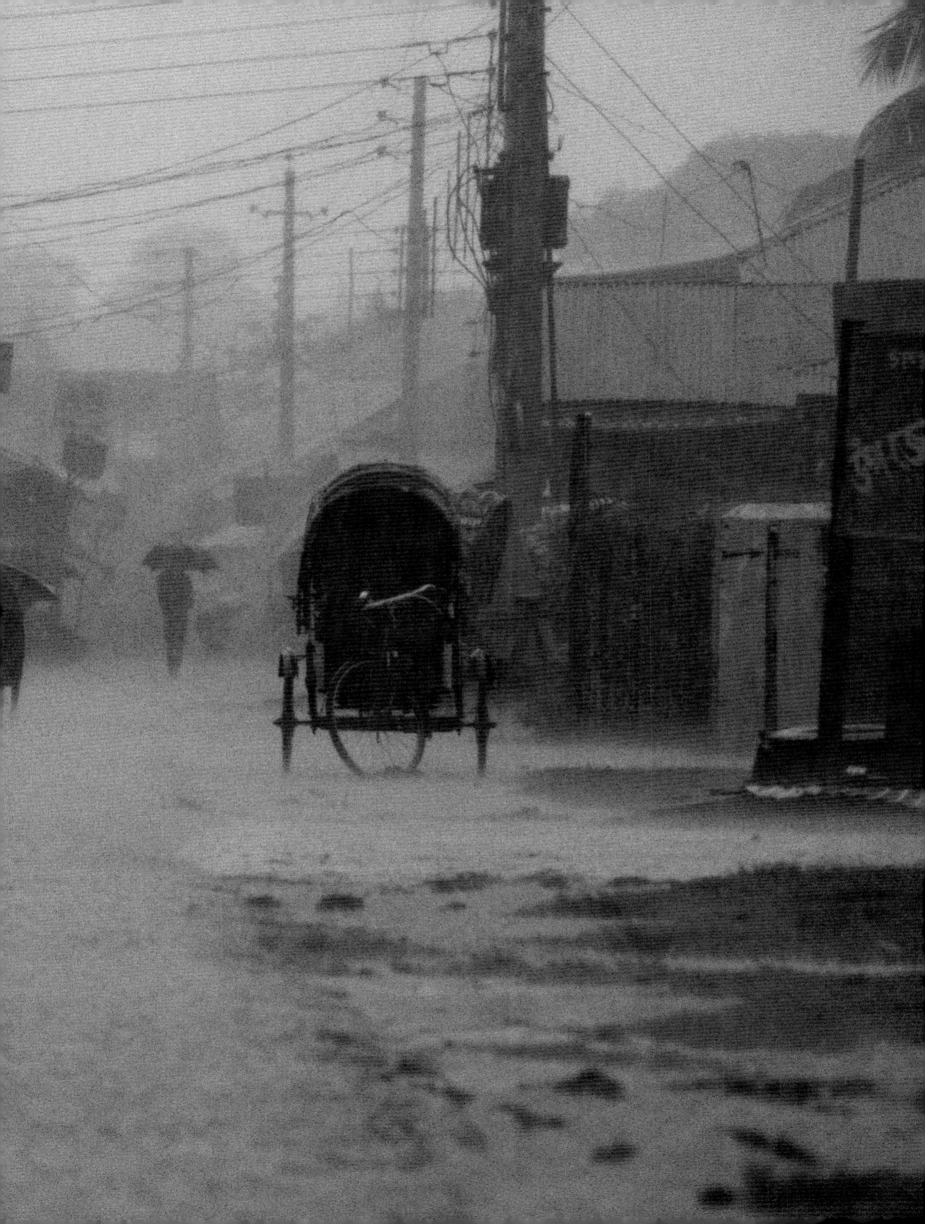

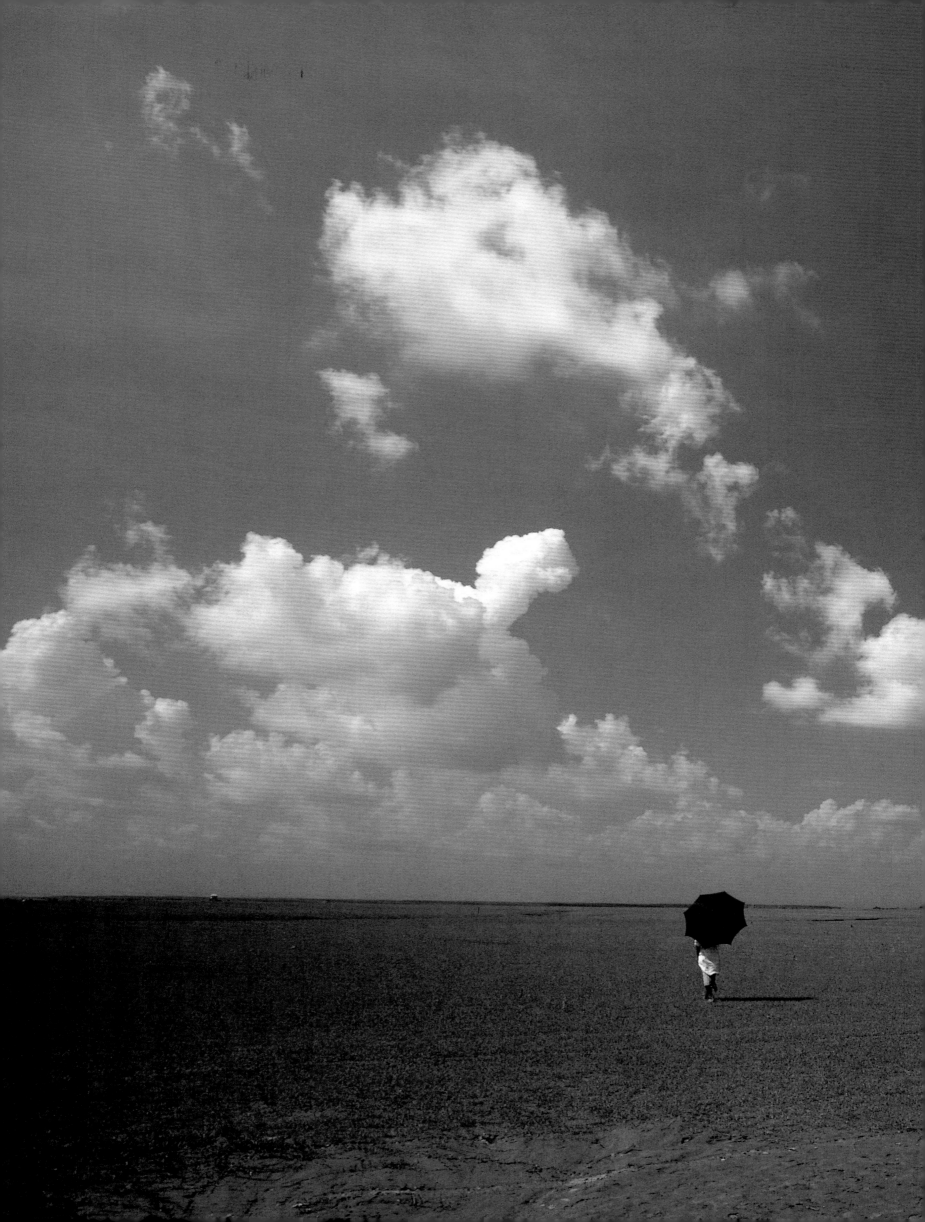

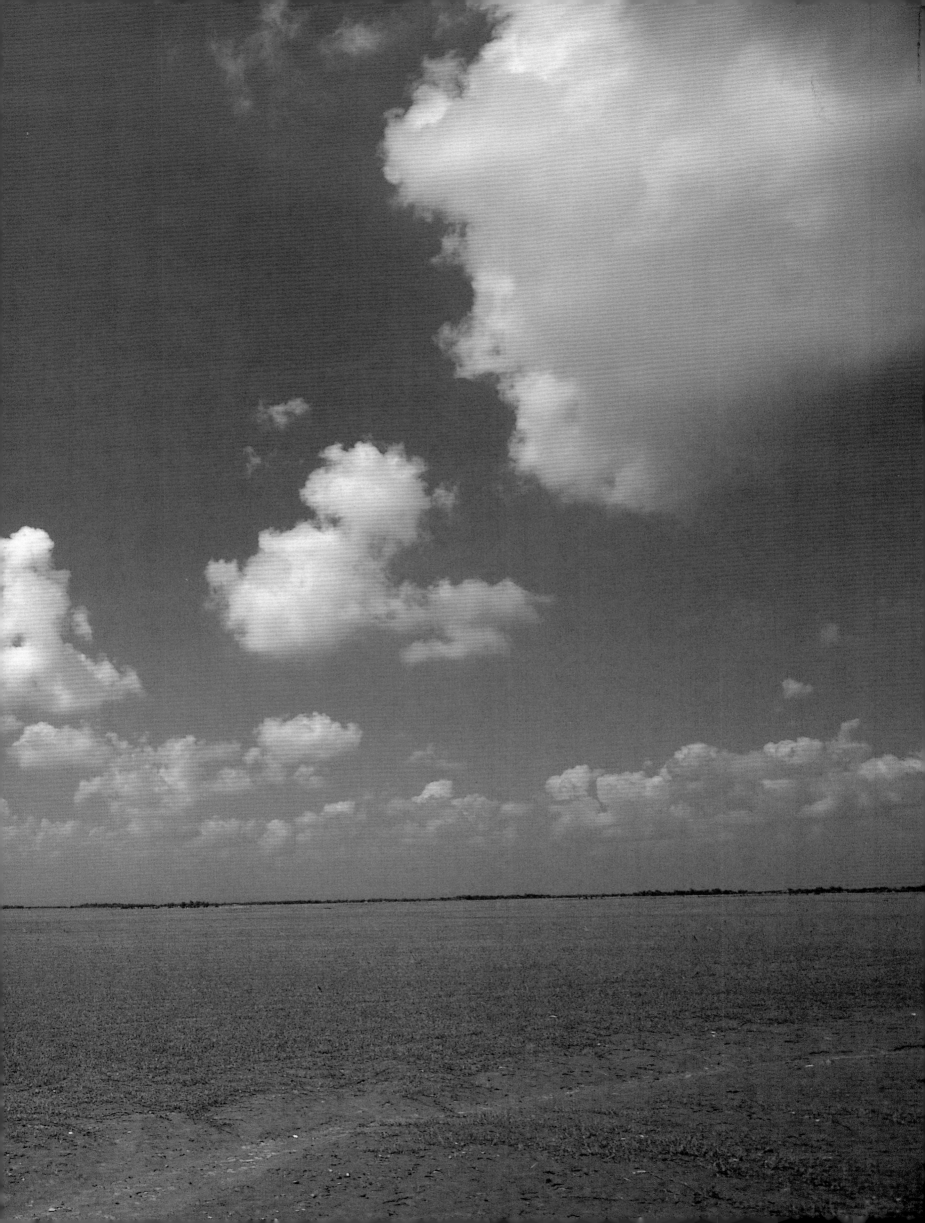

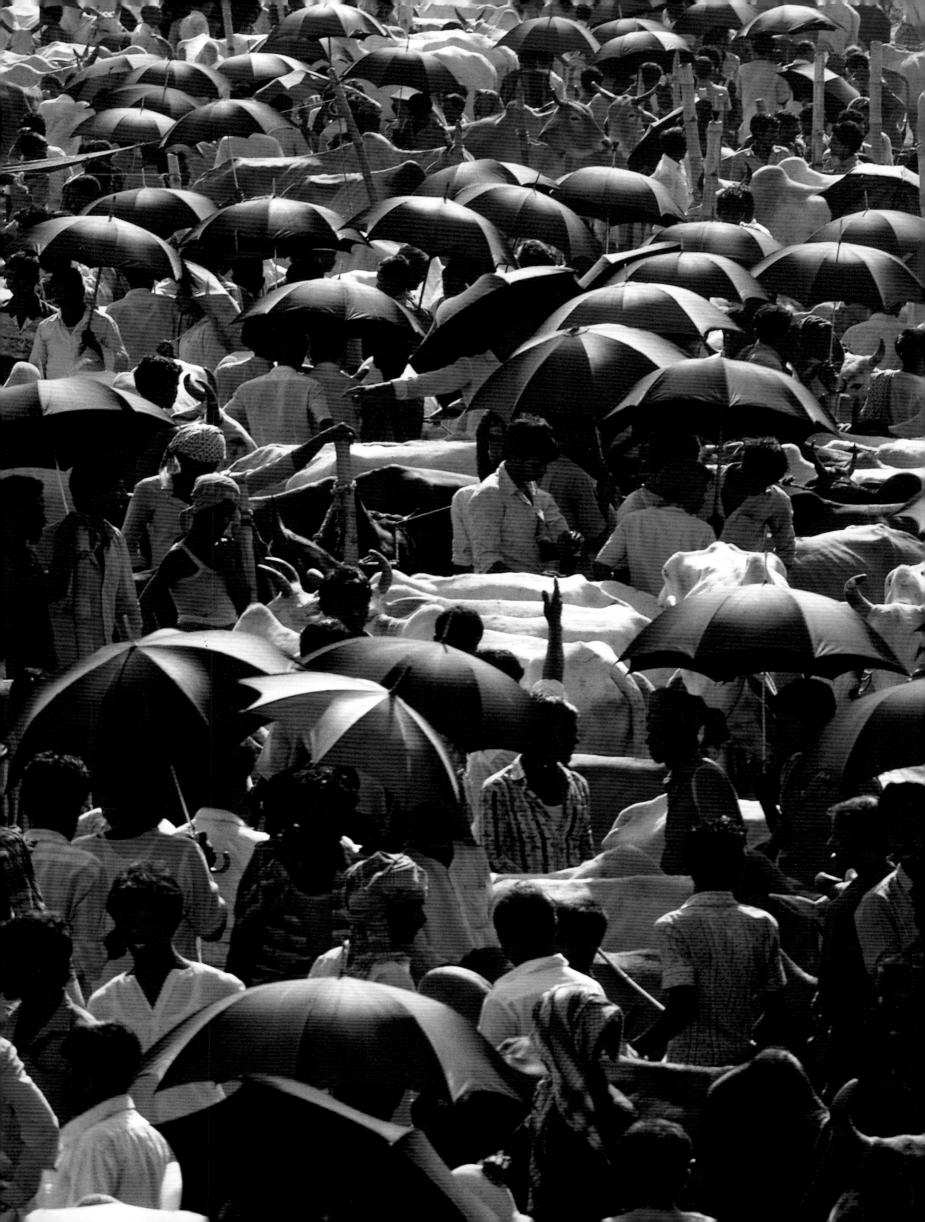

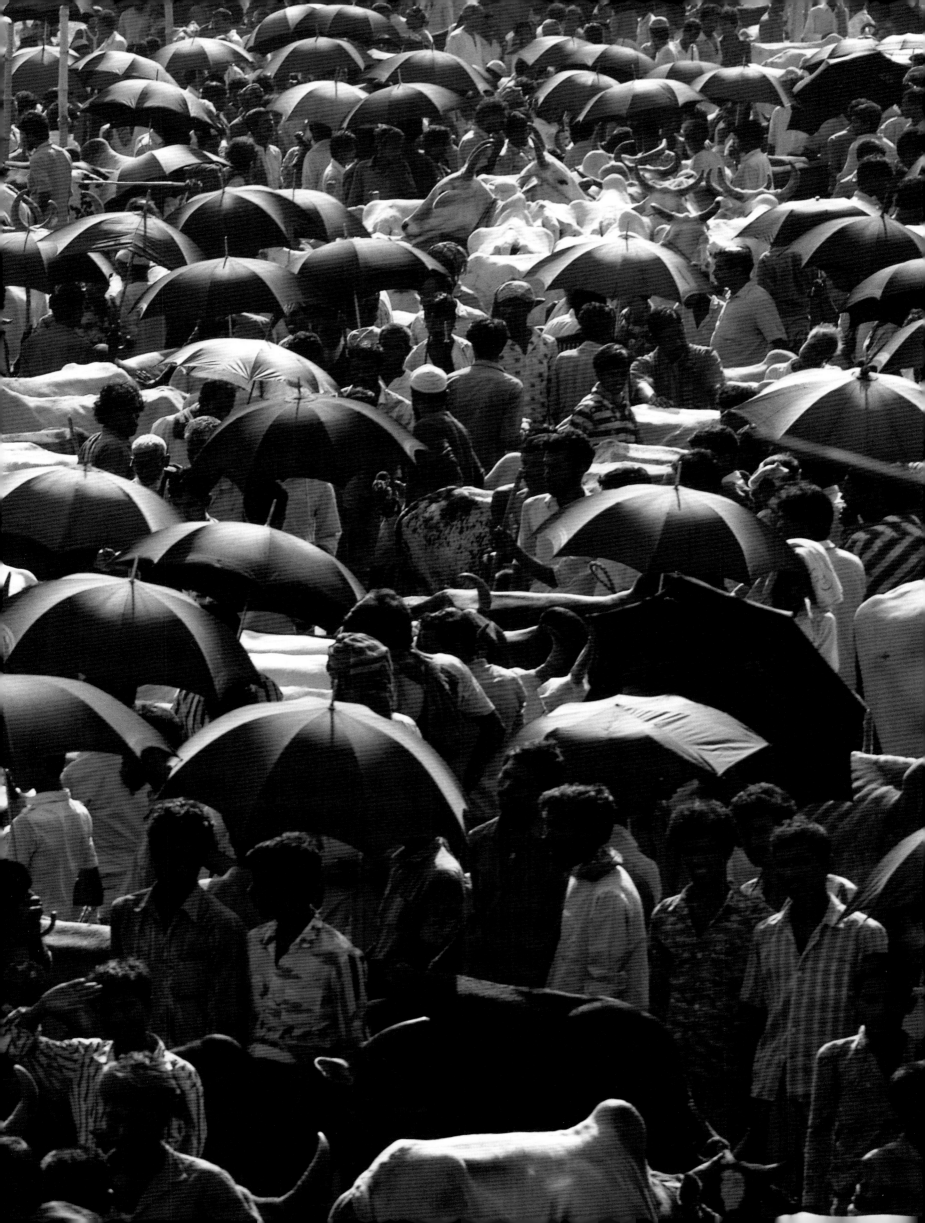

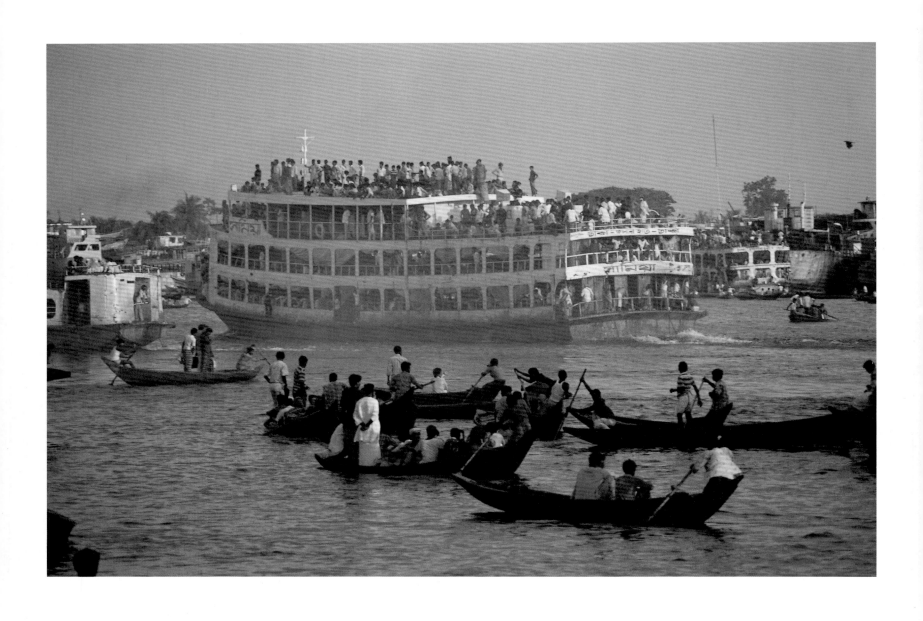

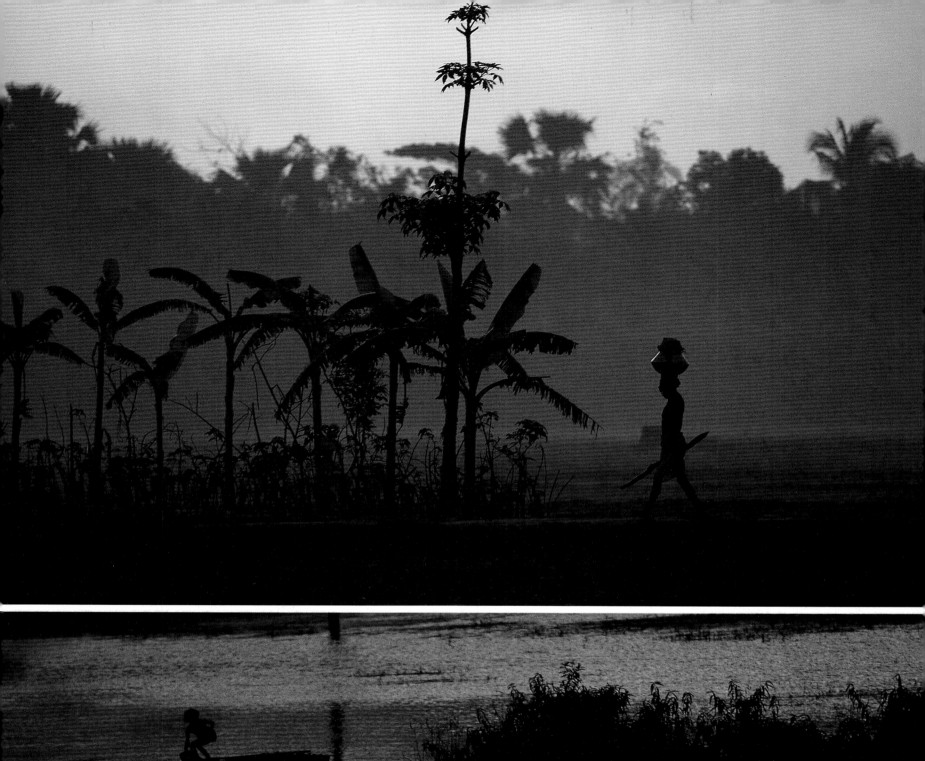
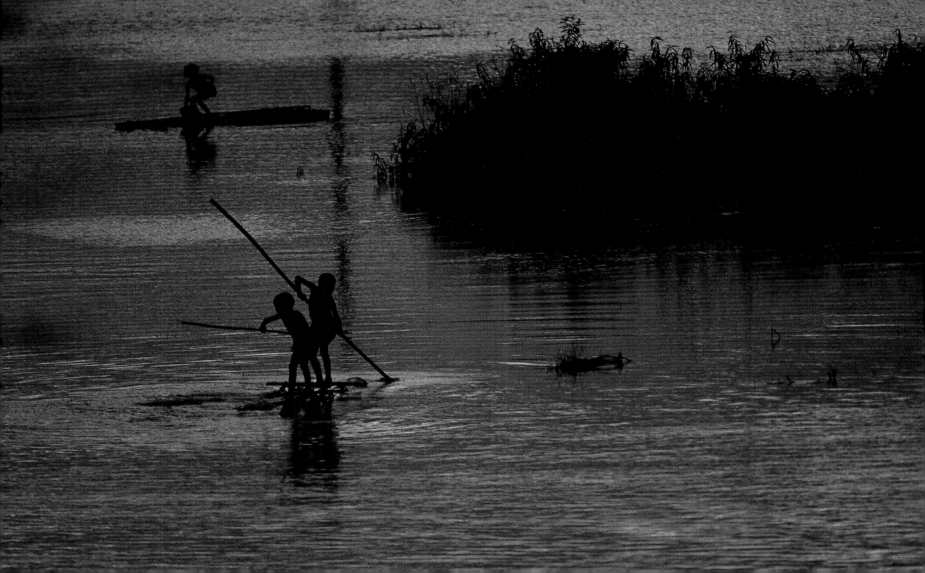

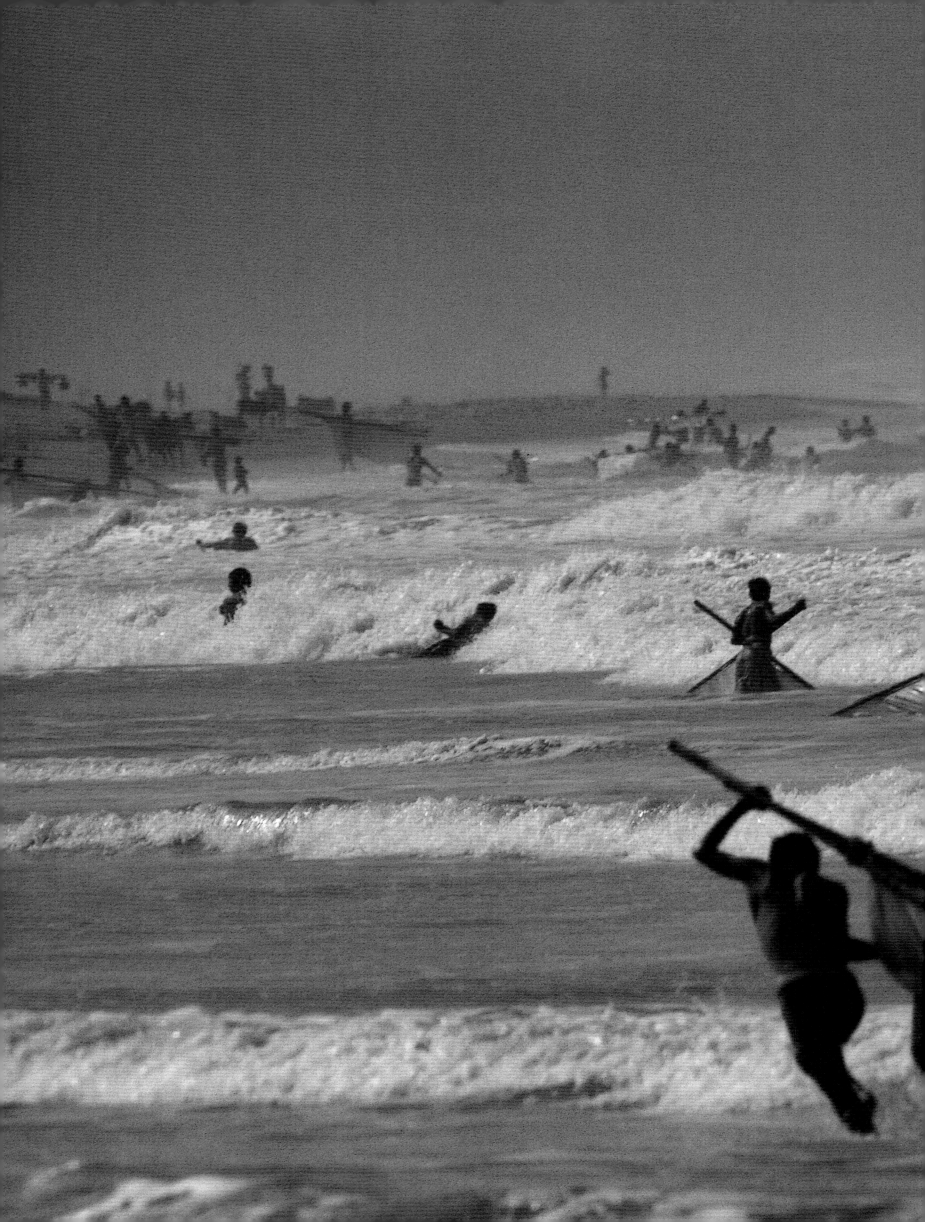

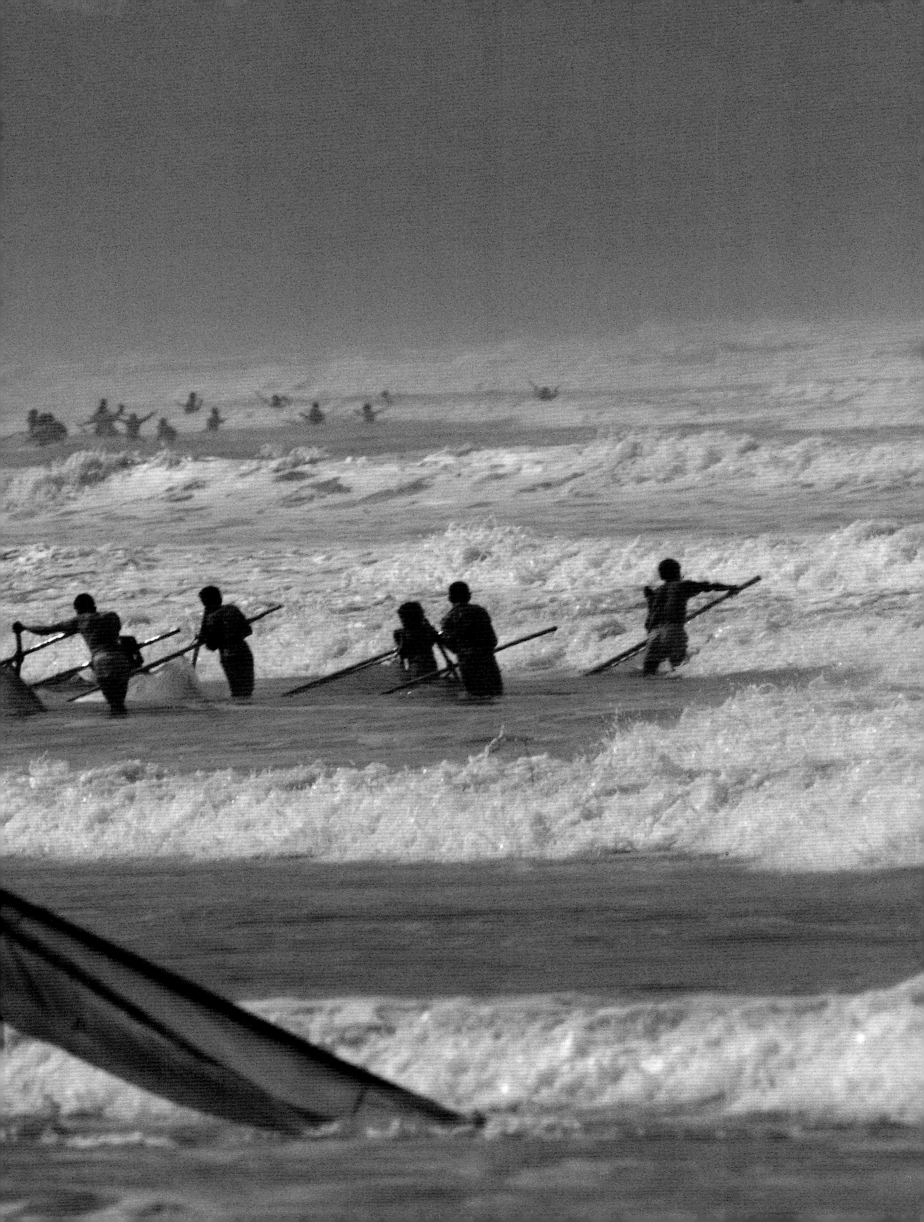

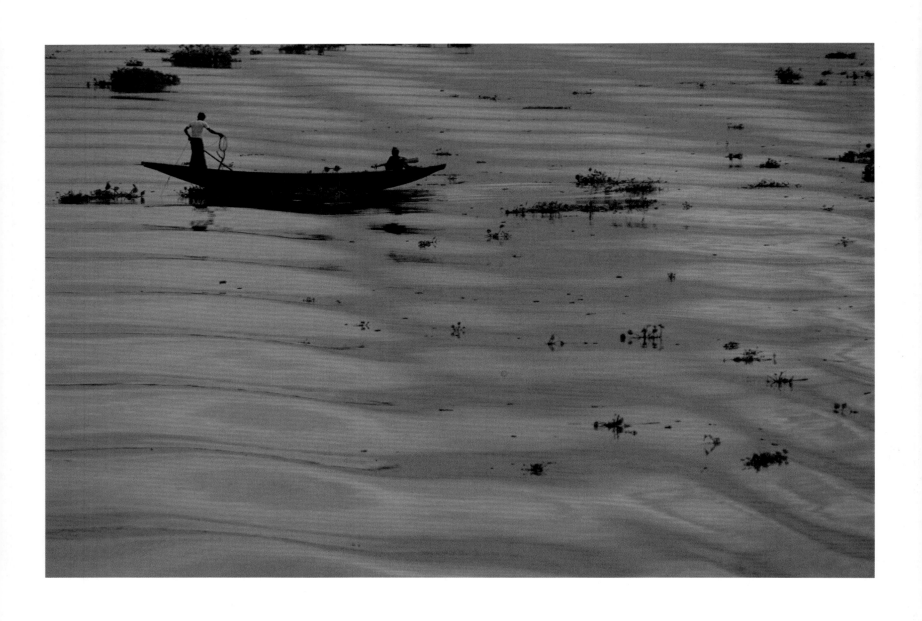

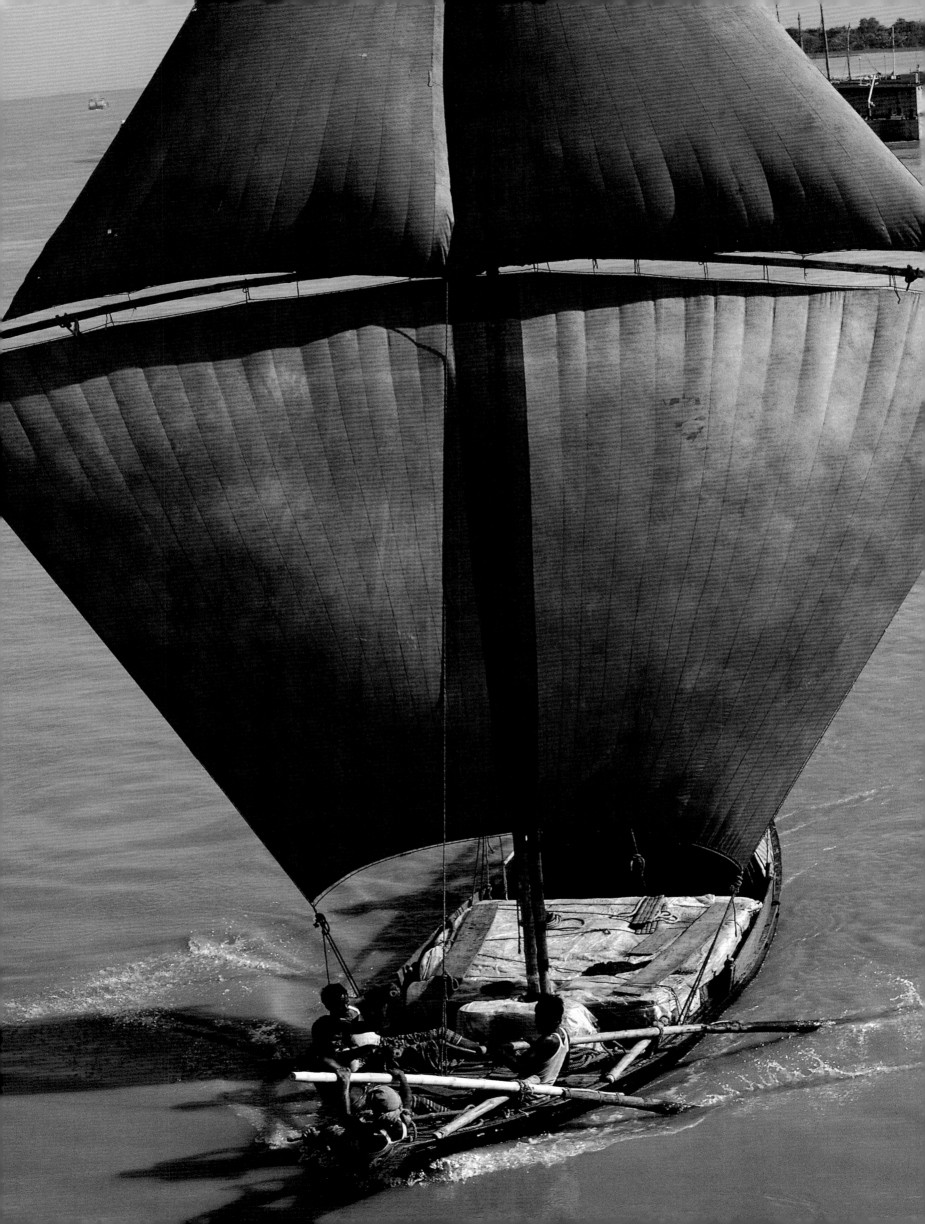

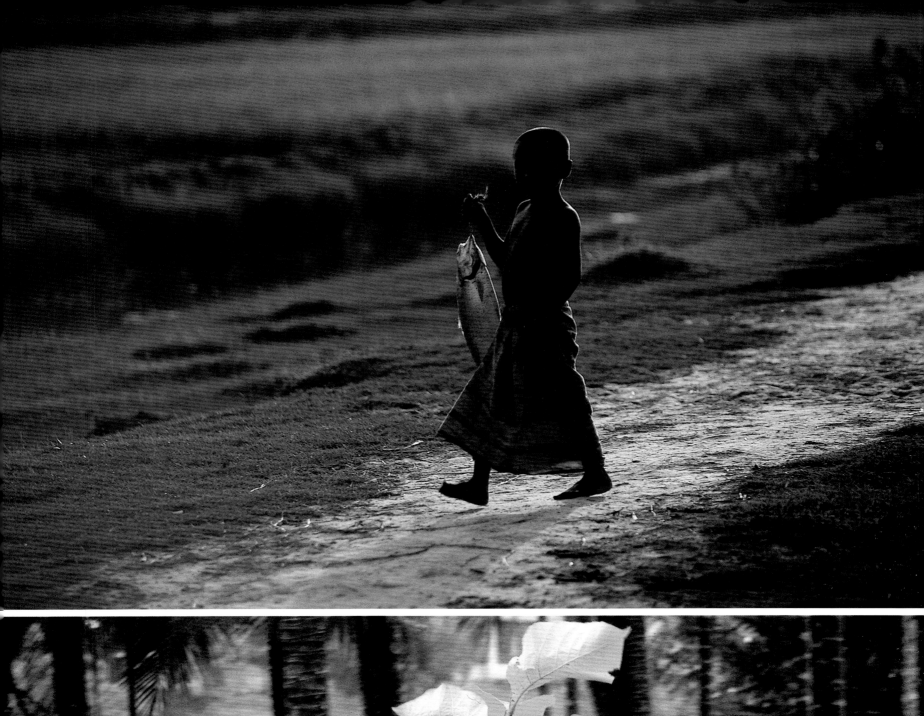
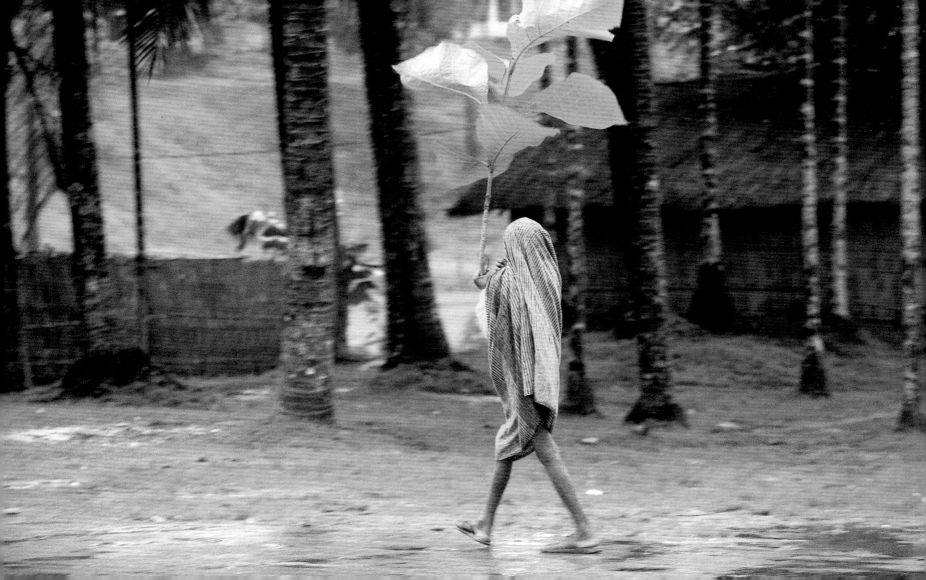

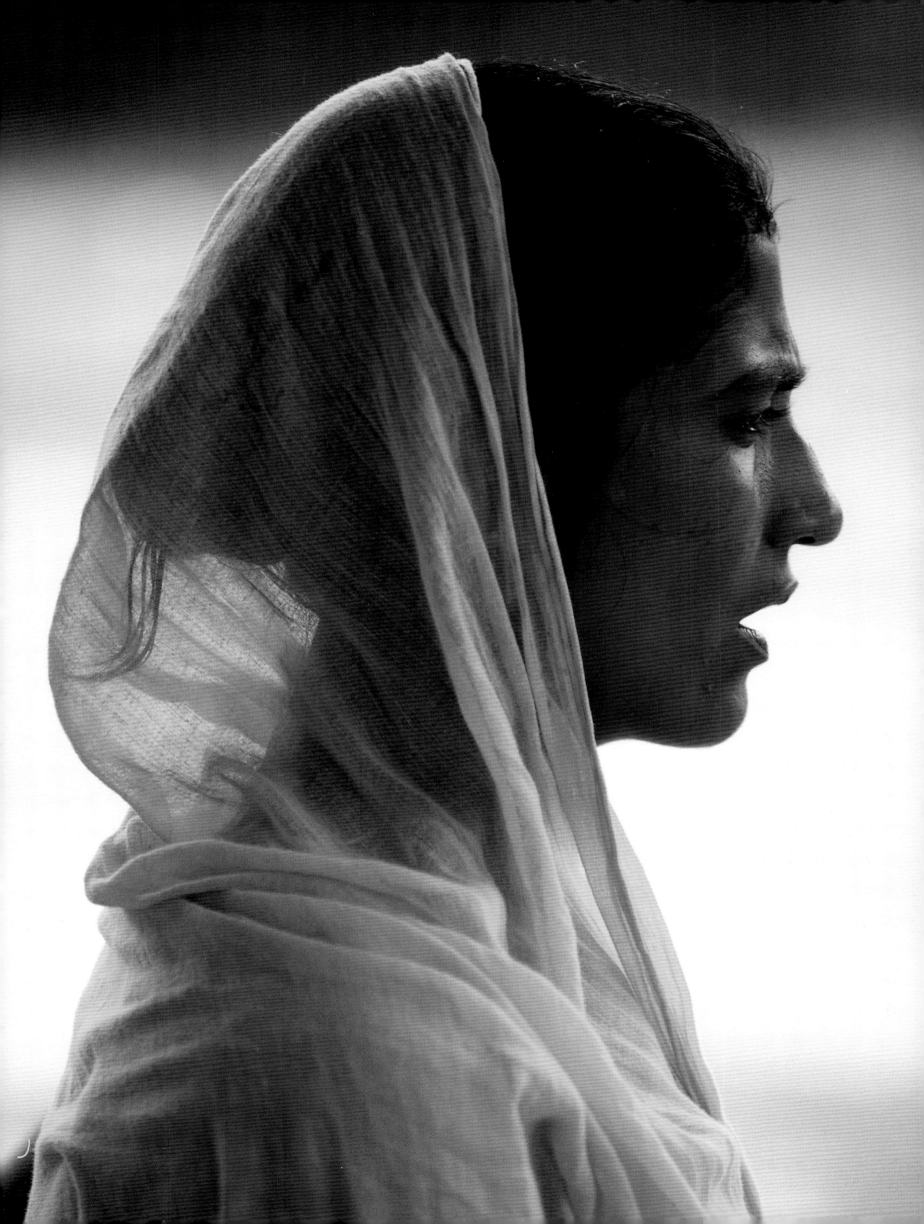

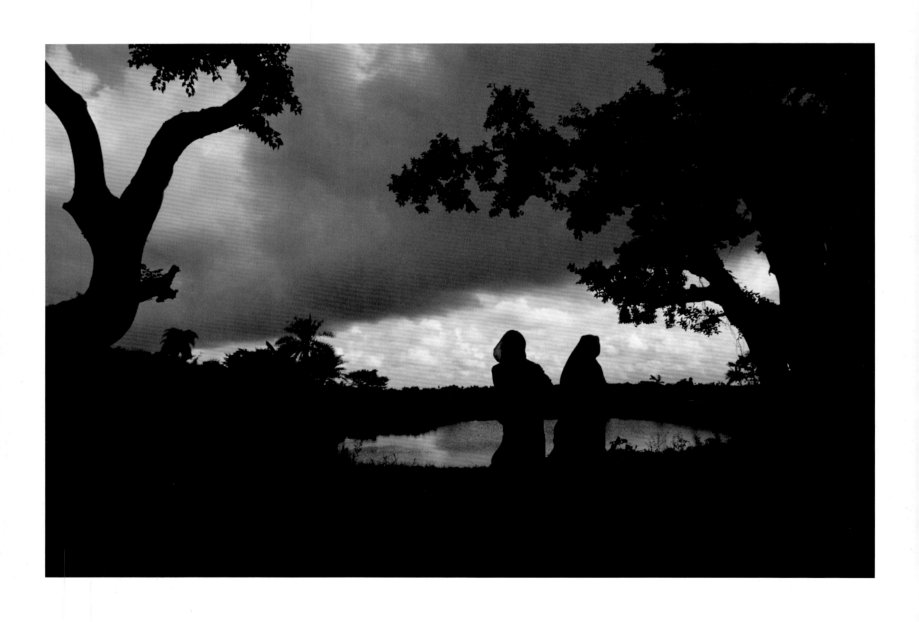

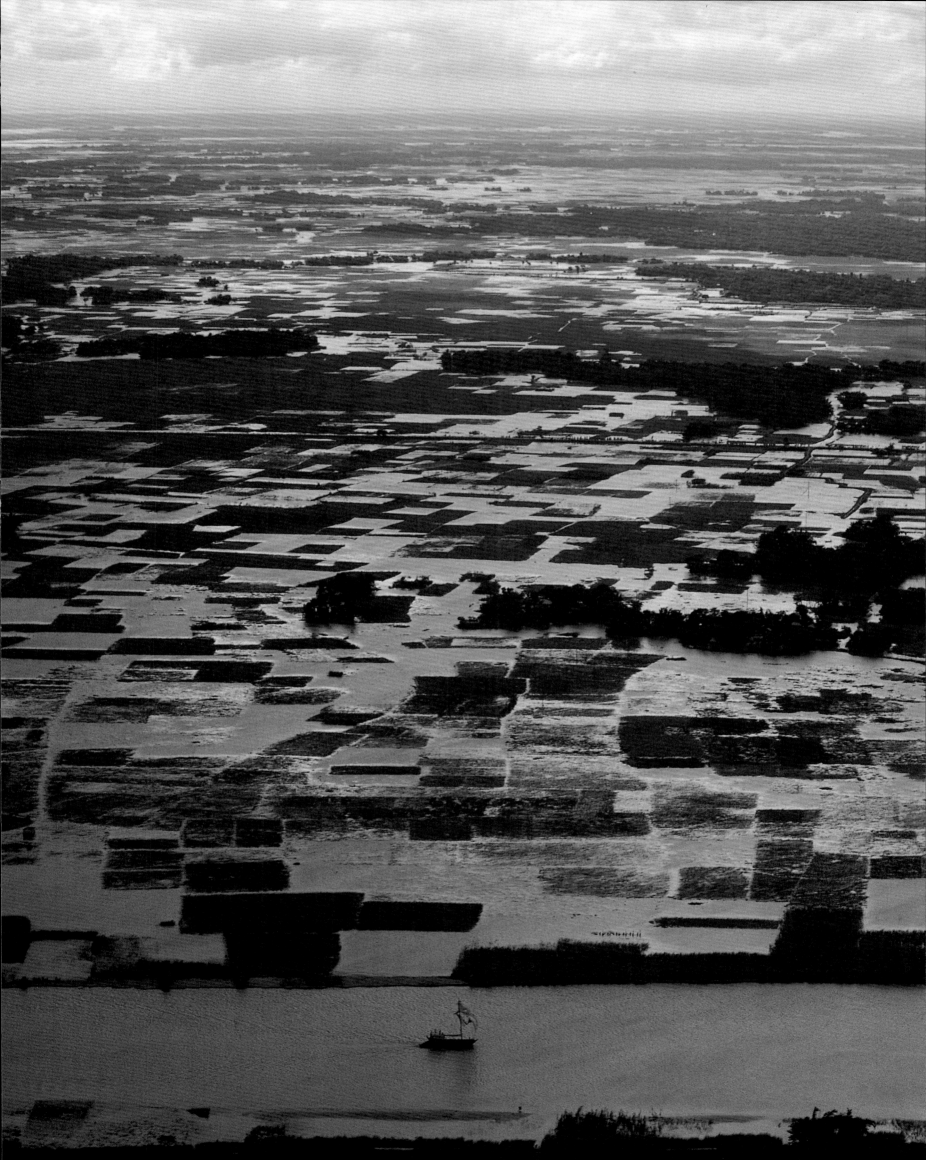

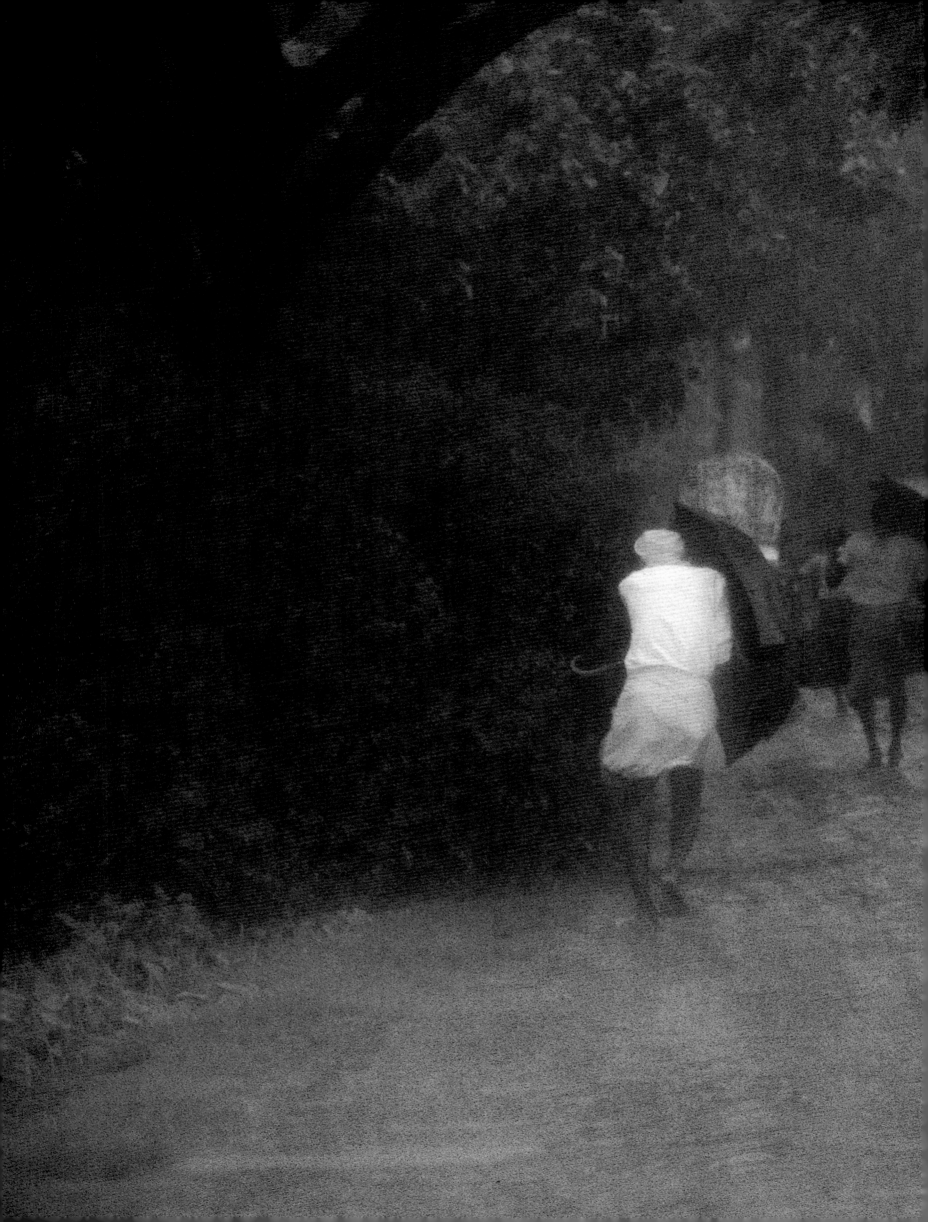

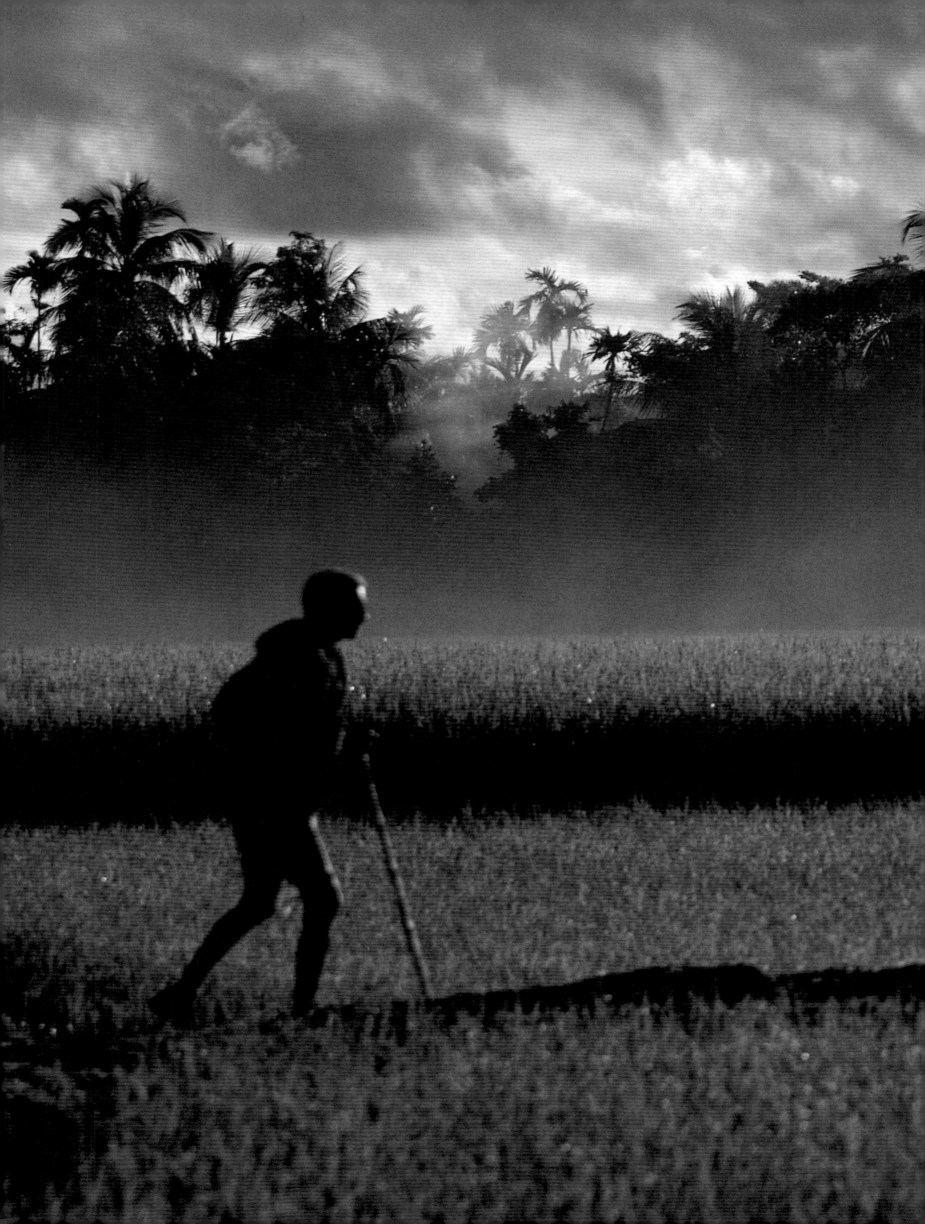

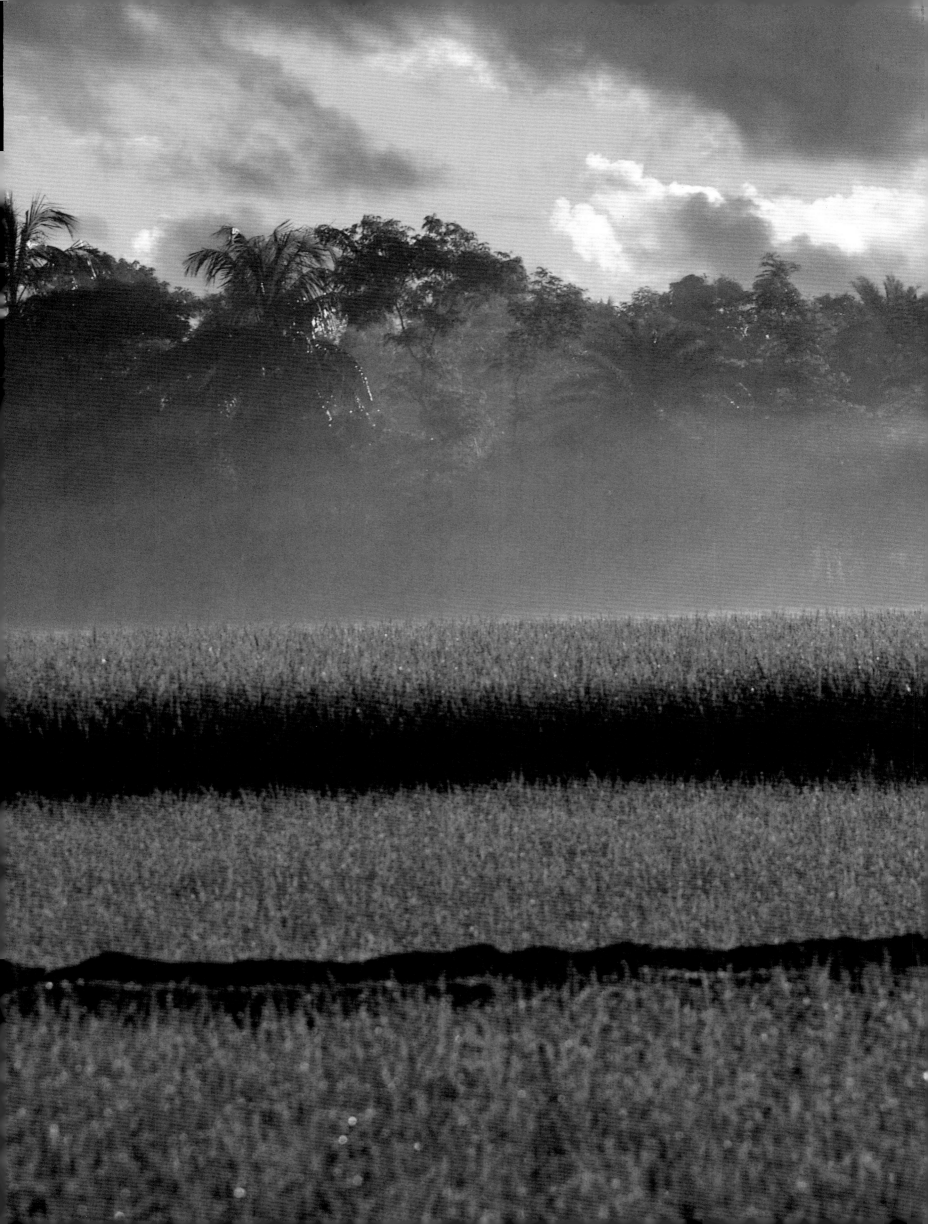

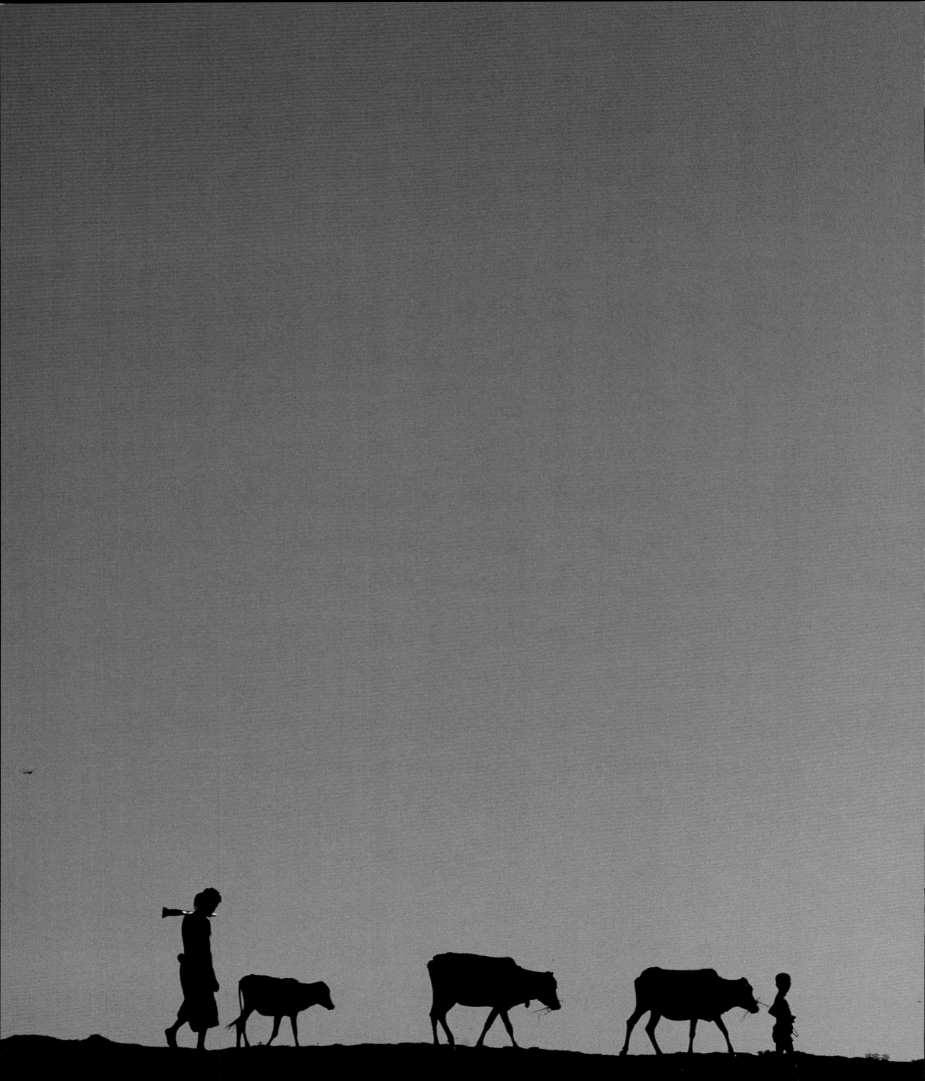

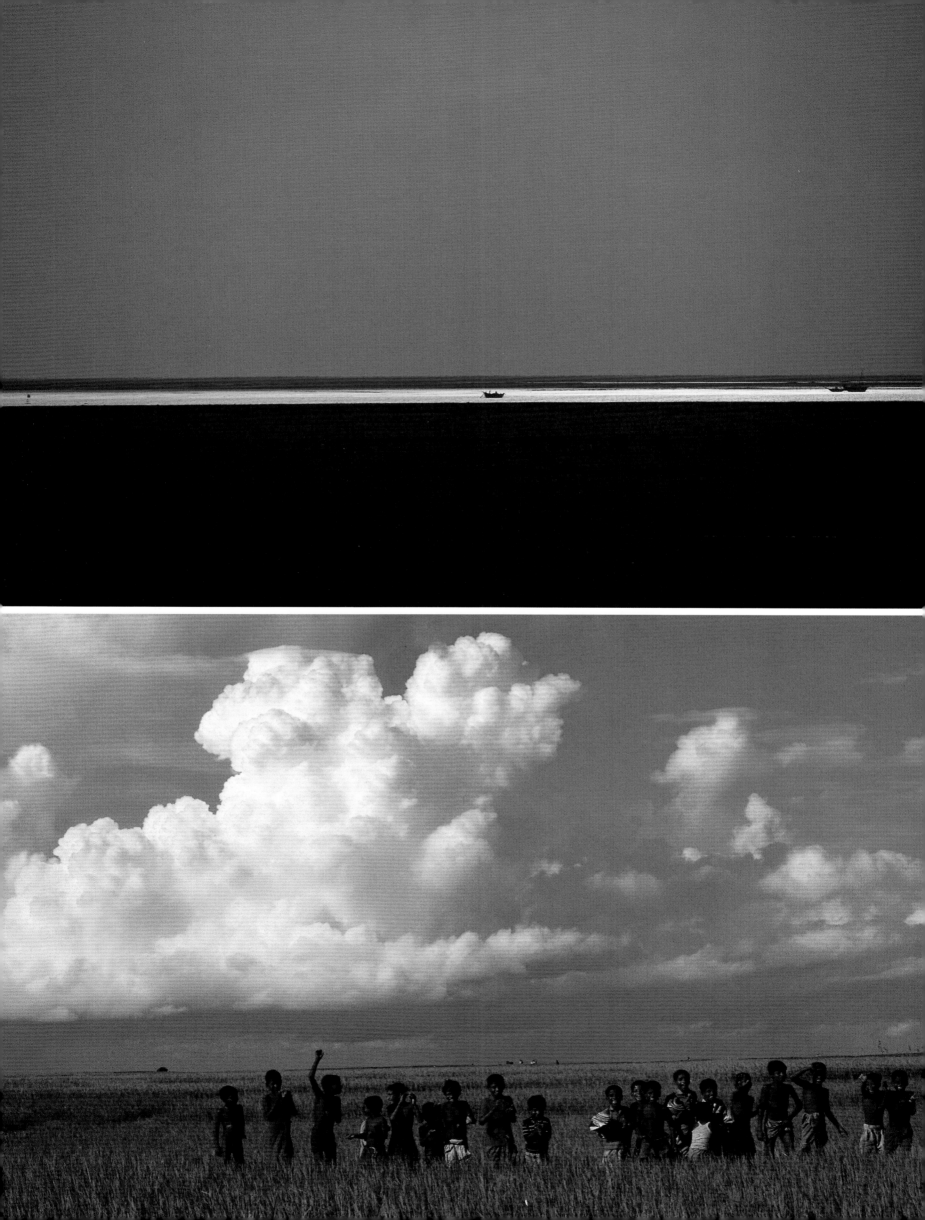

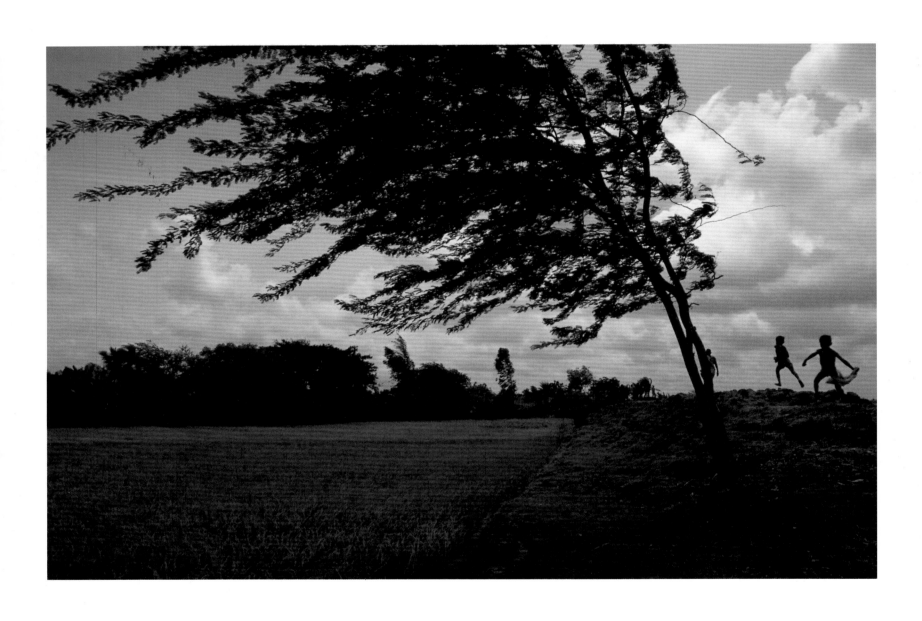

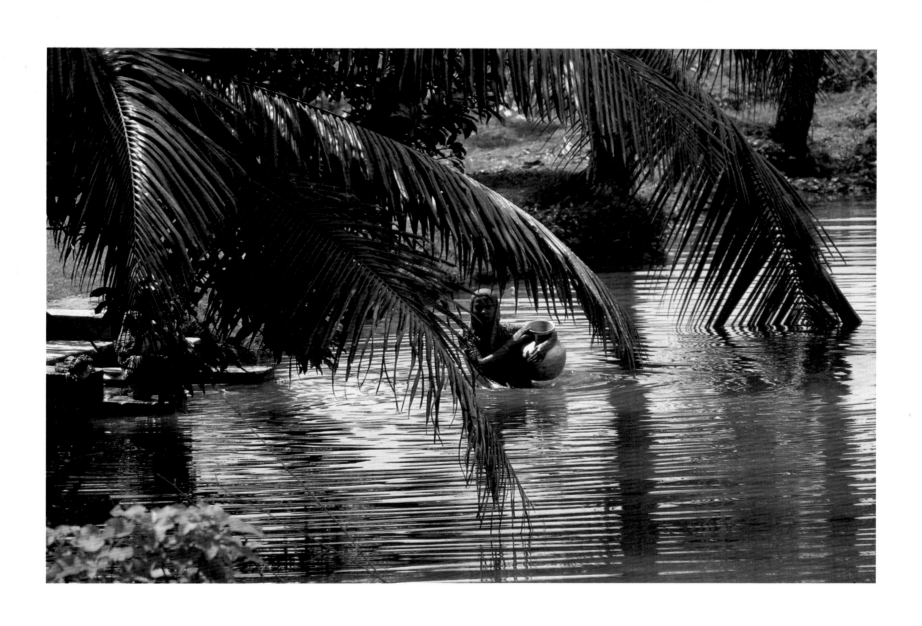

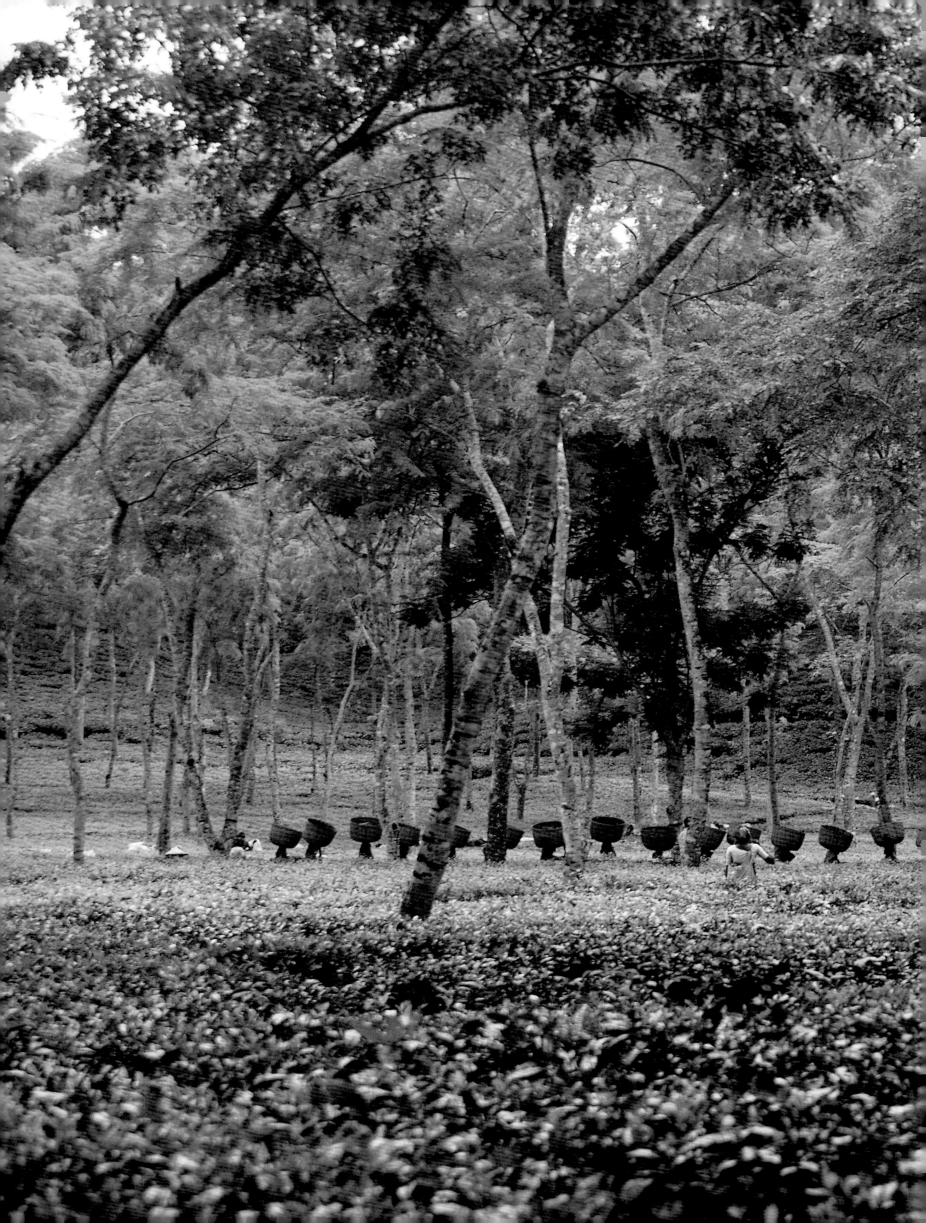

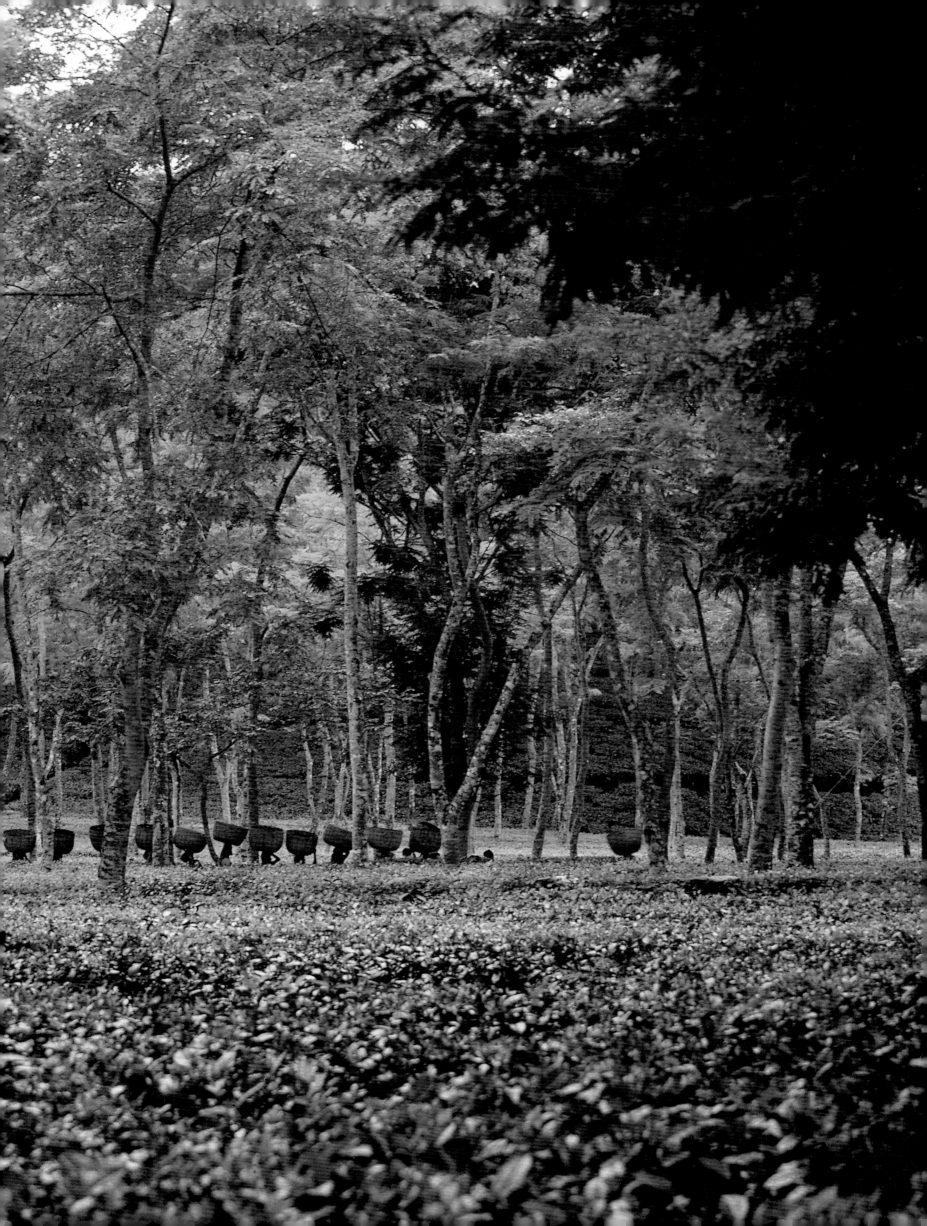

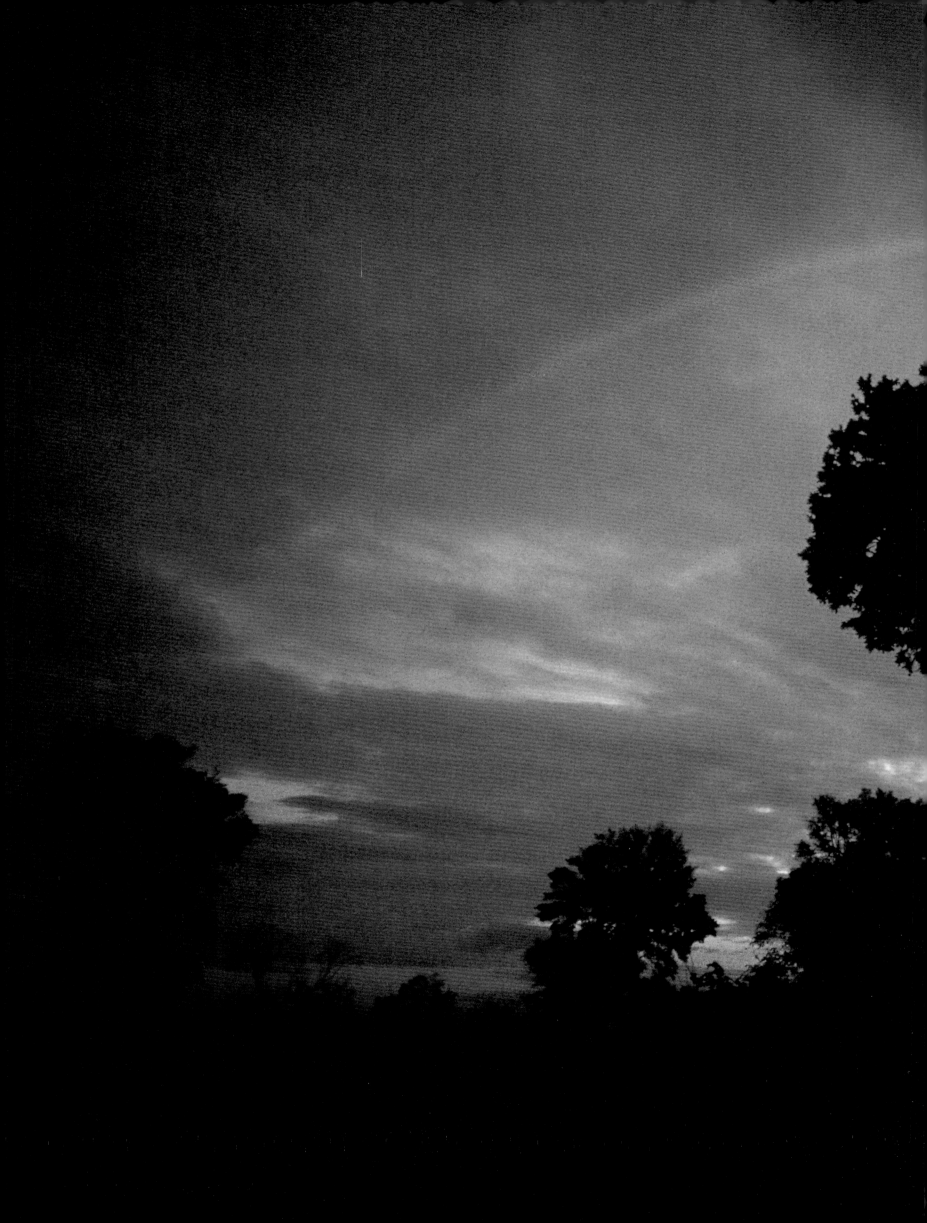

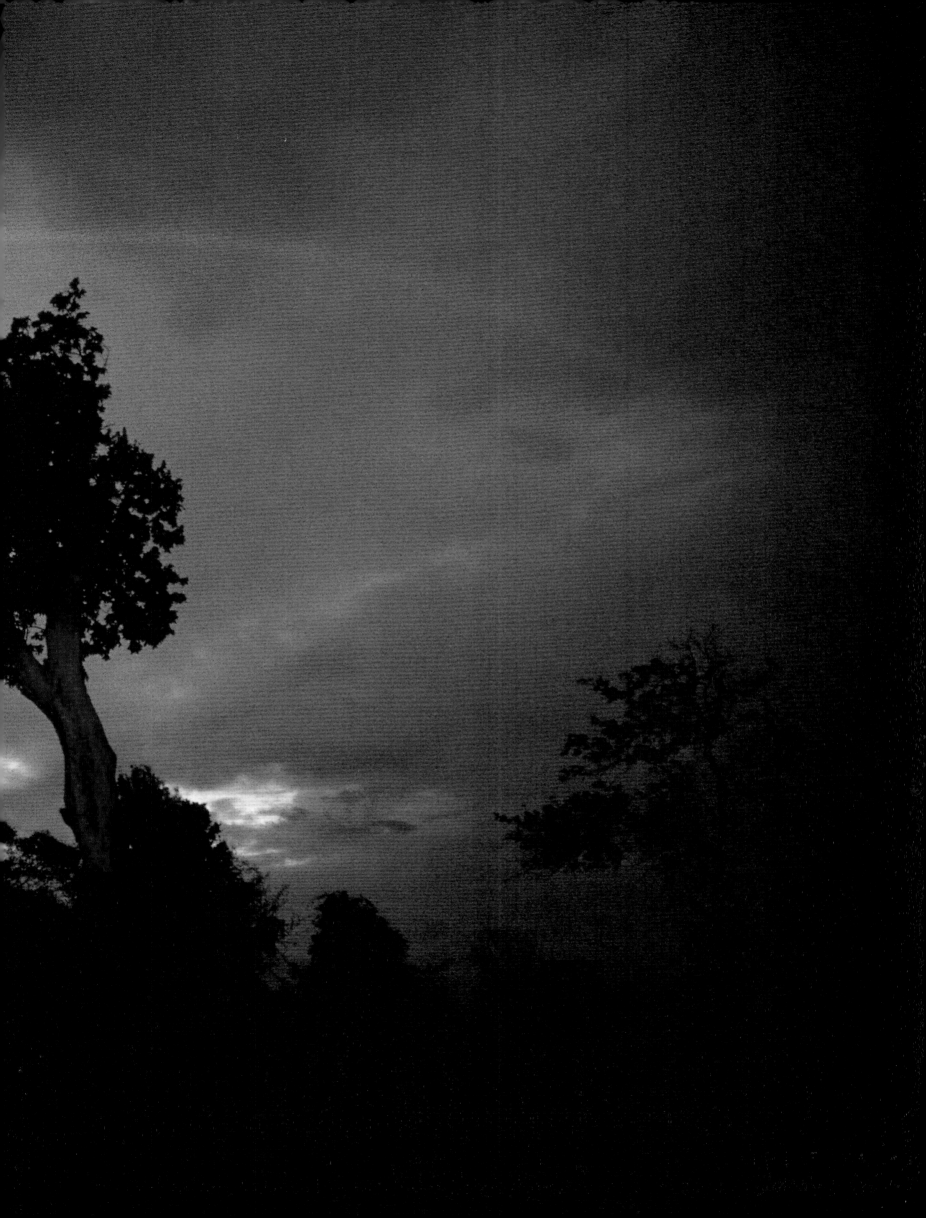

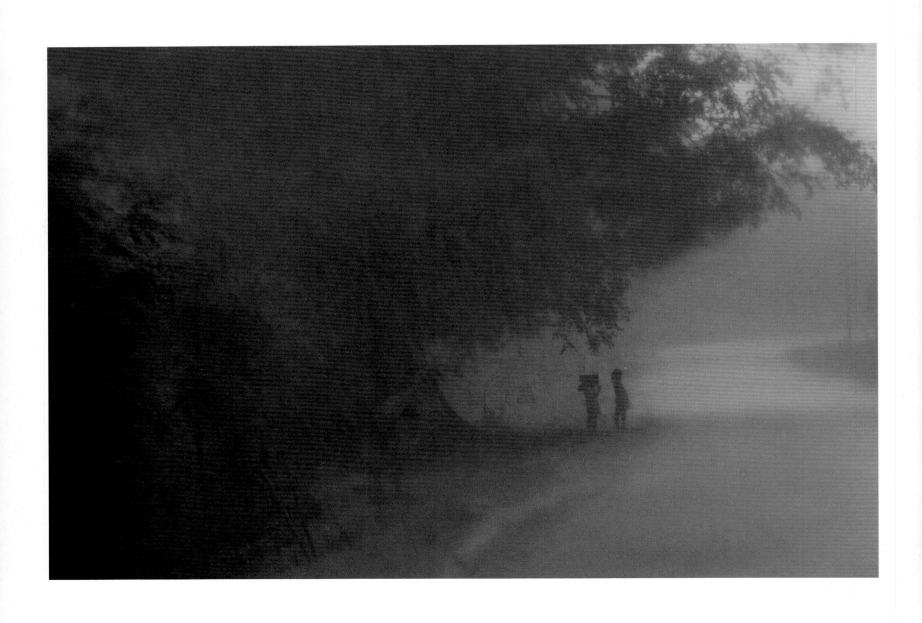

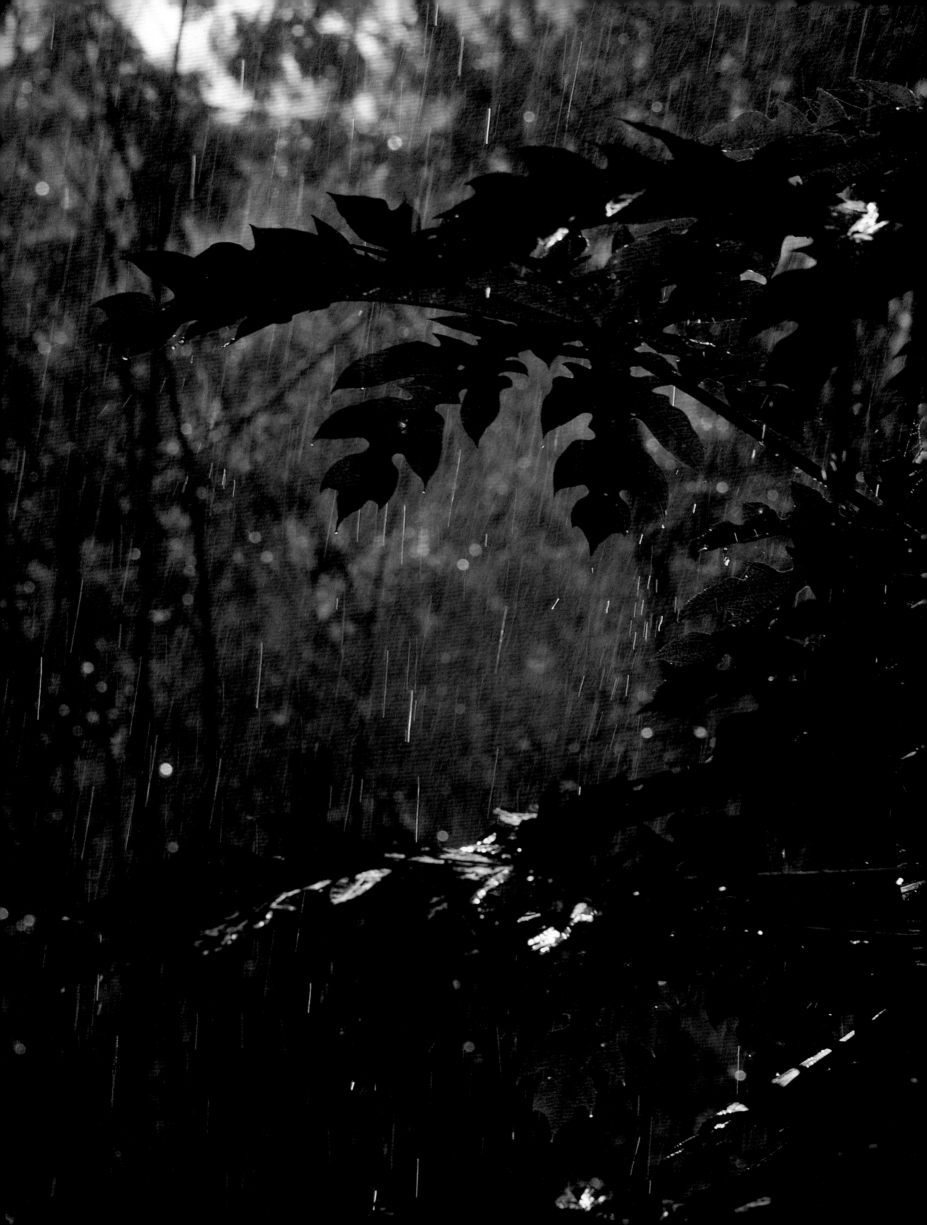

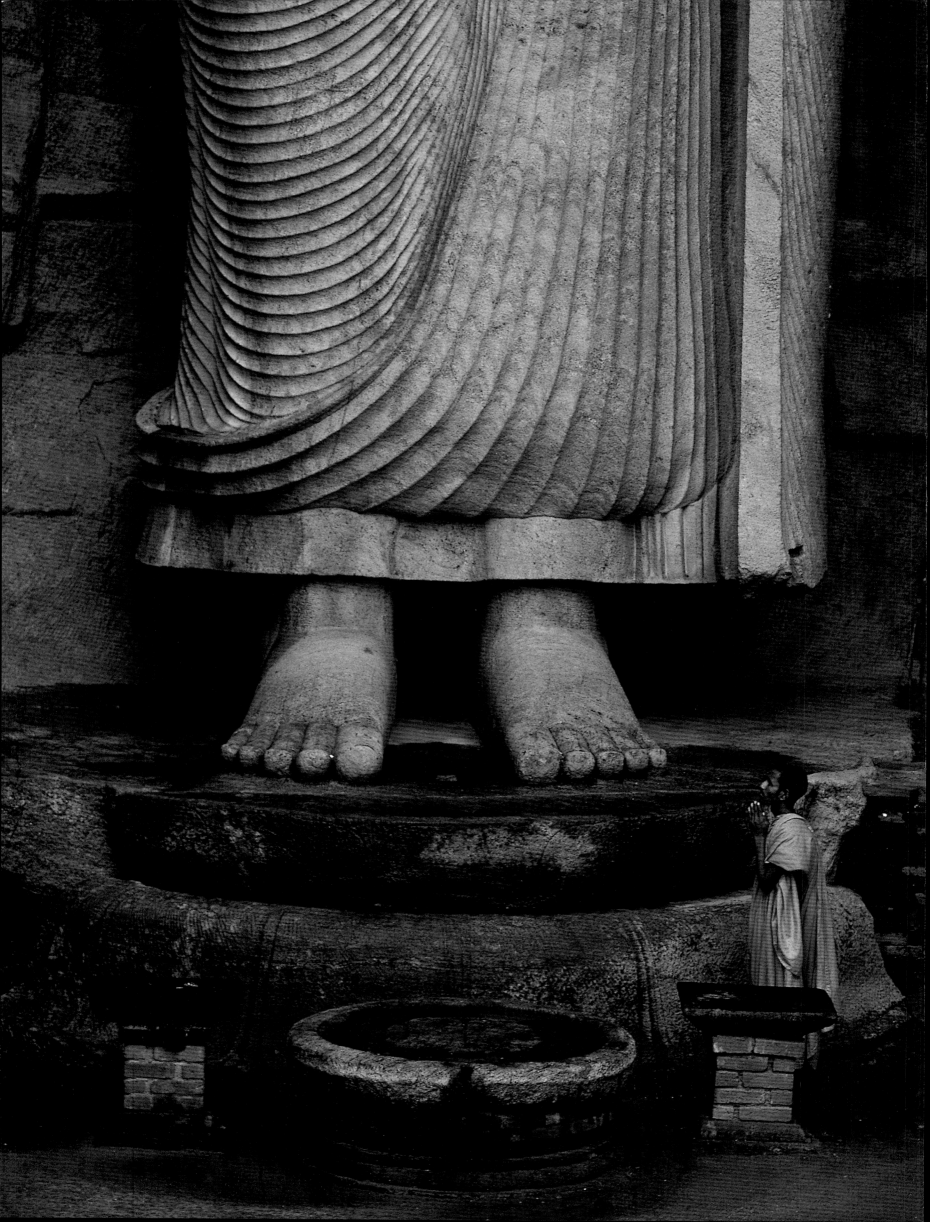

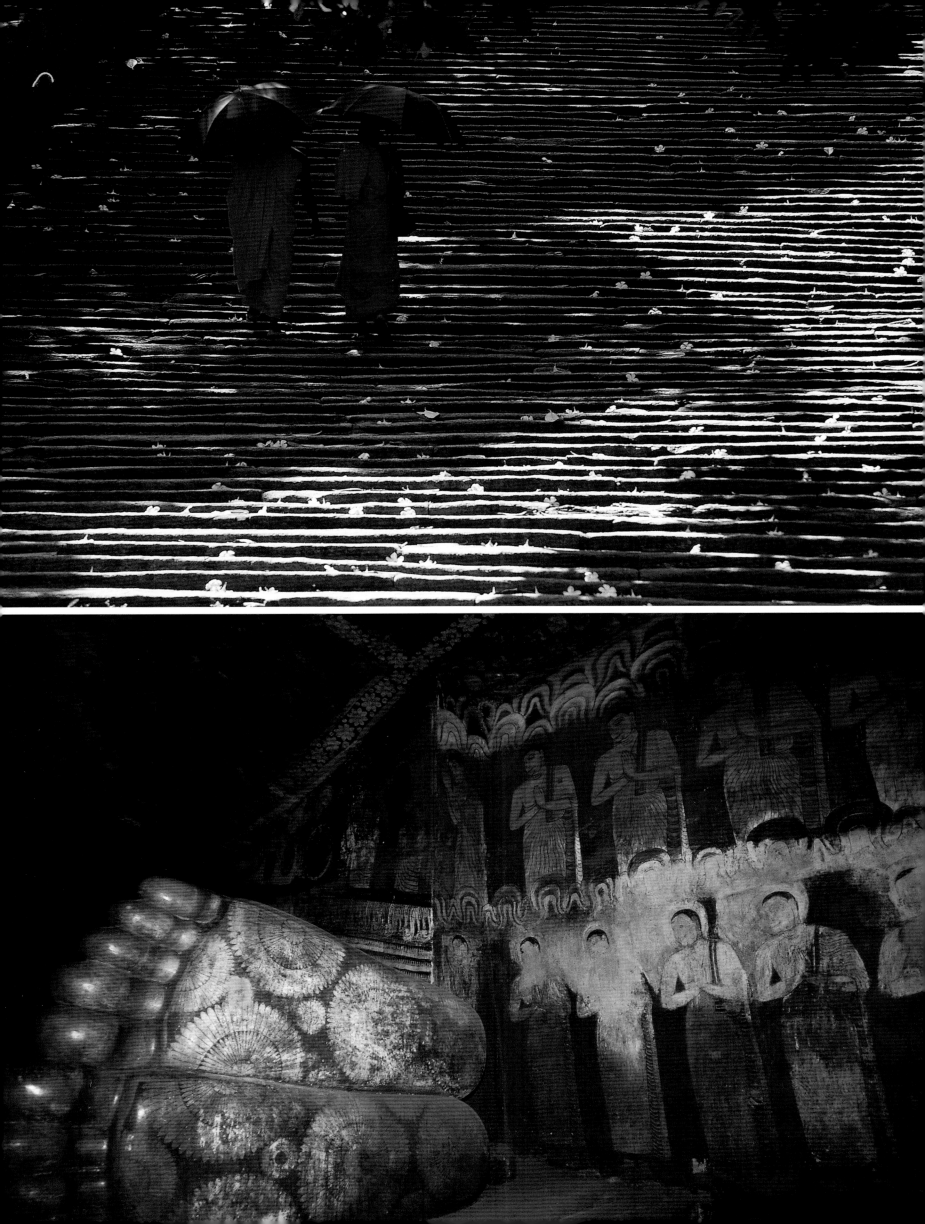

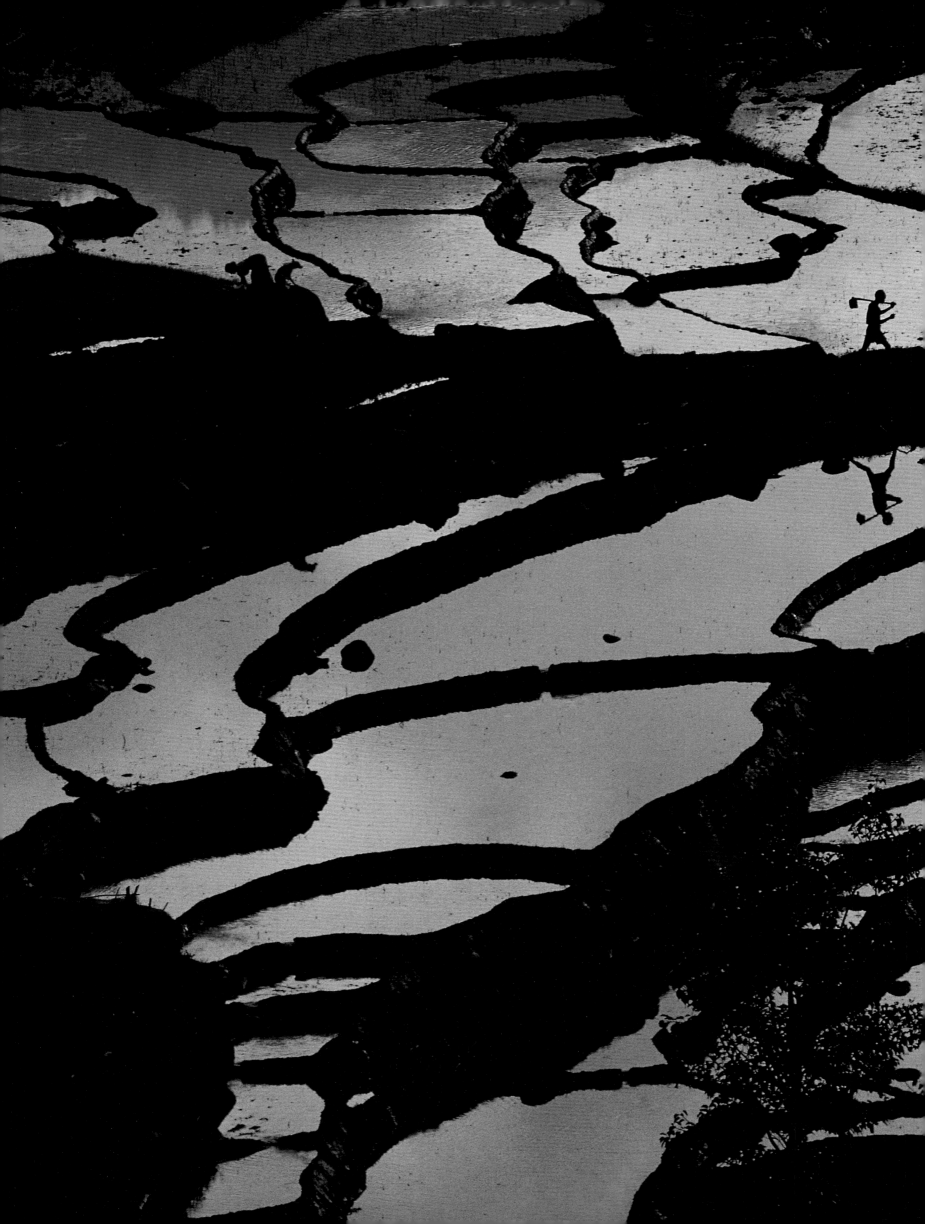

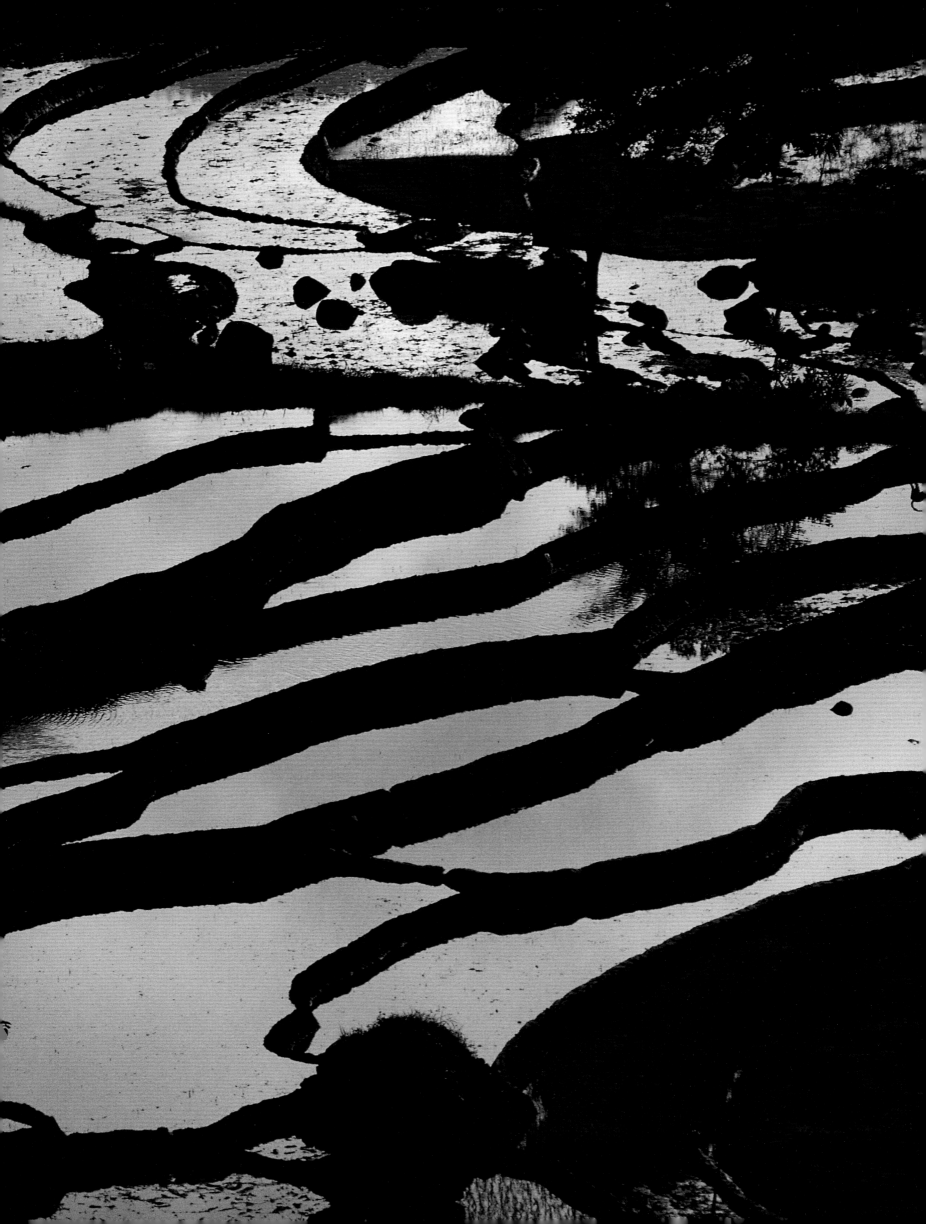

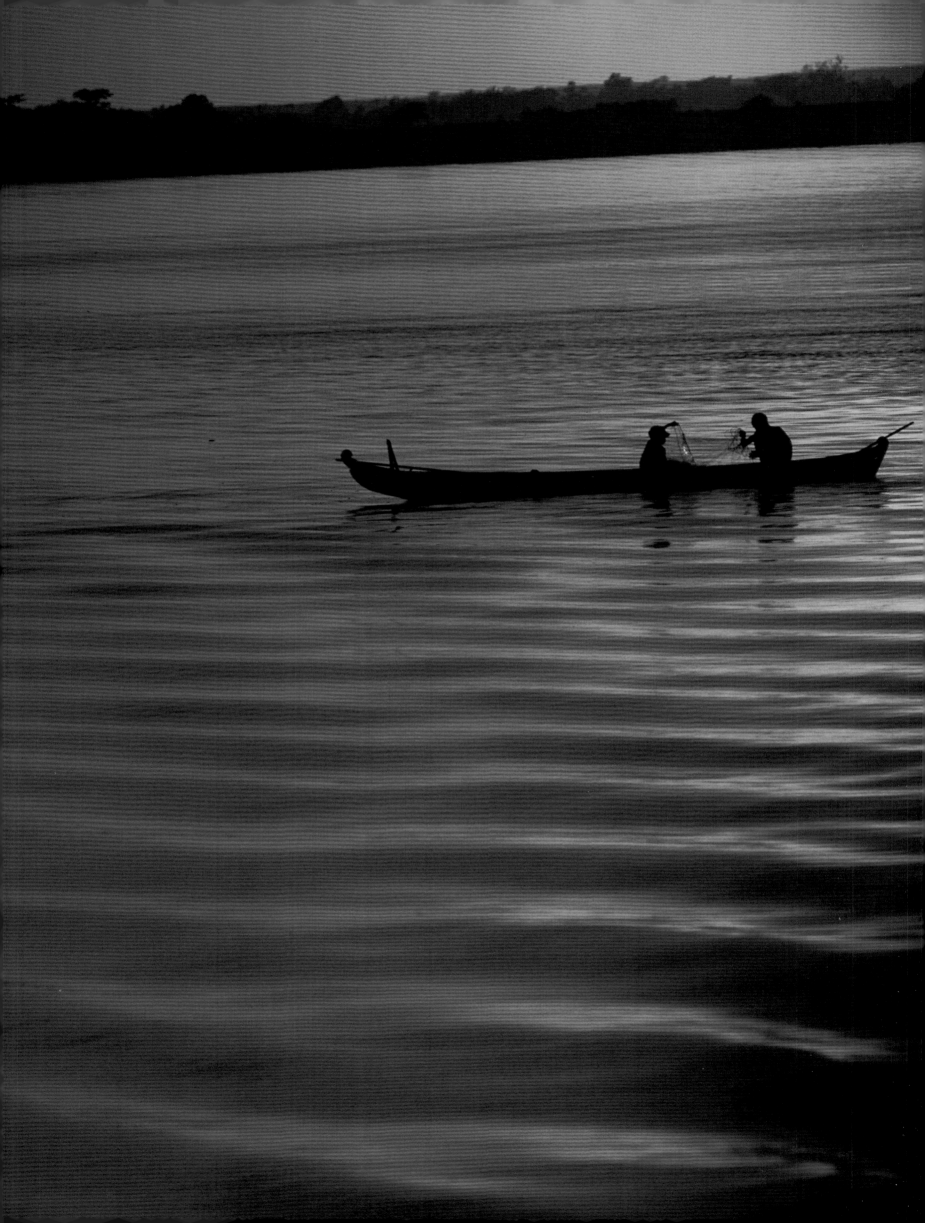

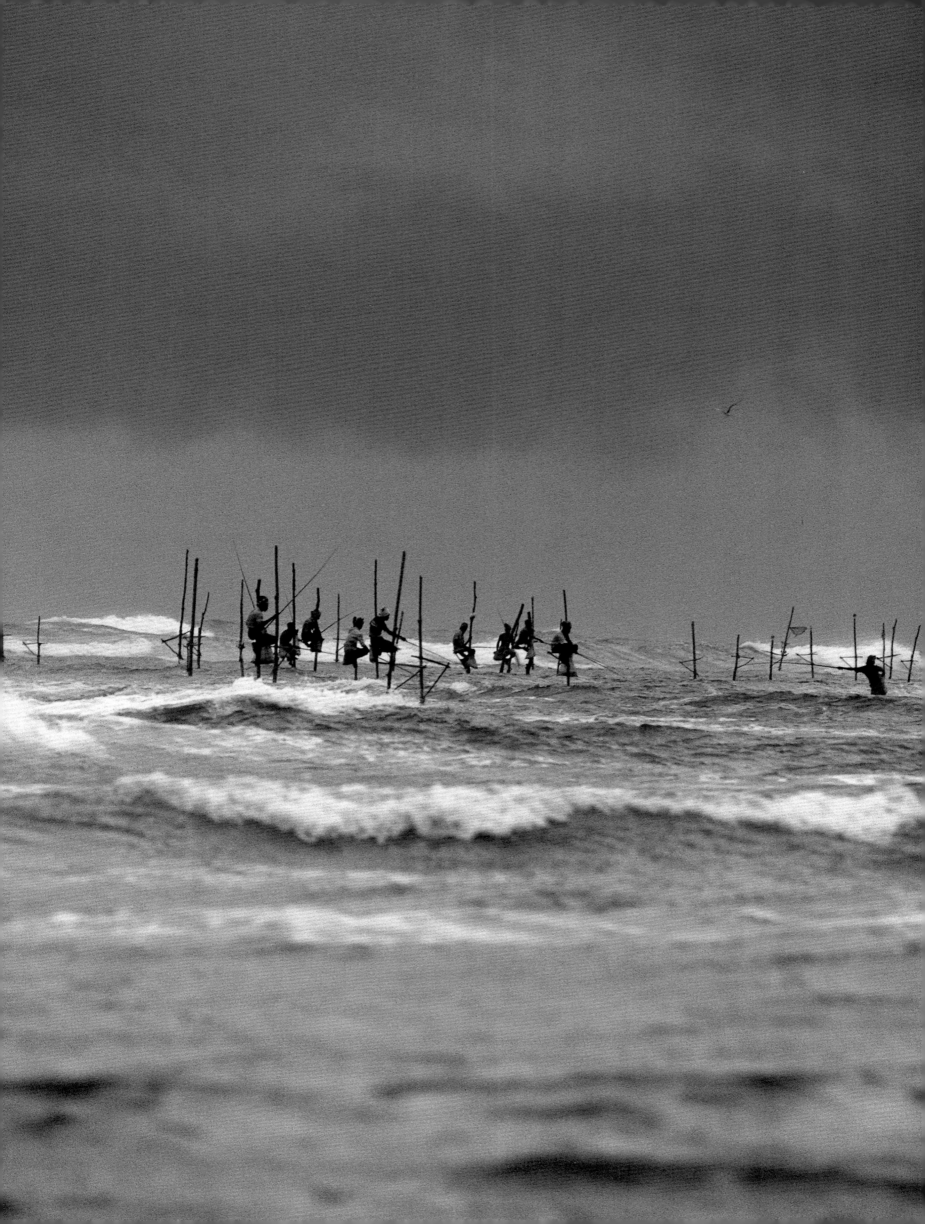

THE HIMALAYAS

Nepal
Bhutan
Tibet
China
India

Towering up impressively, the Himalayas have often been called the home of the gods. Their peaks rend the skies, snow-capped, white, starkly intruding on azure clarity and inspiring reverence among mortals who look on. Yet these lofty peaks were once Tethys seabed between the Indian and the Eurasian continents. Looking at these mountains and recalling that history cannot but inspire awe at the length and power of the earth's history. Pushed by tectonic forces from seabed to oxygen-thin heights, these peaks have captured the hearts of innumerable climbers, and people have cultivated fields and paddies on these slopes where heaven is close enough to touch.

The Himalayan highlands are usually regions of arid cold, but the monsoon brings rain to the southern slopes in summer and snow to the northern slopes in winter. Borne by the winds, this precipitation waters the region's plant life, helps grow the crops and slake the livestock's thirst, and ultimately sustains the people. The snow that falls in the Tibetan highlands in winter effects the timing and strength of the summer monsoons. The more snow there is, the later and slower it thaws, the later the highlands are exposed to the sun's warmth, the weaker is the warming, and the later do the convections set off by the land-sky temperature differentials draw in the monsoon winds from the far-off Indian Ocean. In effect, more snow in winter means less rain in summer.

Just as the cranes take advantage of the monsoon winds to fly over the Himalayas, people judge from the clouds' appearance when to flood their terraced paddies, and rice is planted first in the warmer lowlands and then at increasing heights. The energy from the monsoons spreads out from the Himalayas and affects all of Asia. This is the drama of the Himalayas—the traditional home of the gods—as nature plays out its cycle.

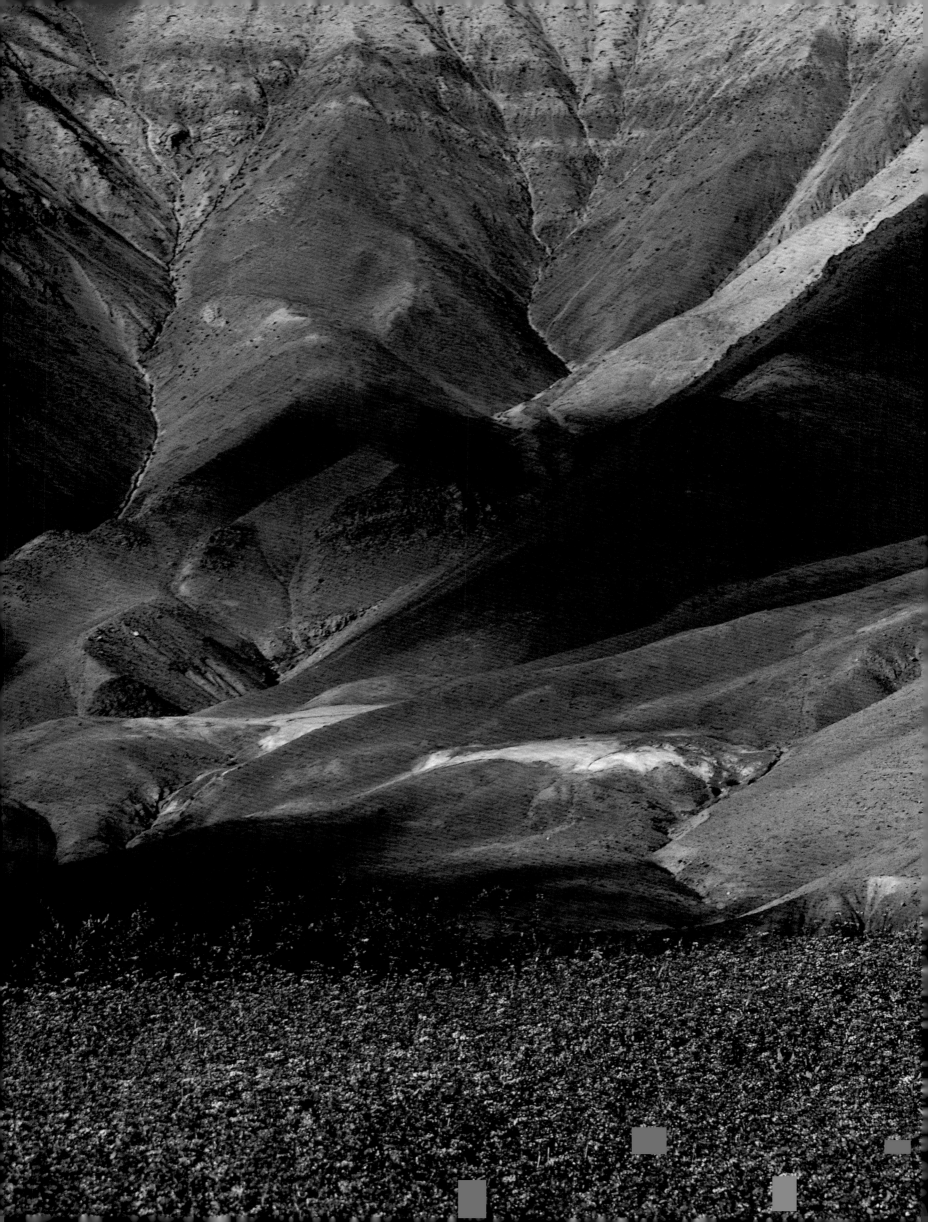

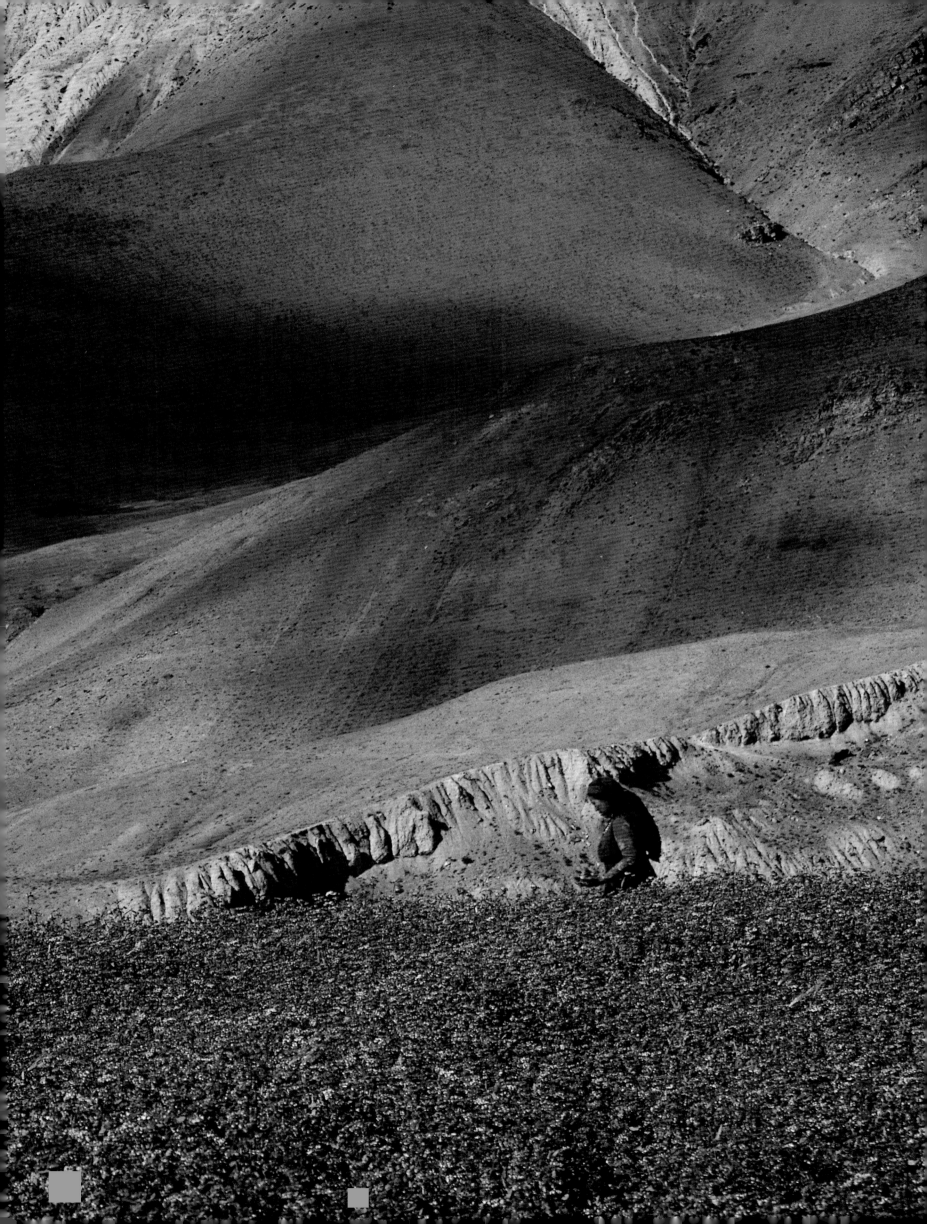

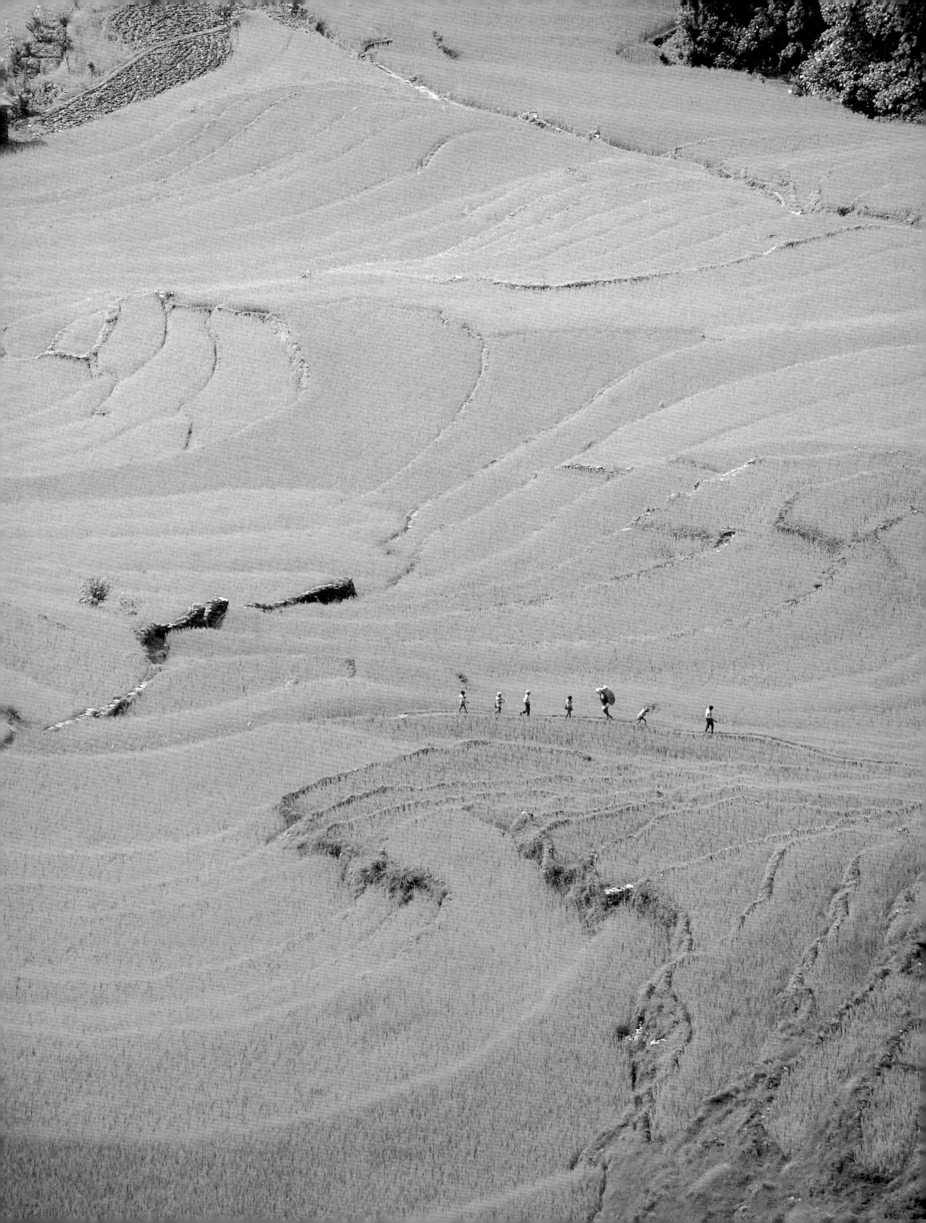

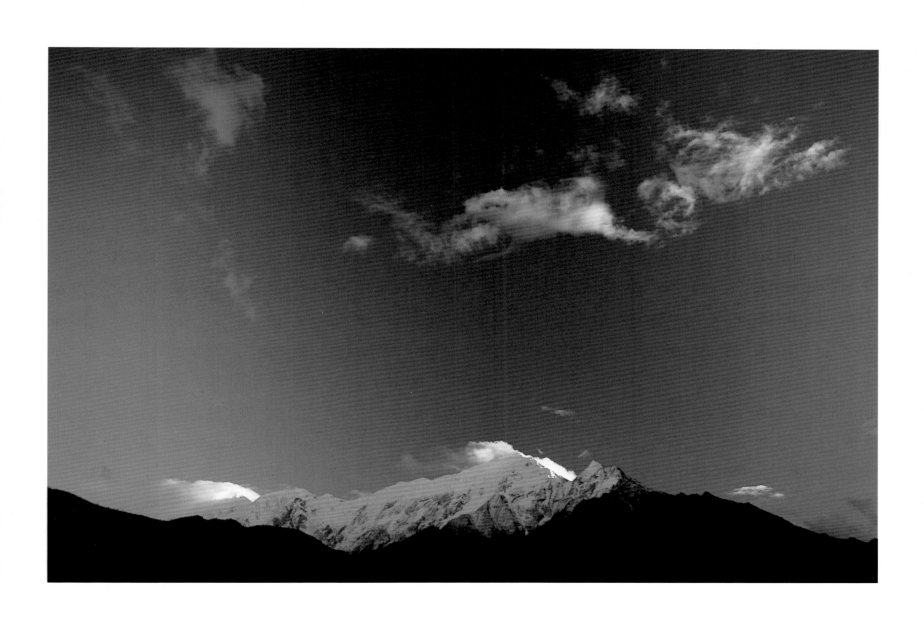

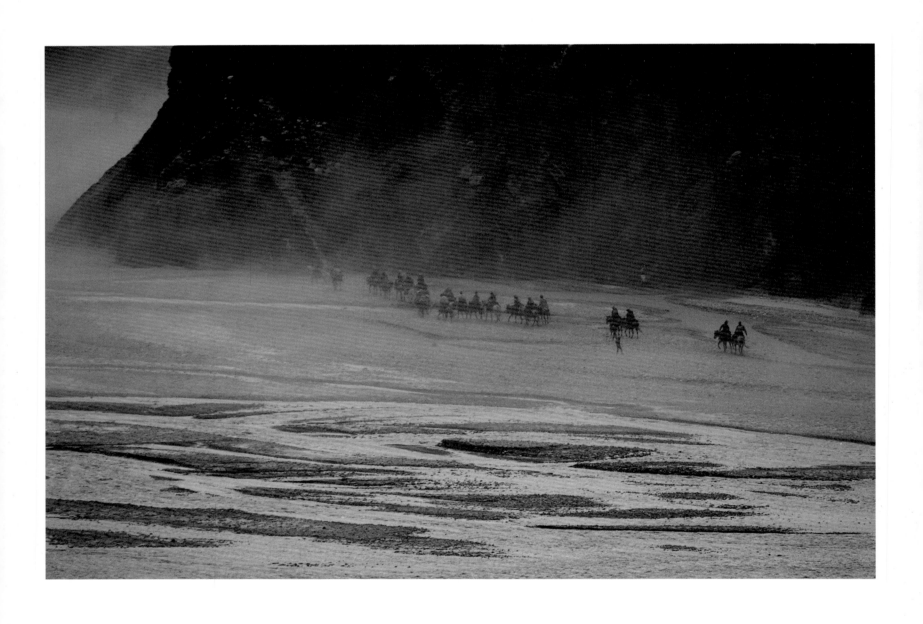

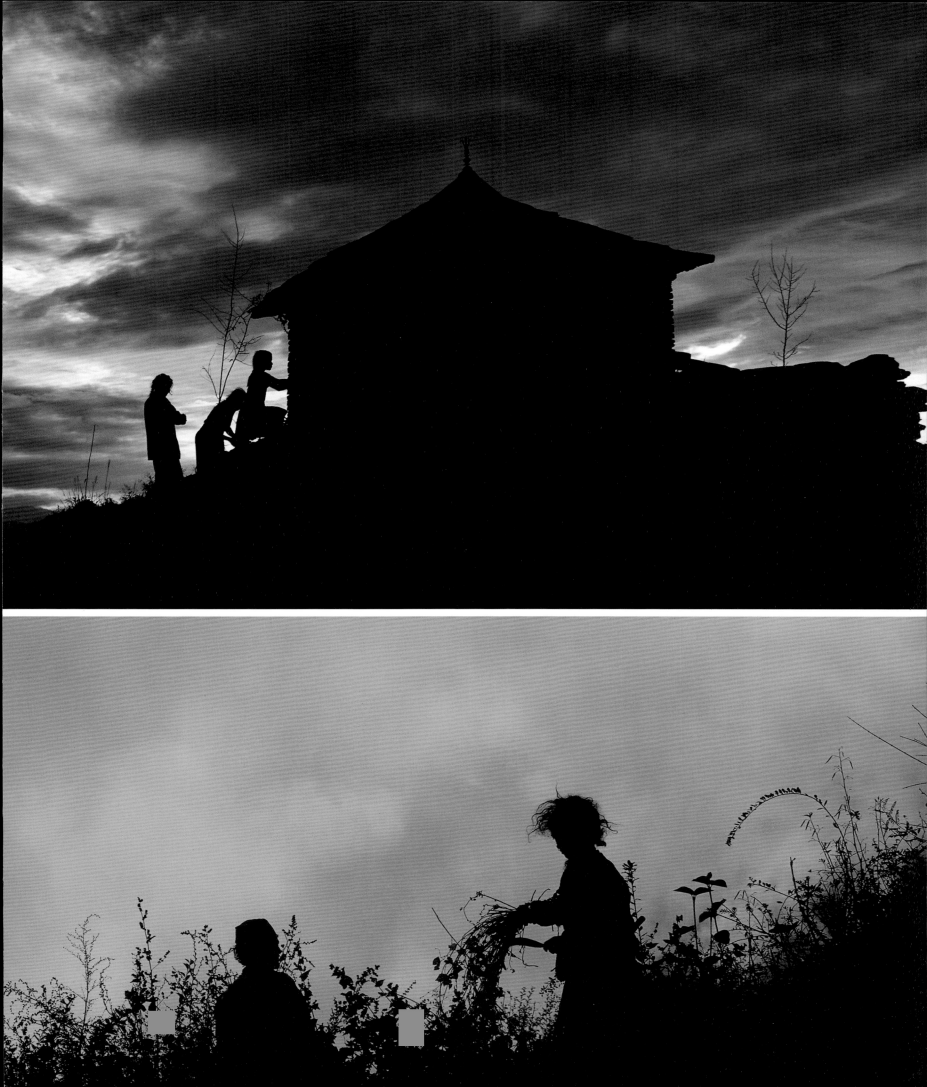

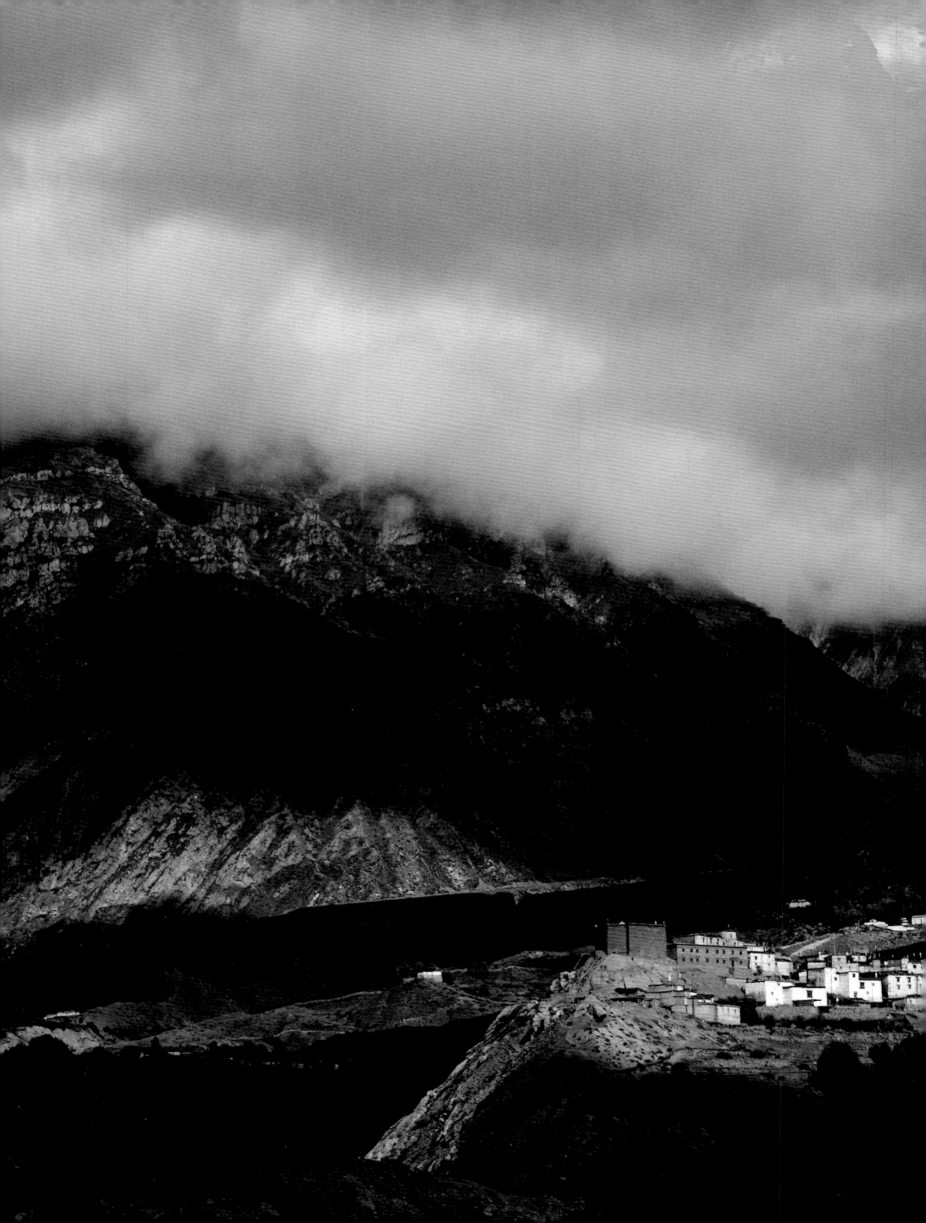

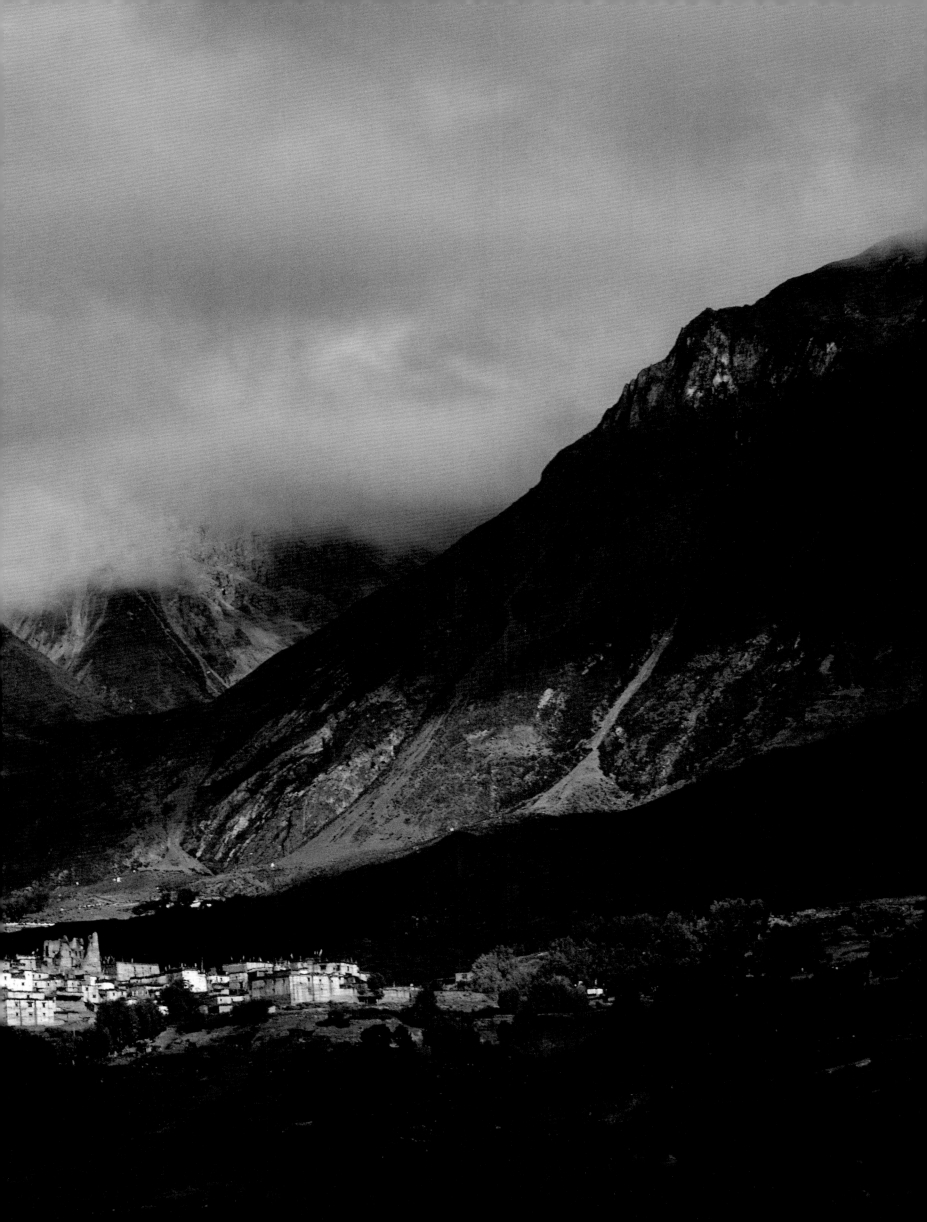

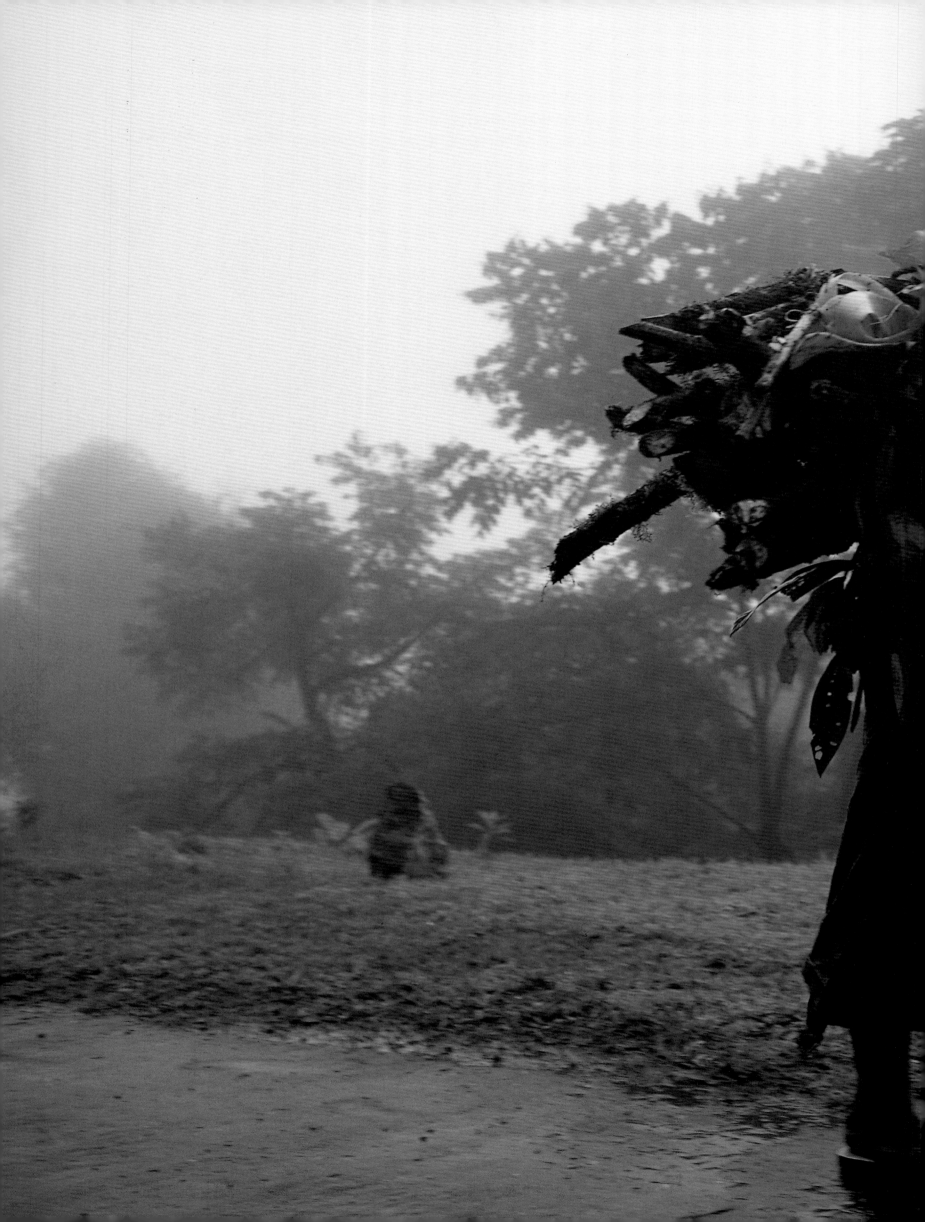

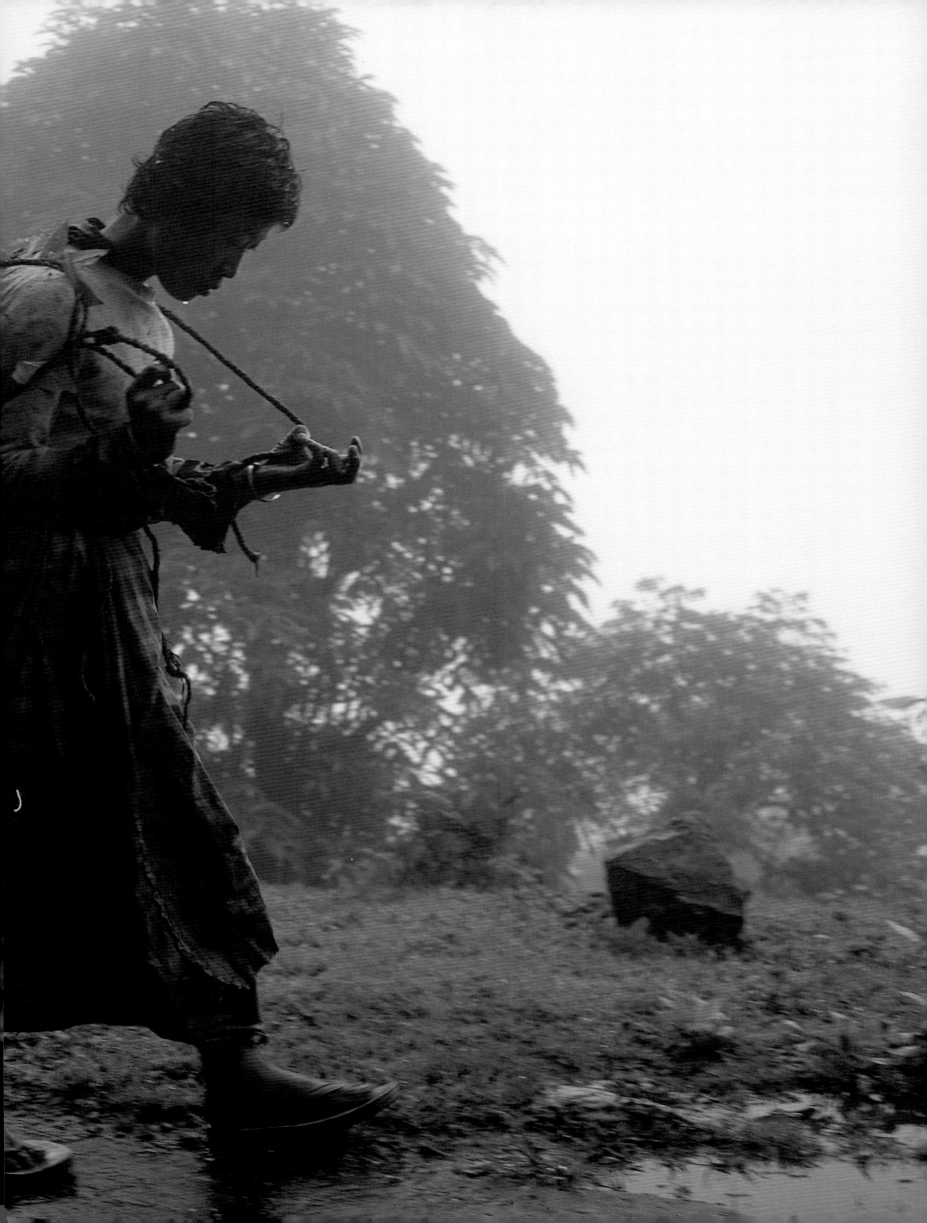

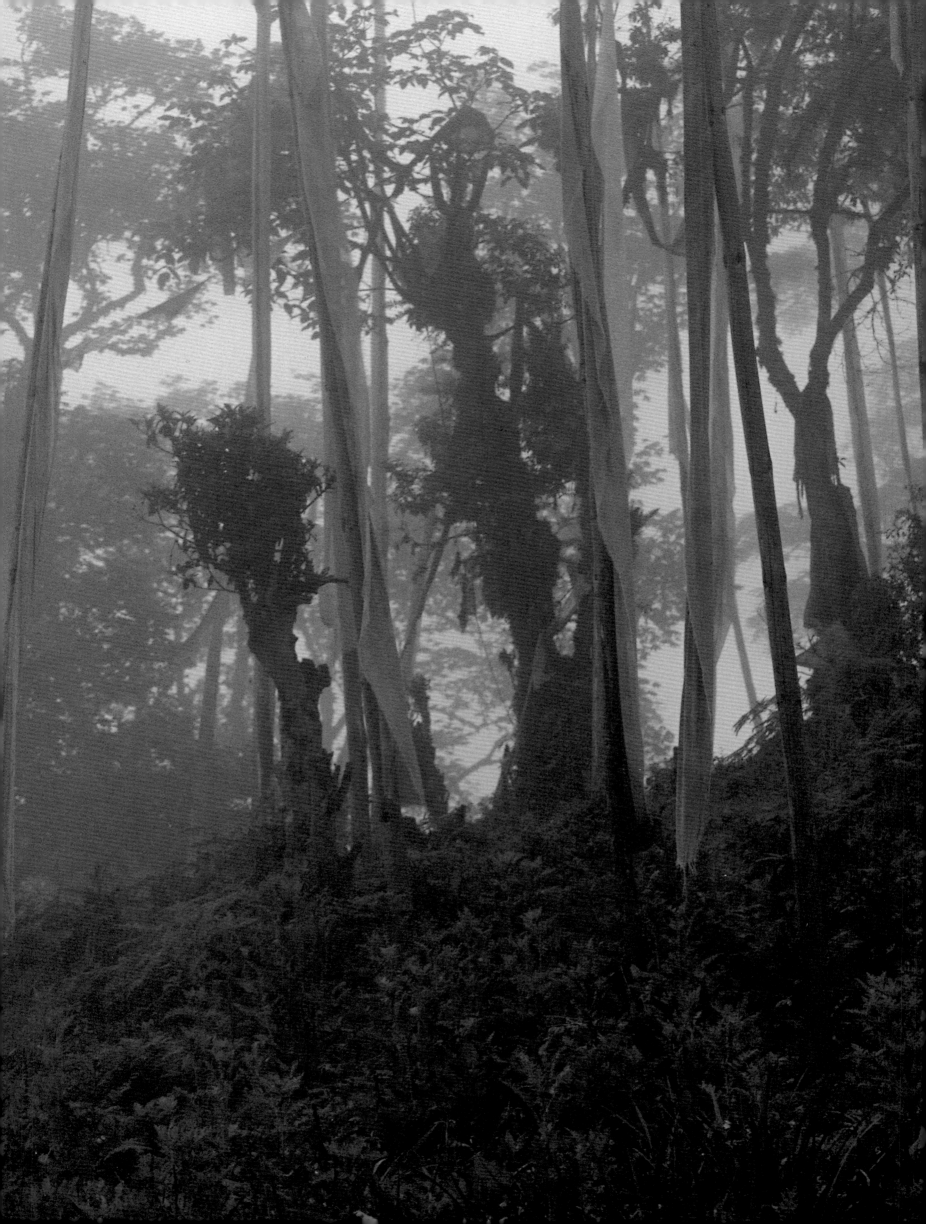

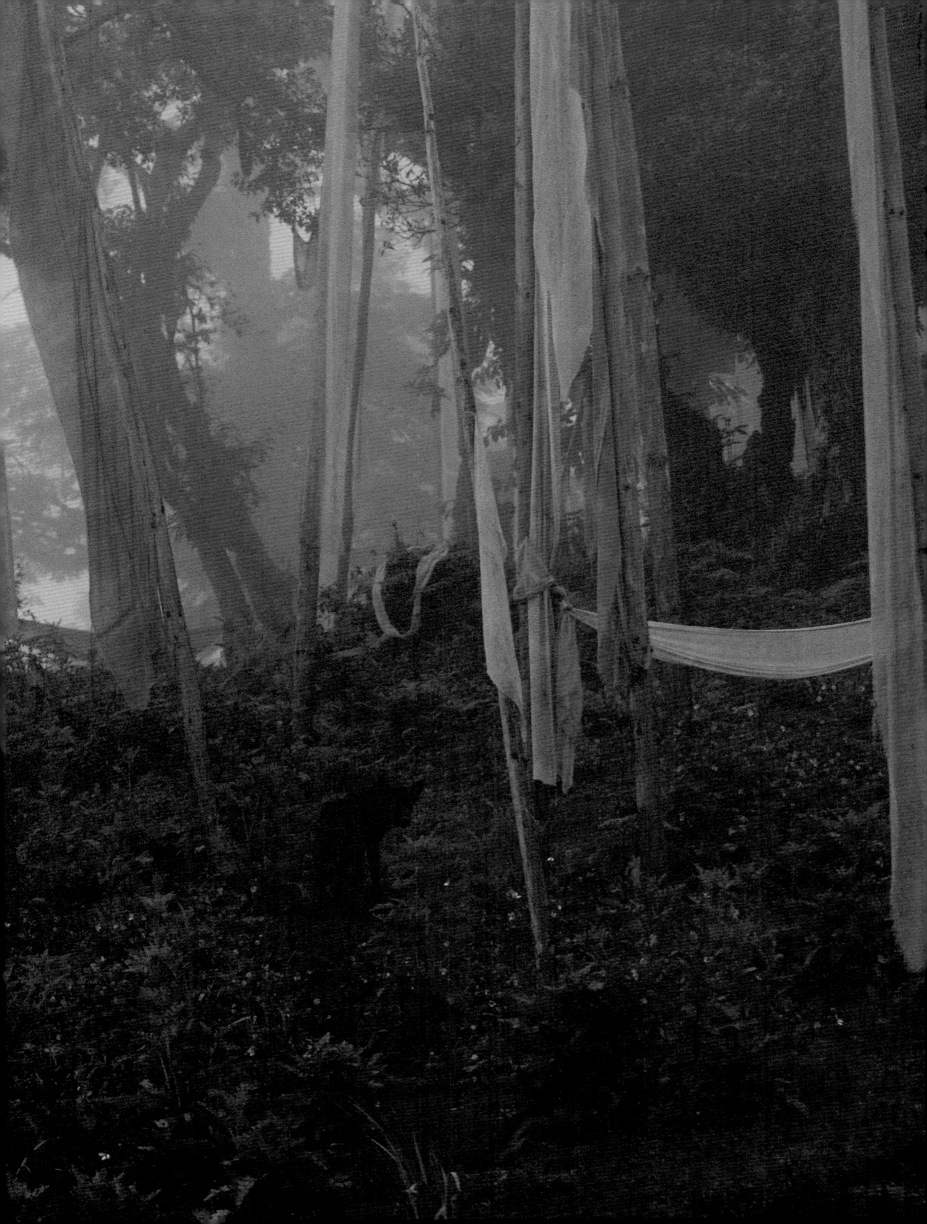

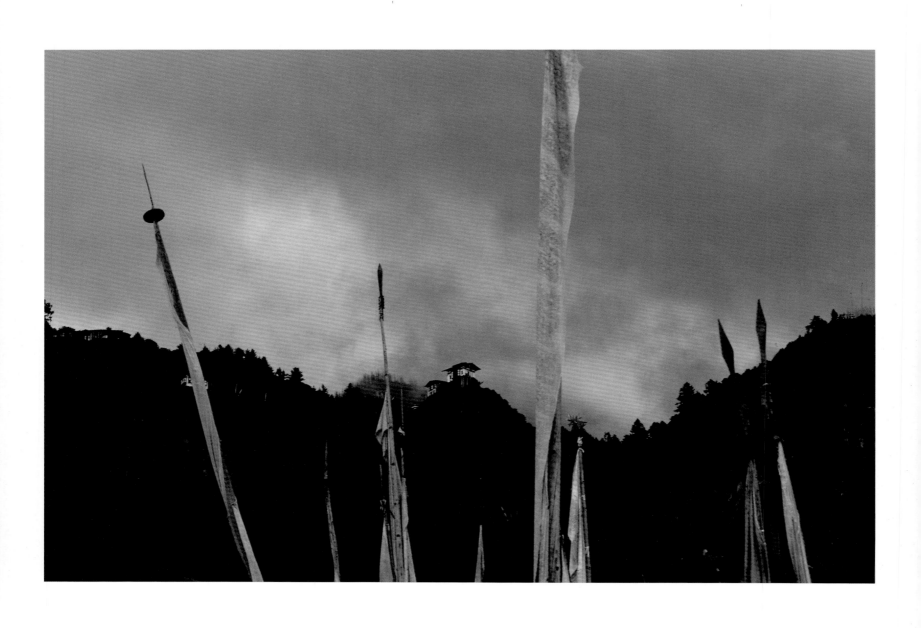

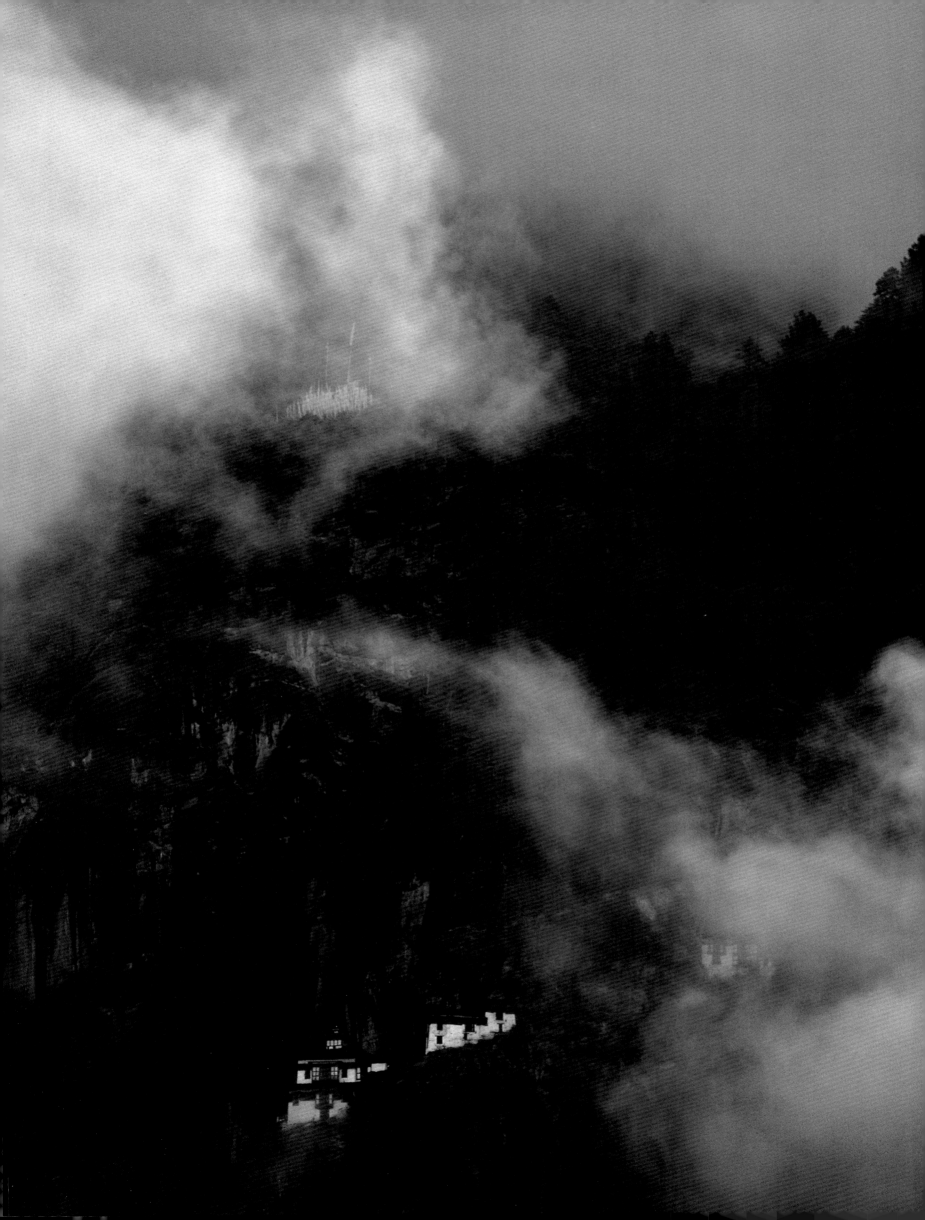

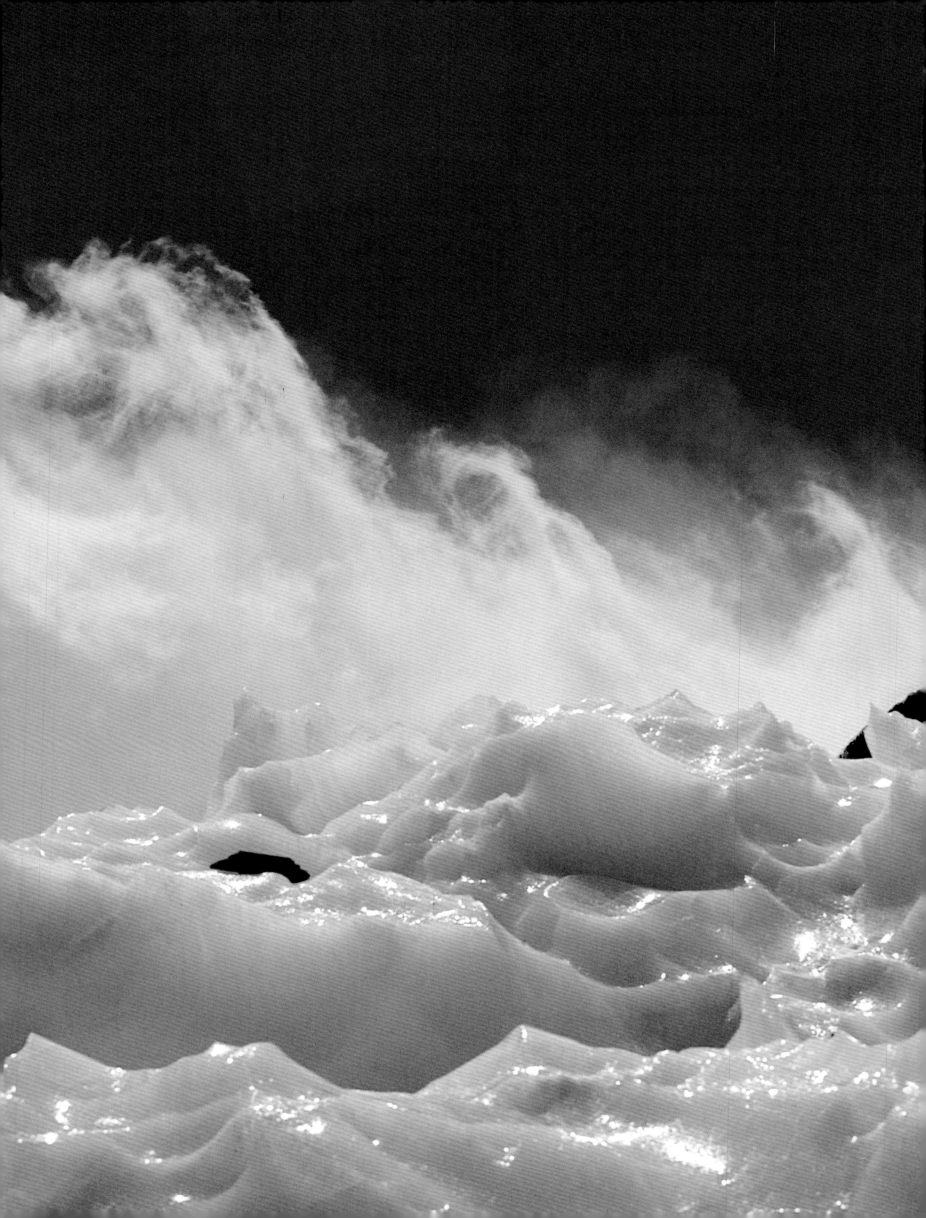

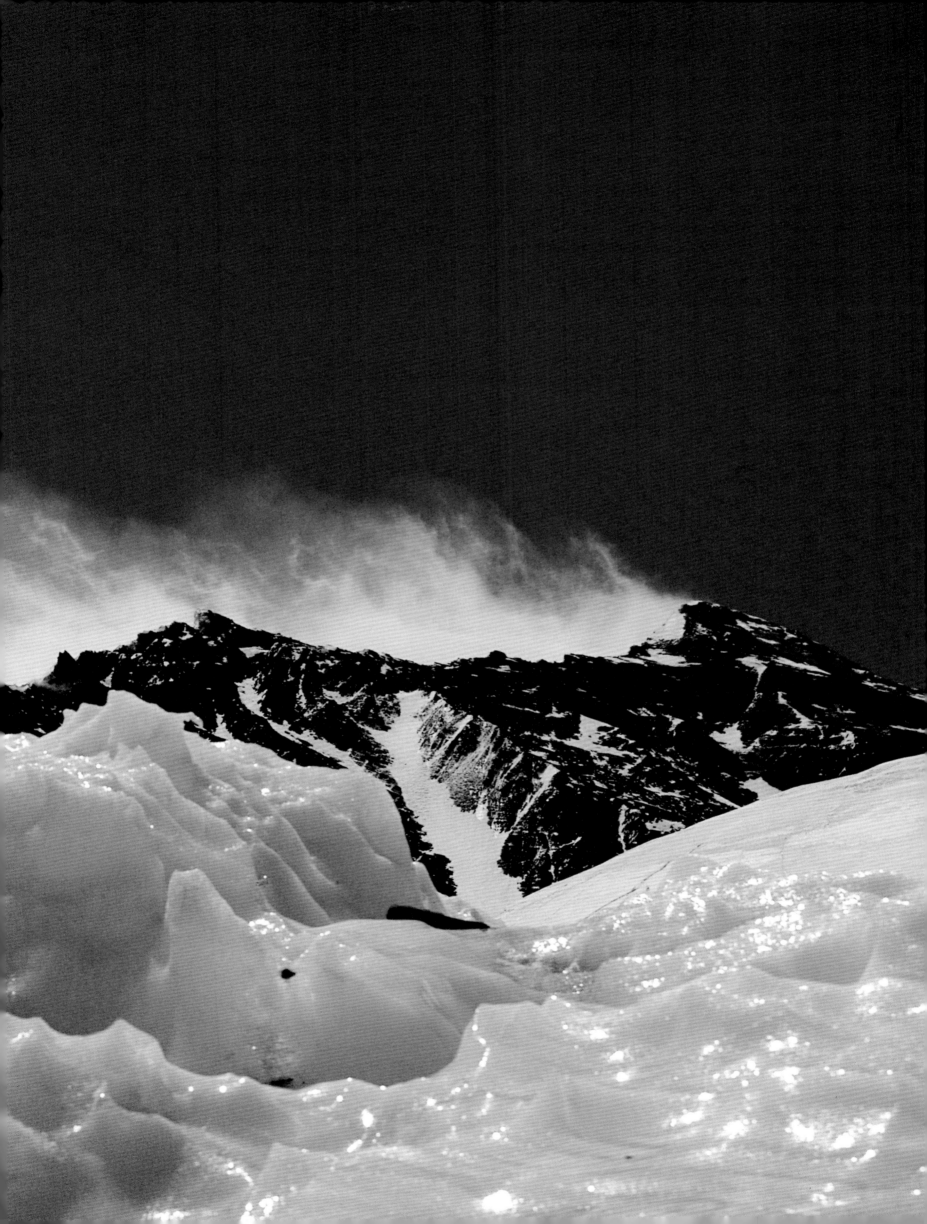

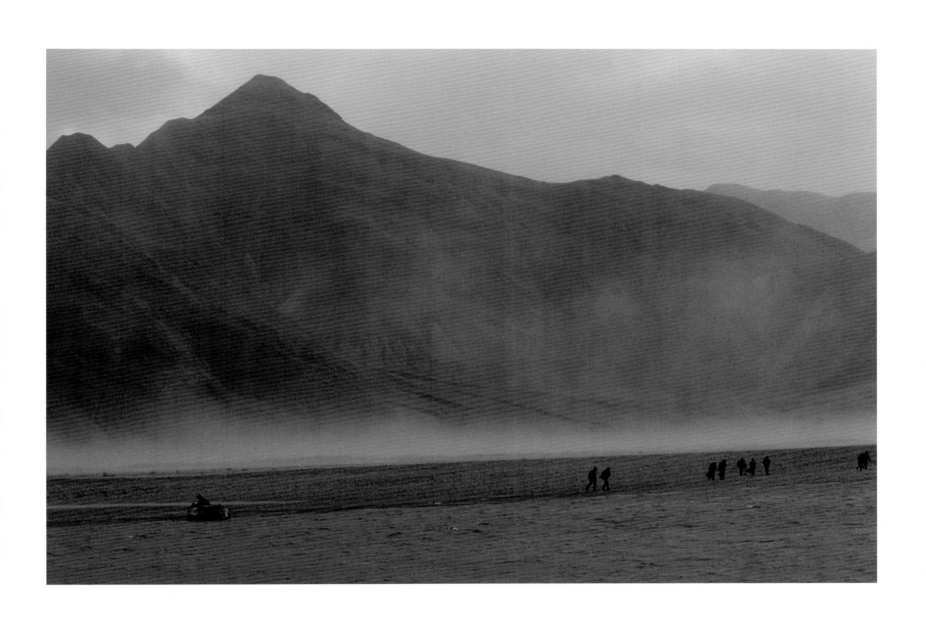

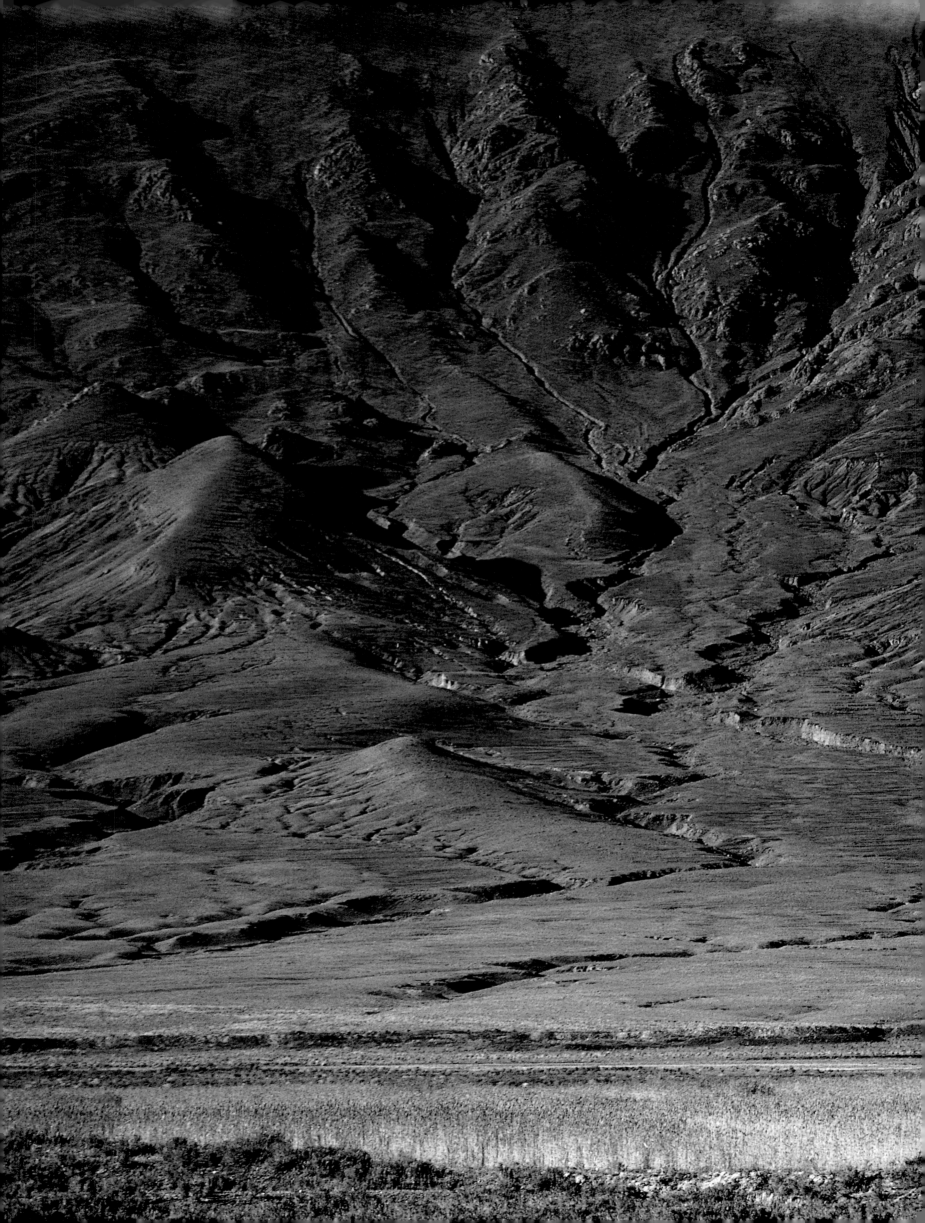

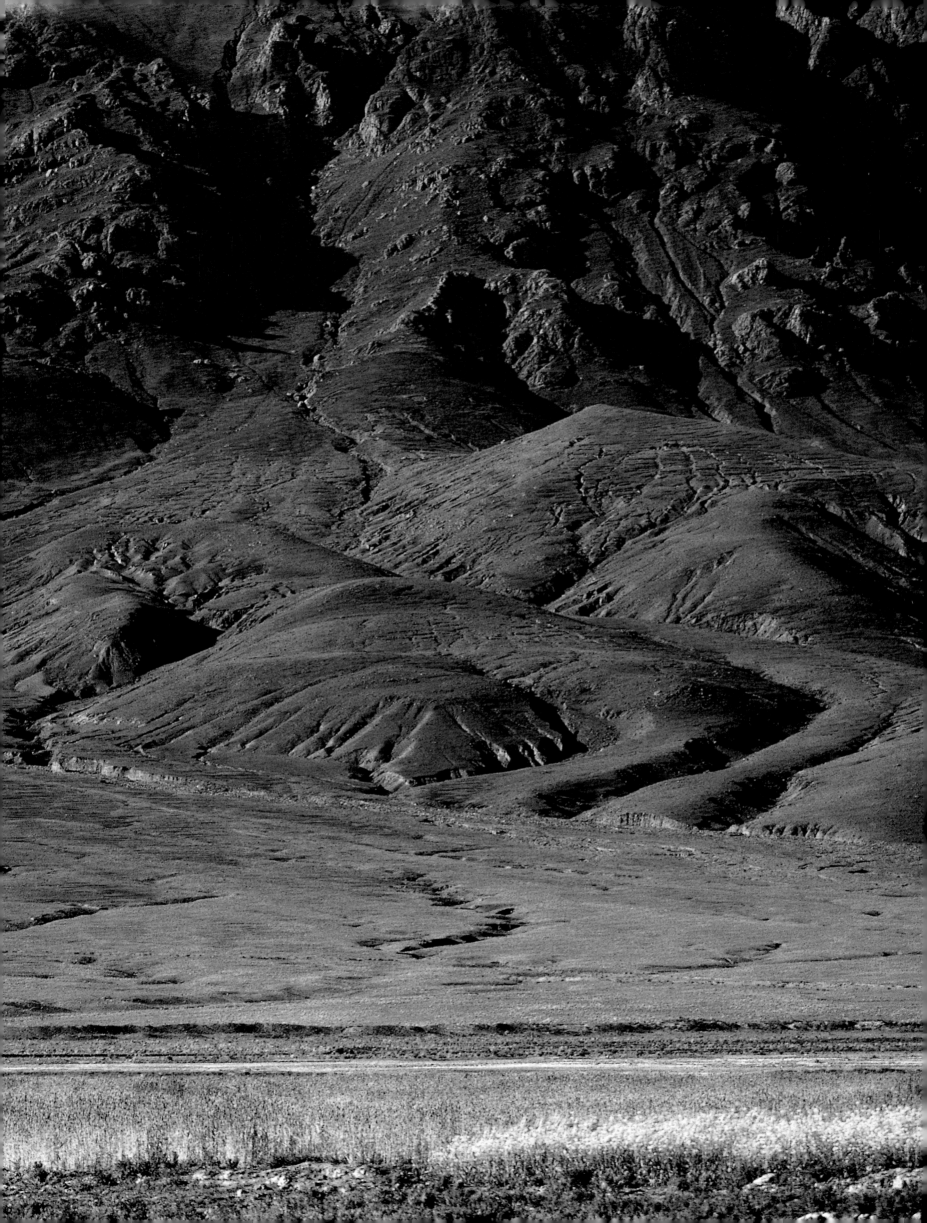

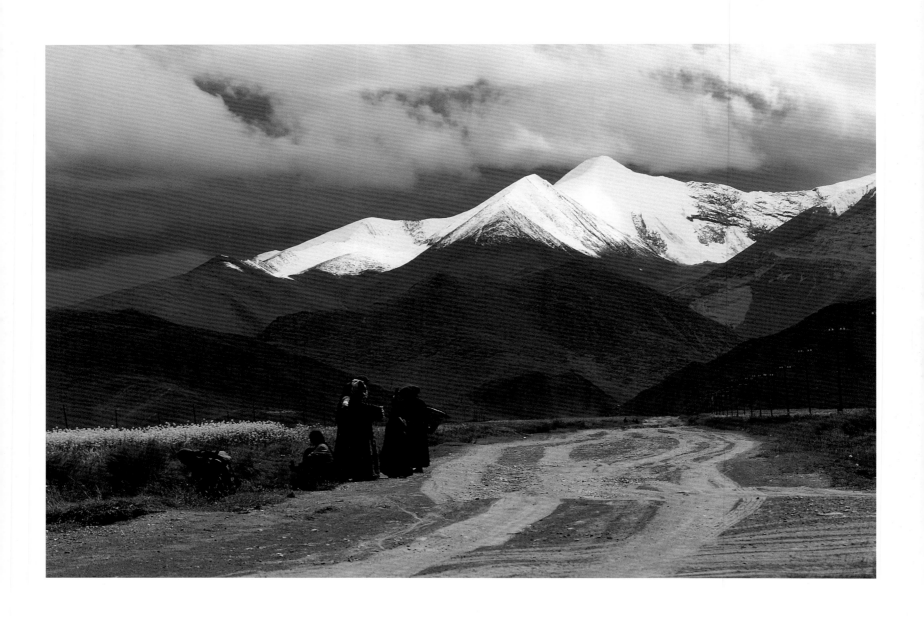

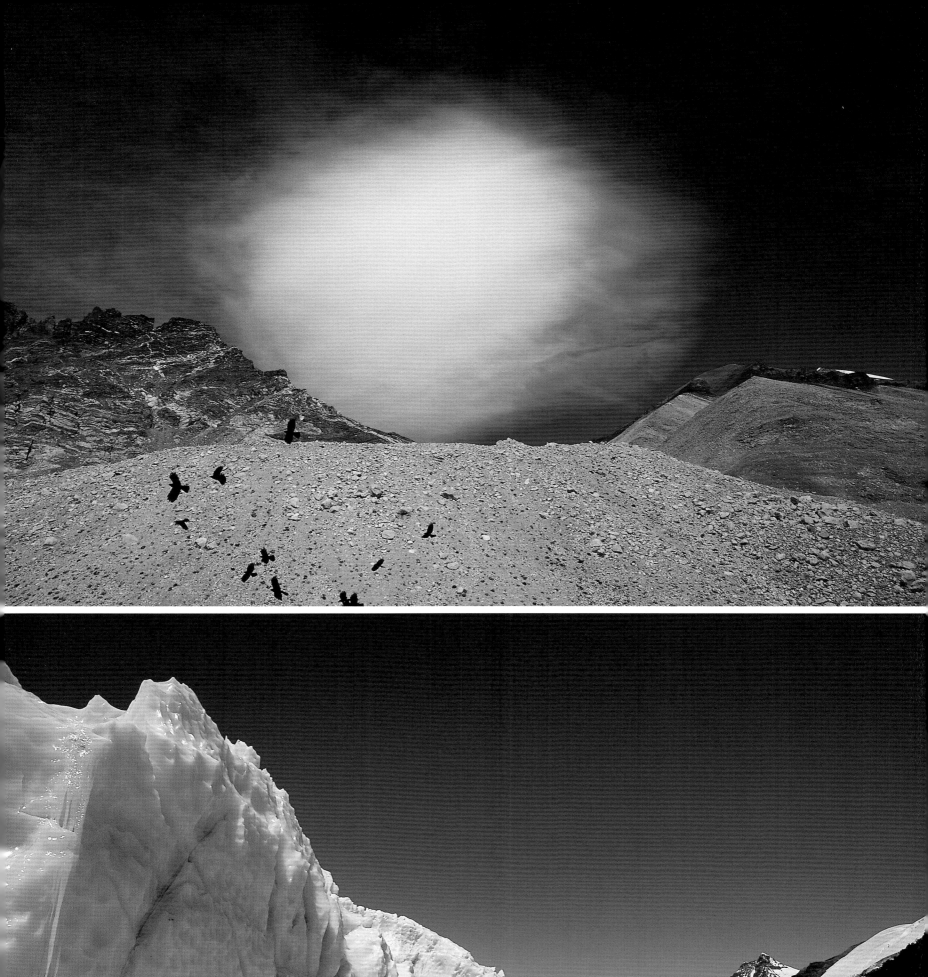
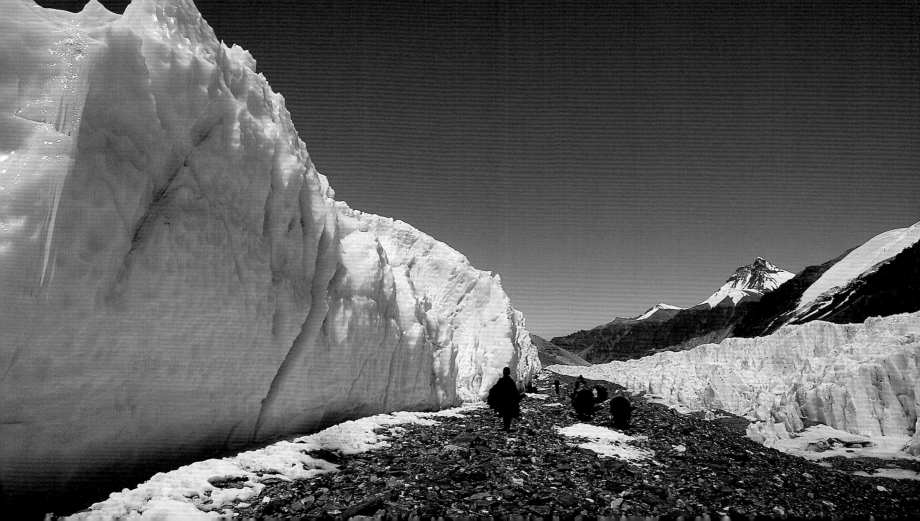

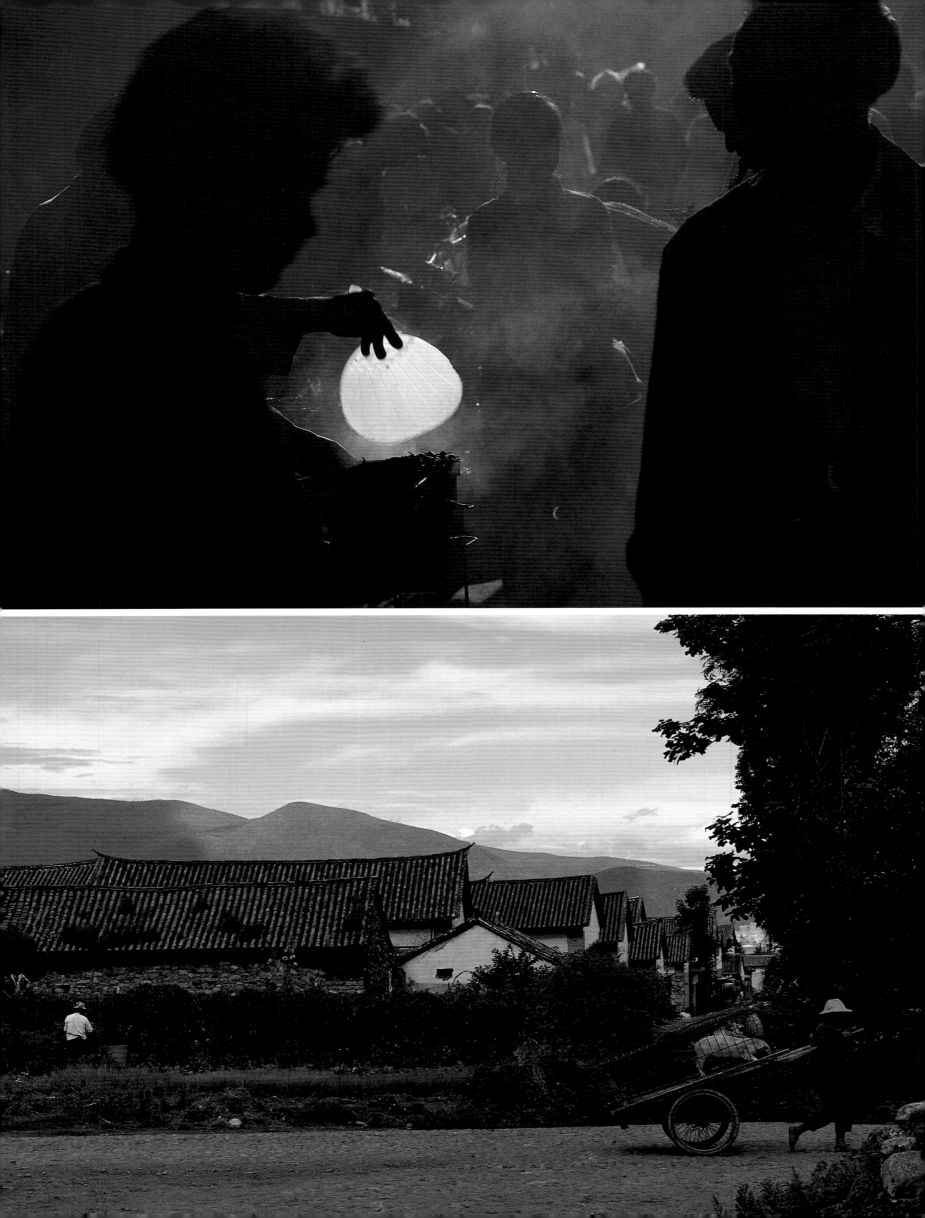

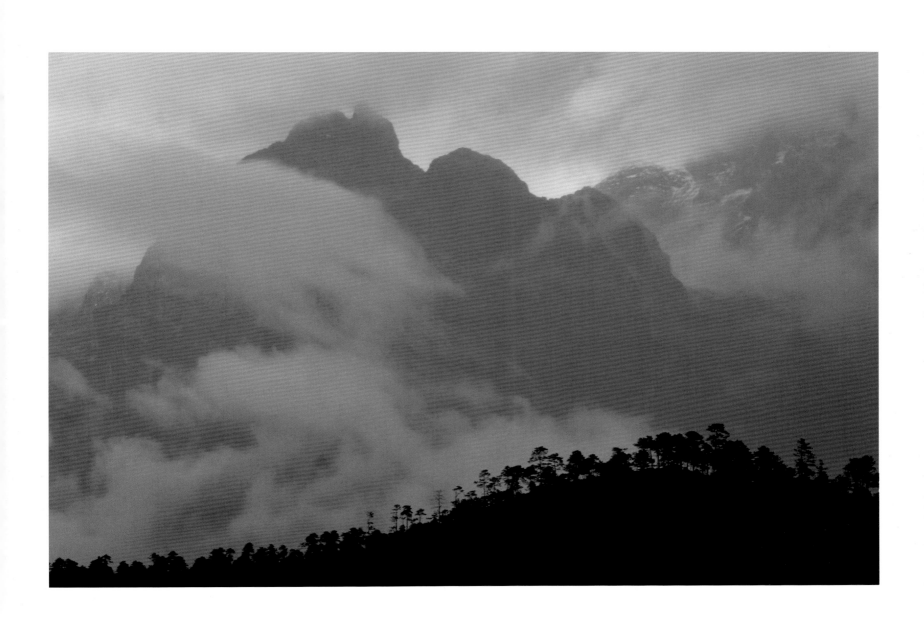

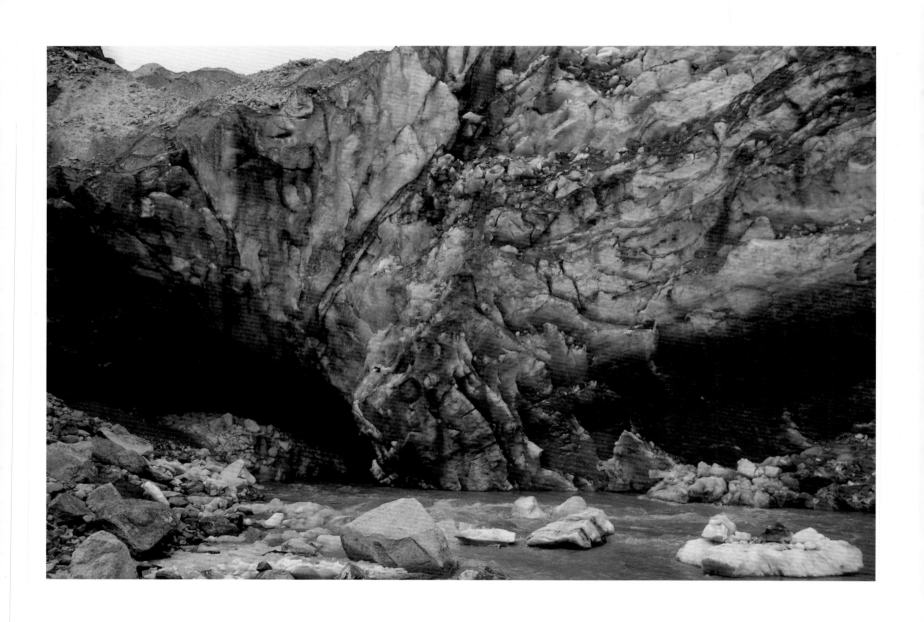

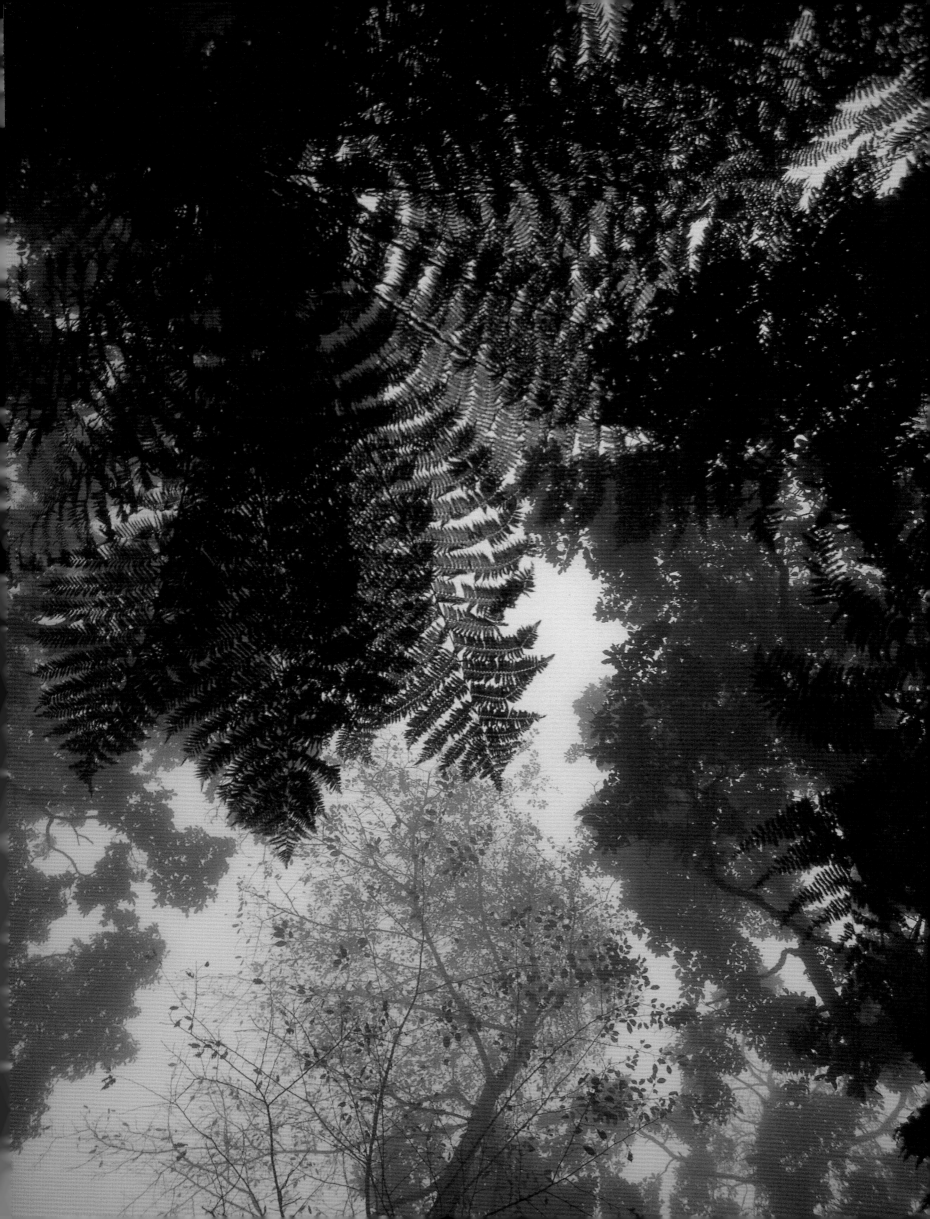

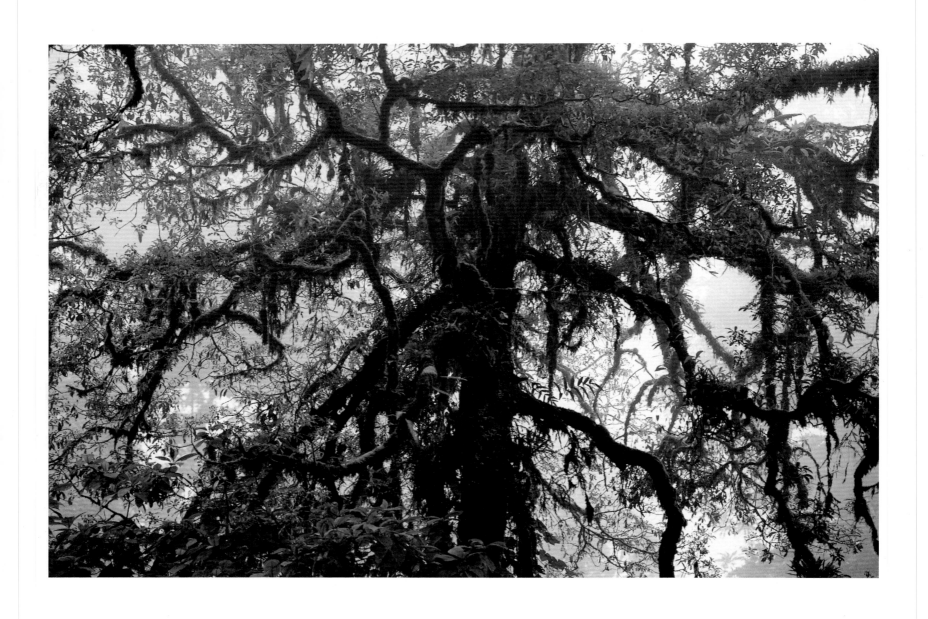

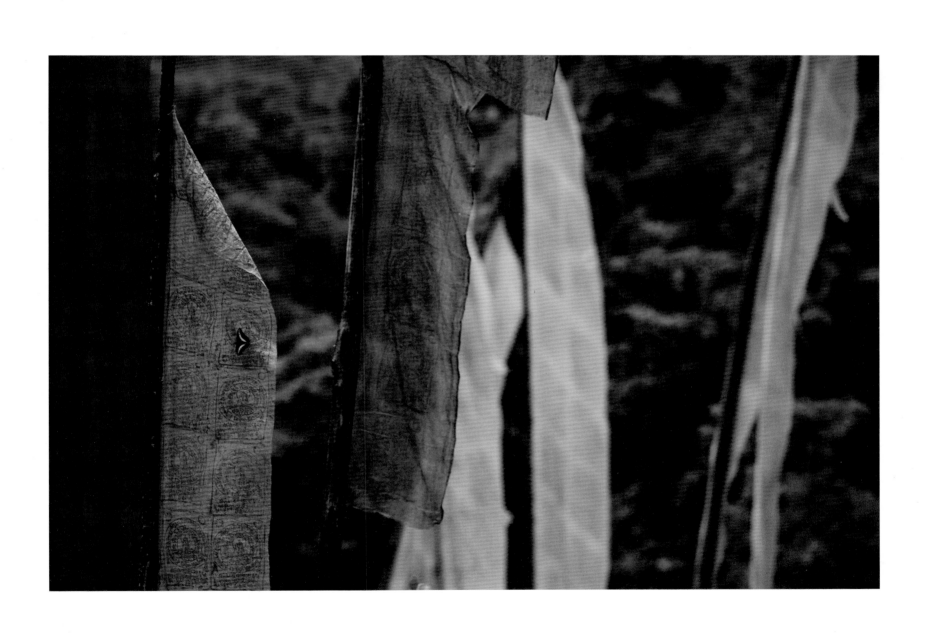

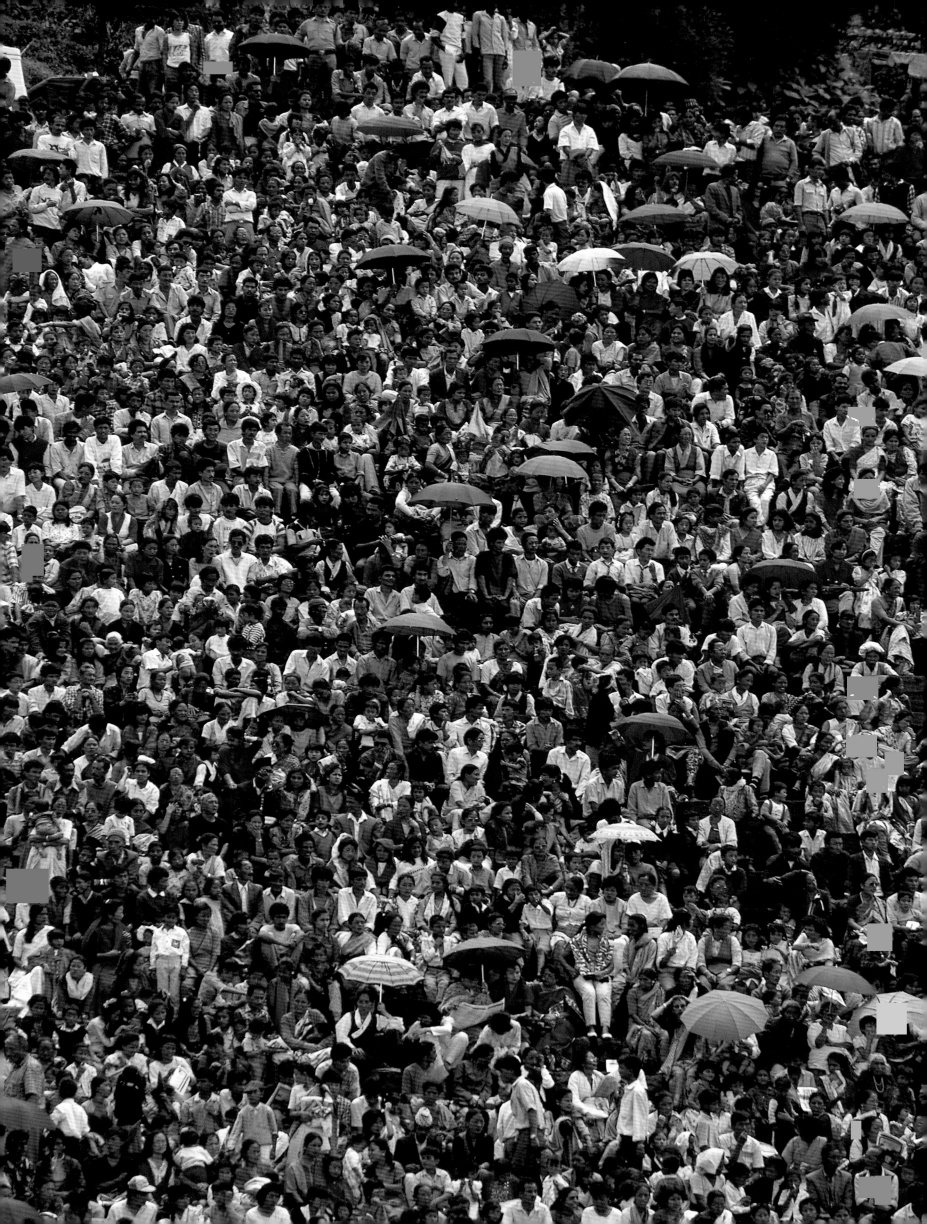

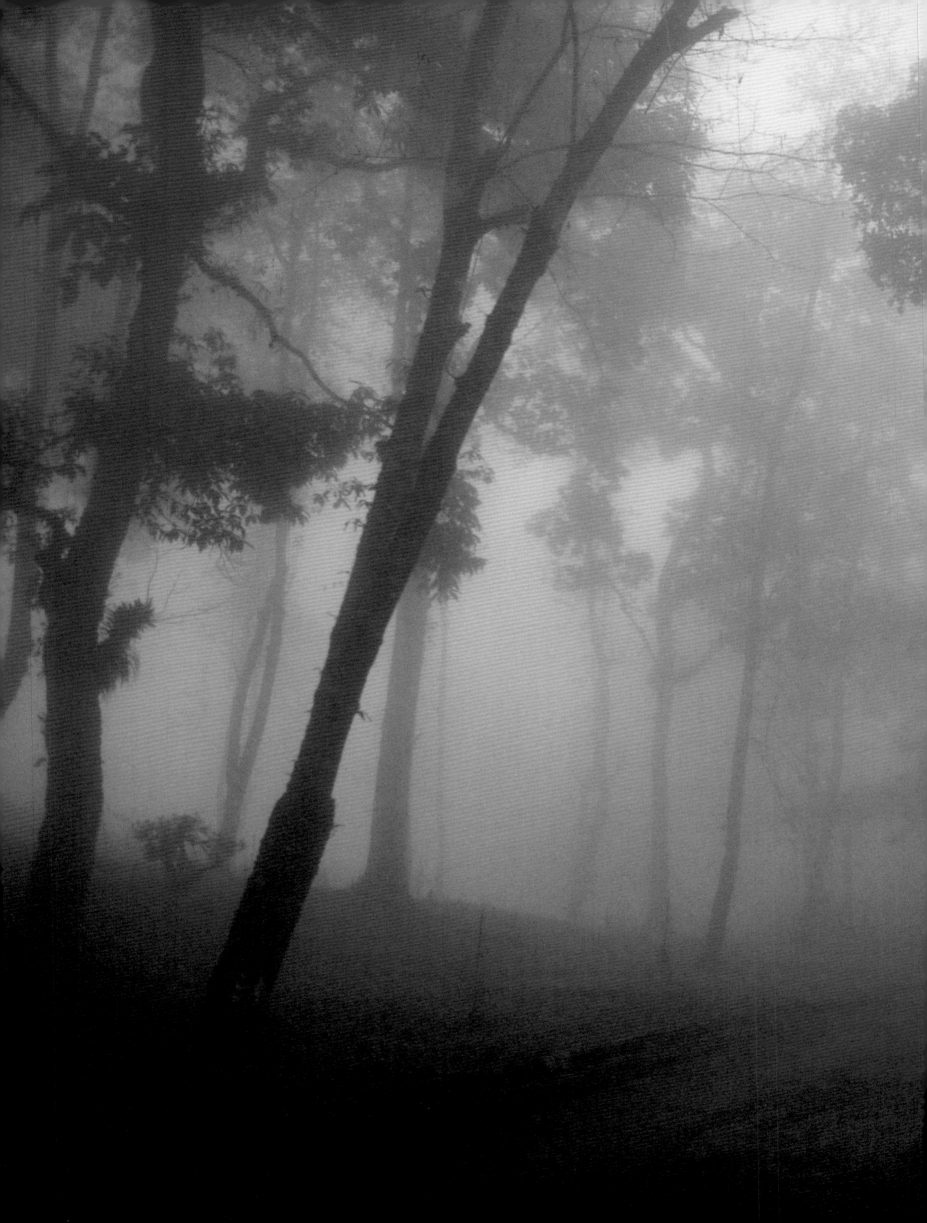

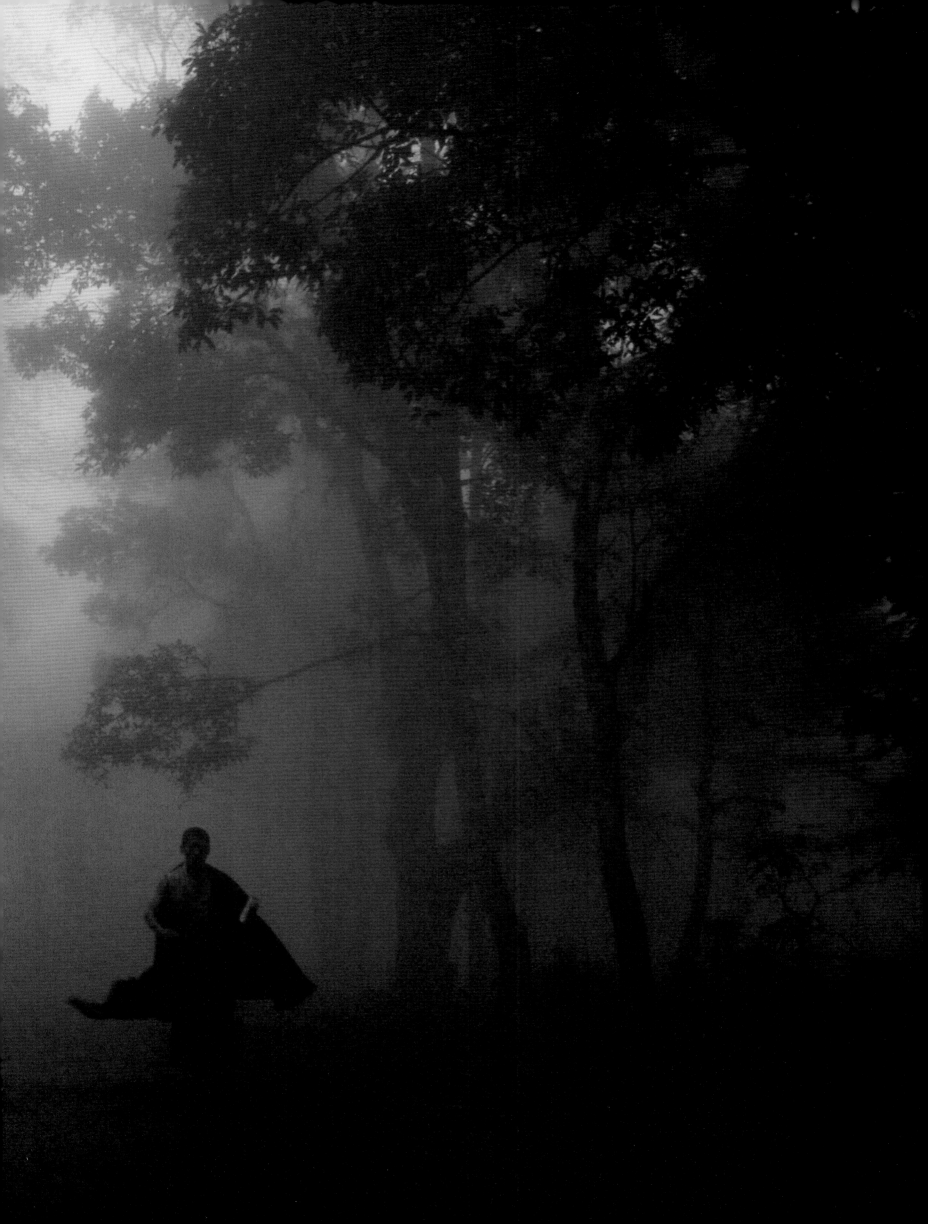

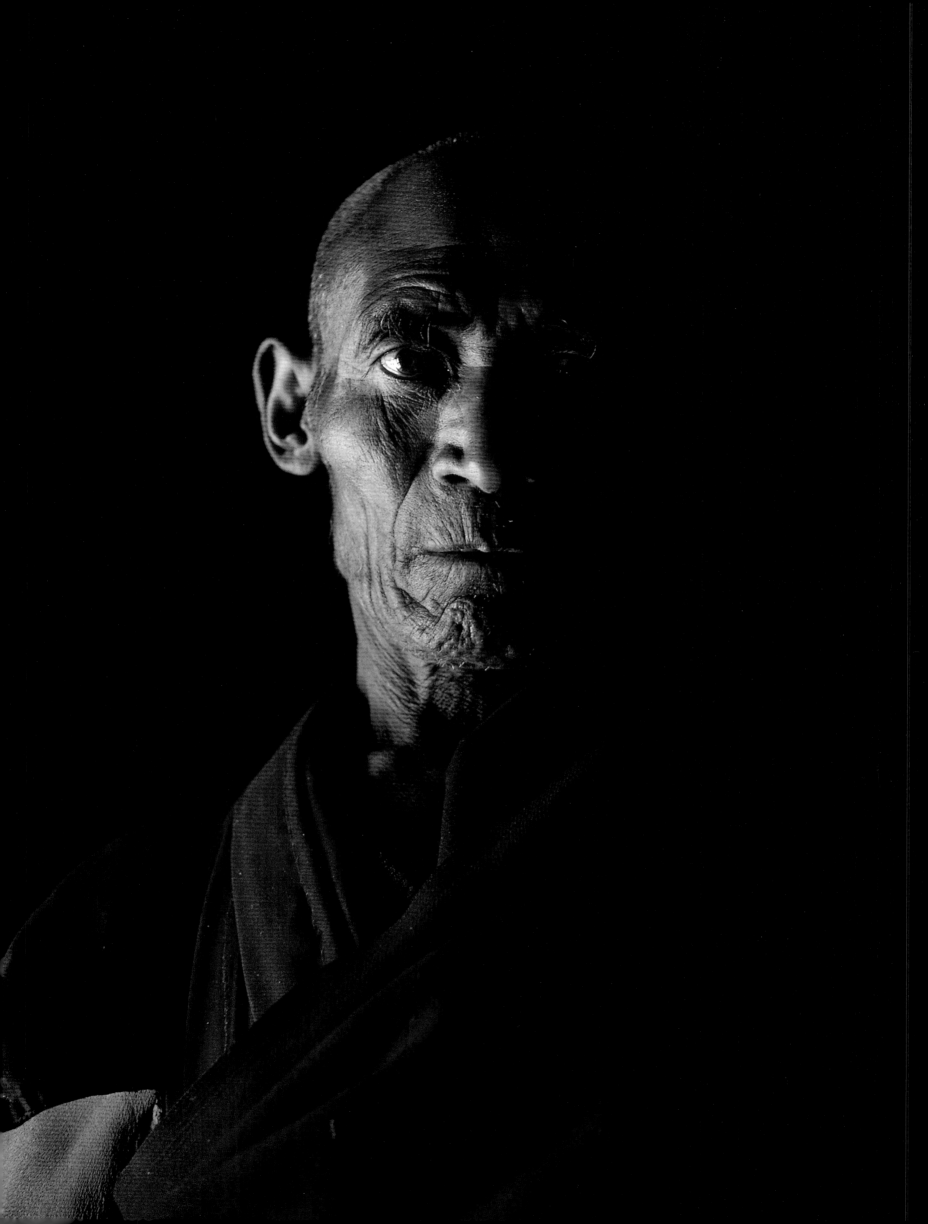

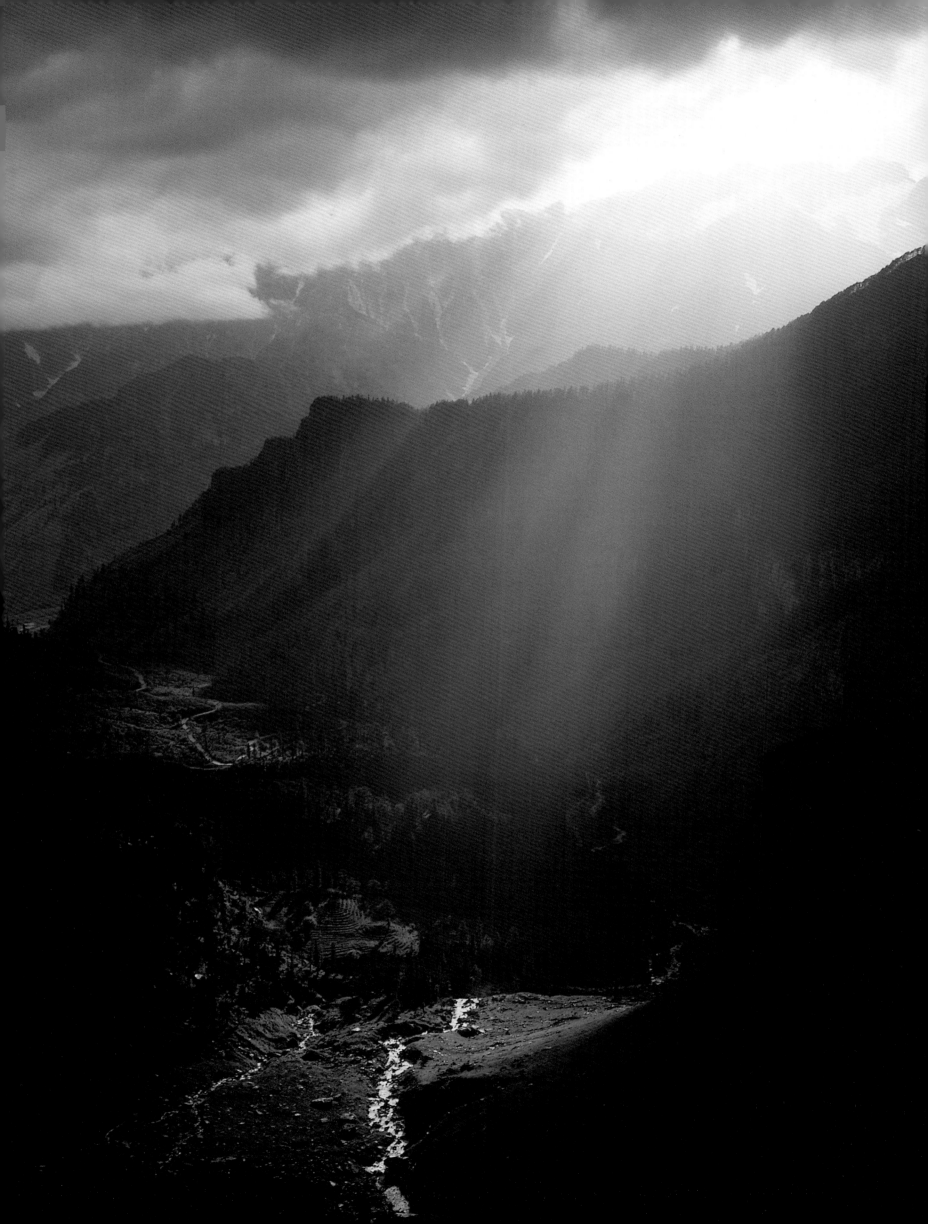

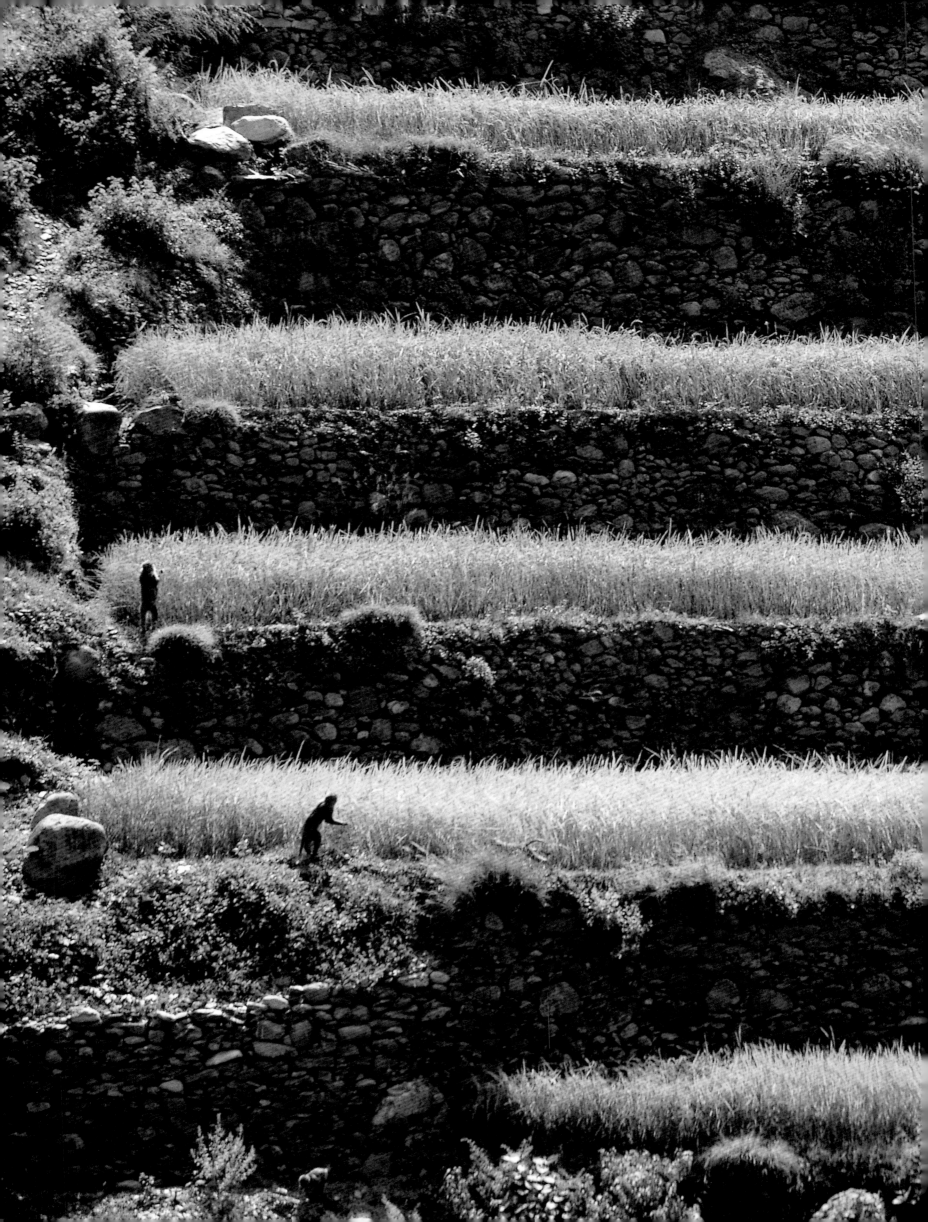

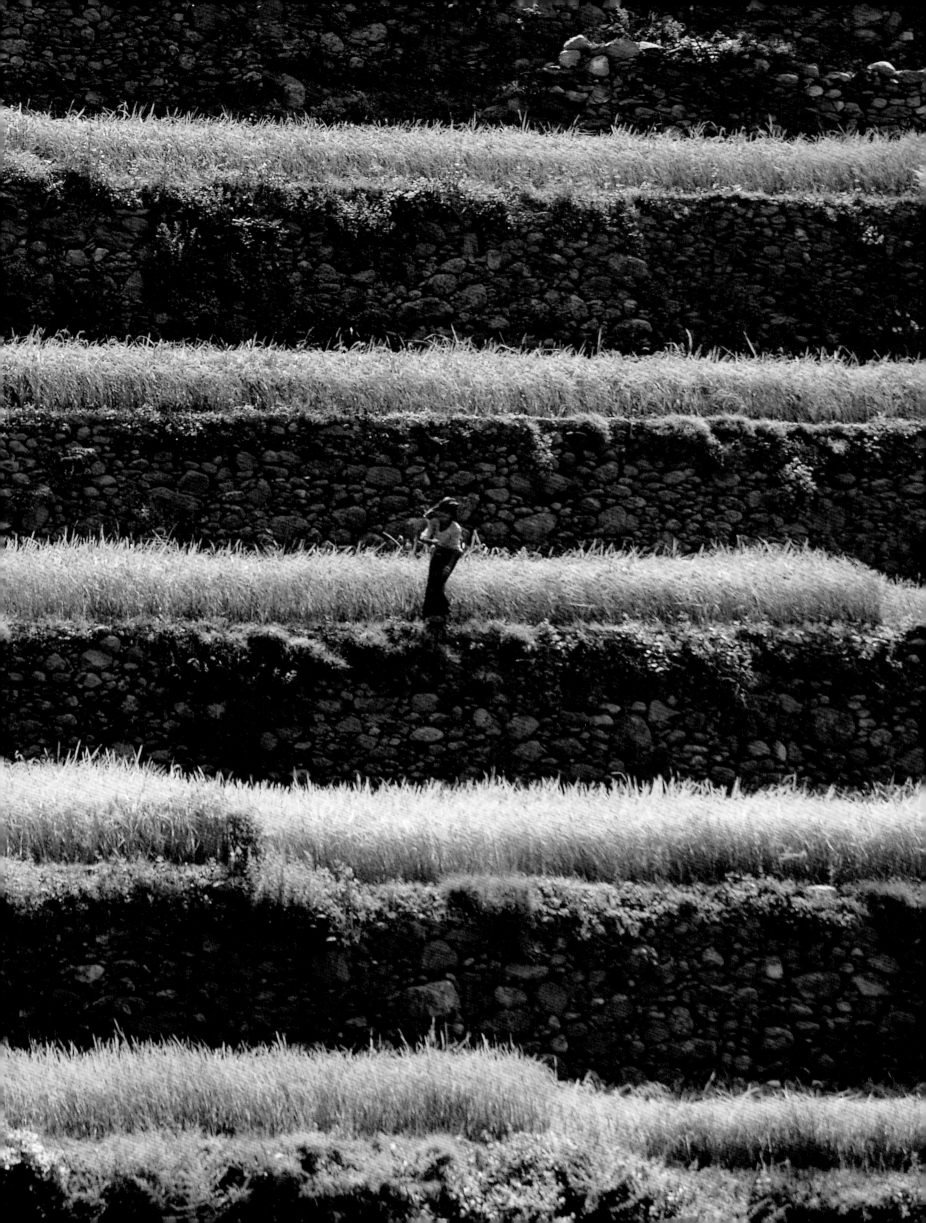

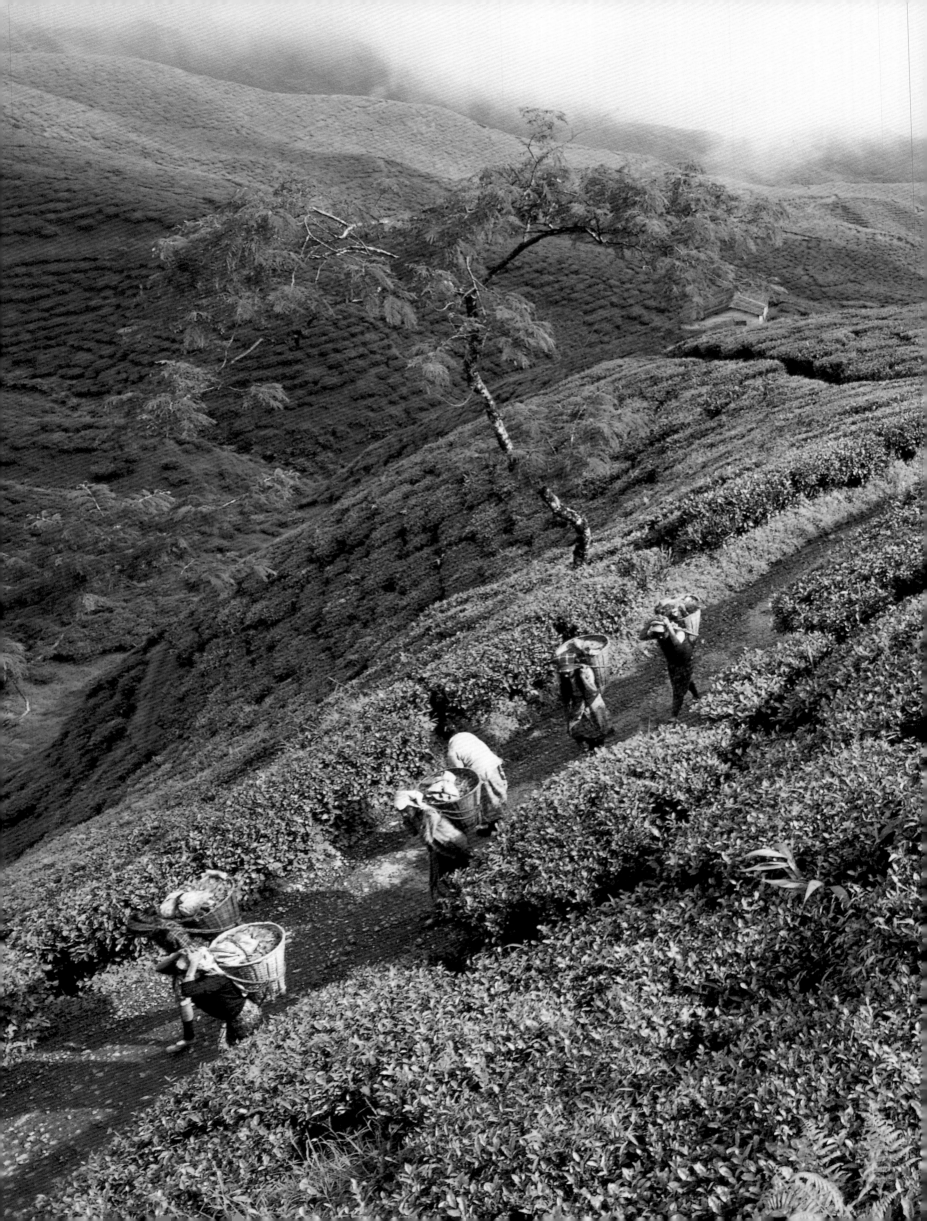

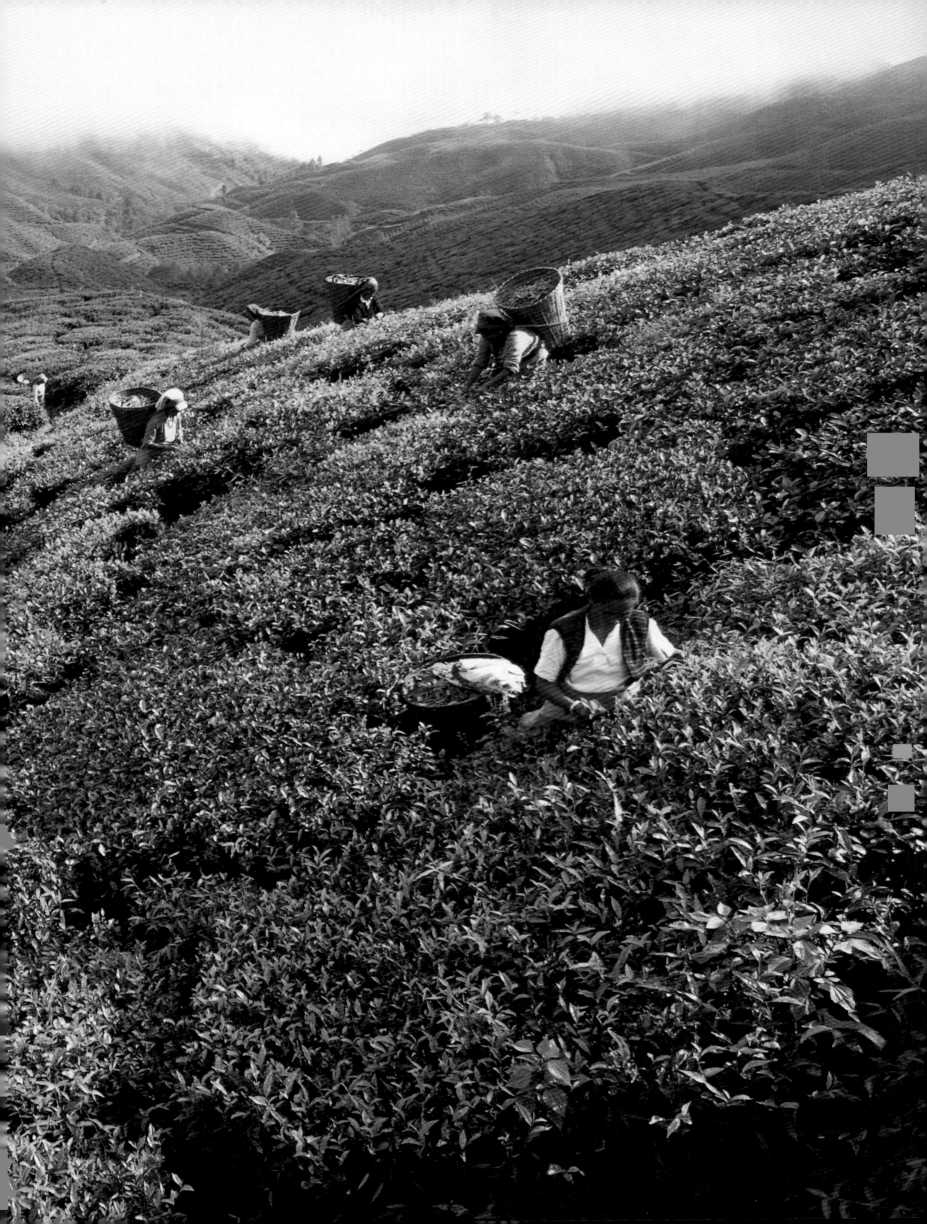

SOUTHEAST ASIA

Thailand
Laos
Vietnam
Cambodia
Malaysia
Indonesia
Philippines

This region is one of the few natural wonderlands left in Asia—a vast area where the tropical sun and the abundant rainfall combine to produce lush jungles teeming with life. Yet ironically, it was the natural riches of spices and tea and more that drew the European colonial powers to the area and that provoked long centuries of subjugation and conflict. Even after the colonial powers finally withdrew, proxy war devastated Indochina until the recent past, making life immeasurably harder for people and all other living things. Only recently has peace returned to this region and have lives returned to normal.

Yet even now there is considerable uncertainty and anxiety about the morrow. Oil and other mineral riches have been discovered throughout the region, and governments are vying for territorial control and posting conflicting claims to this buried treasure. The risk of conflict is once more all too real.

The monsoons are oblivious to this. They have nurtured the tropical forests from time immemorial and have offered their baptism through good times and bad. They have ensured that this is a bountiful region.

Indeed, it was this fecundity that supported the palm, sugar, and other plantations during colonial times and that today sustains the region's economic development.

Yet even this tropical life force is not invincible. Tropical nature is faltering in the face of slash-and-burn agriculture, indiscriminate logging, and other ravages. As a result, the region is now at a difficult juncture between inexhaustible human greed and nature's finite capacity for renewal, and the land cries out in pain and sorrow. I am hopeful that Asian wisdom will prevail and that this irreplaceable heritage will not be lost—that the monsoon's blessings will continue to benefit all humankind—but this is guarded optimism. It will not be easy to reconcile the preservation of nature and the enhancement of living standards, but nor is it impossible if people will realize that there is no quality of life on a sterile planet.

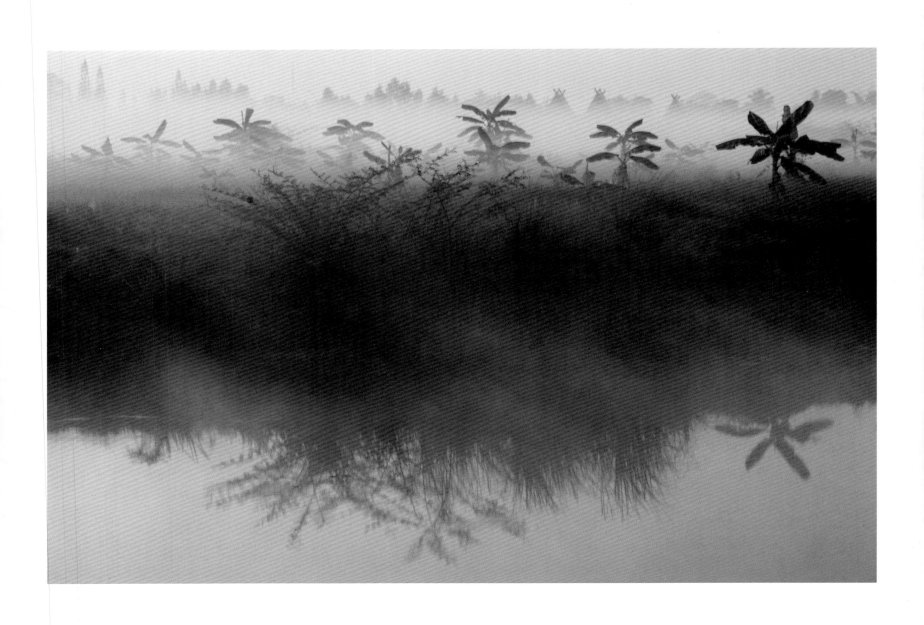

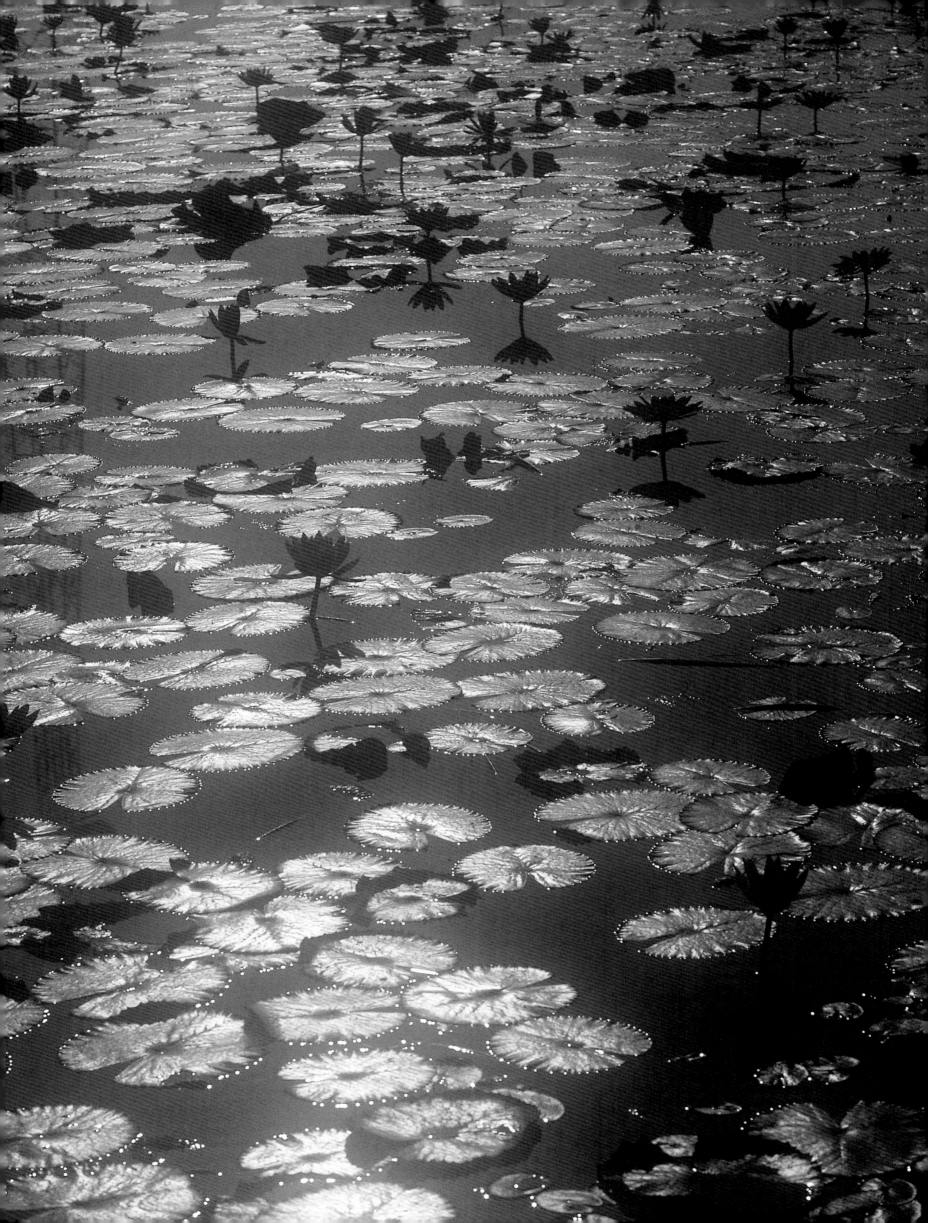

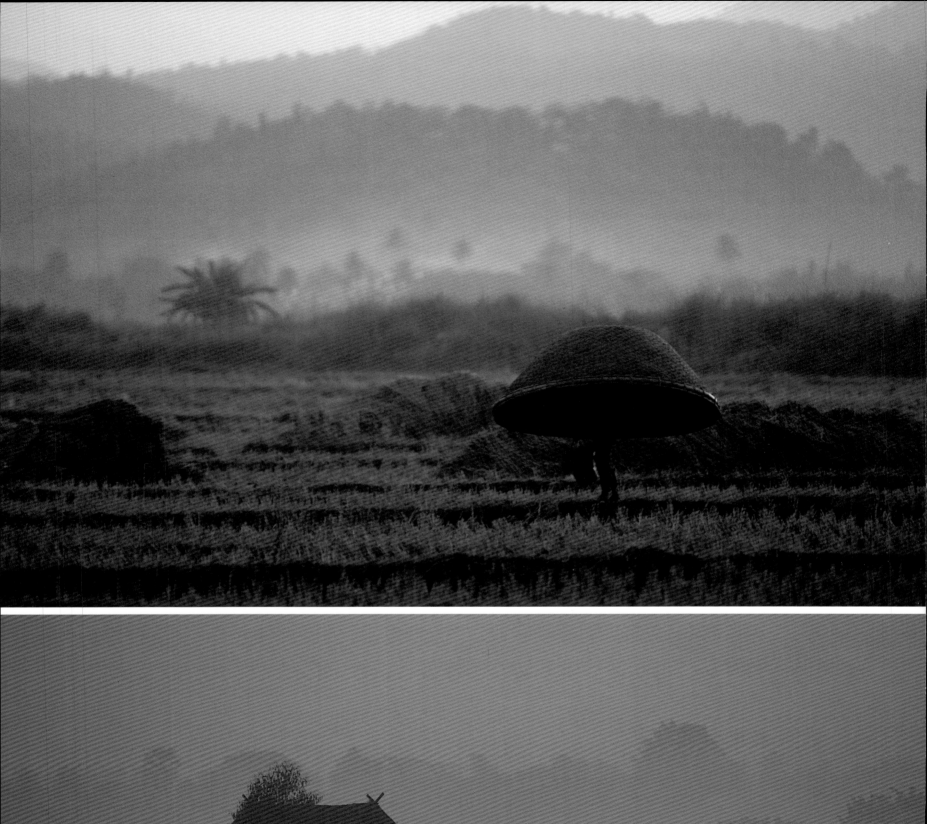

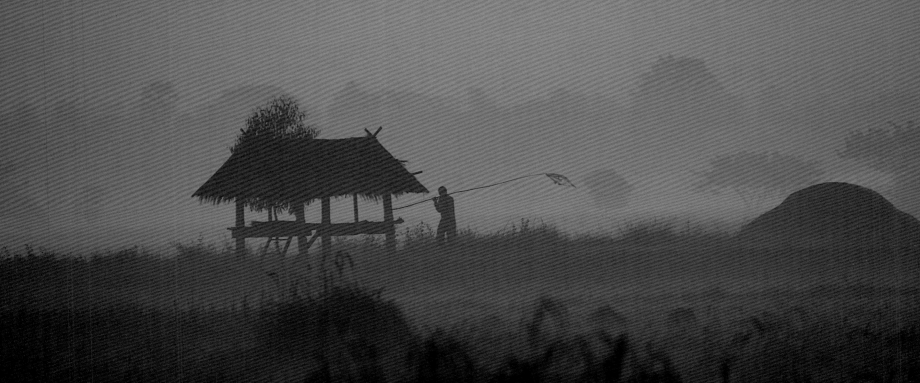

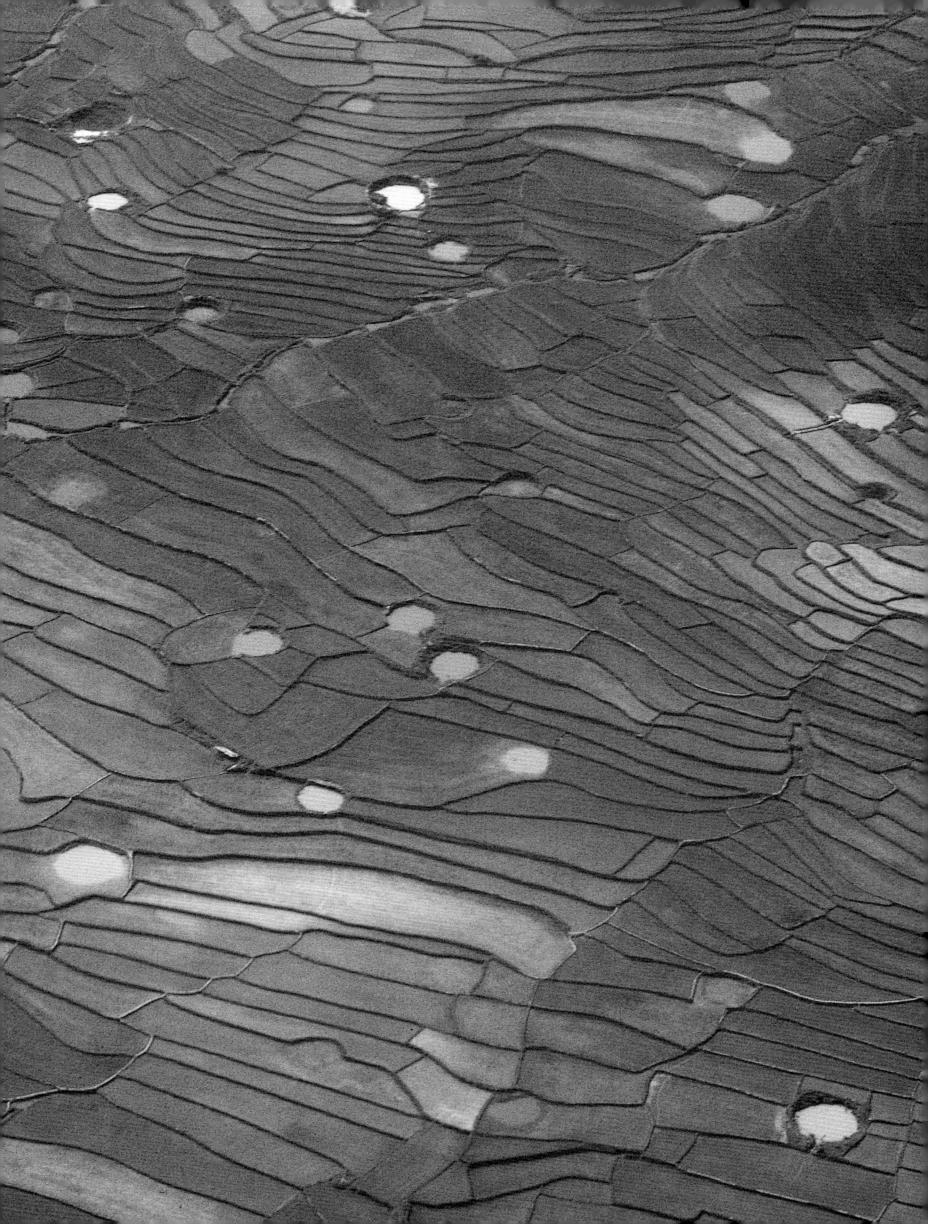

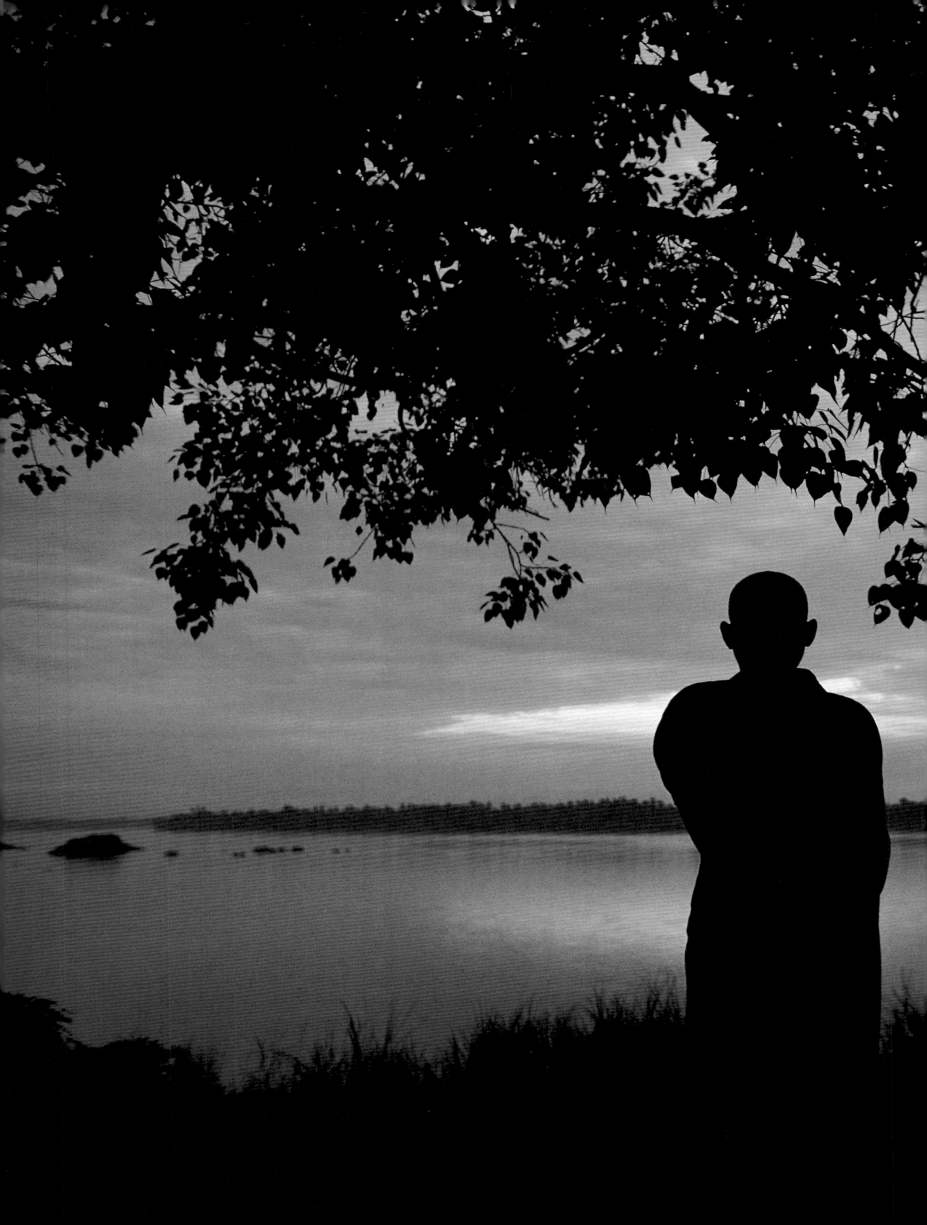

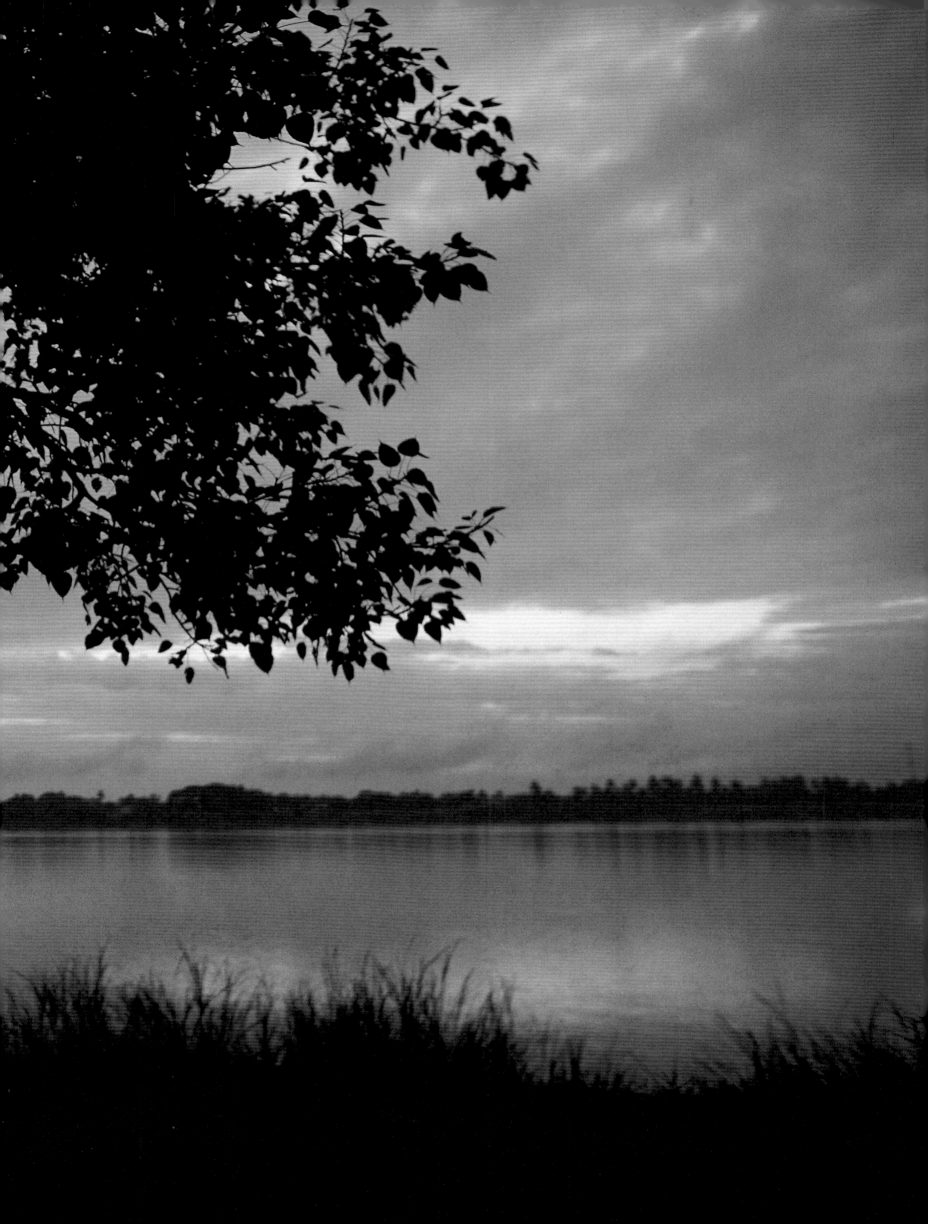

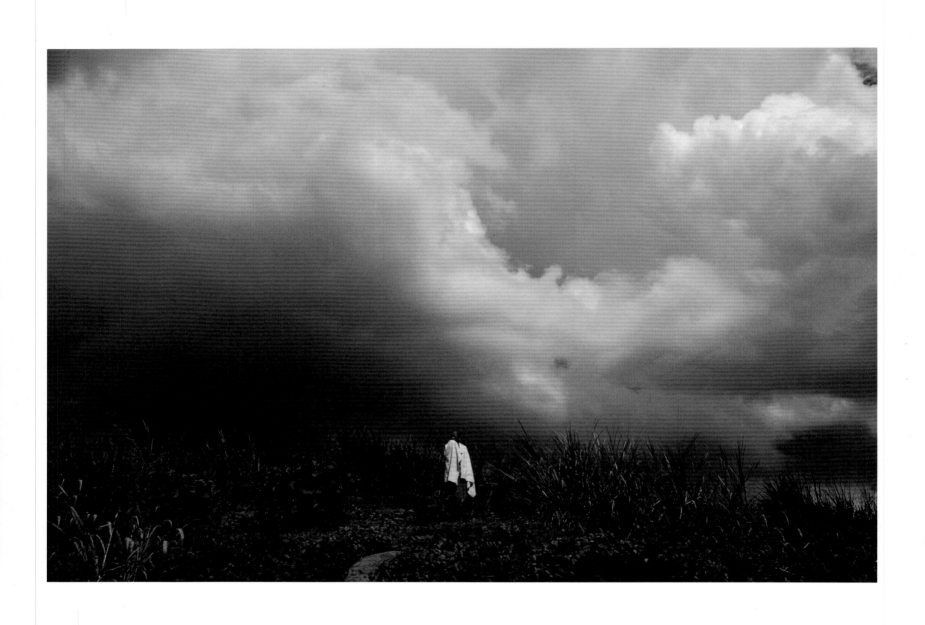

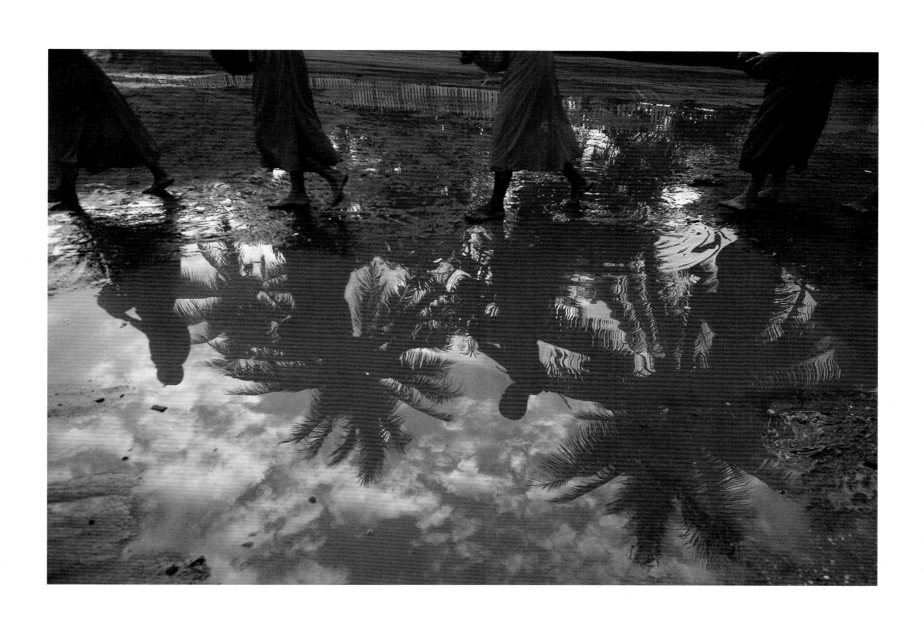

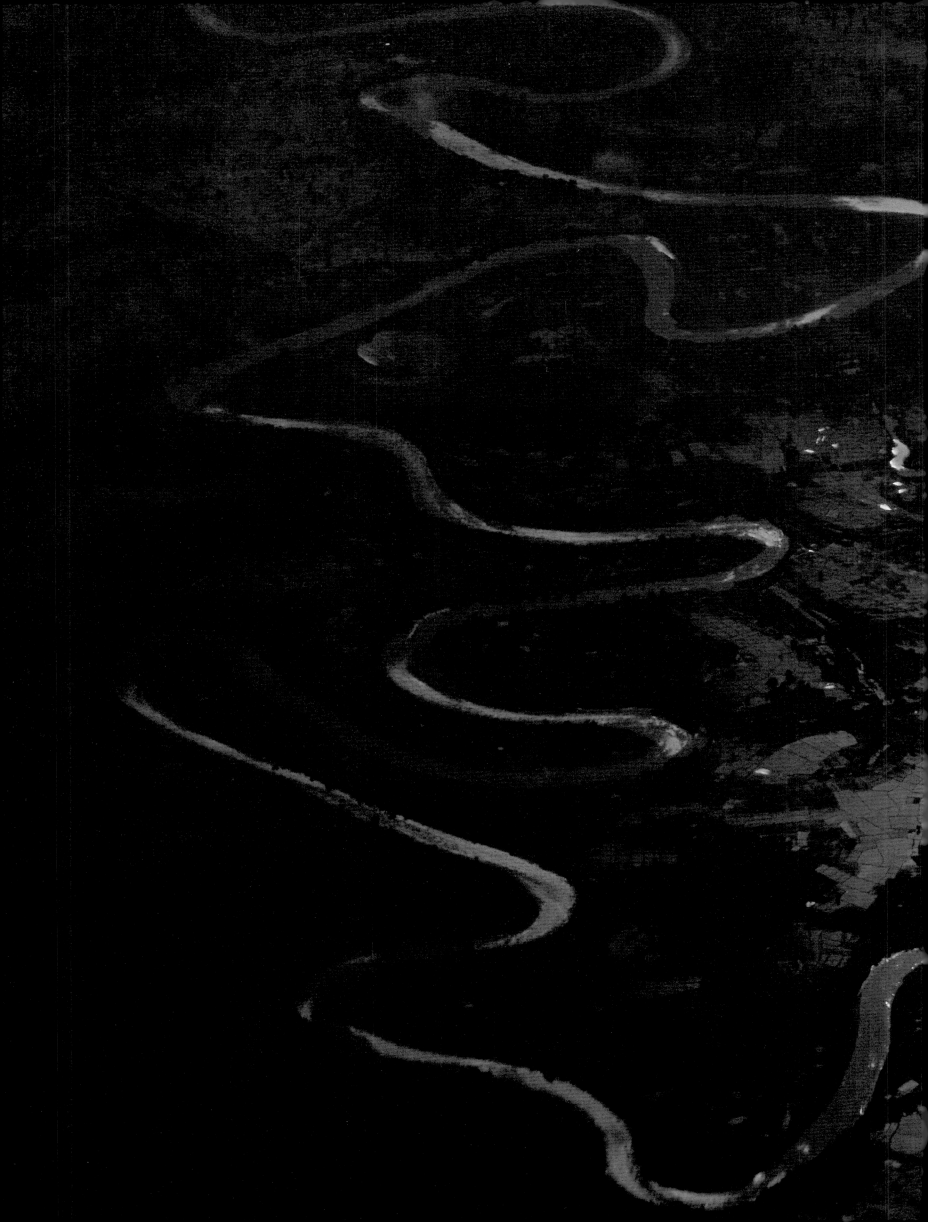

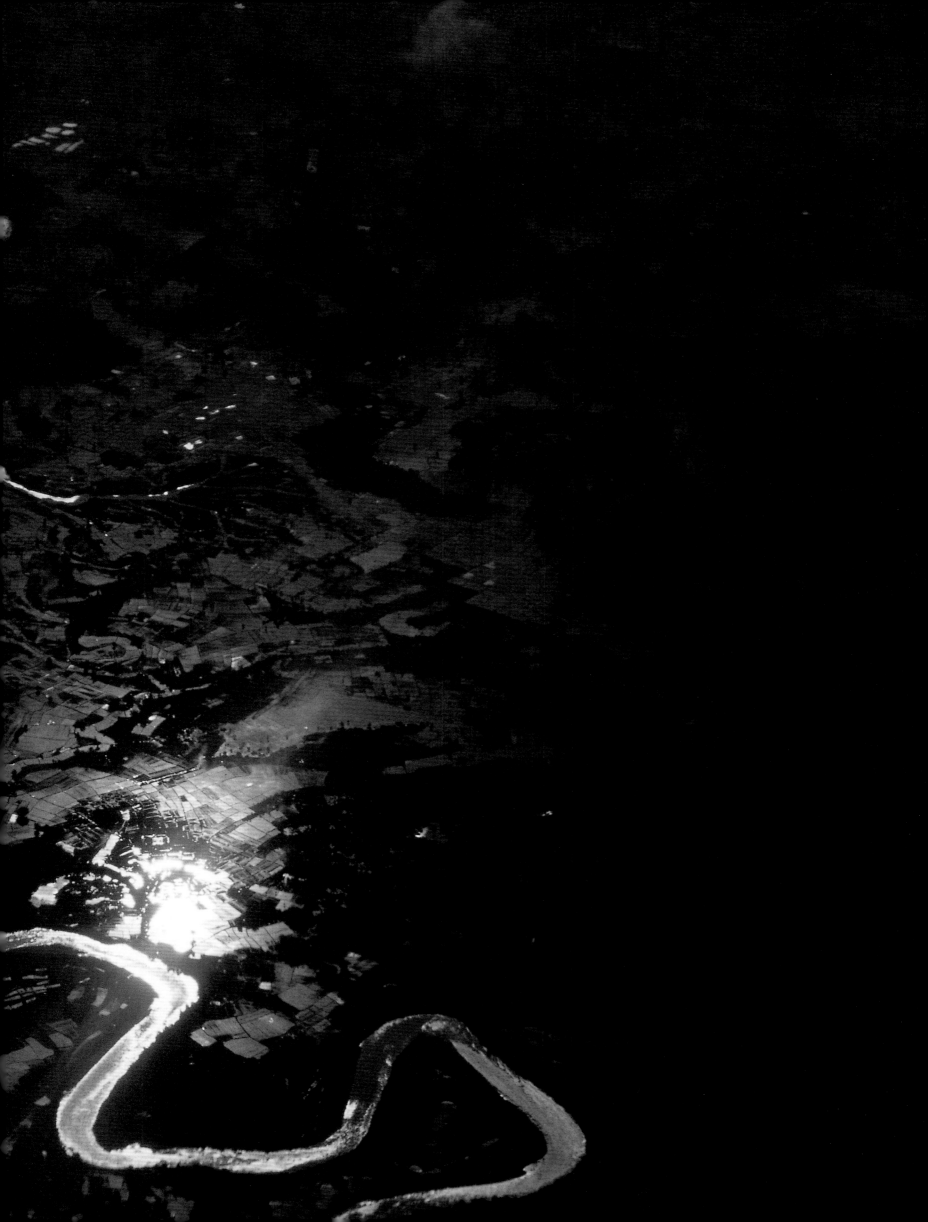

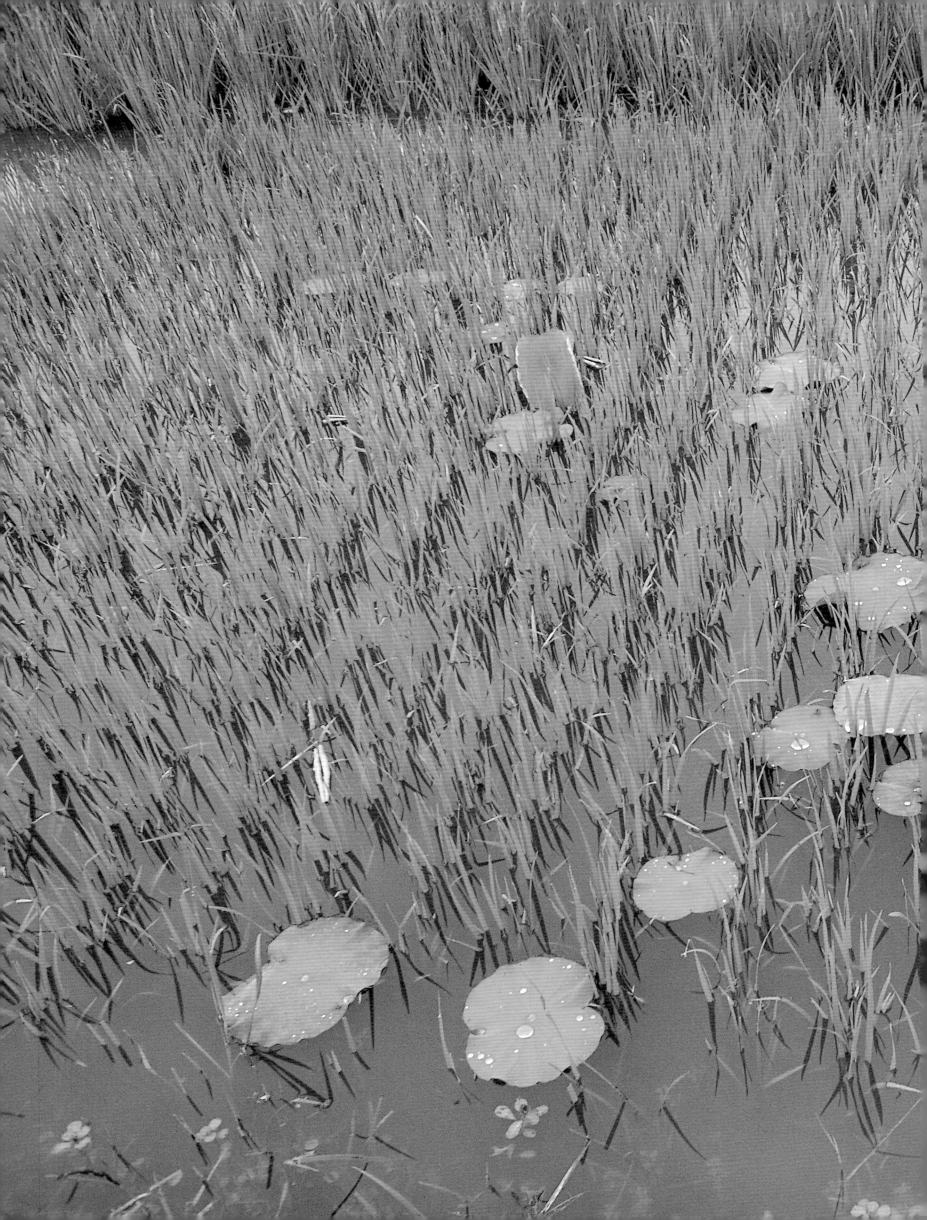

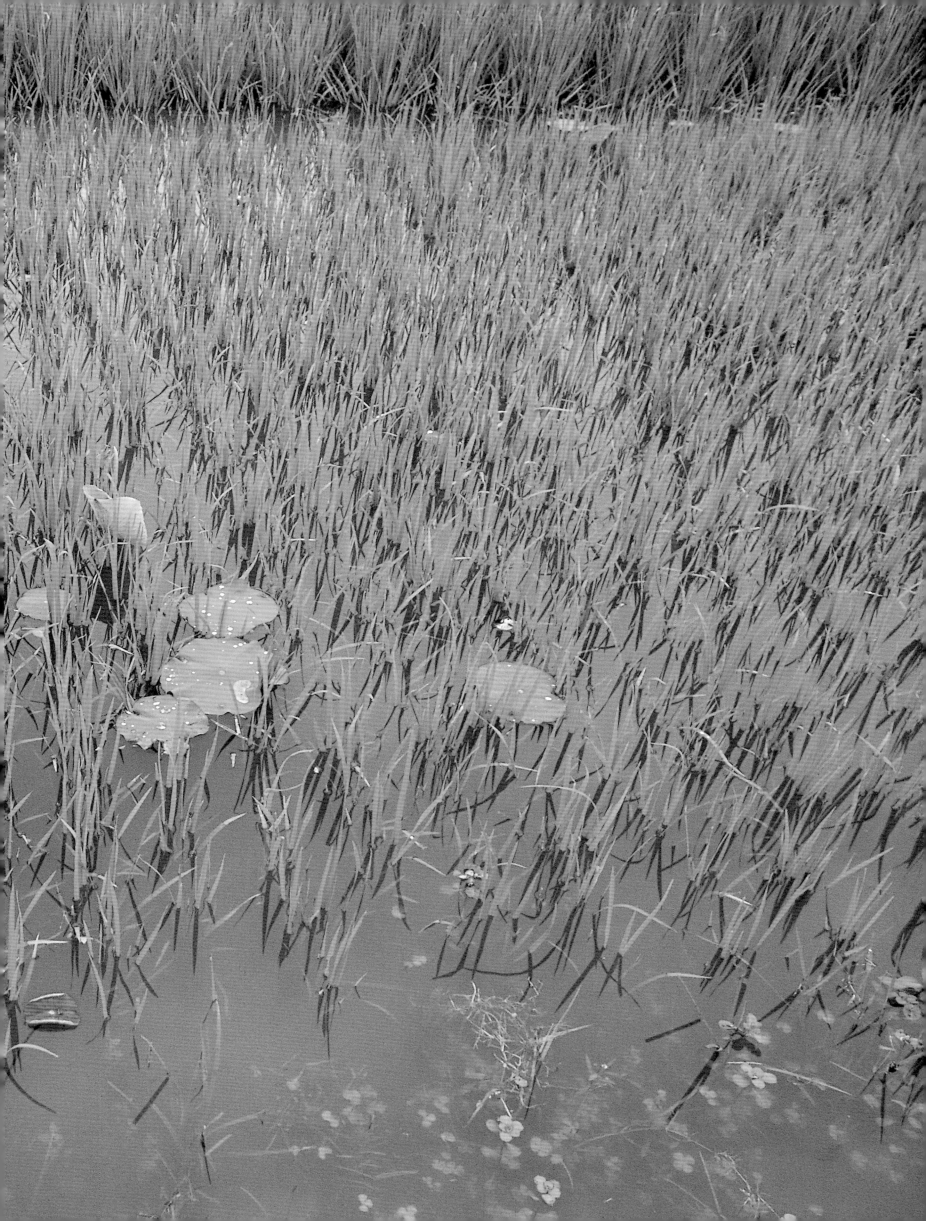

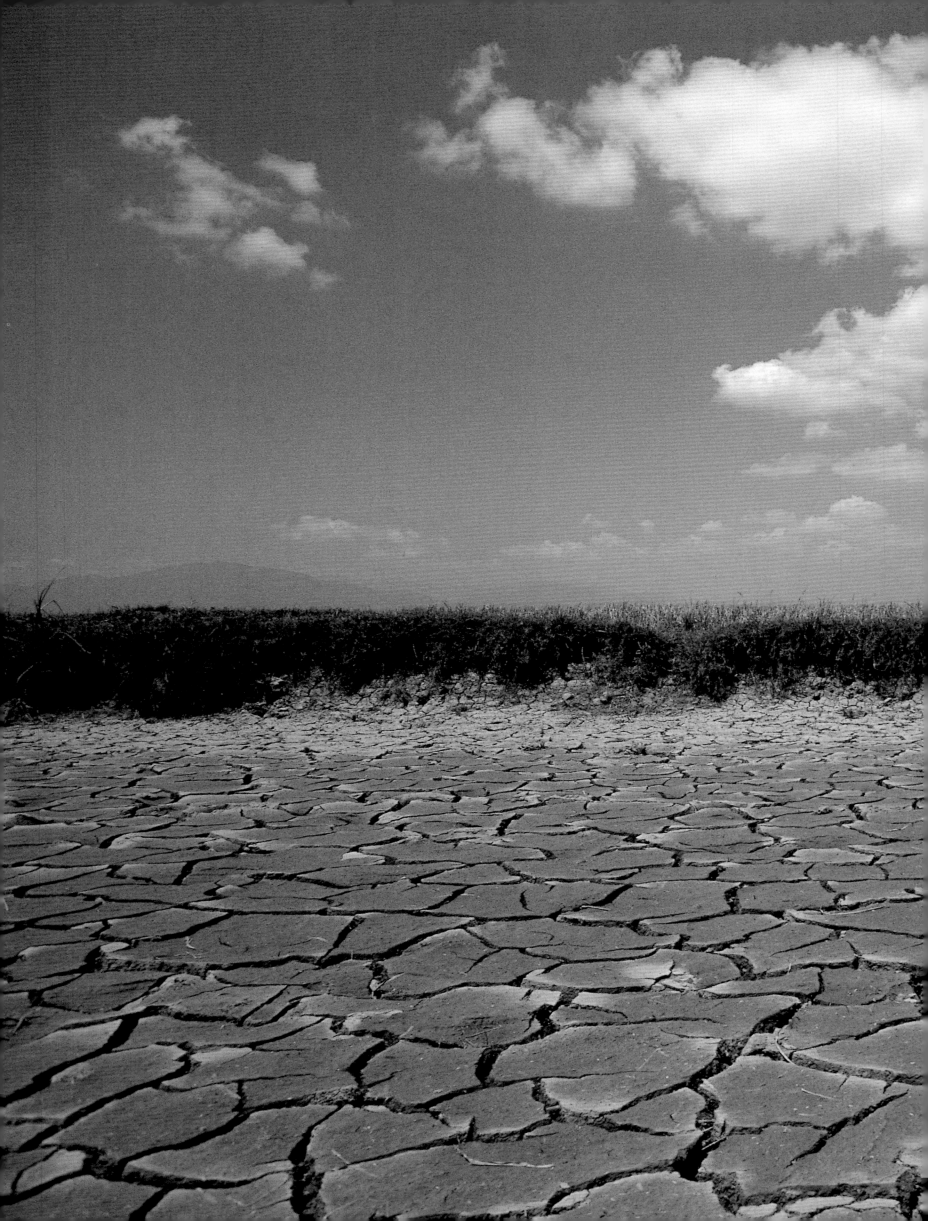

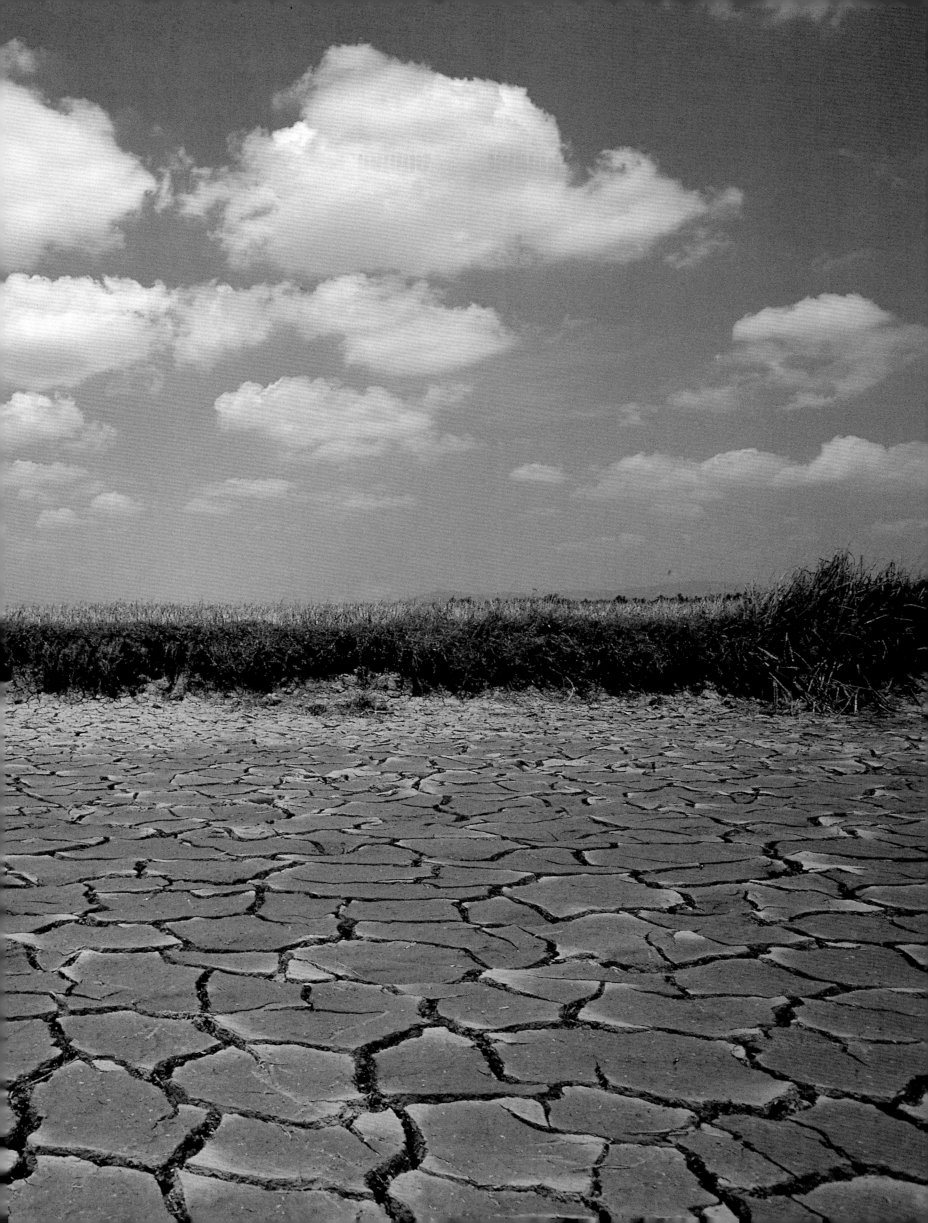

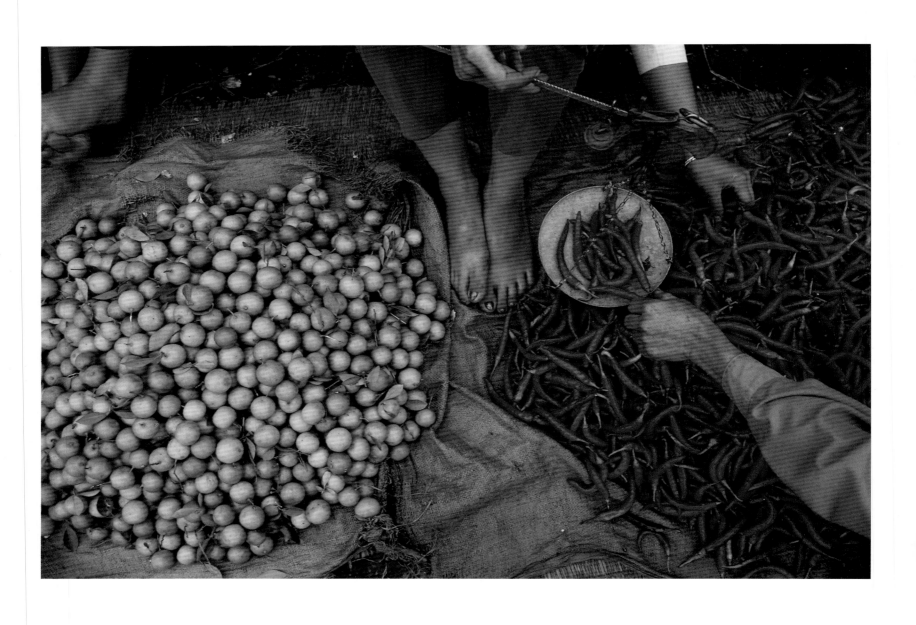

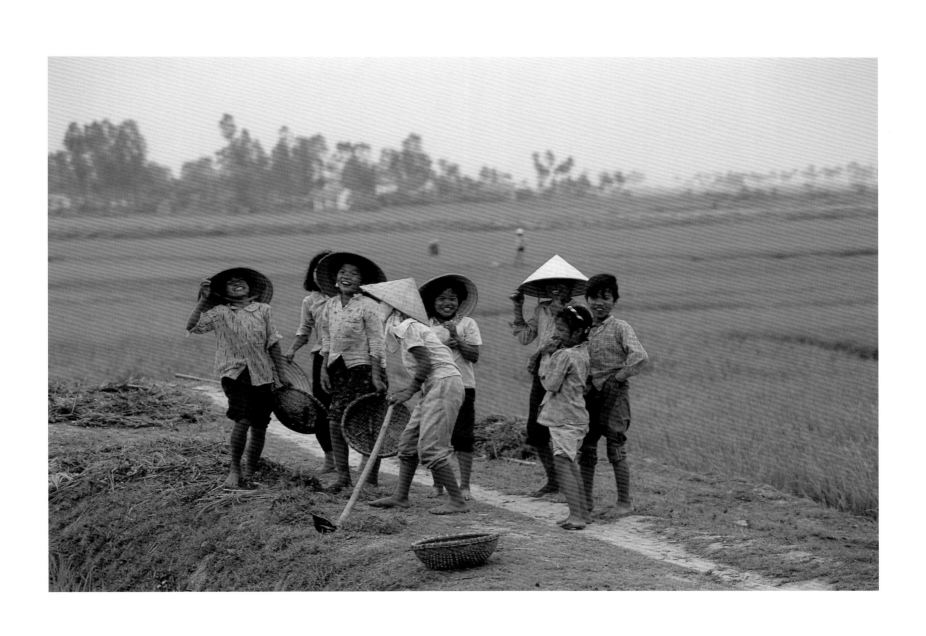

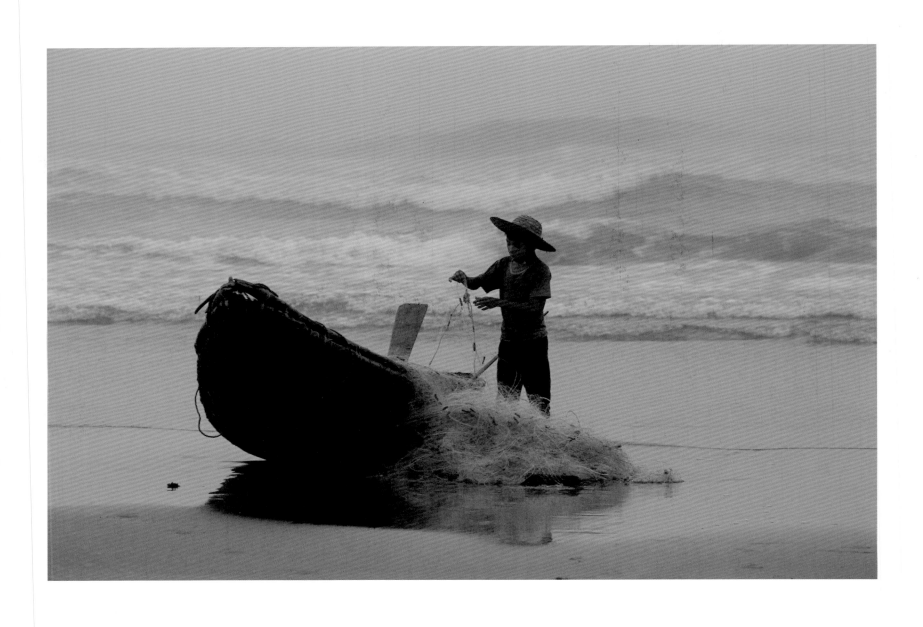

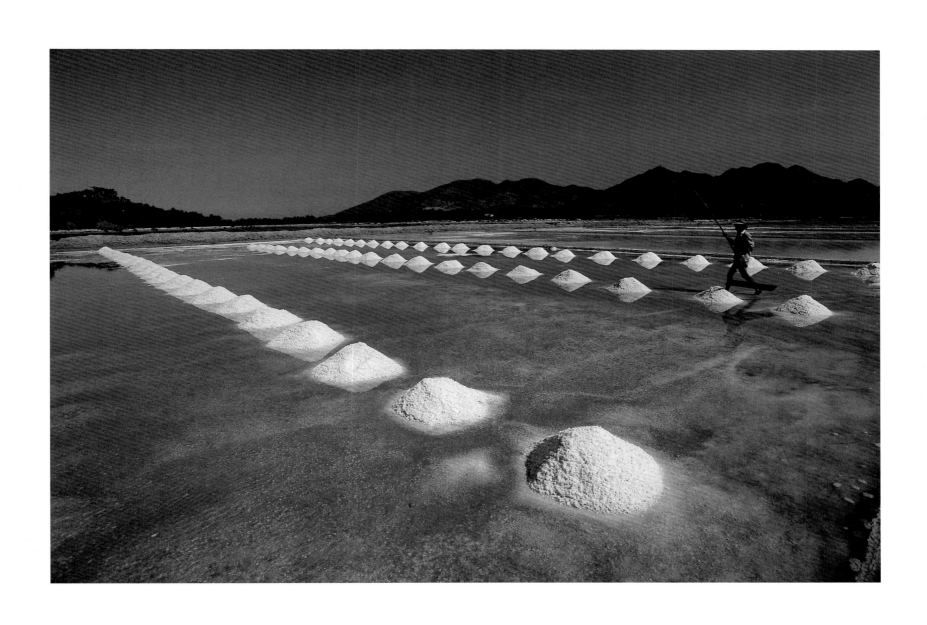

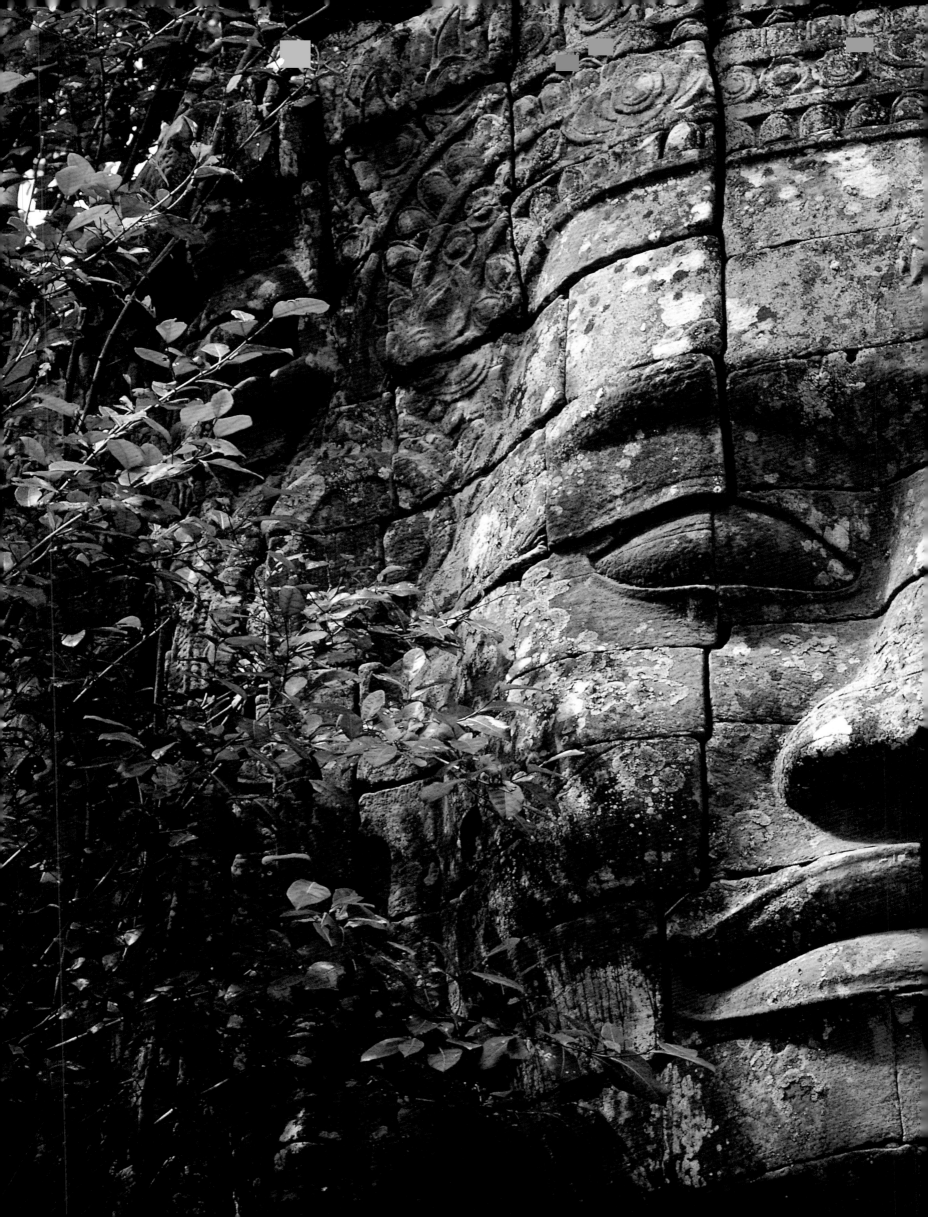

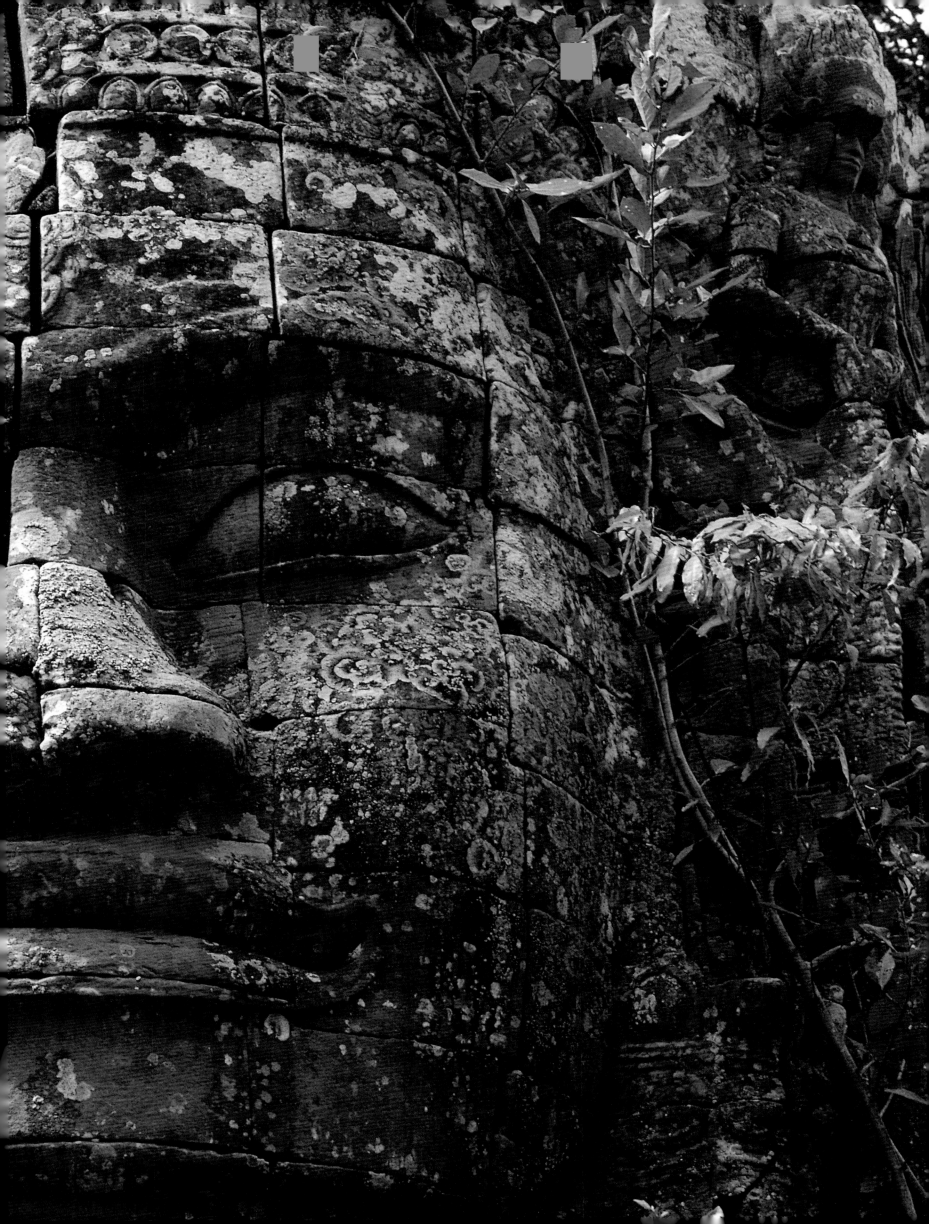

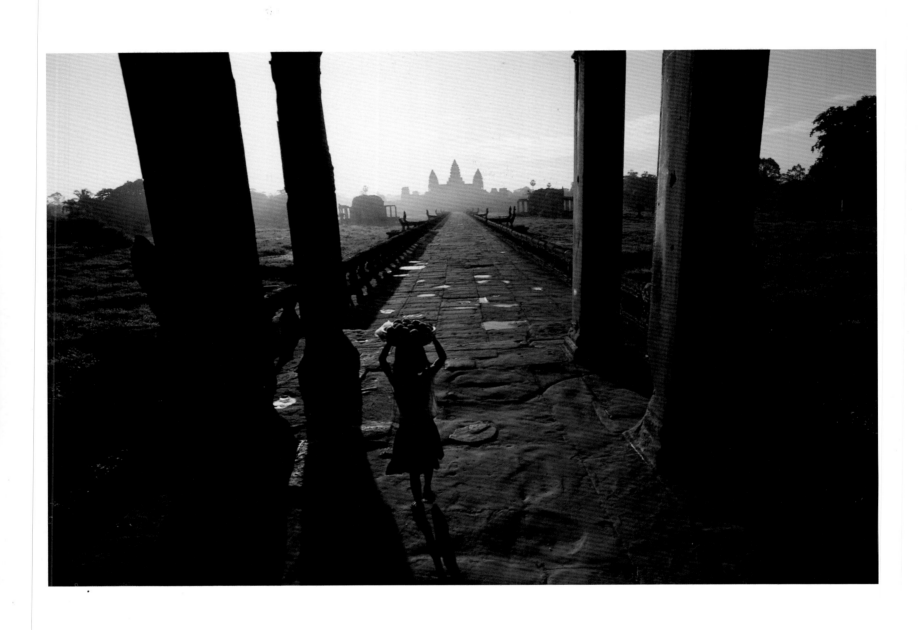

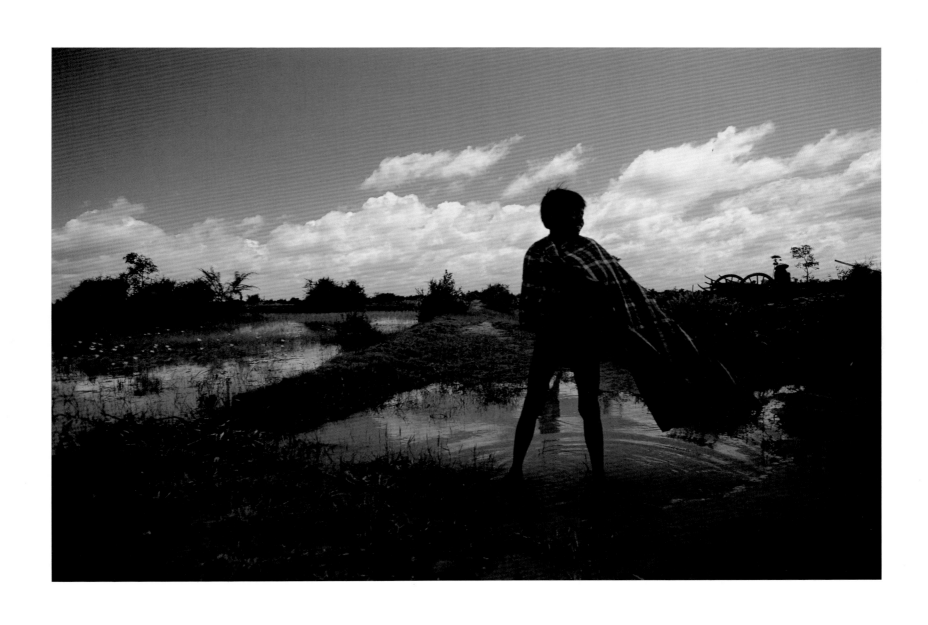

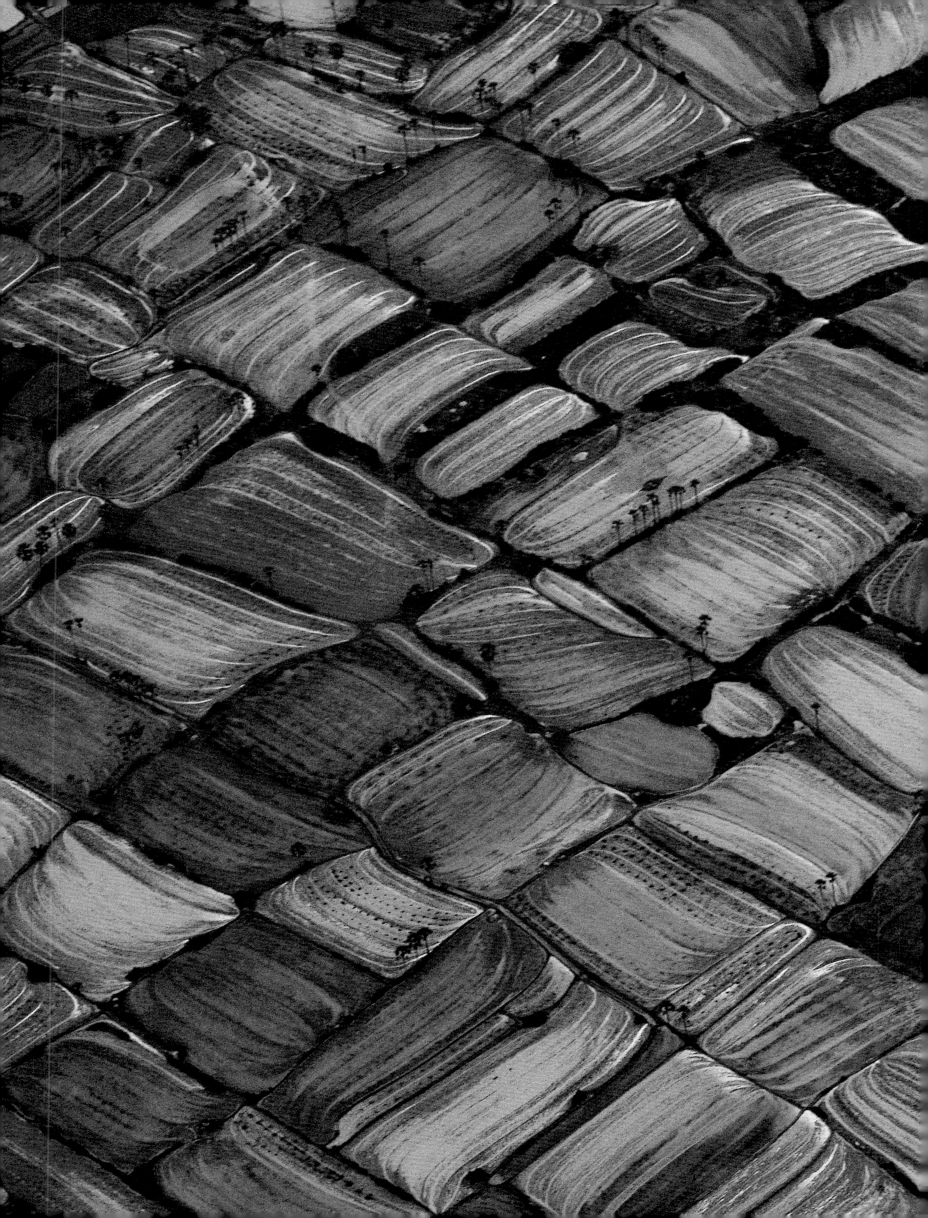

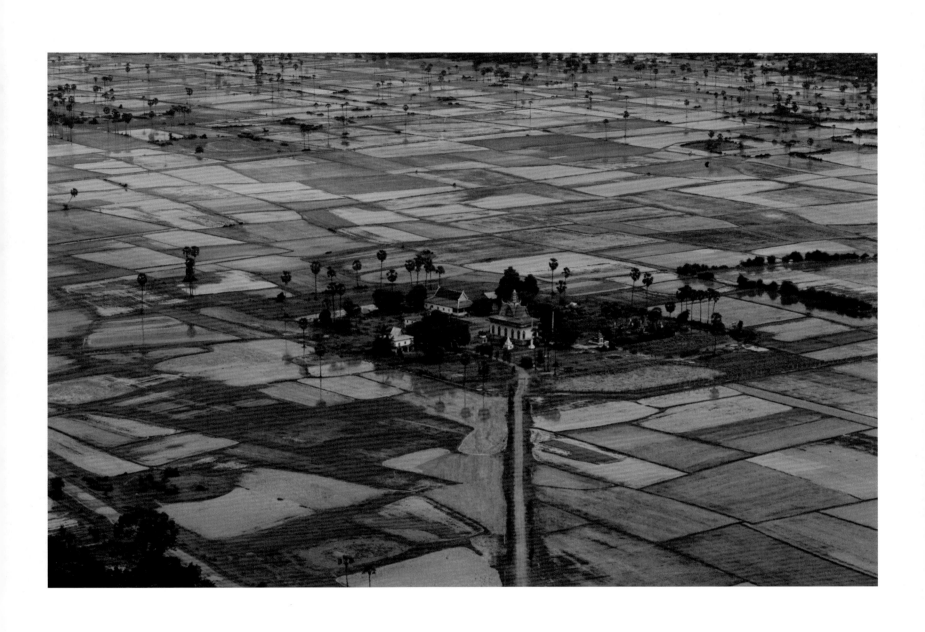

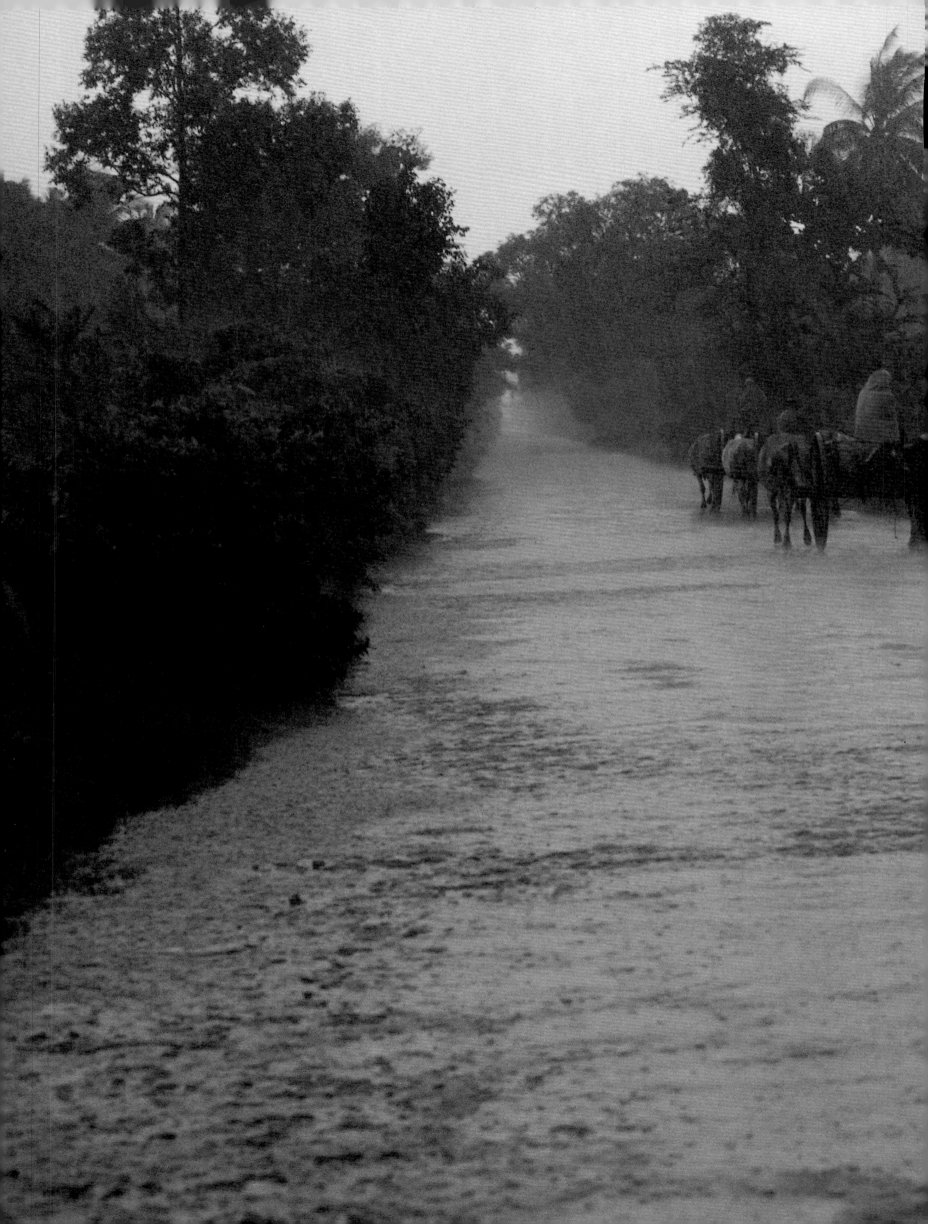

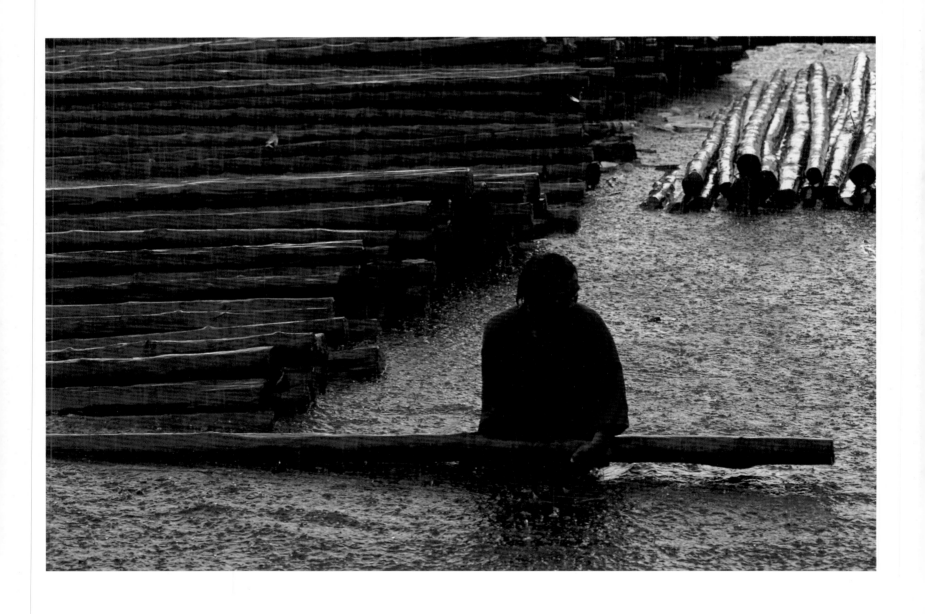

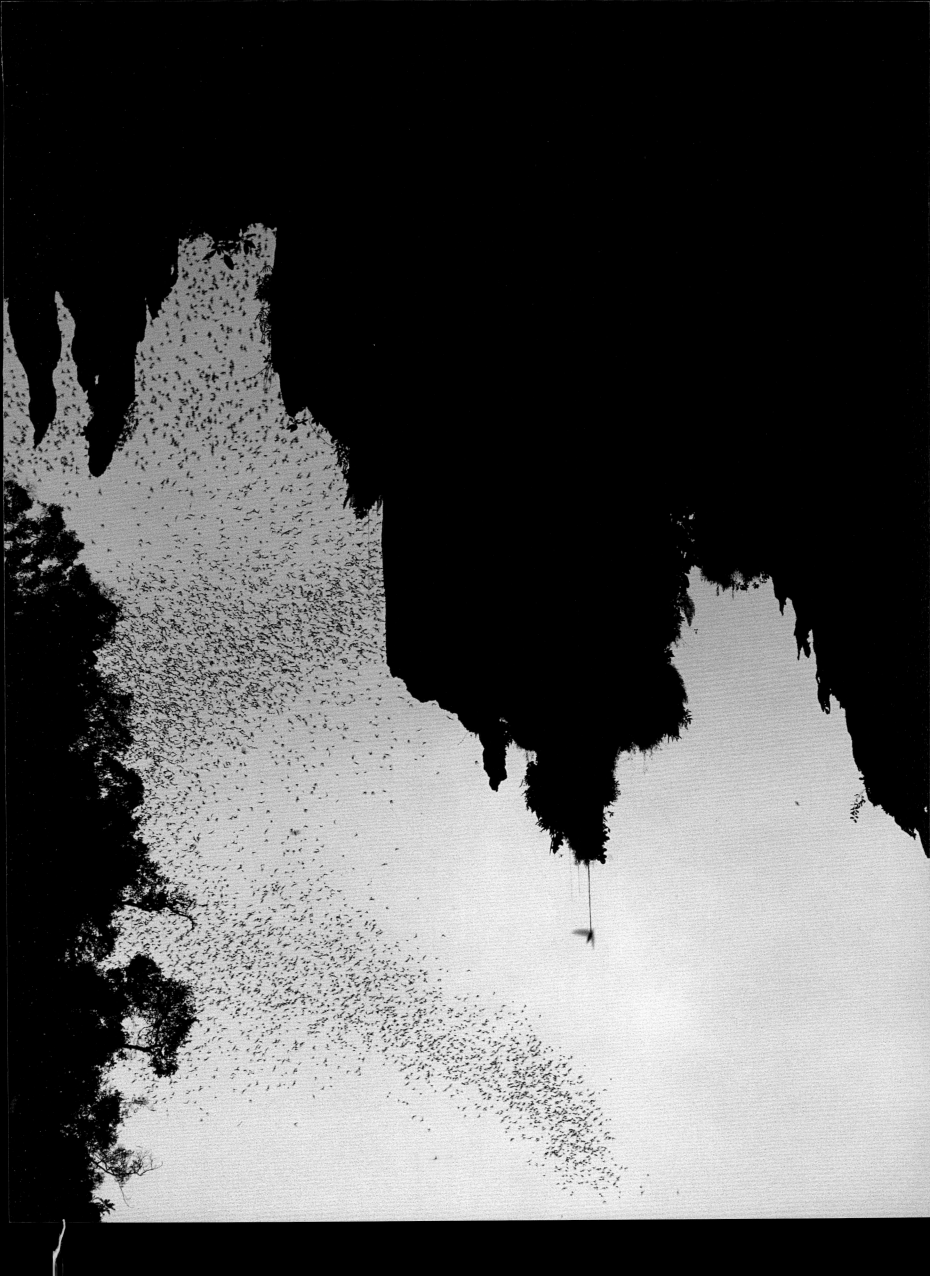

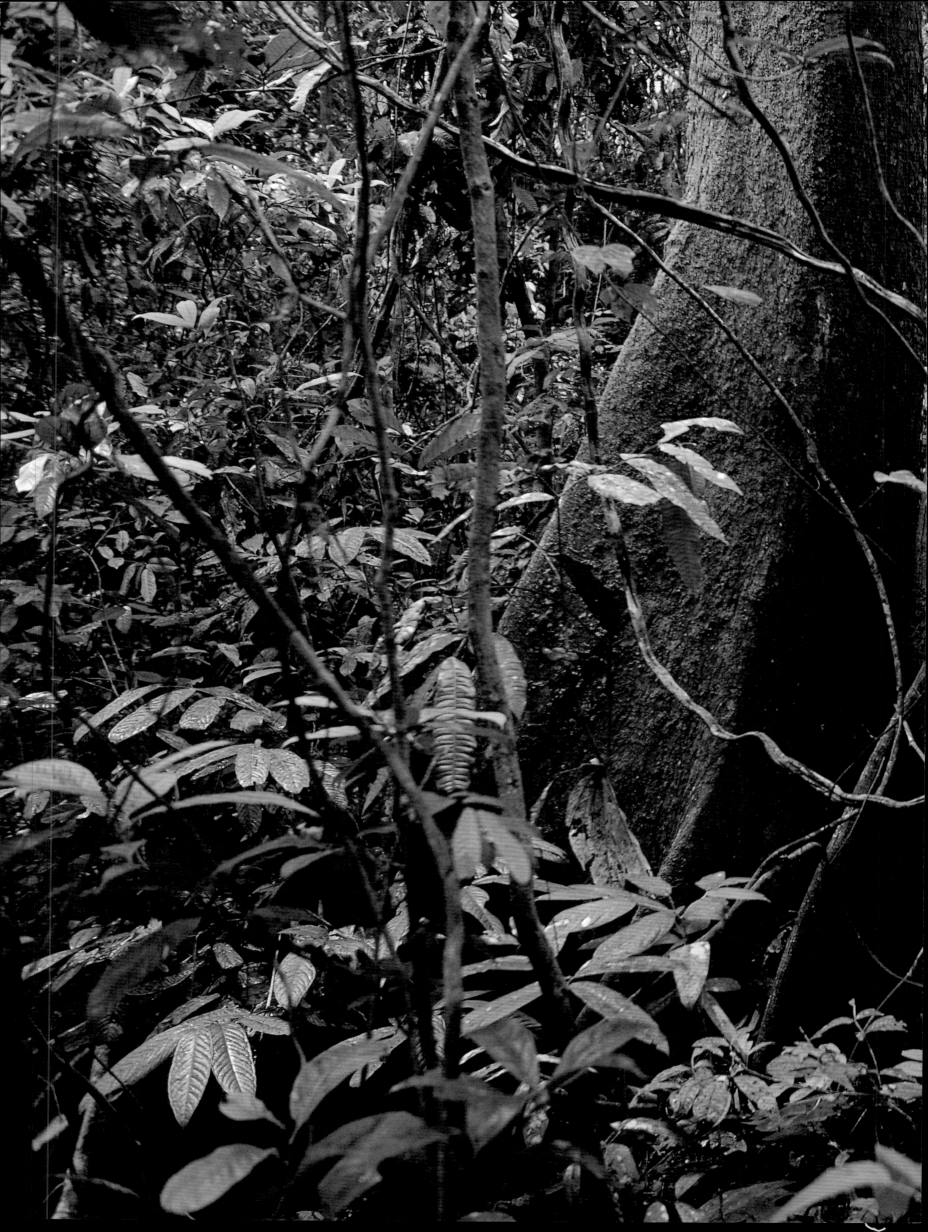

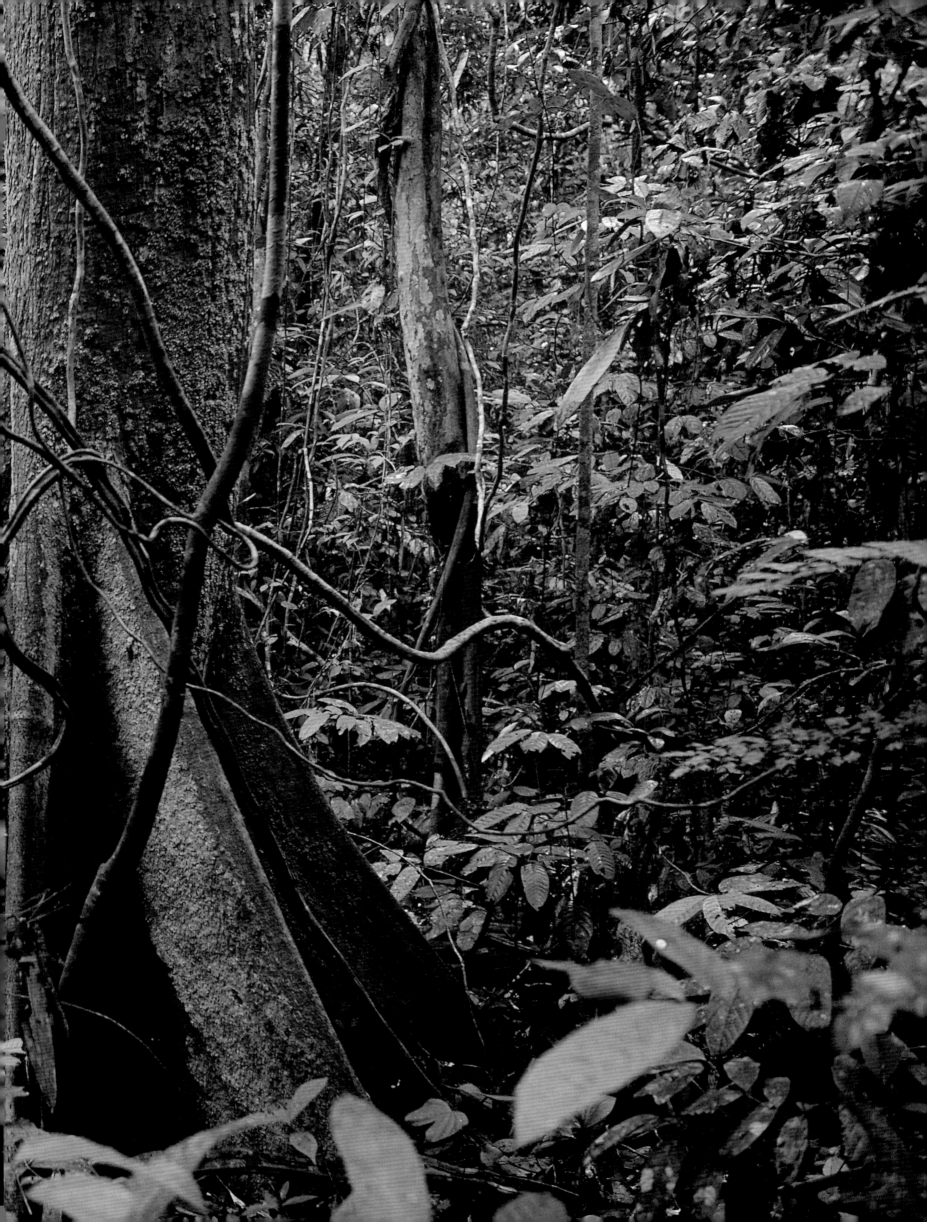

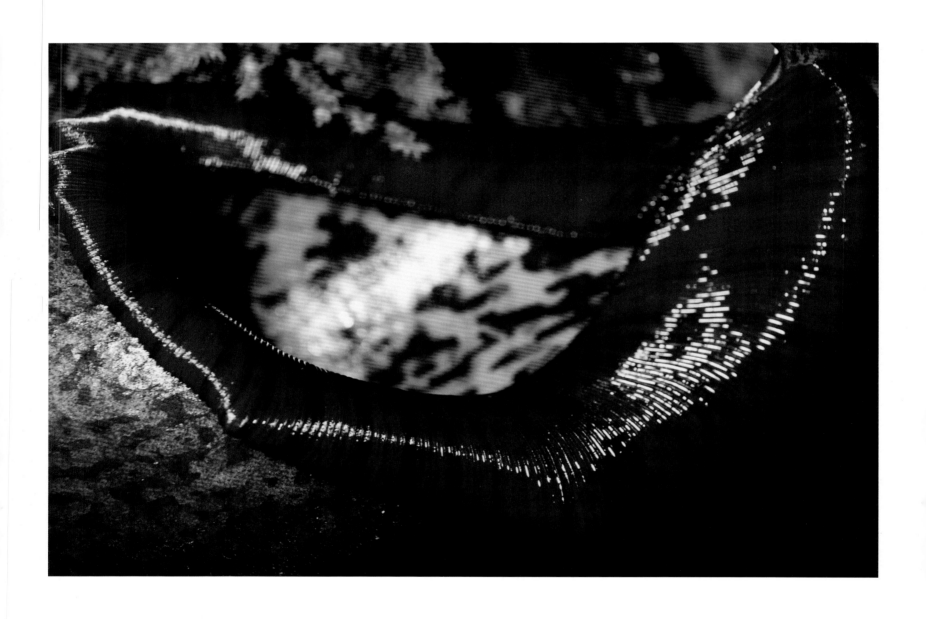

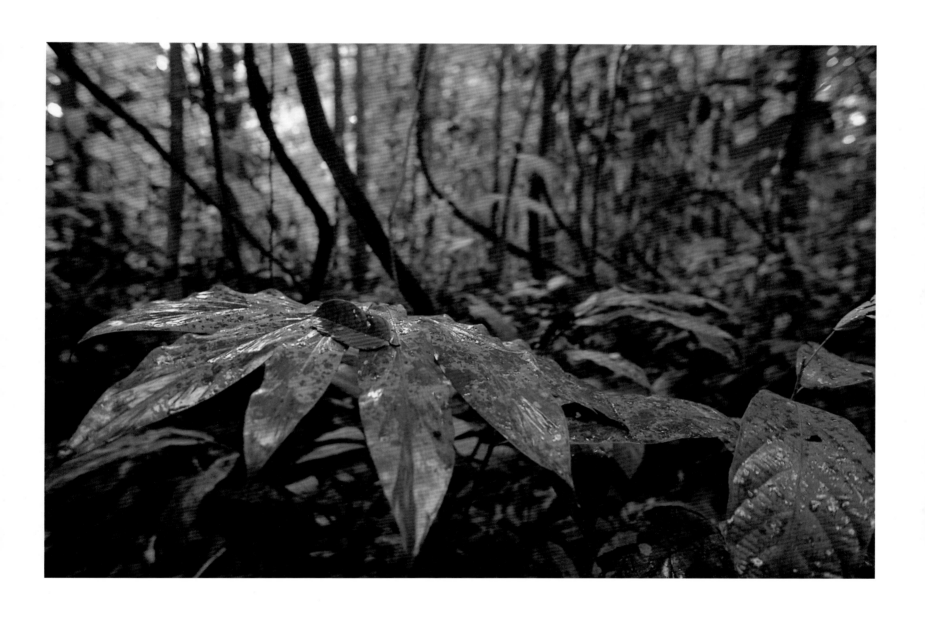

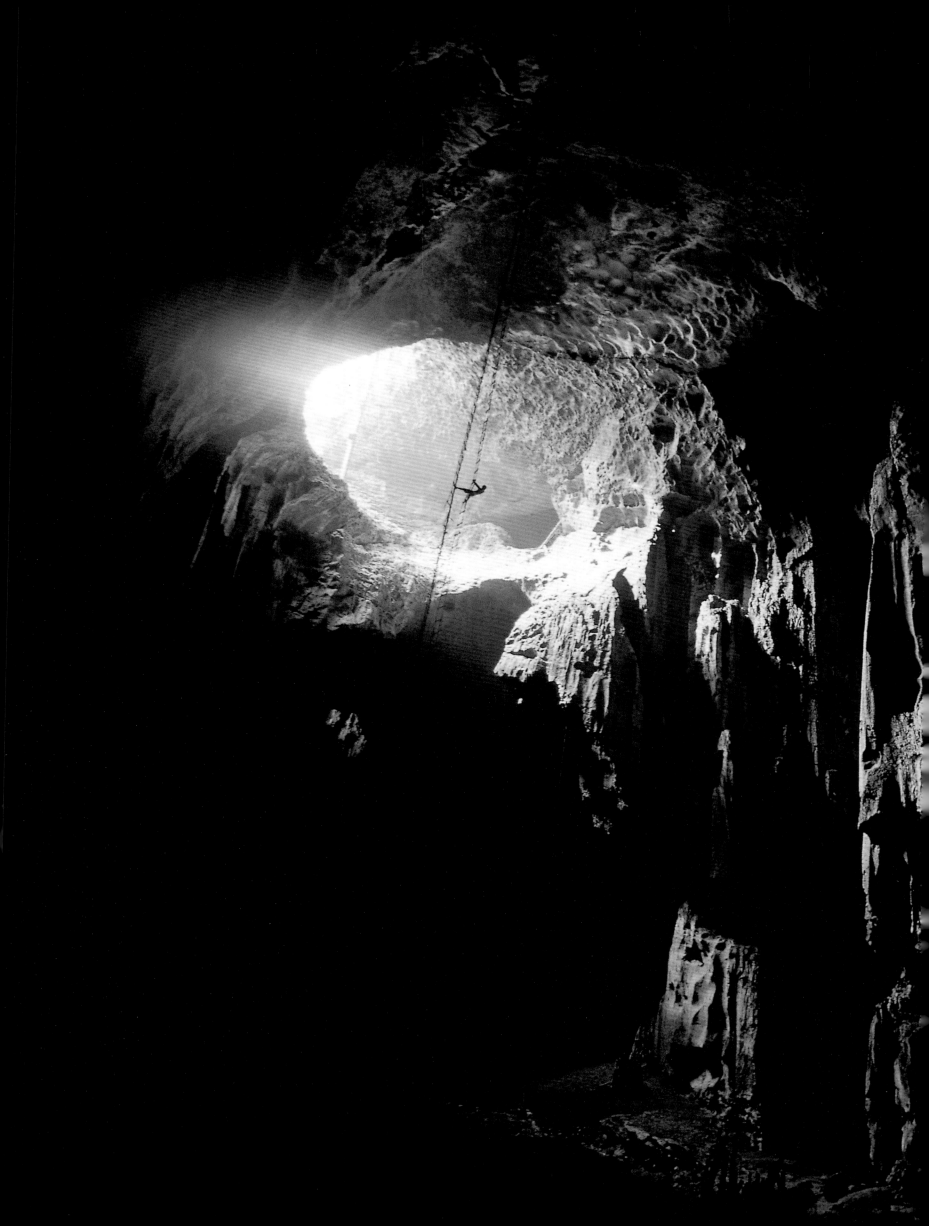

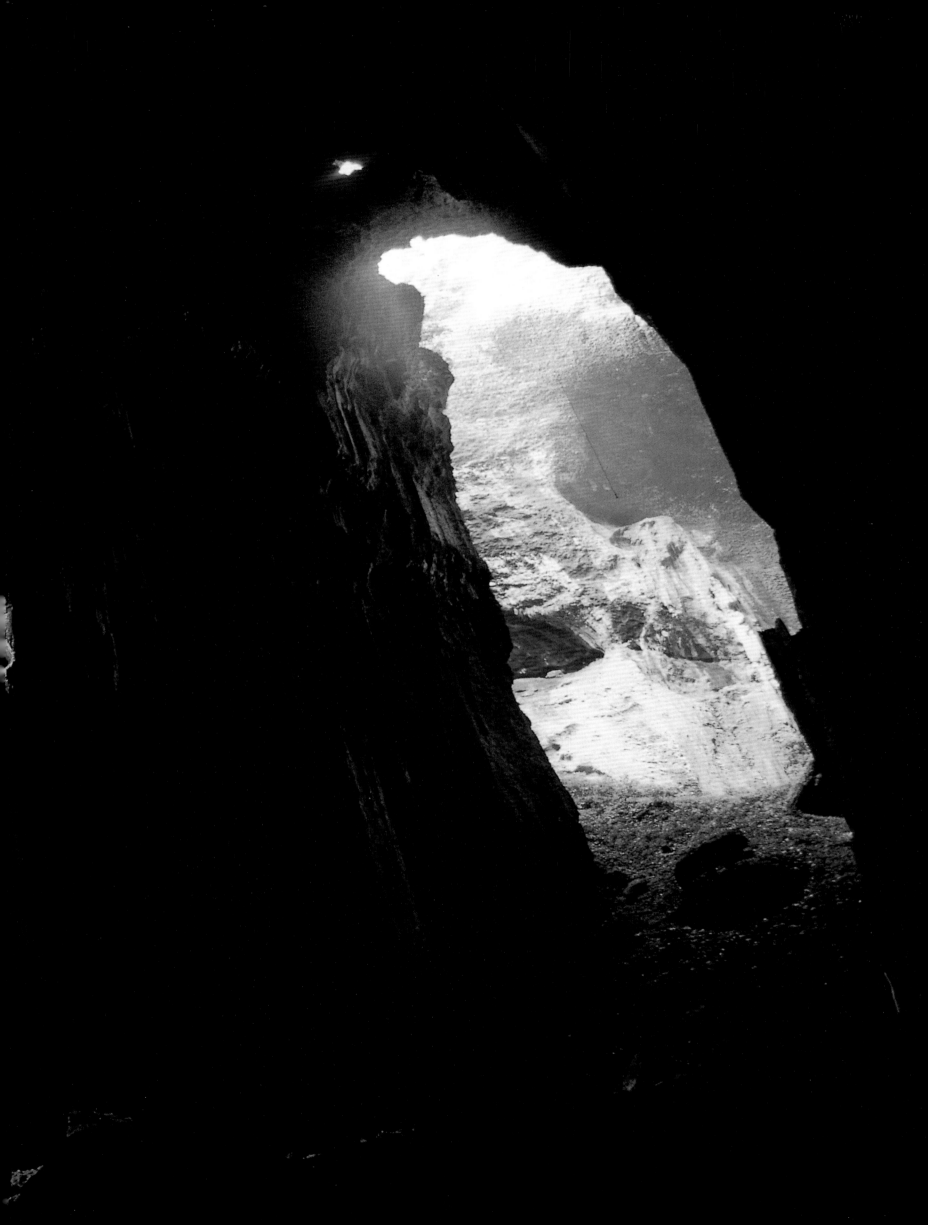

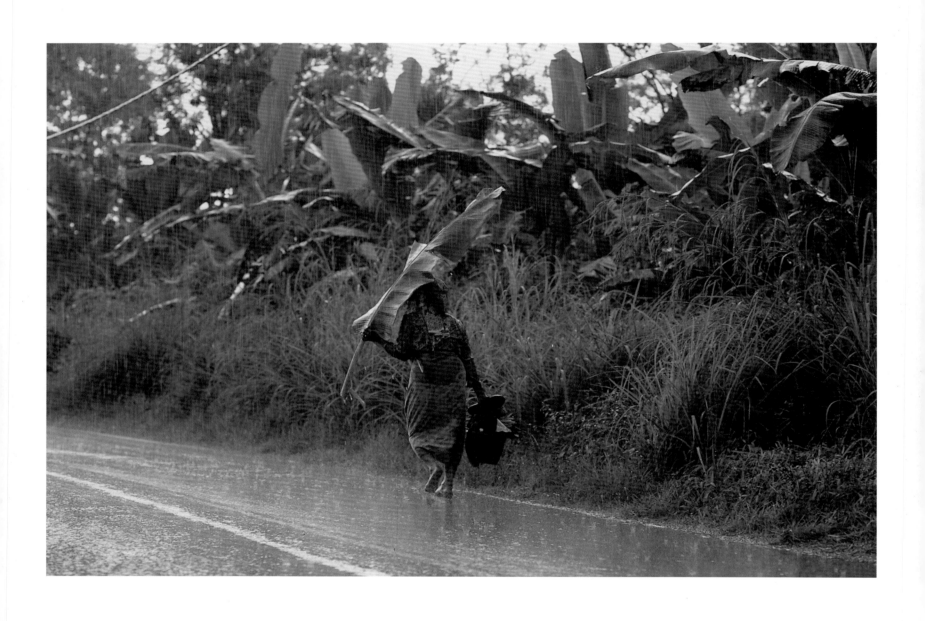

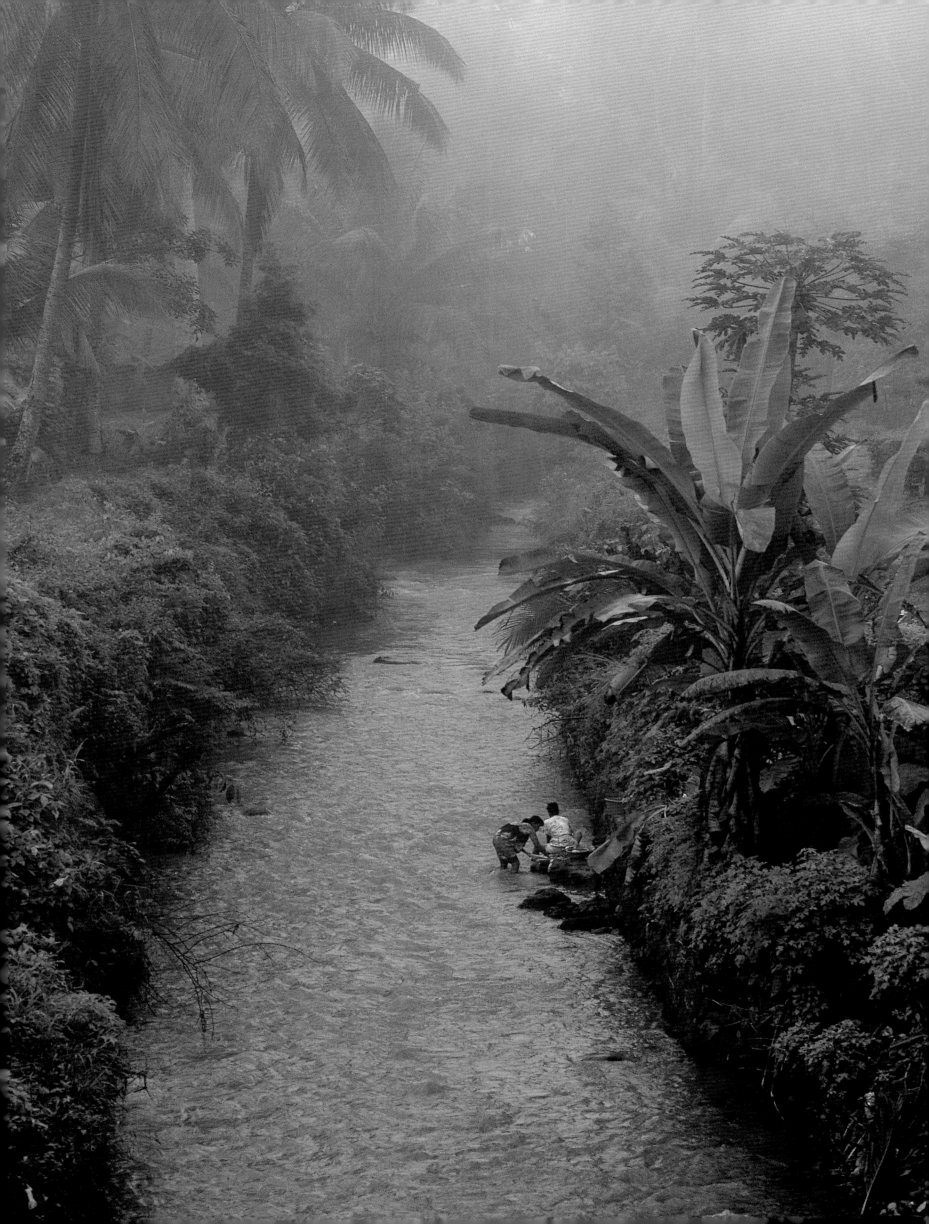

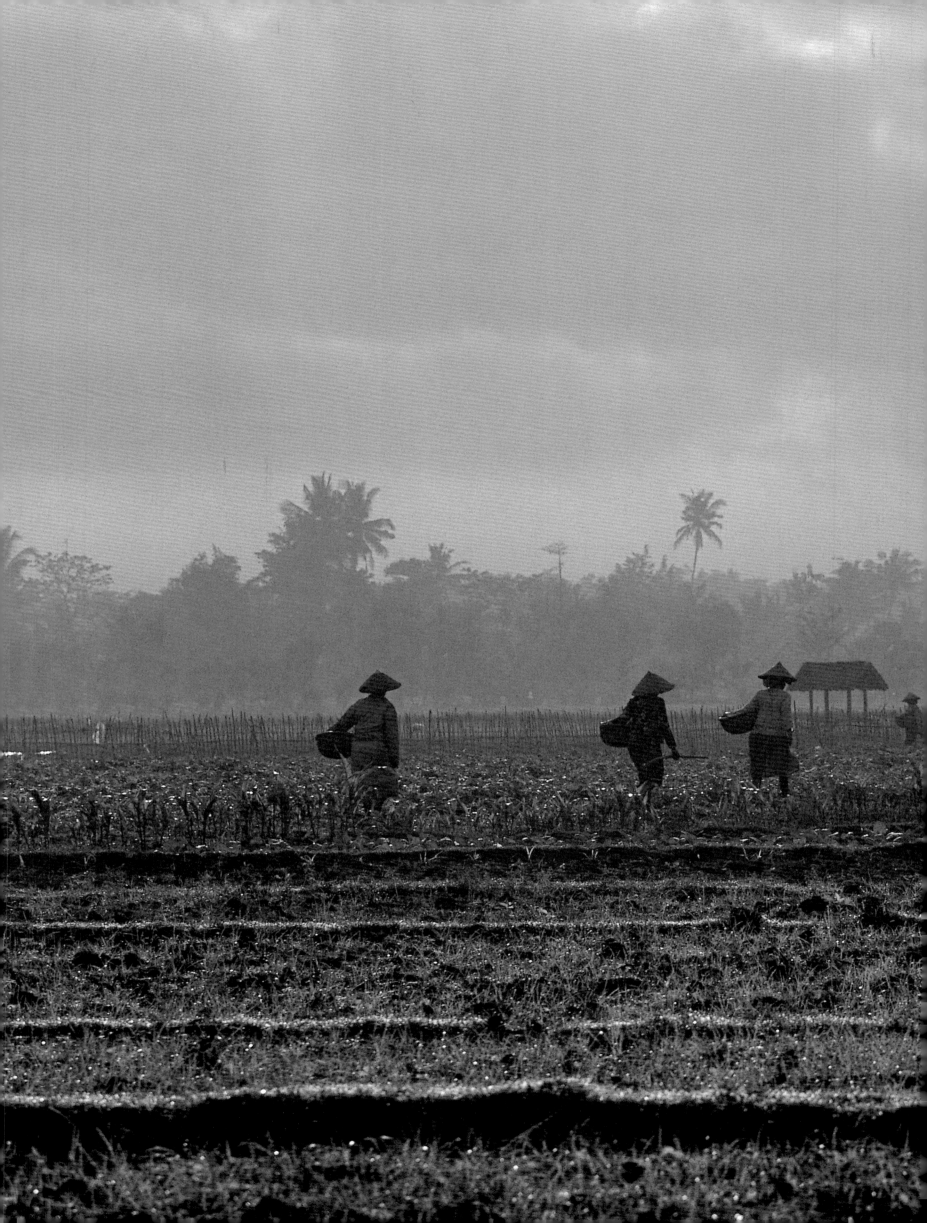

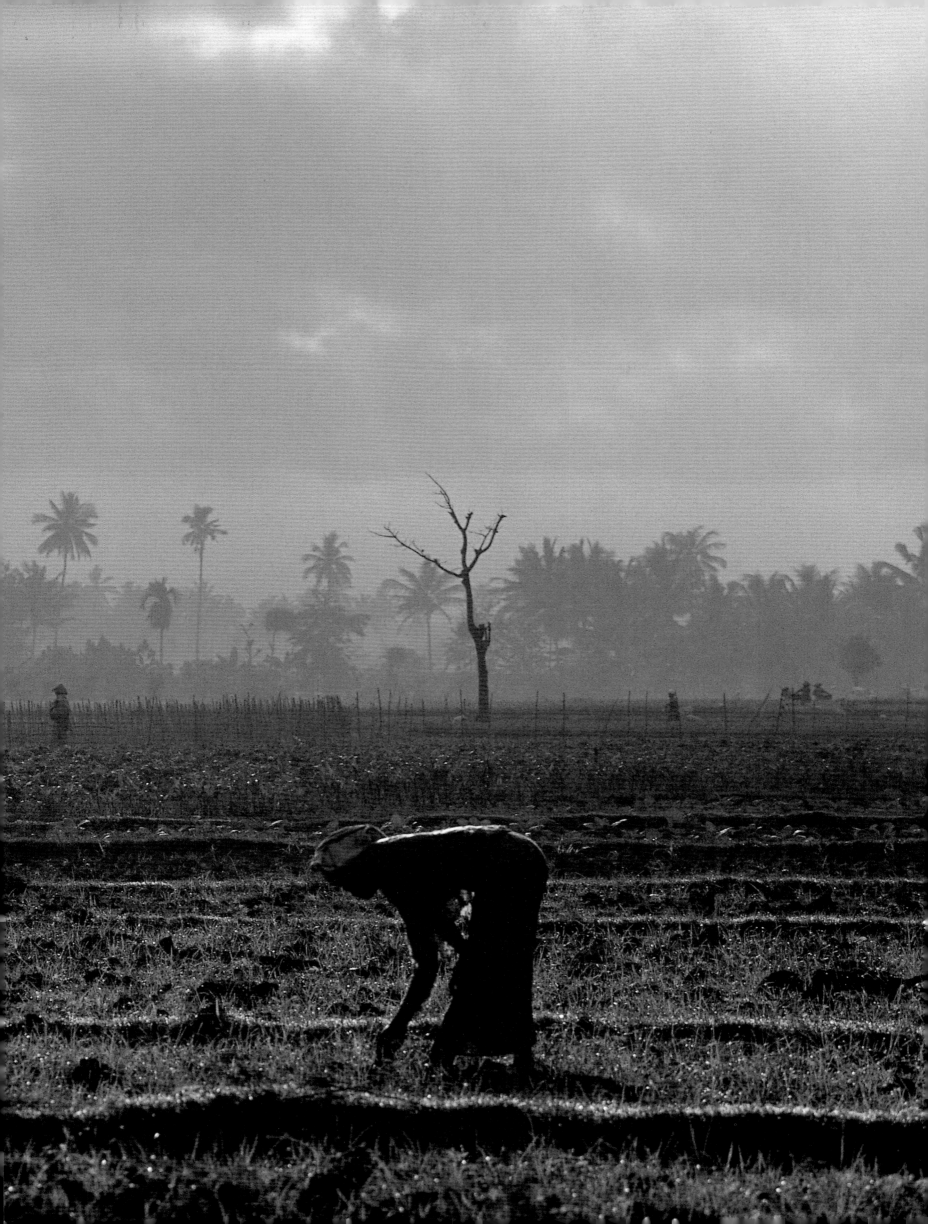

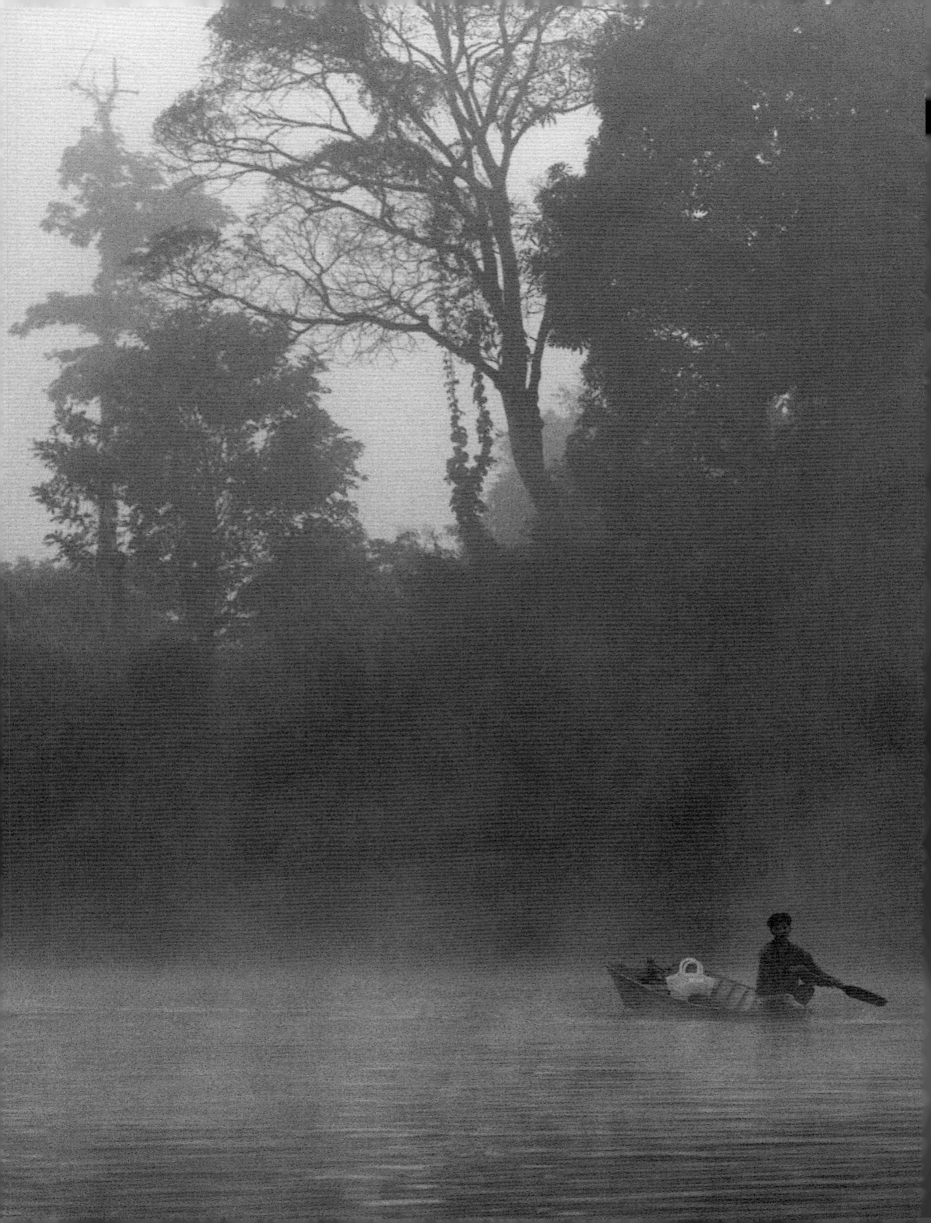

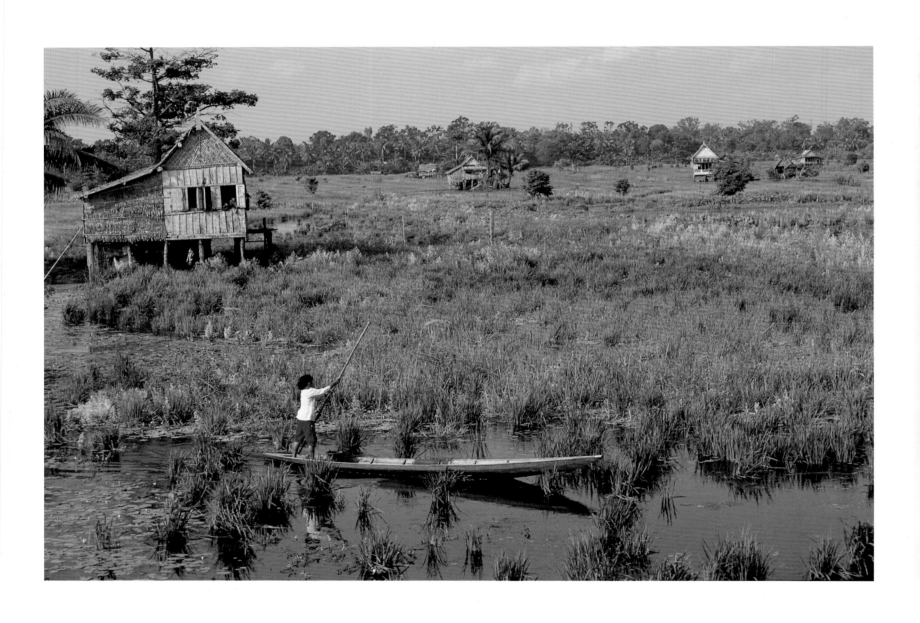

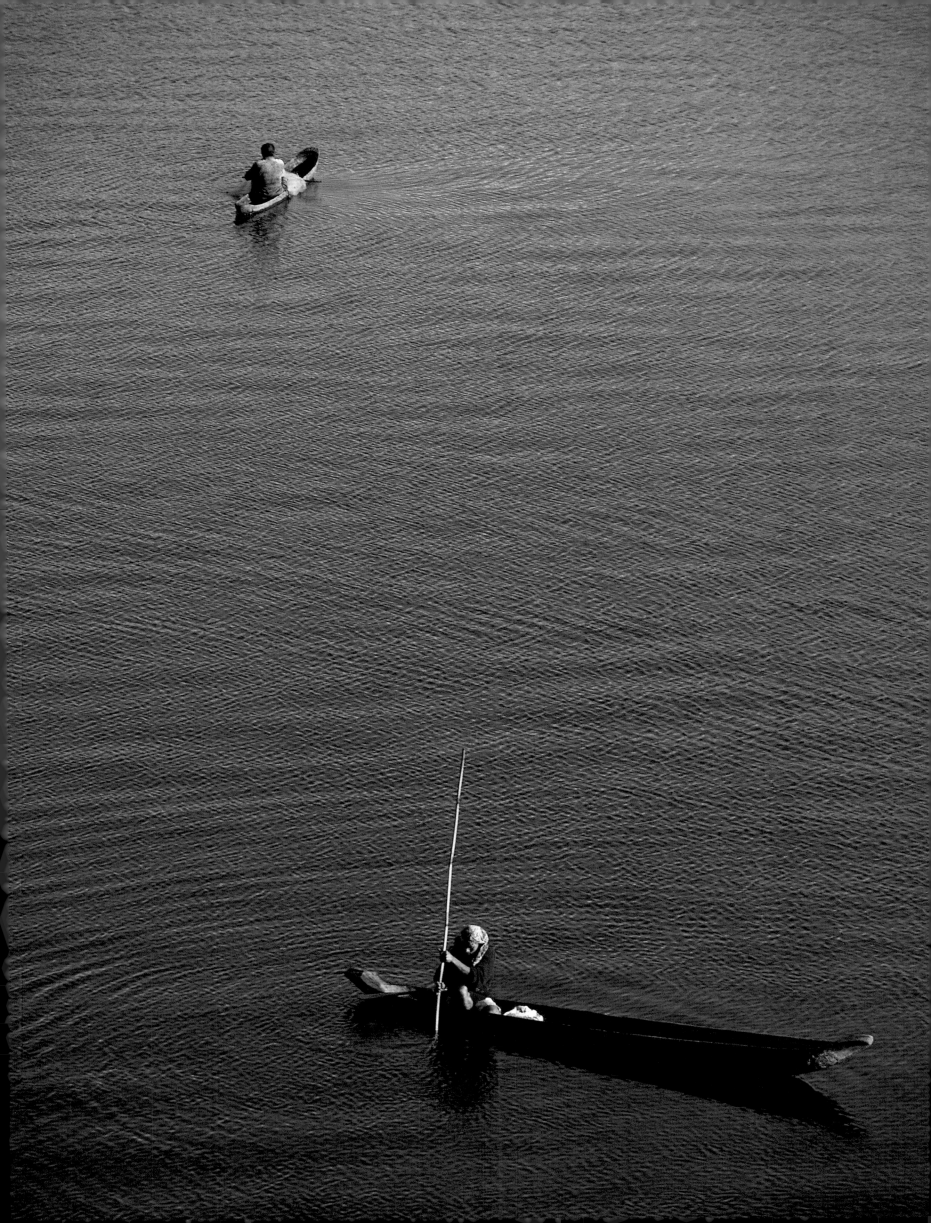

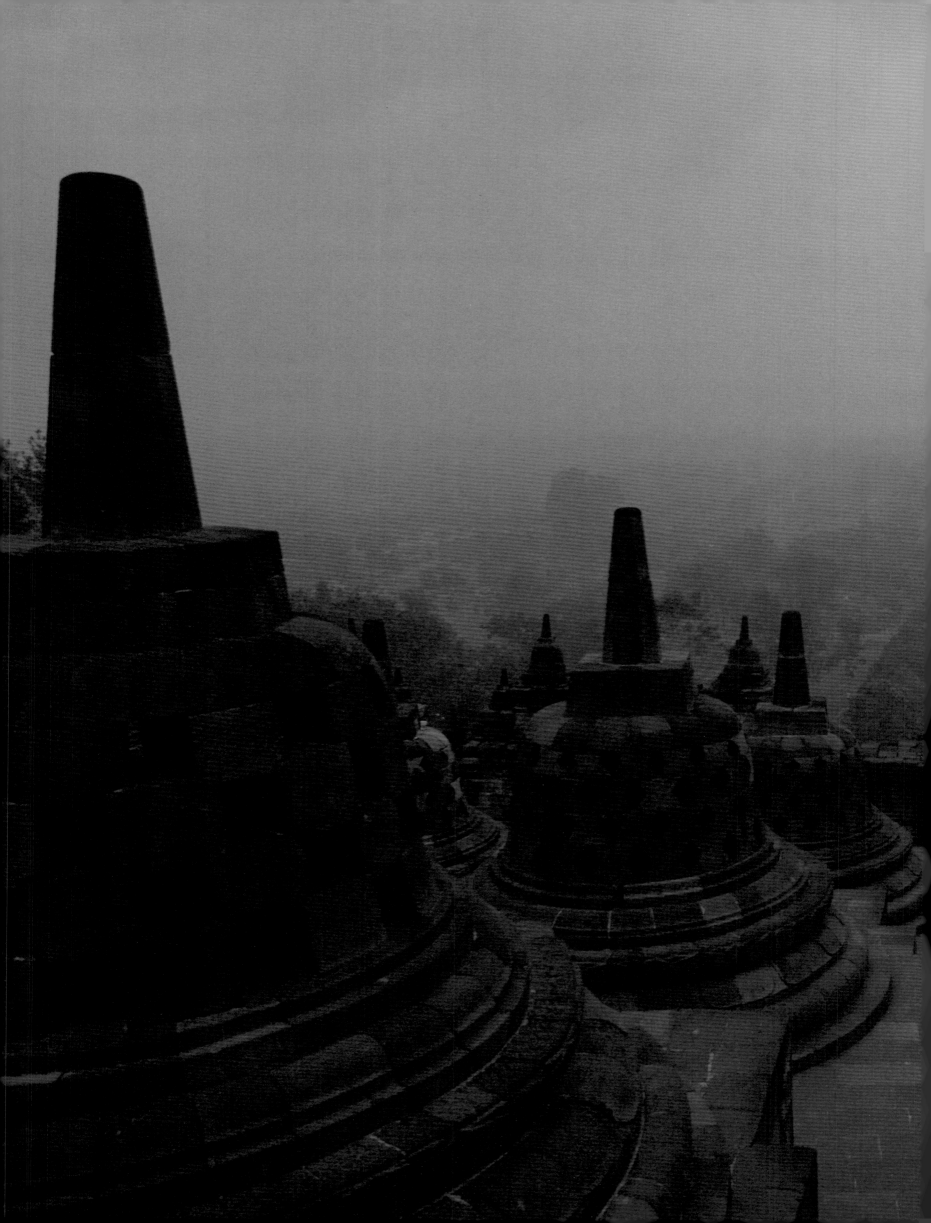

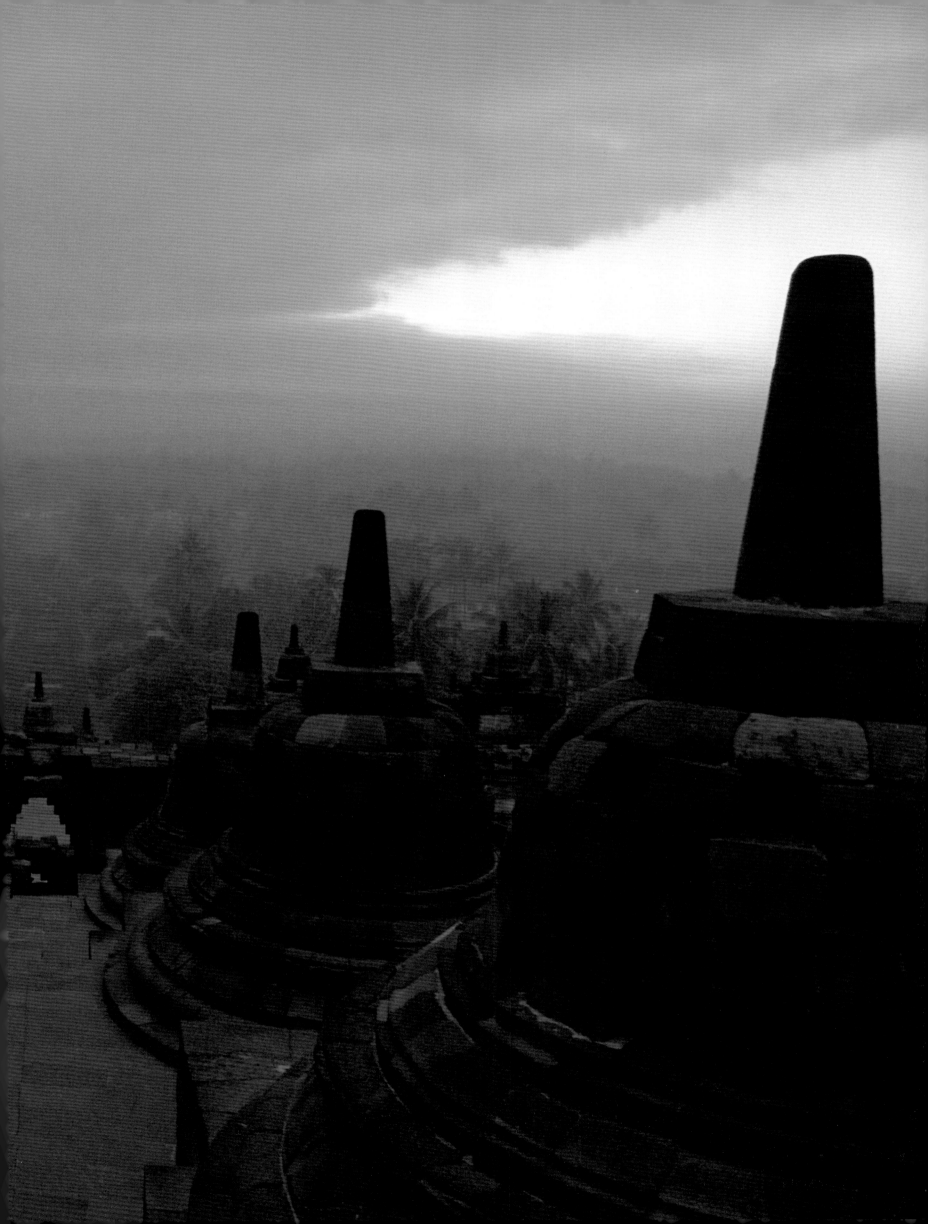

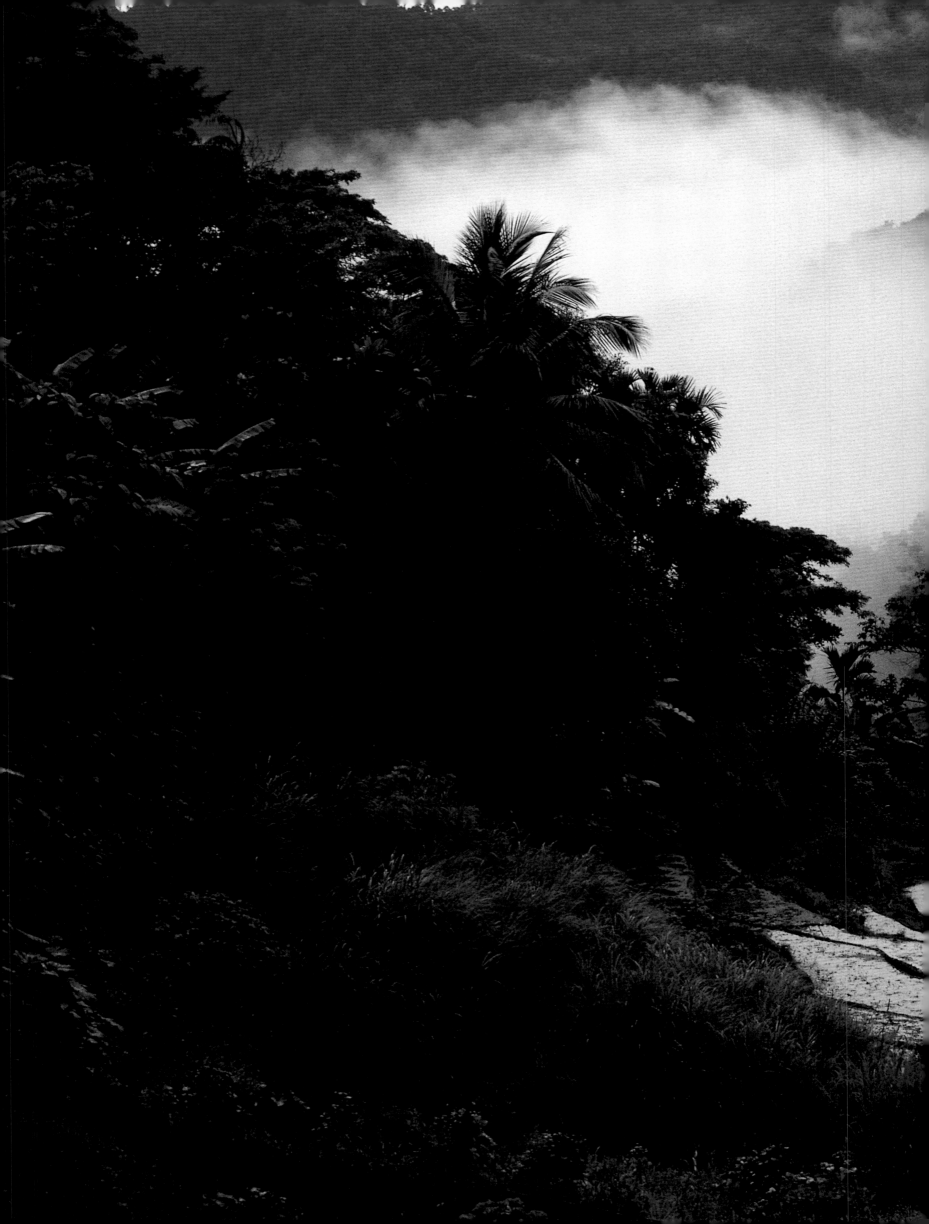

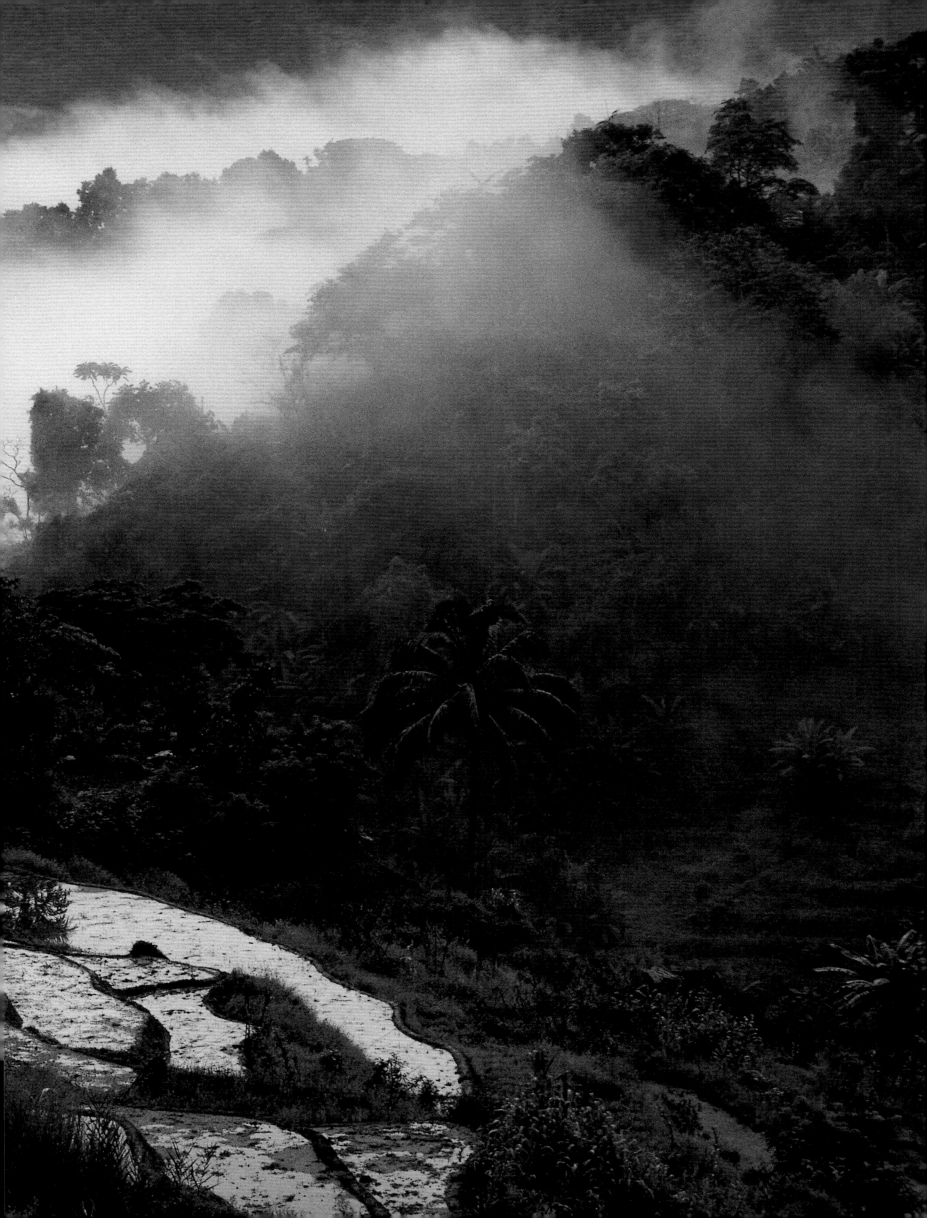

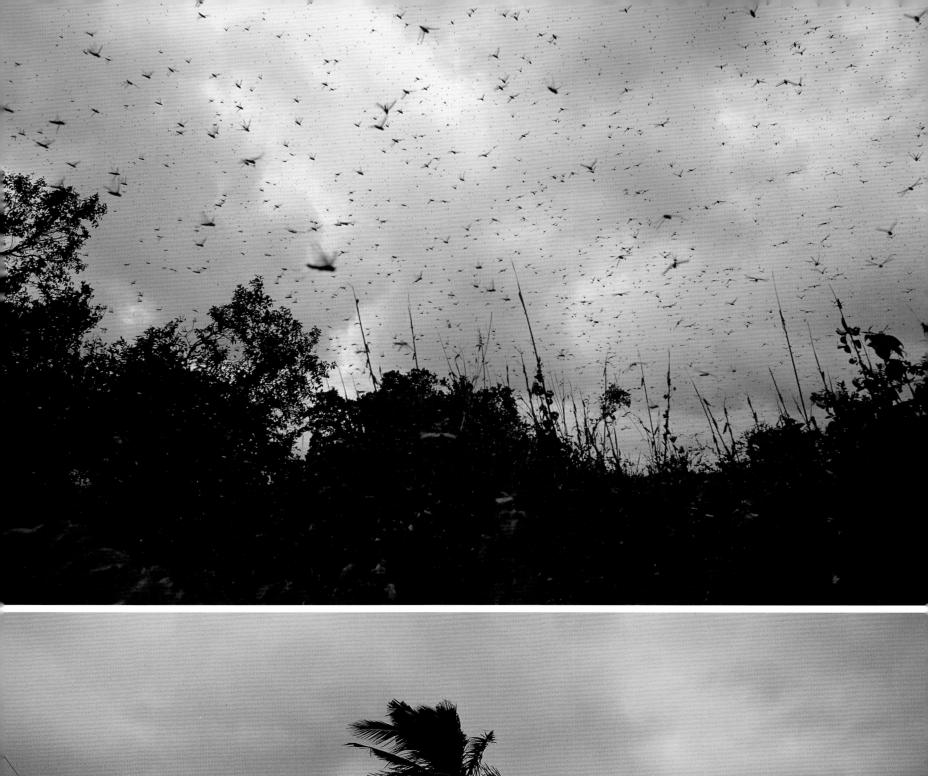
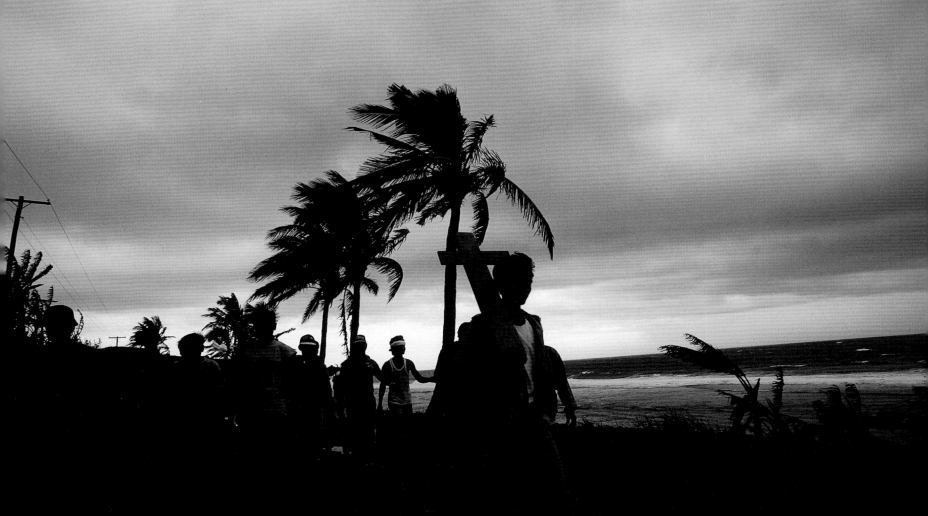

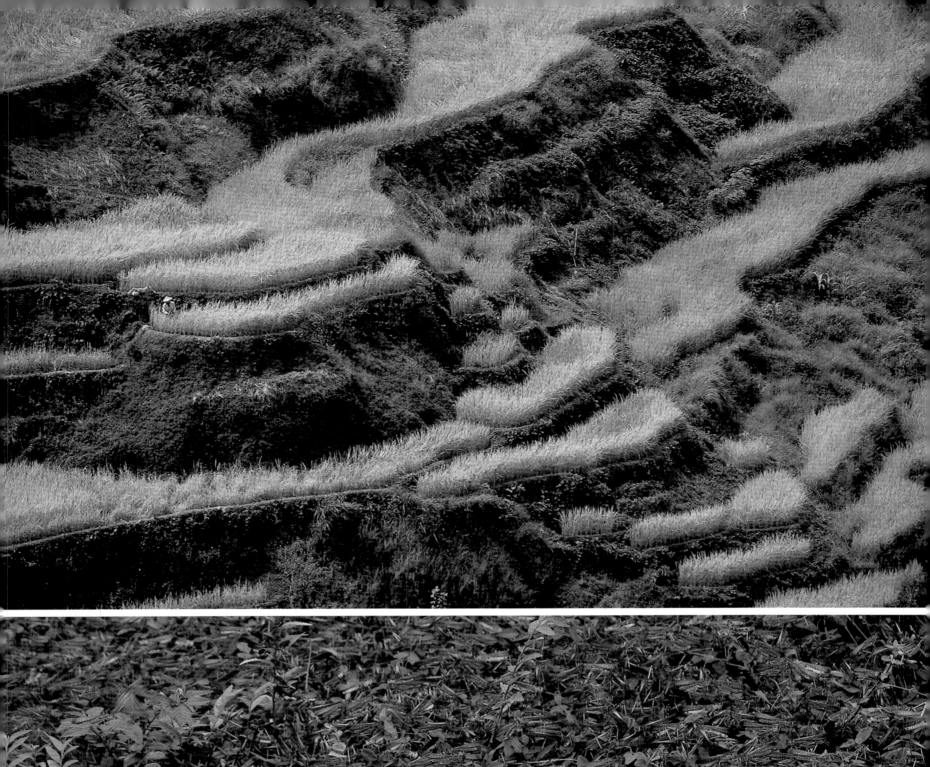

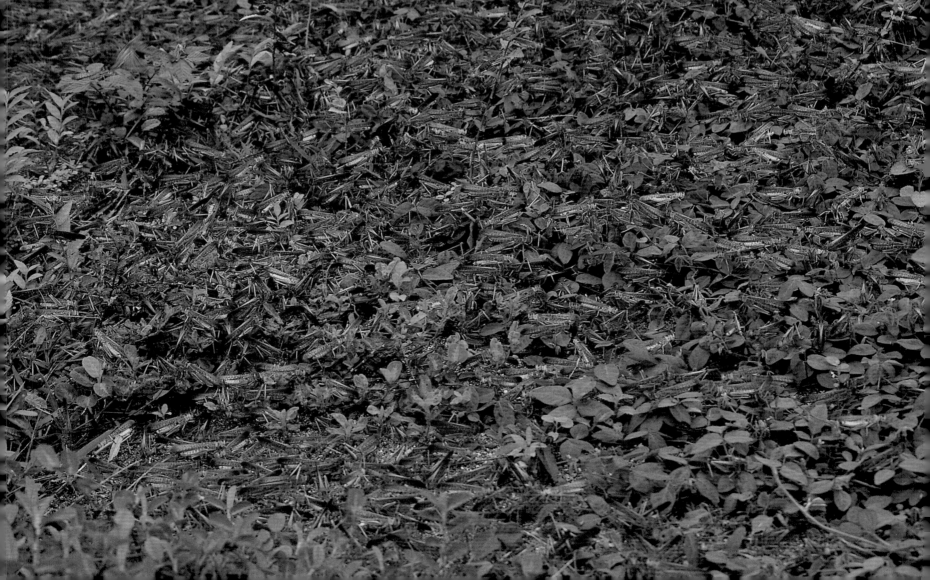

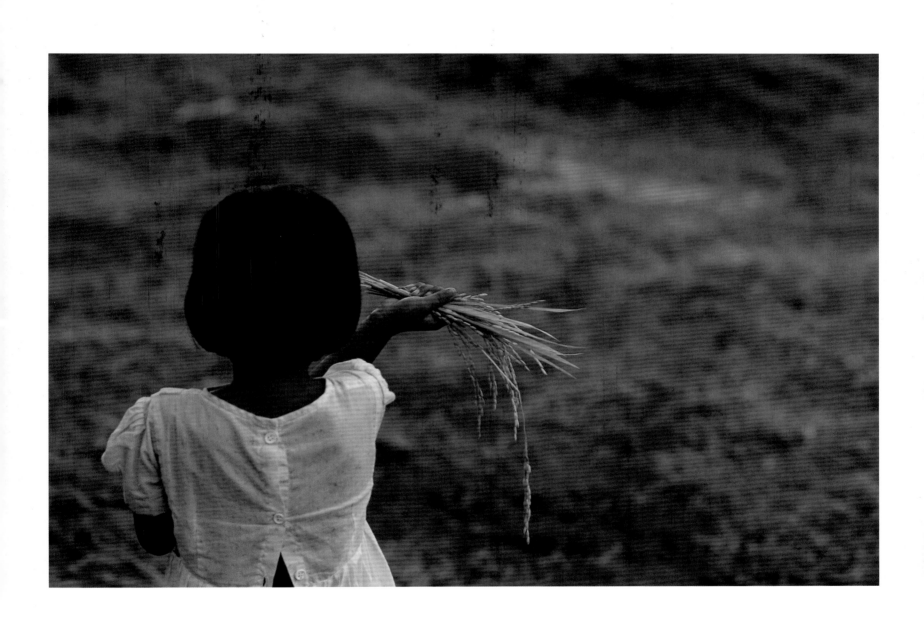

THE FAR EAST

Taiwan
China
Korea
Japan

This is the region that hangs on the eastern edge of the Asian Continent—the region that greets each new day first. This was also the region that greeted Western culture first and that industrialized and modernized first. As a result, this is the region that saw its lifestyles change first and that first started moving away from the centuries-old traditions of rice farming. Industrialization and other forces gradually gave the people a glimpse of real economic power, and this lure then turned them into *homo oeconomicus*, moving their spirits away from agrarian acceptance to industrial acquisitiveness and making financial worth the prime determinant in their values system. As such, this is the region that first jettisoned the traditional Asian values of harmony and betrayed the environment in its rush to more transient wealth.

This was once a region of caring families and Confucian values nurtured over the generations, but this has been largely forgotten in the rush to material wealth. At the same time, this rush is compounded by population pressures that trigger grave food shortages and other dysfunctionalities threatening not only Asia but the whole world's future.

While the region's headstrong economic development seems to be abating, the recession's silver lining has been a rediscovery of human values and a rueful awareness of how much has been forfeited to gain so little. People have realized anew the importance of family ties, their cultural heritage, and a sound ecosystem. If this perspective can be regained, recession will have been a small price to pay for salvation.

Oblivious to these human-scale changes, the monsoon winds continue to blow over the region's paddies, bringing rain to grow the all-important rice and holding out hope for the future. Now it is up to the people of the region to regain the natural rhythm of life and to restore nature to its place of primacy—to rethink the region's rush to materialism and to return to the tranquility and happiness that comes from simple living in harmony with nature.

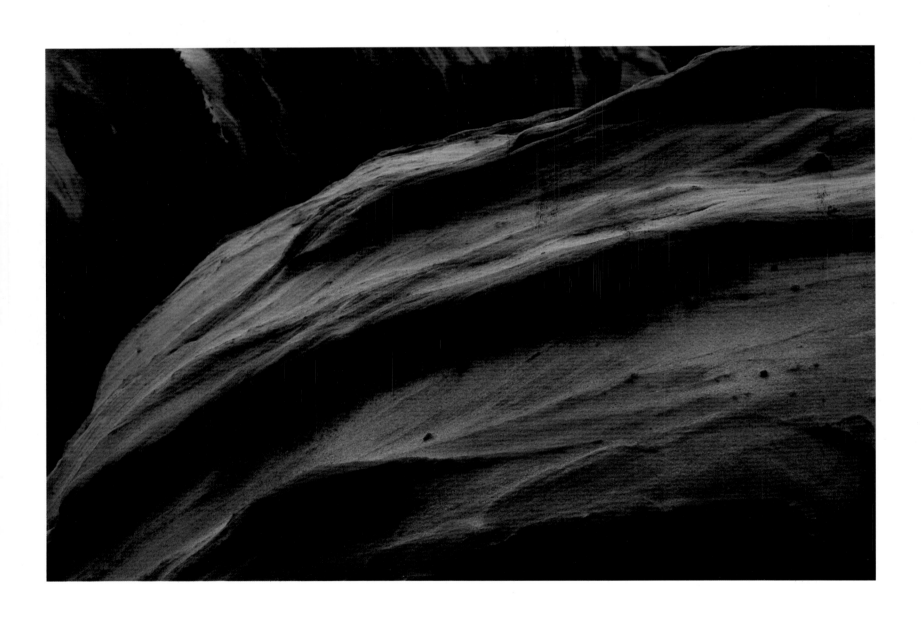

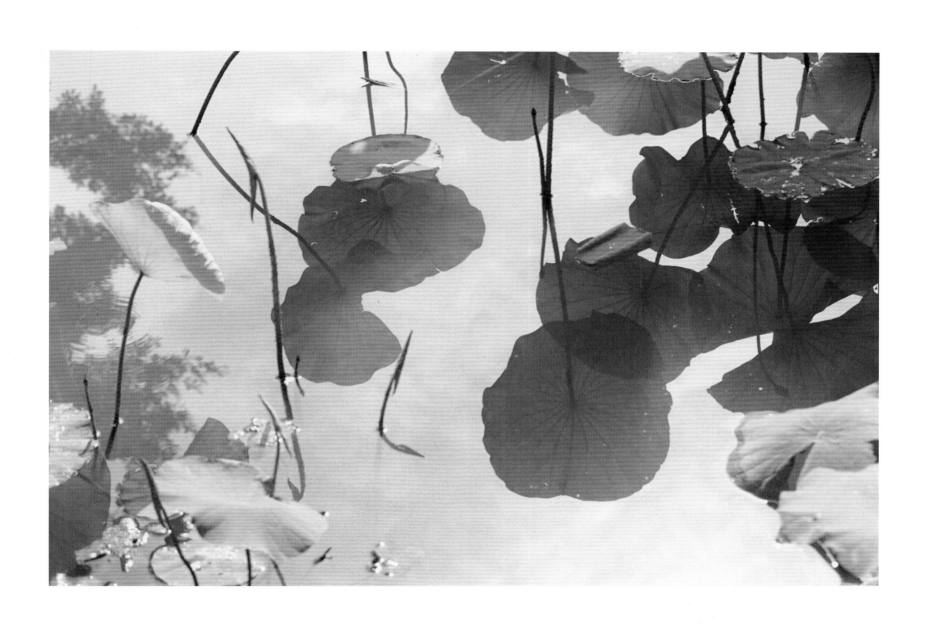

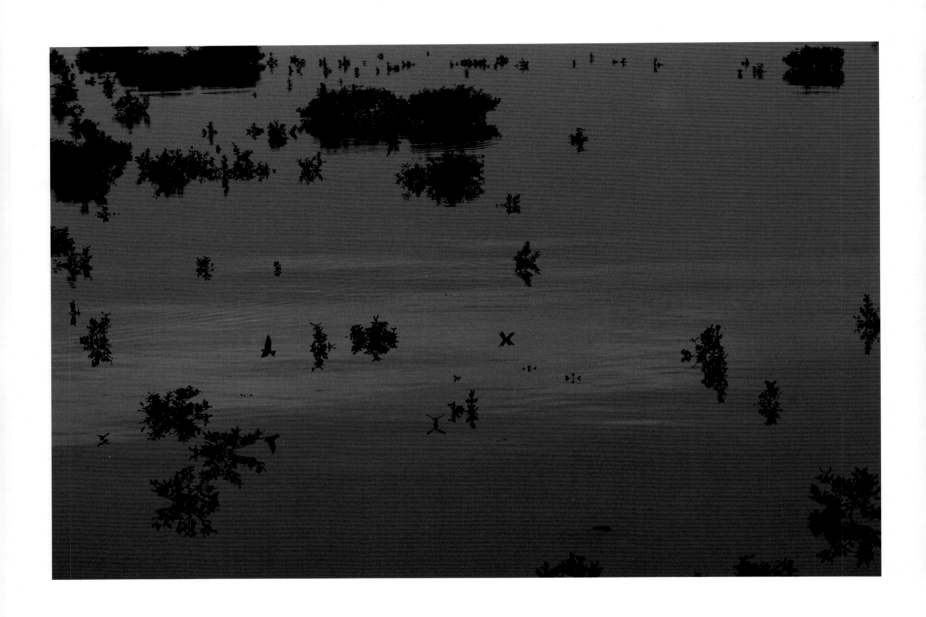

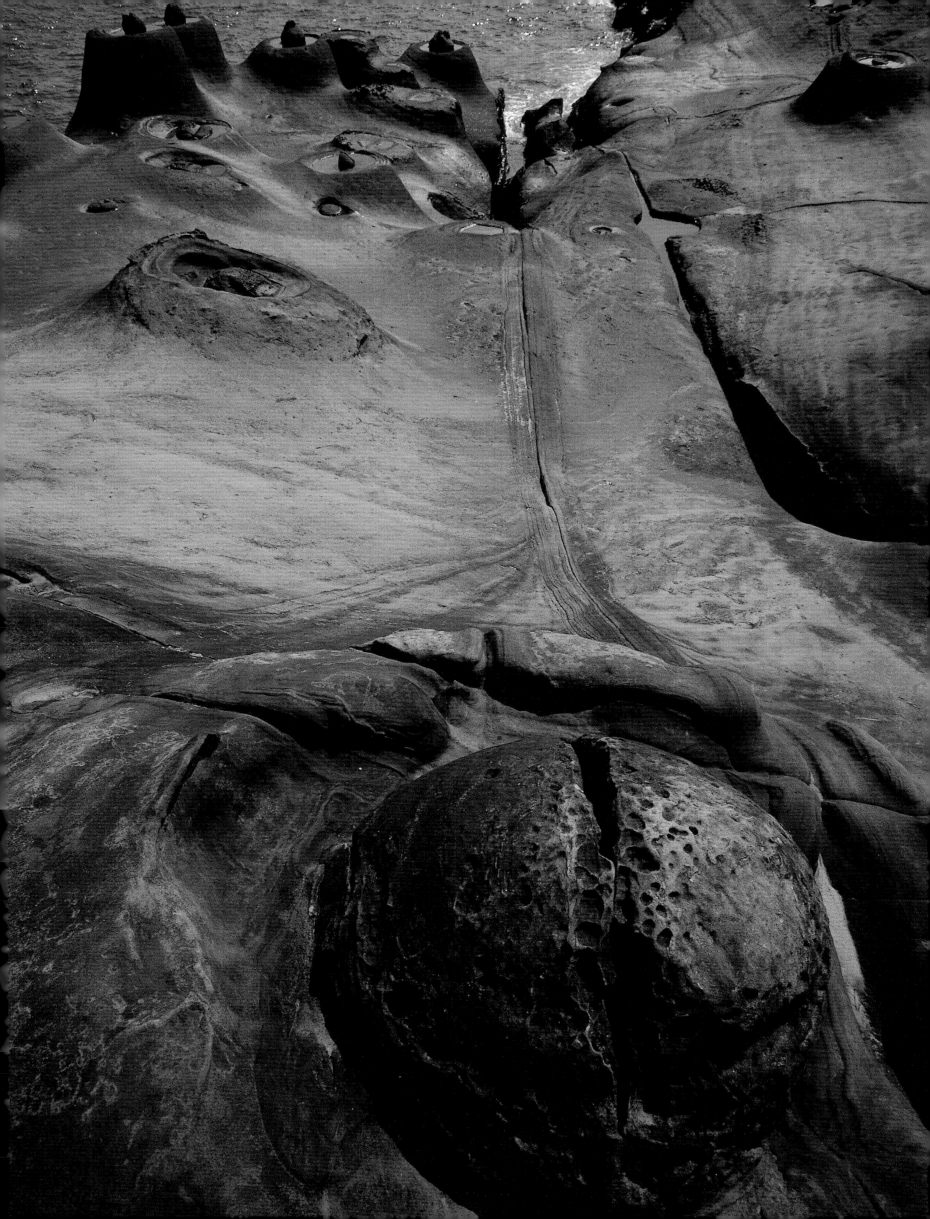

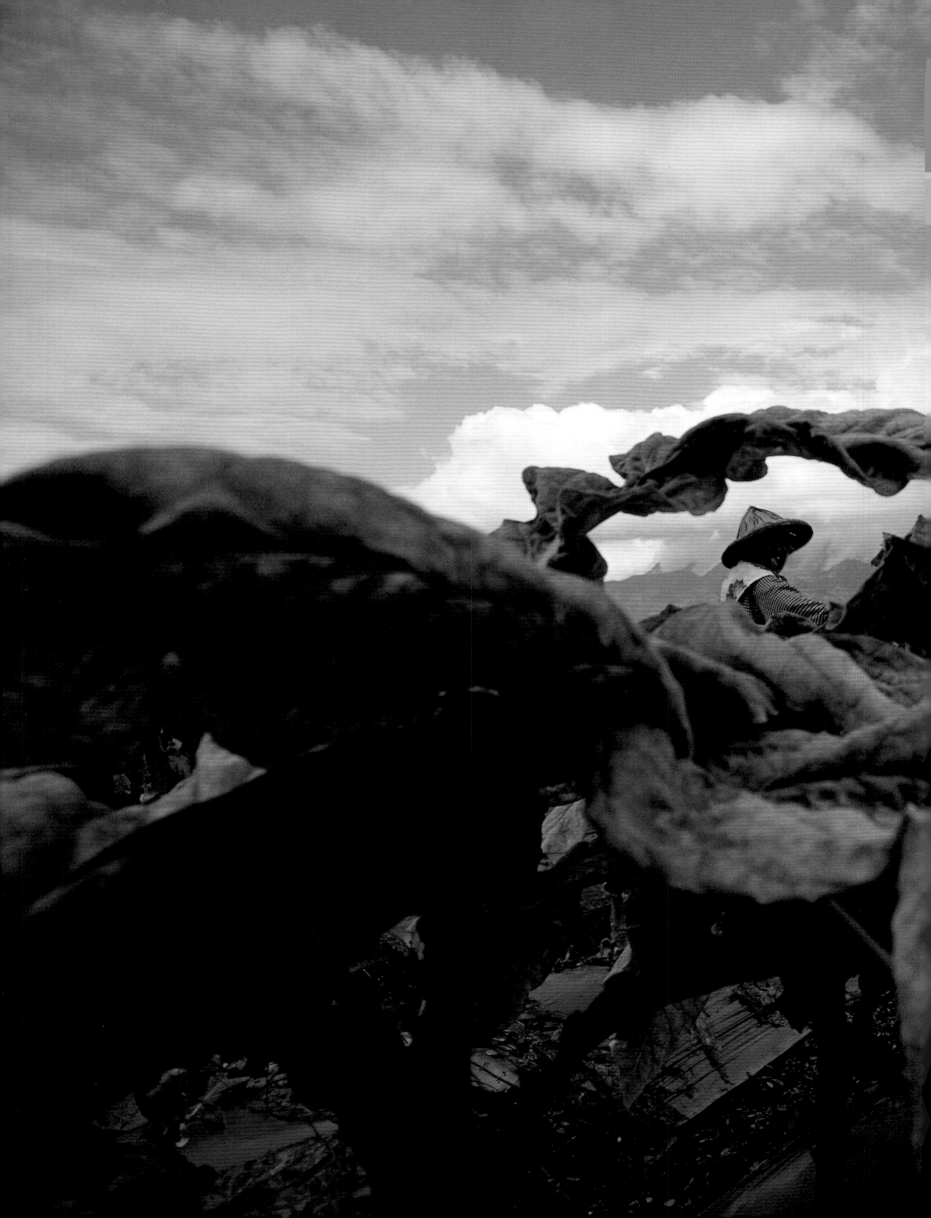

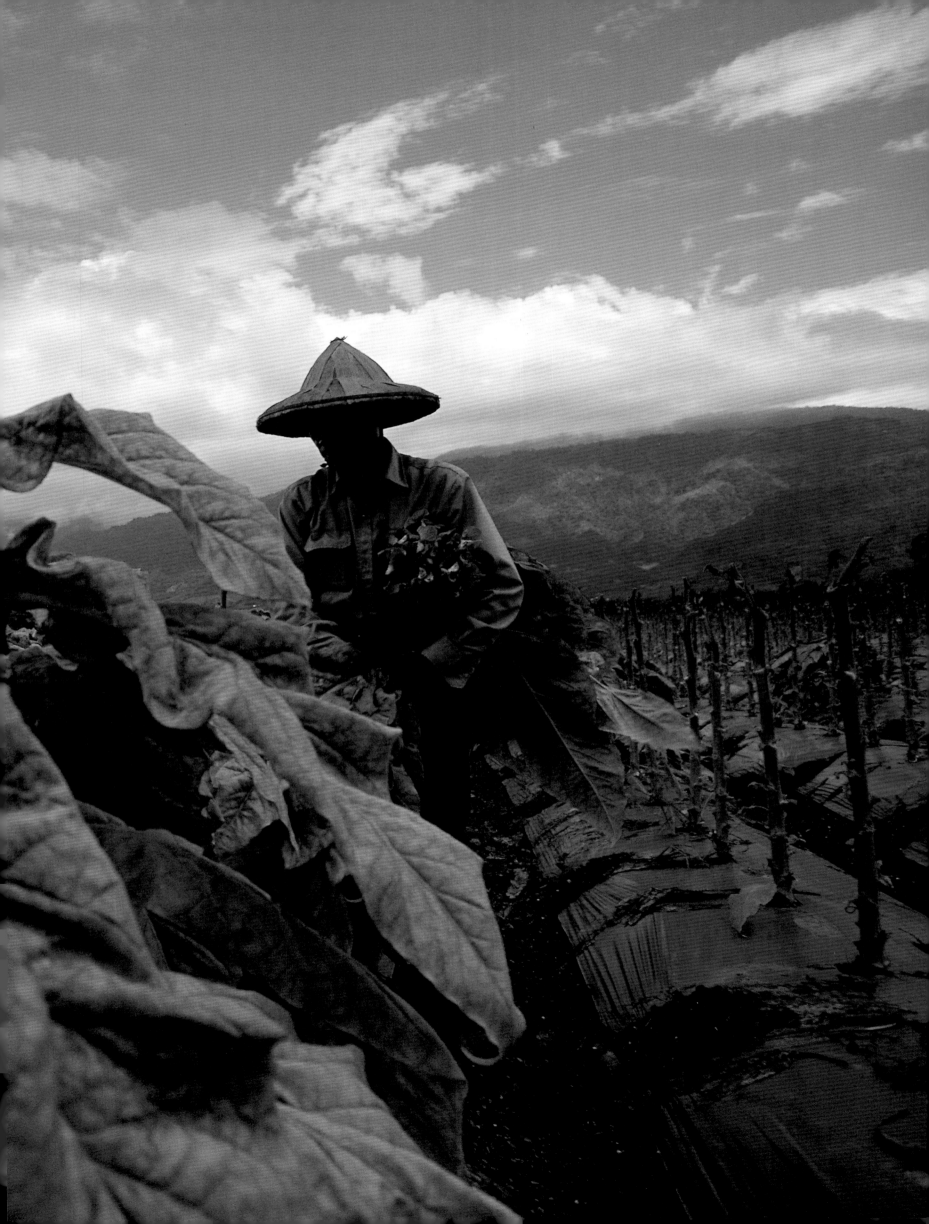

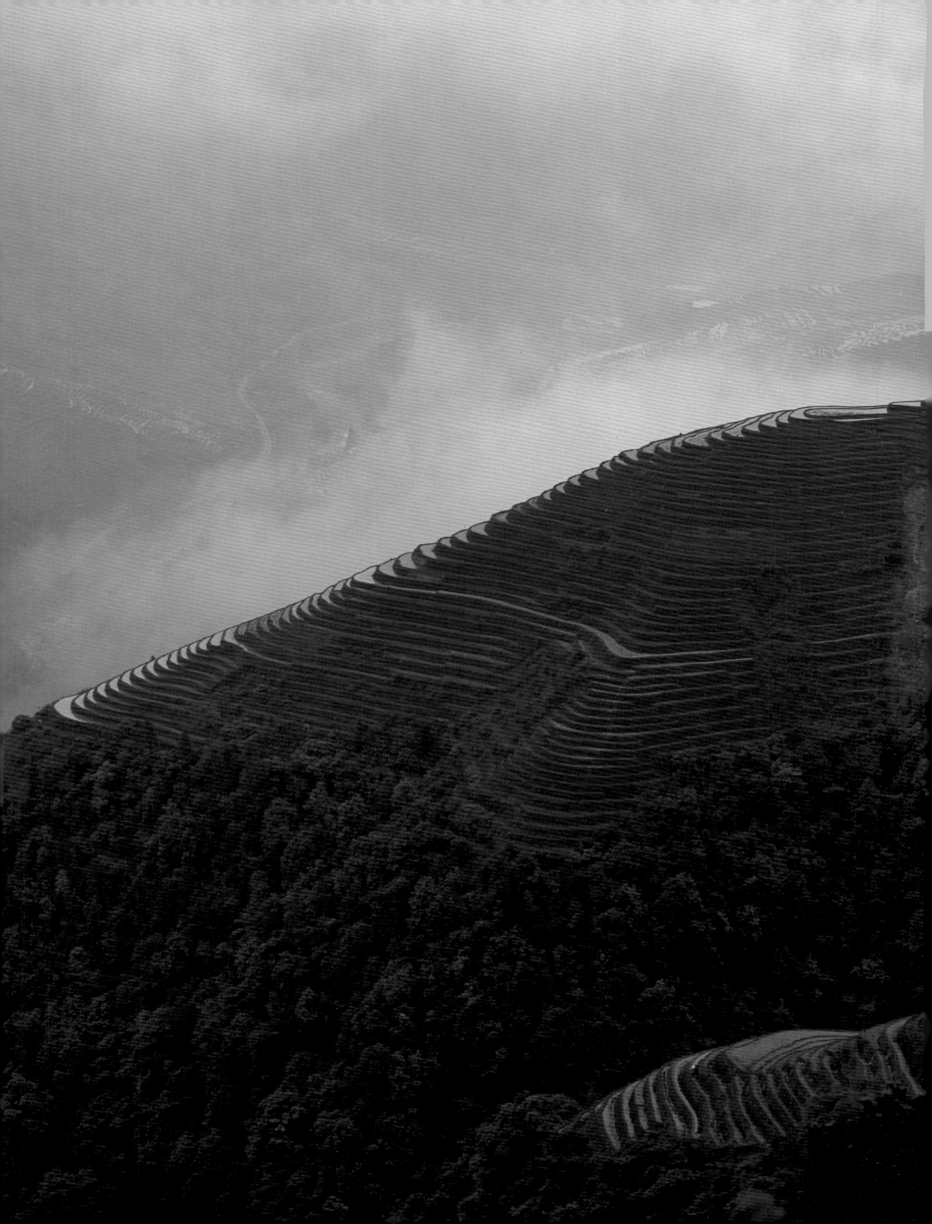

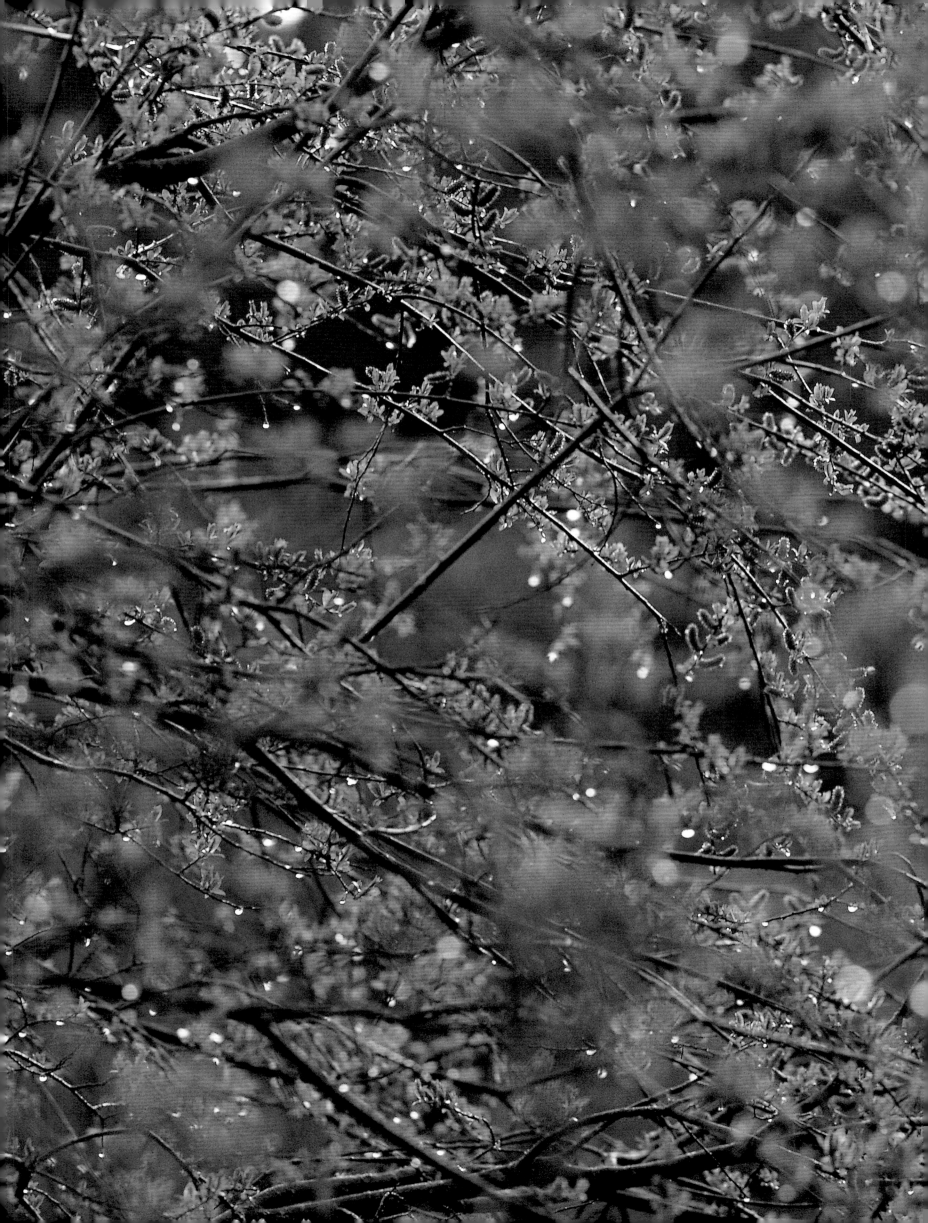

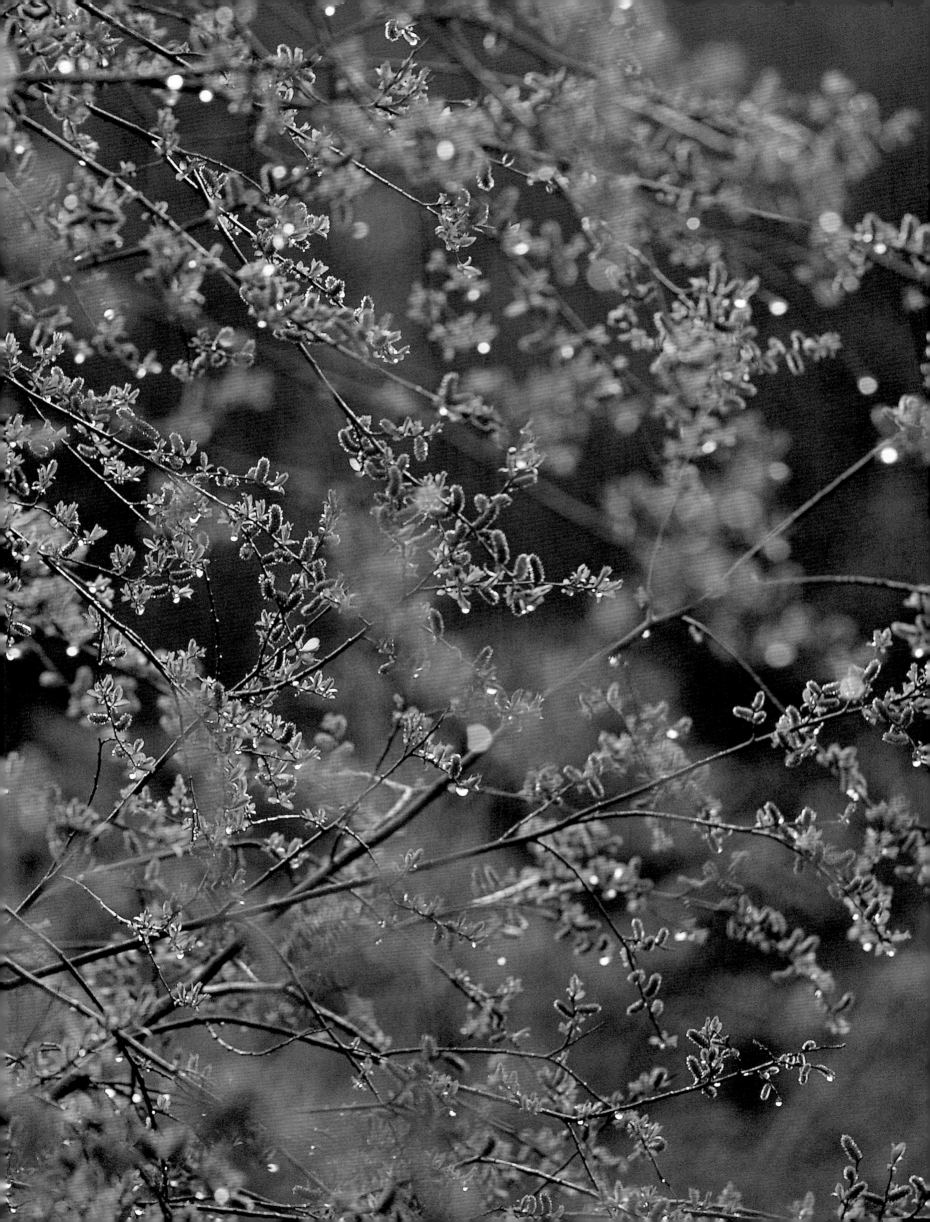

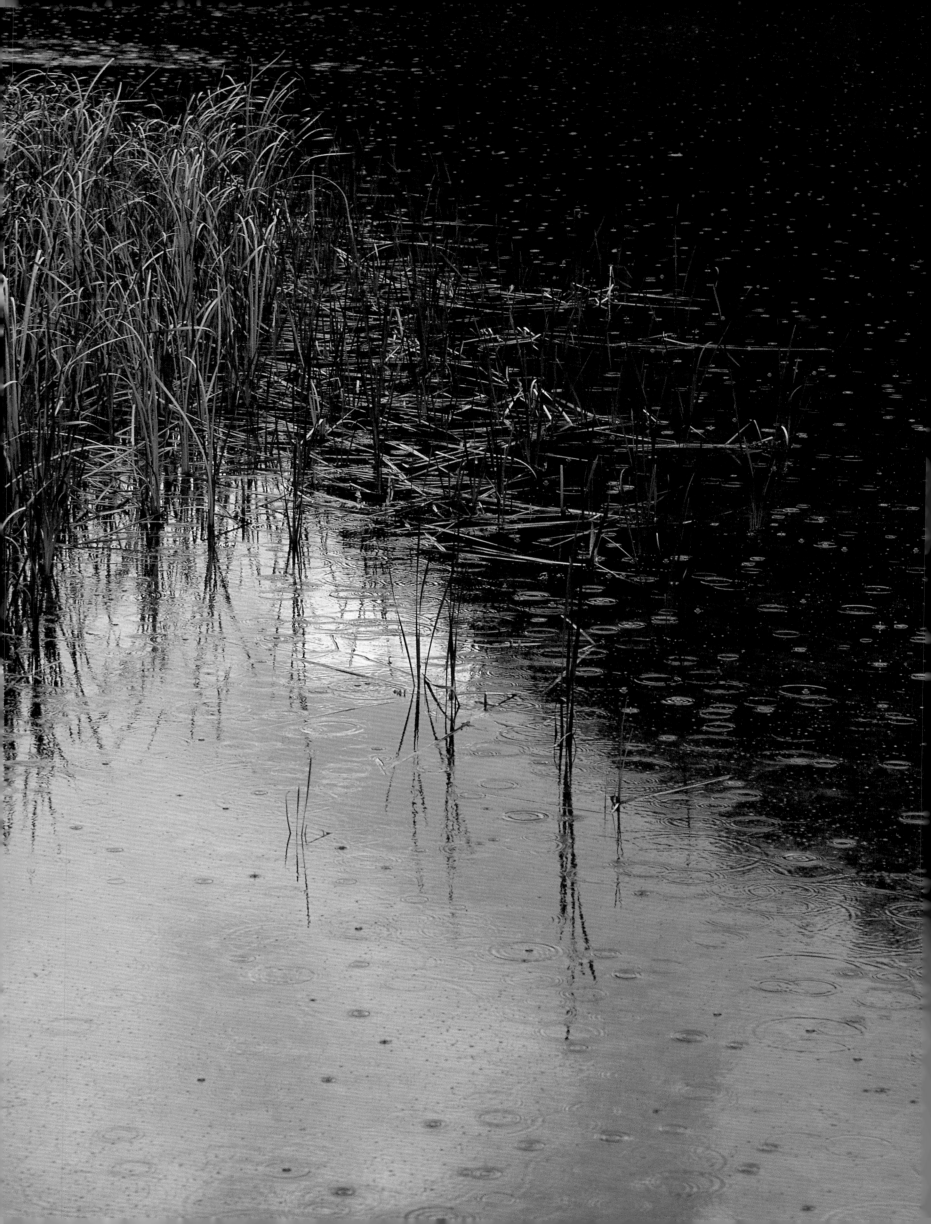

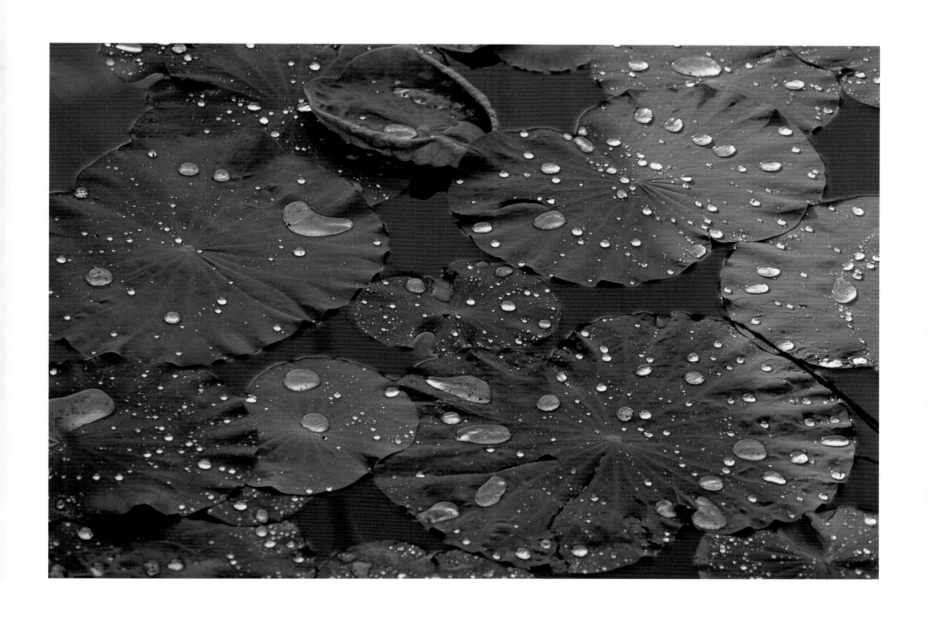

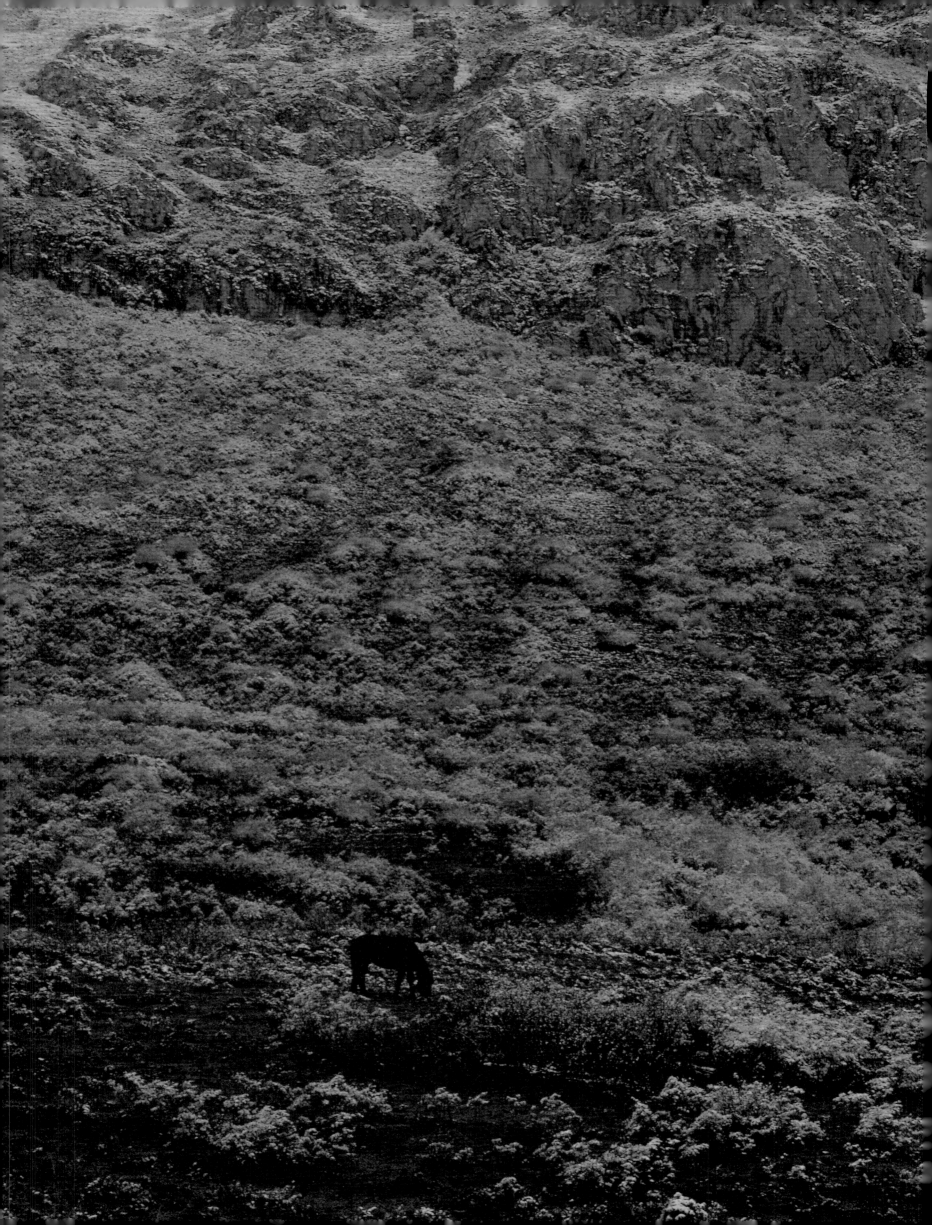

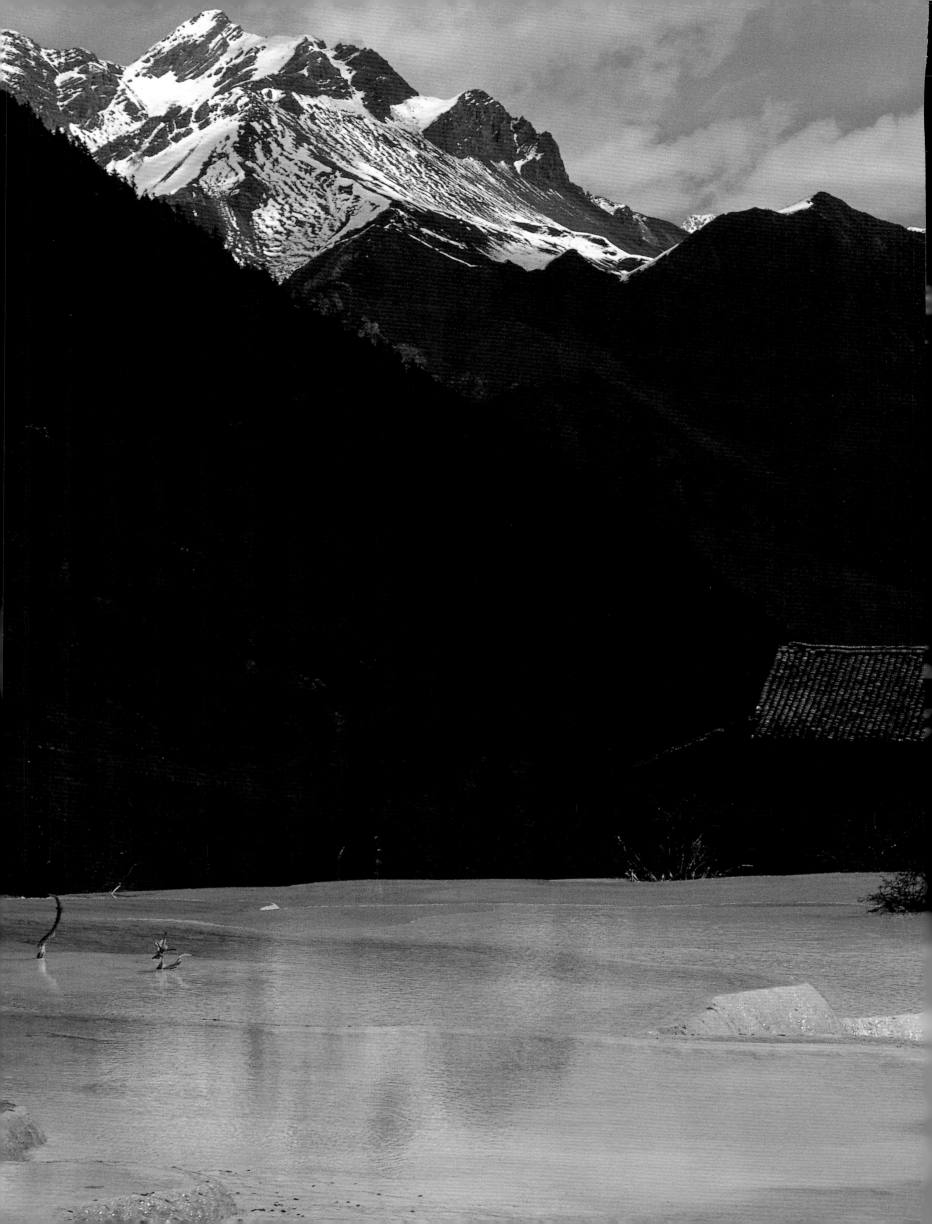

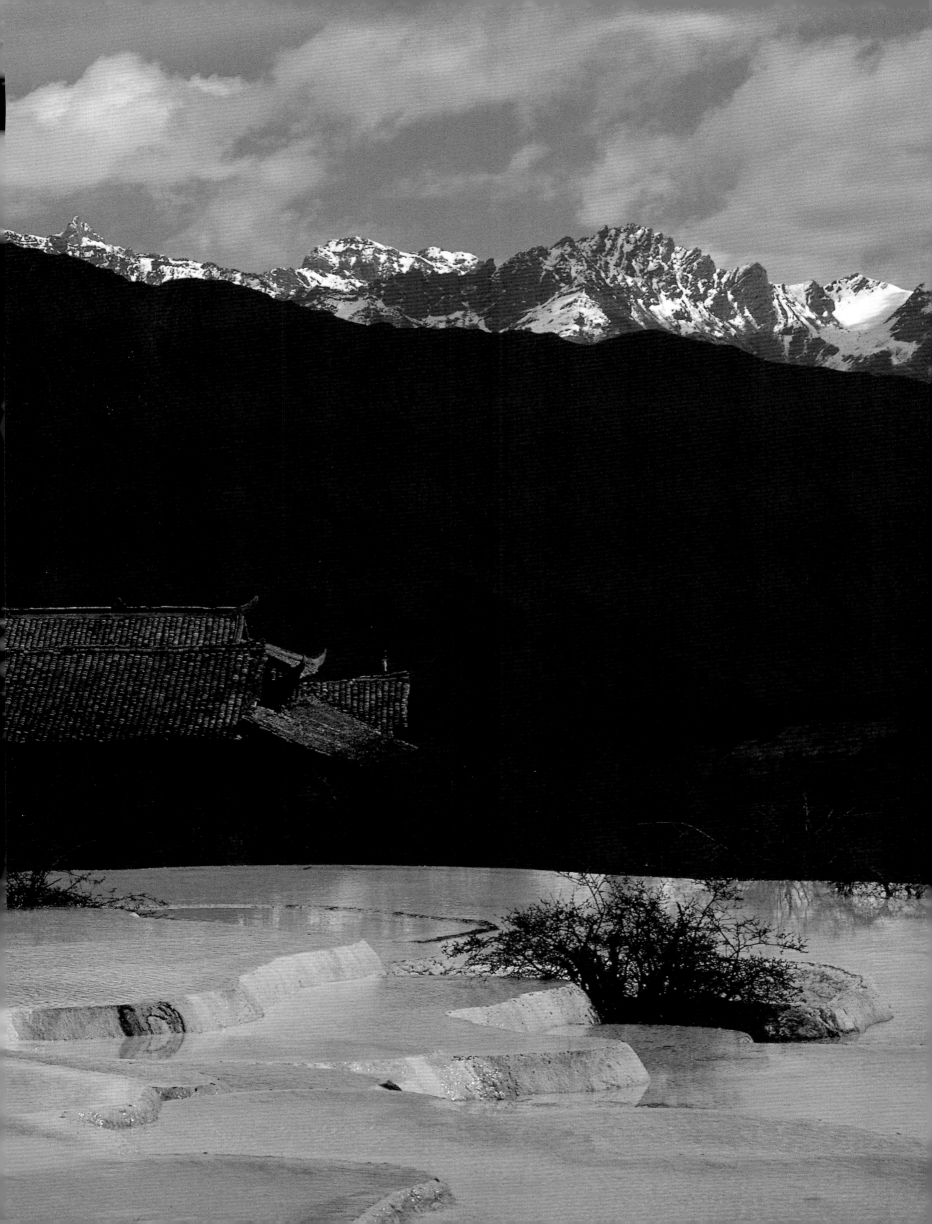

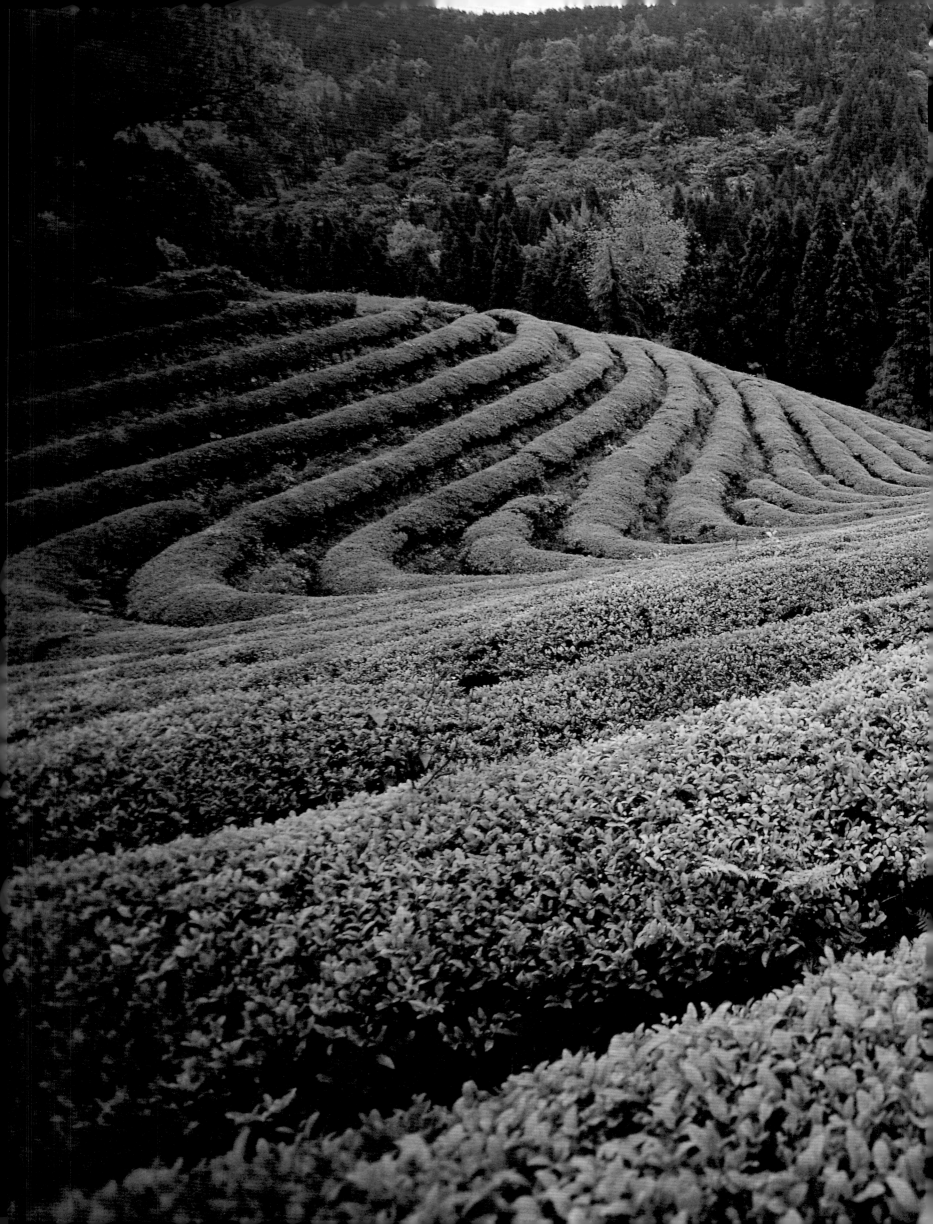

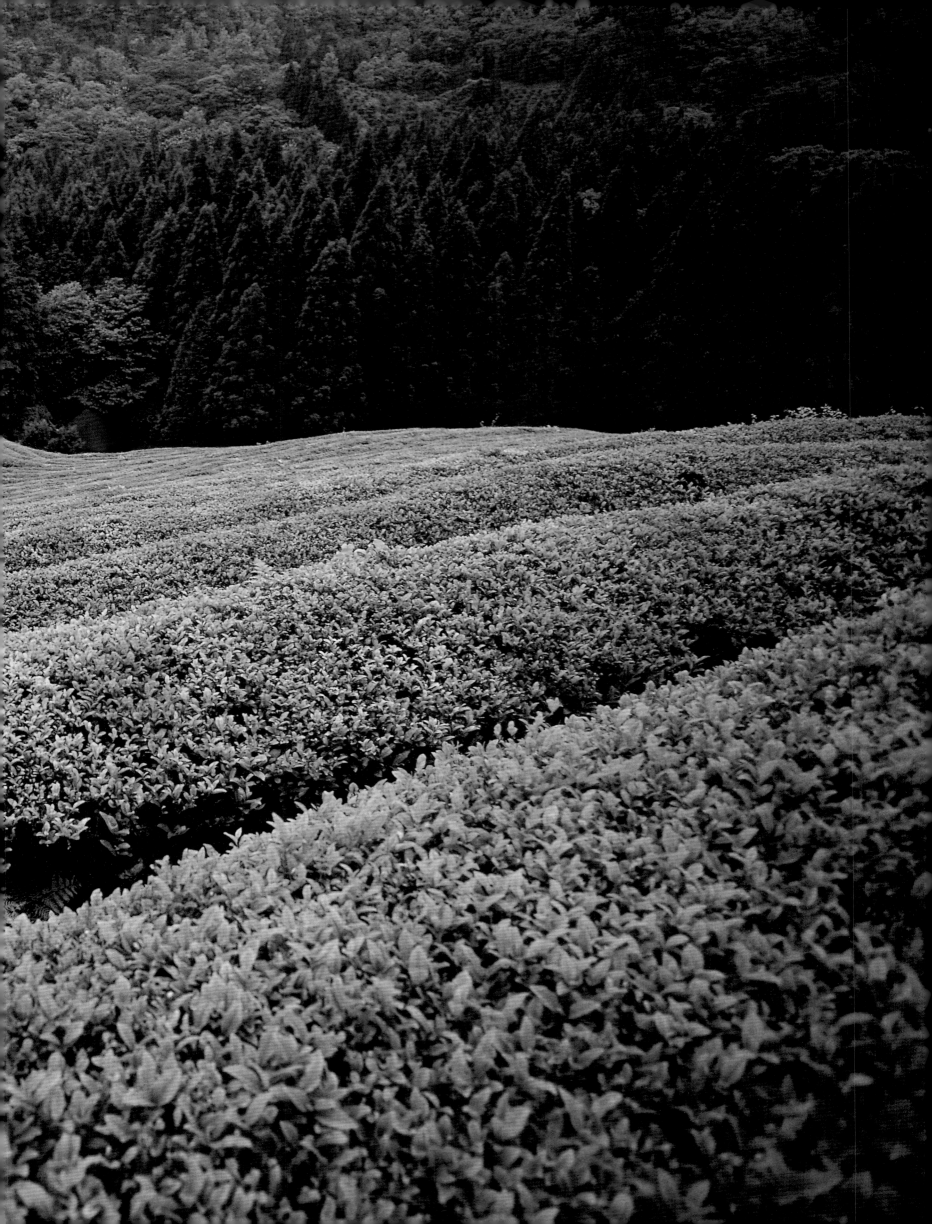

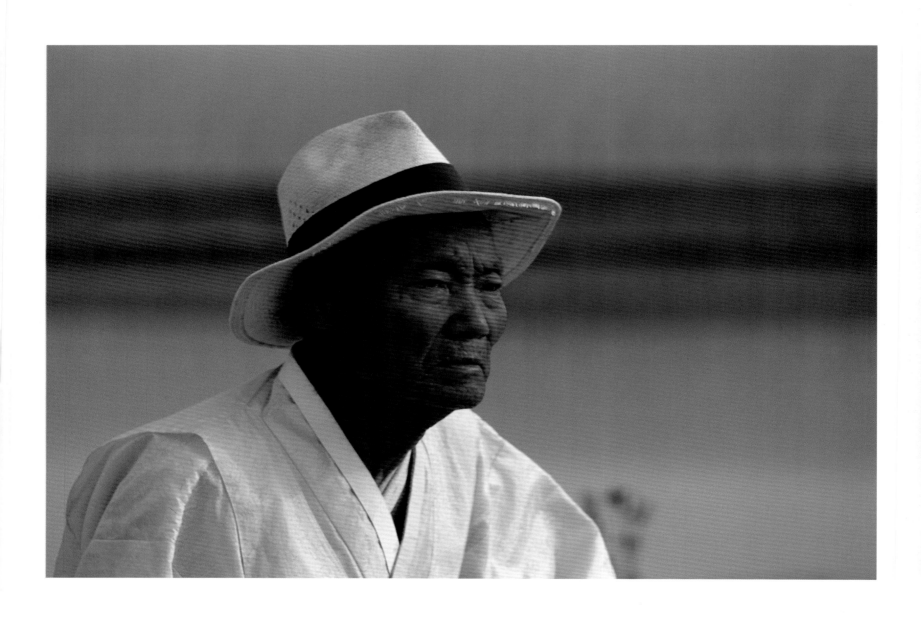

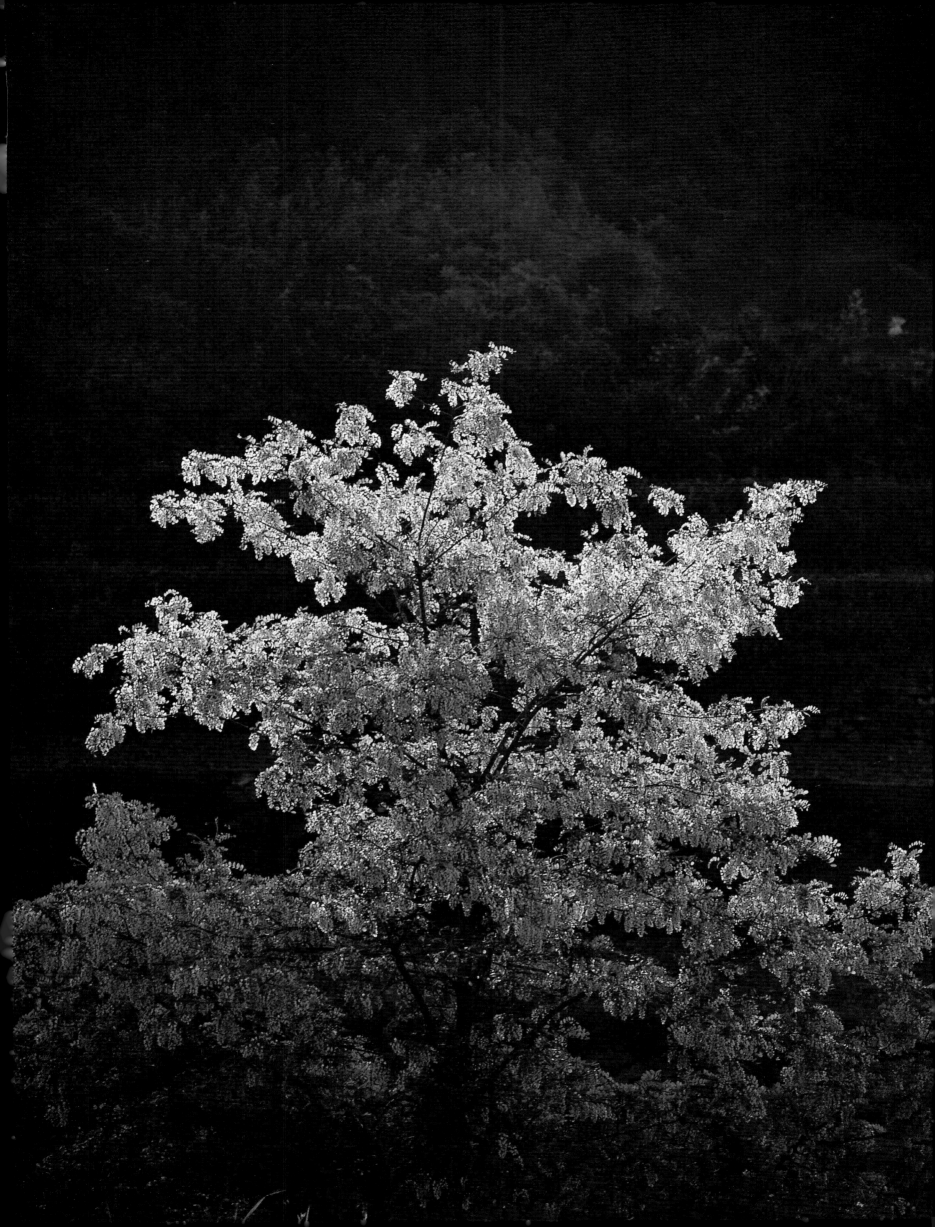

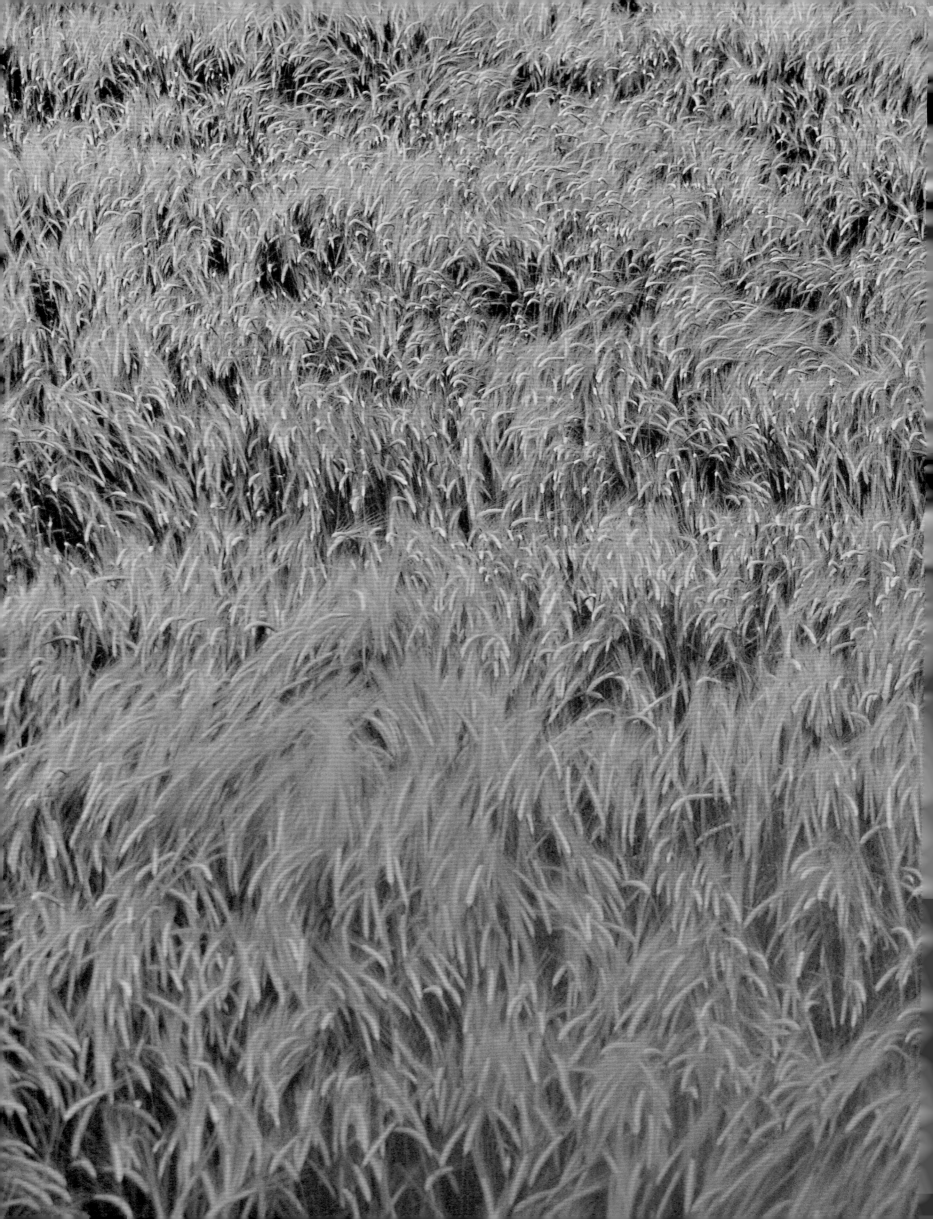

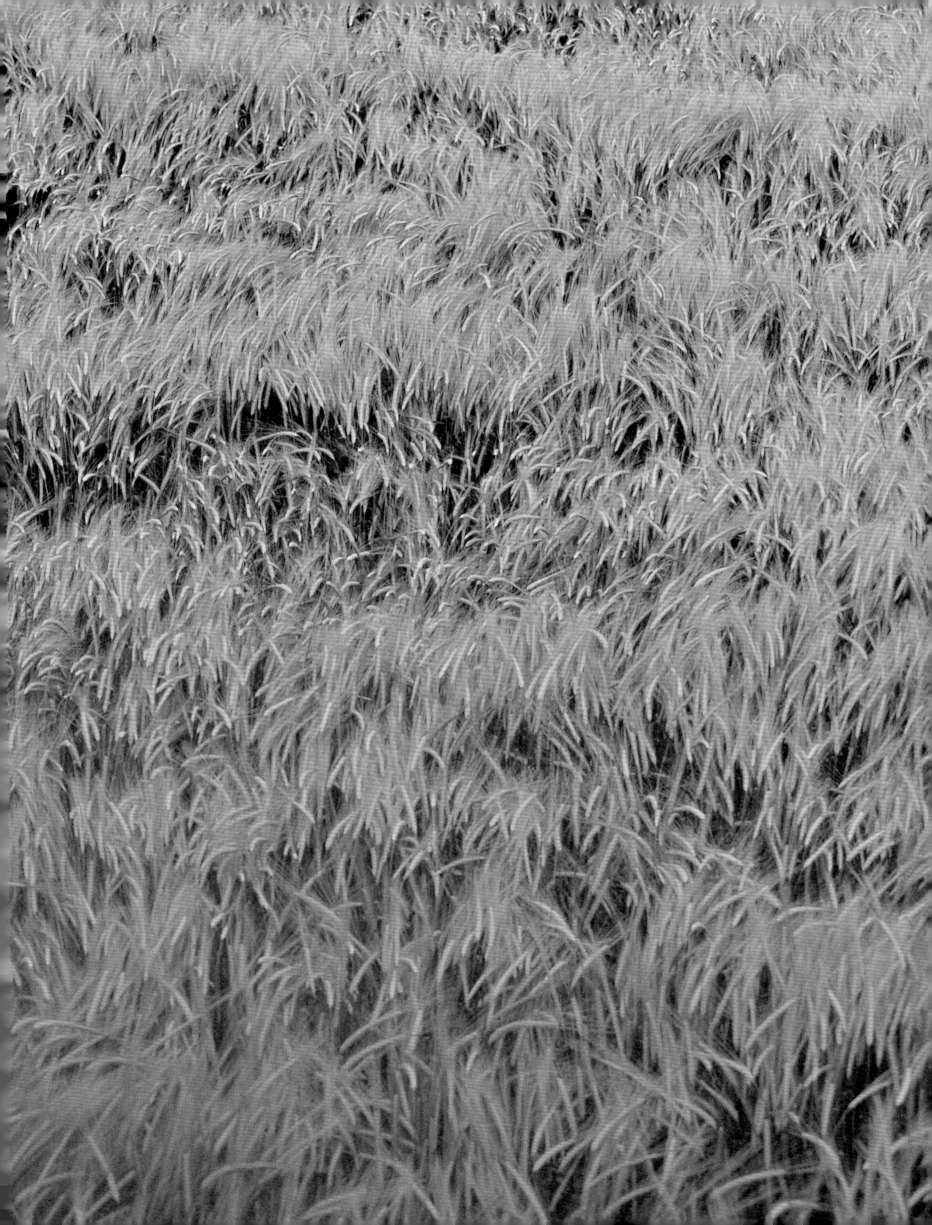

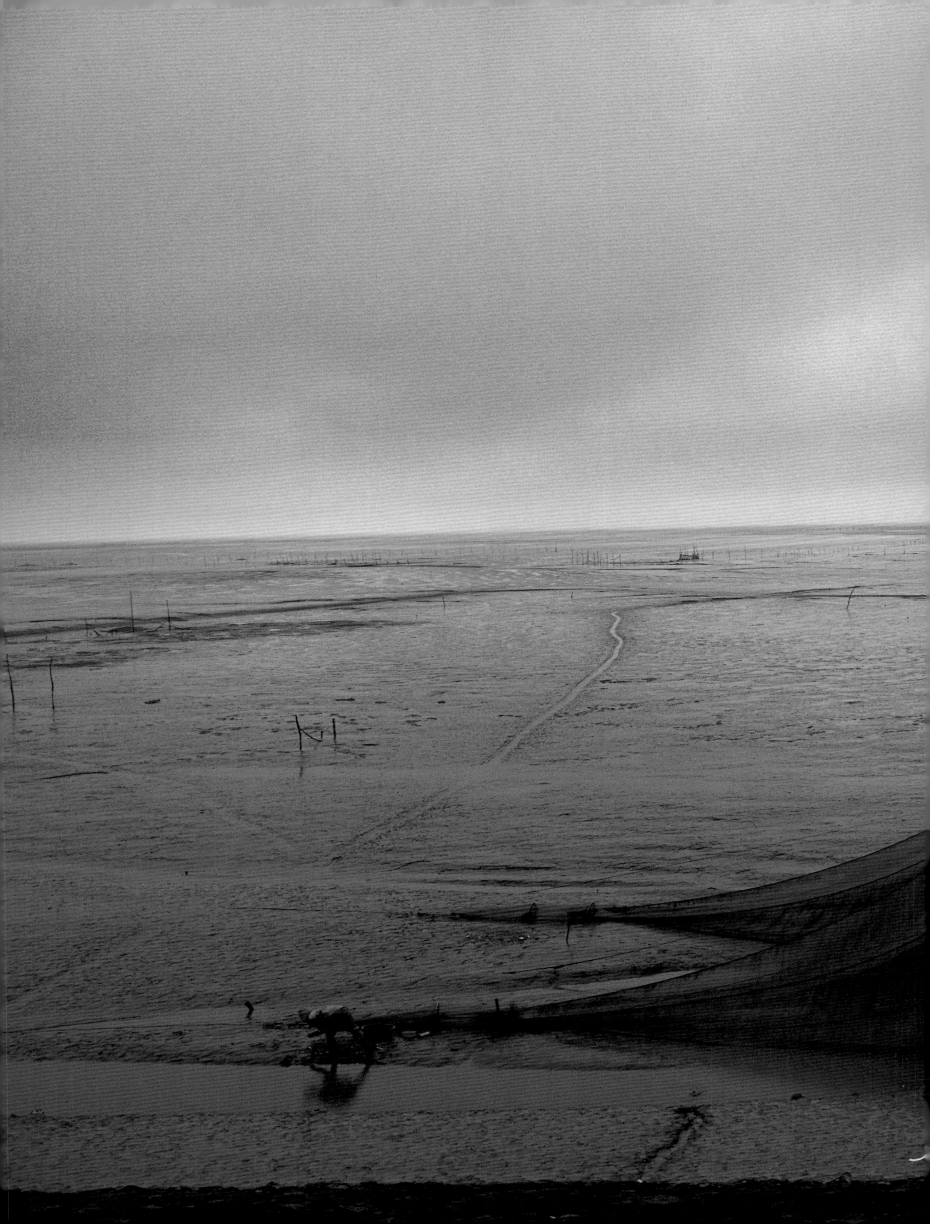

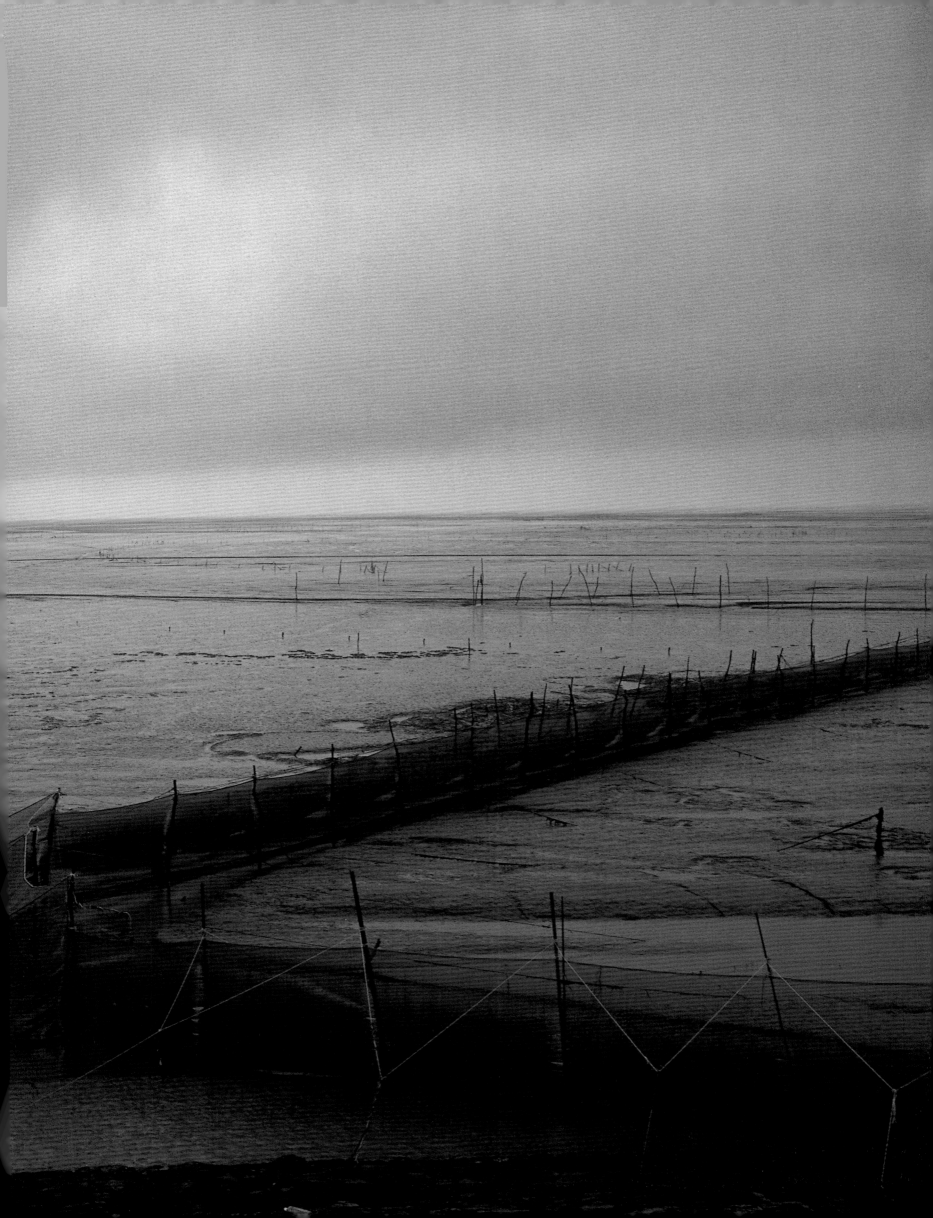

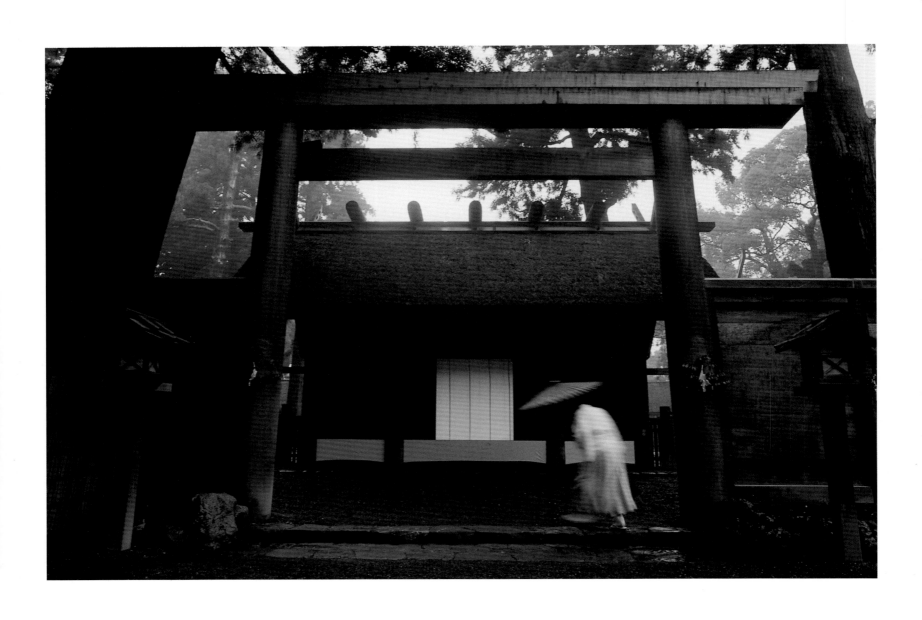

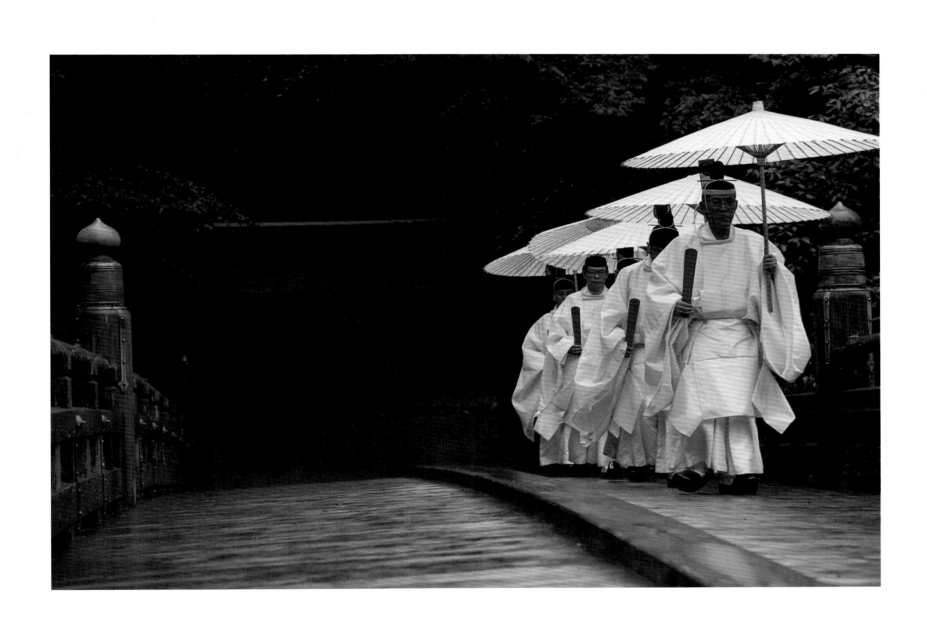

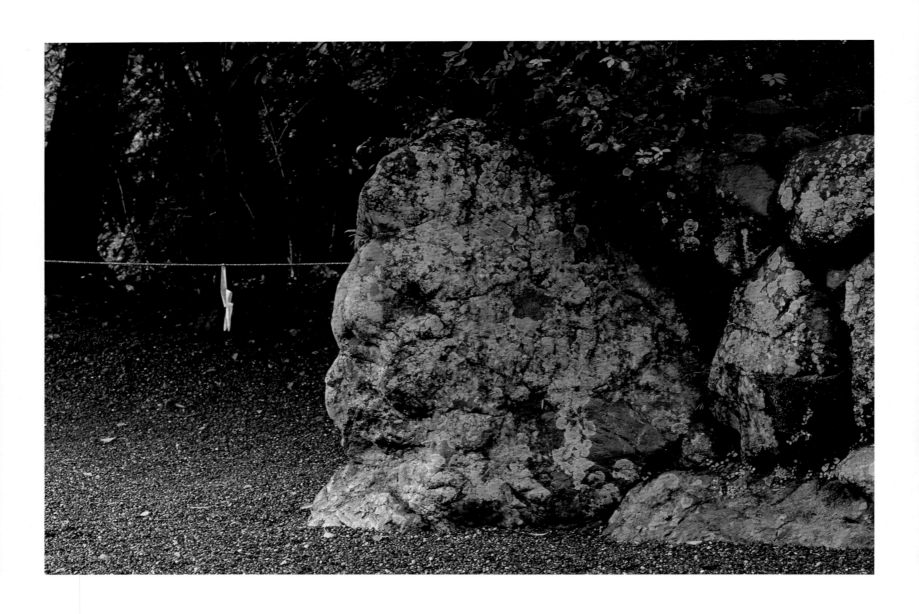

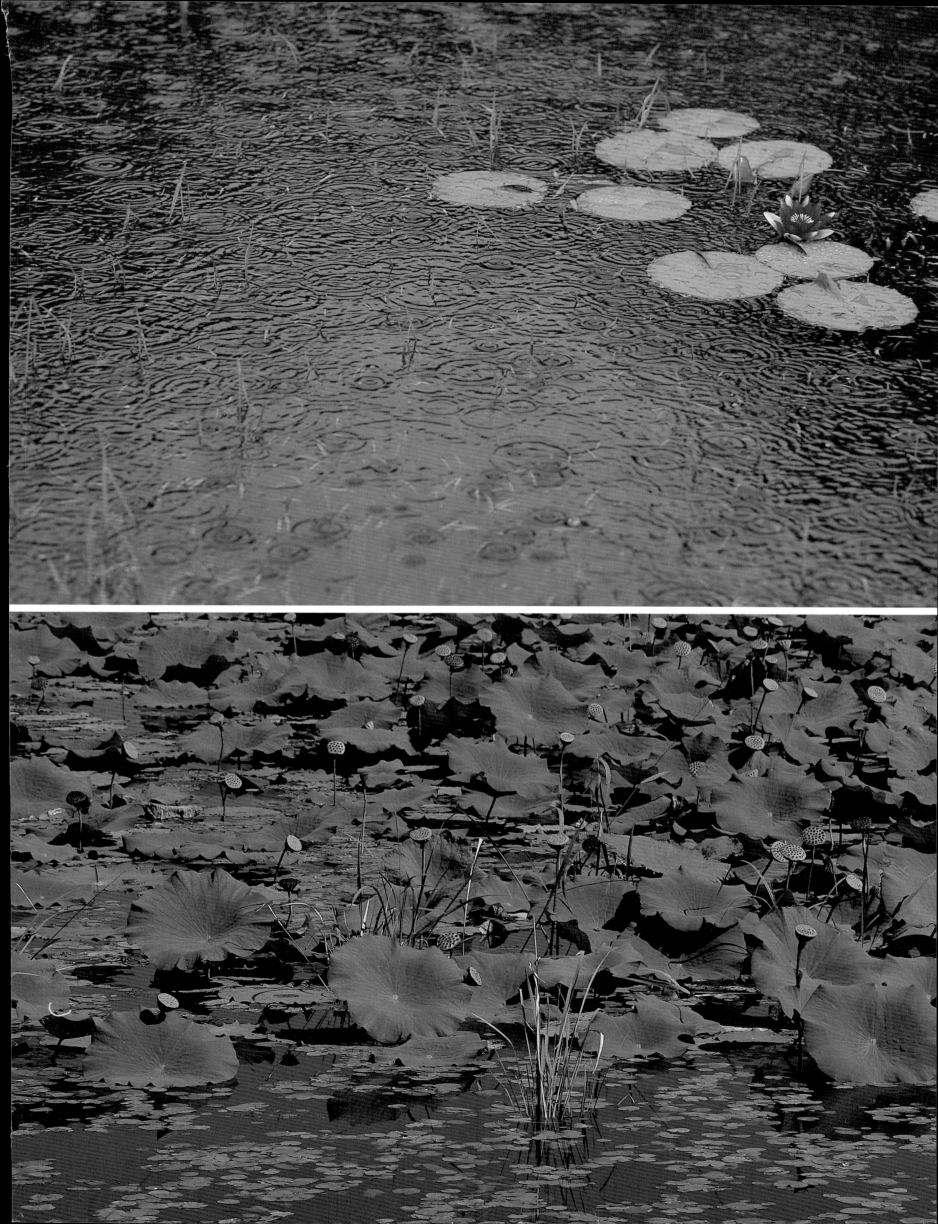

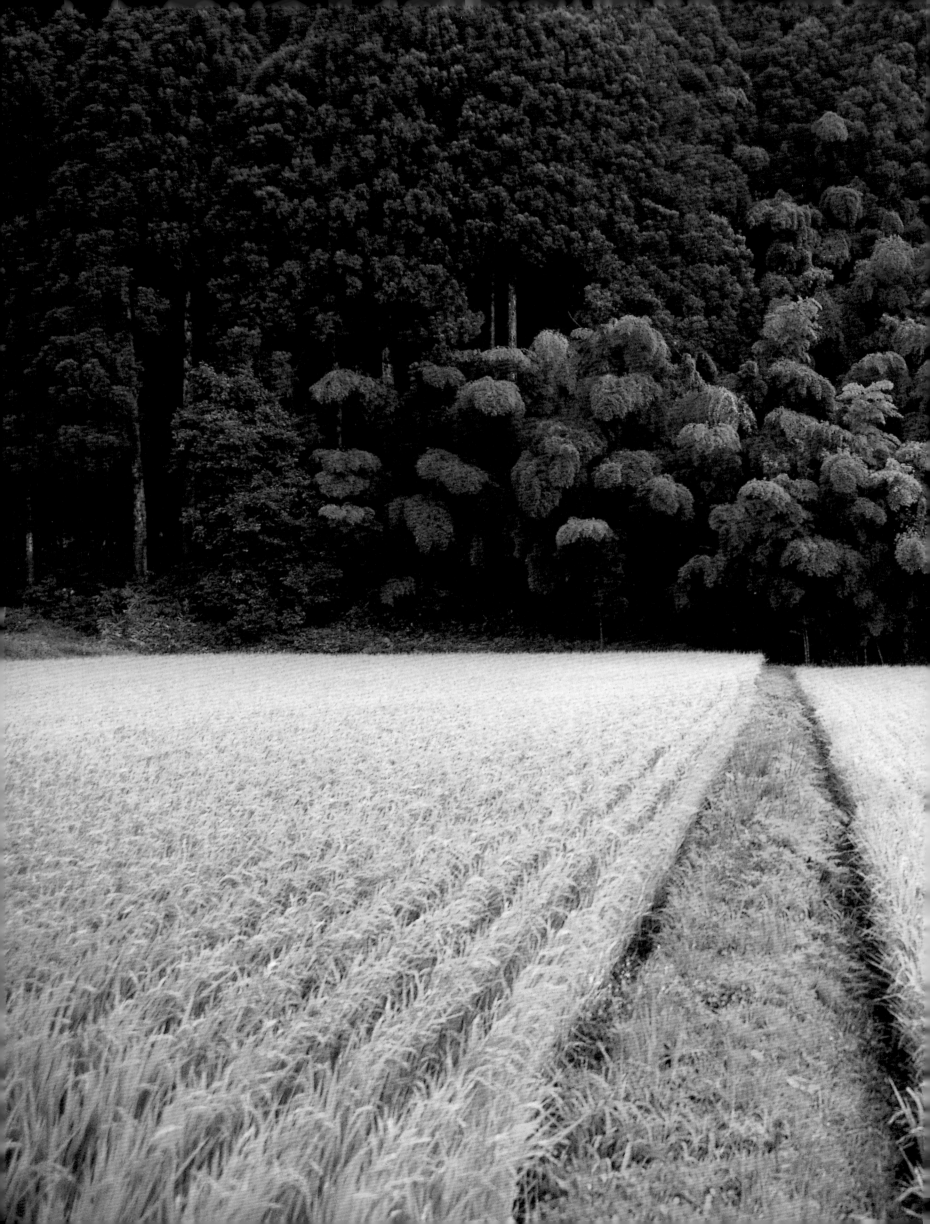

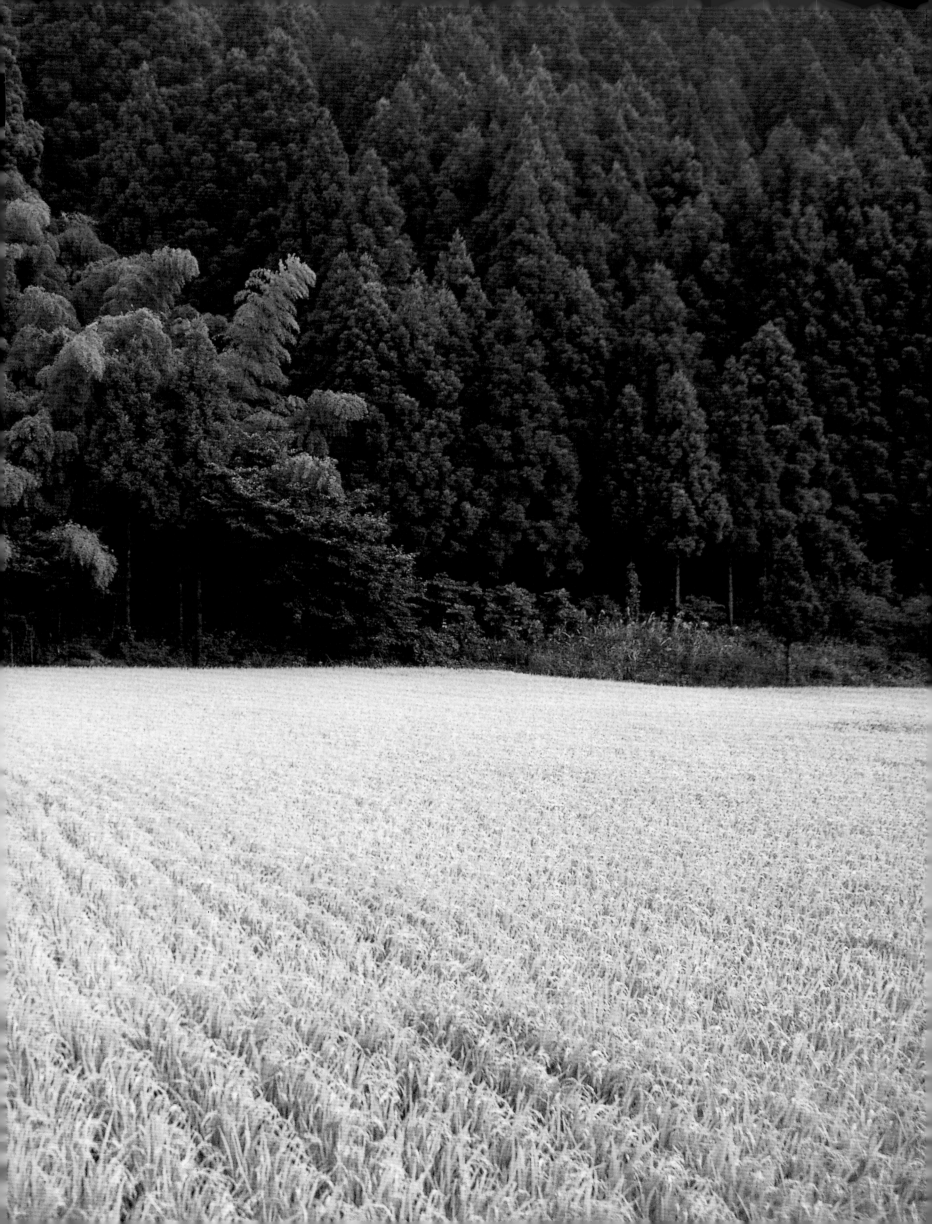

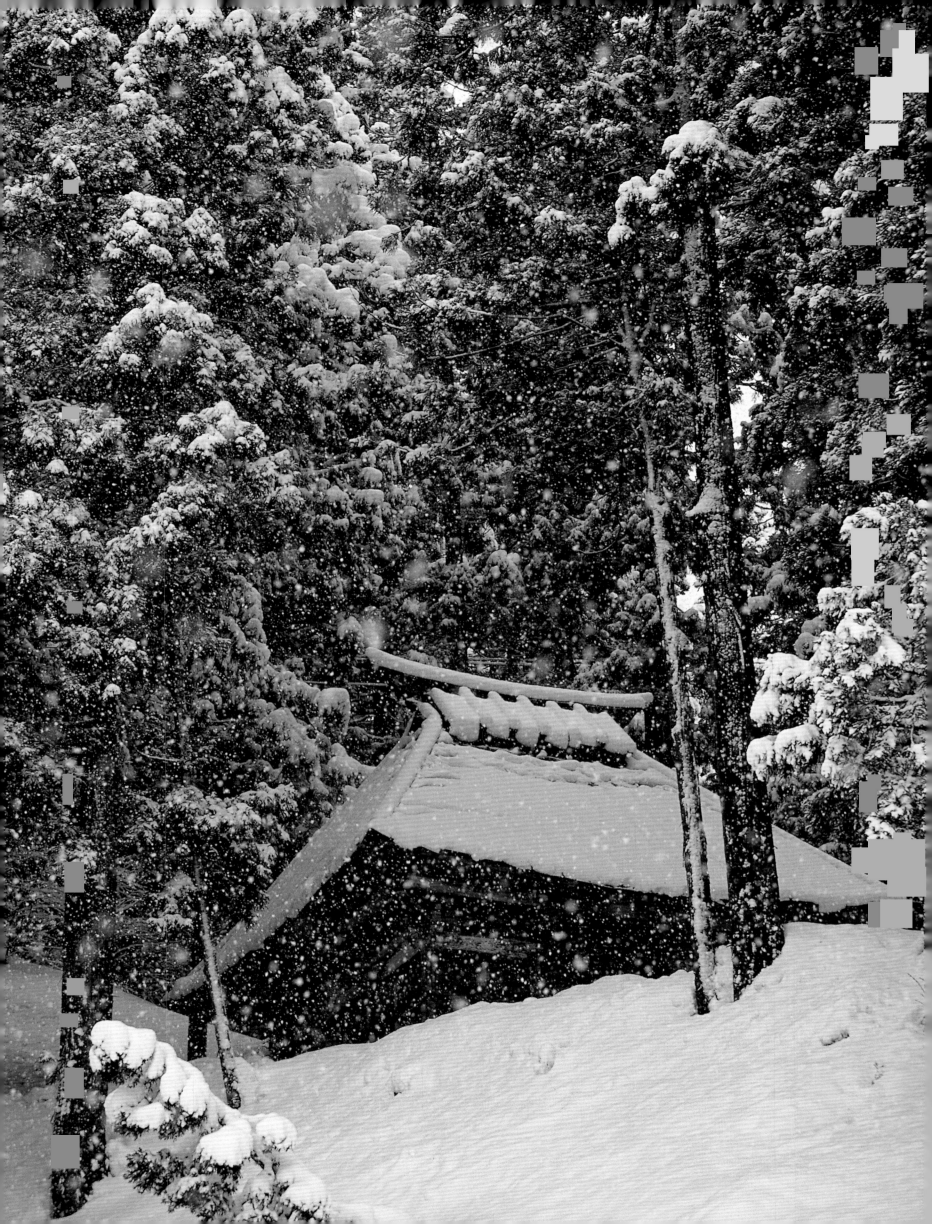

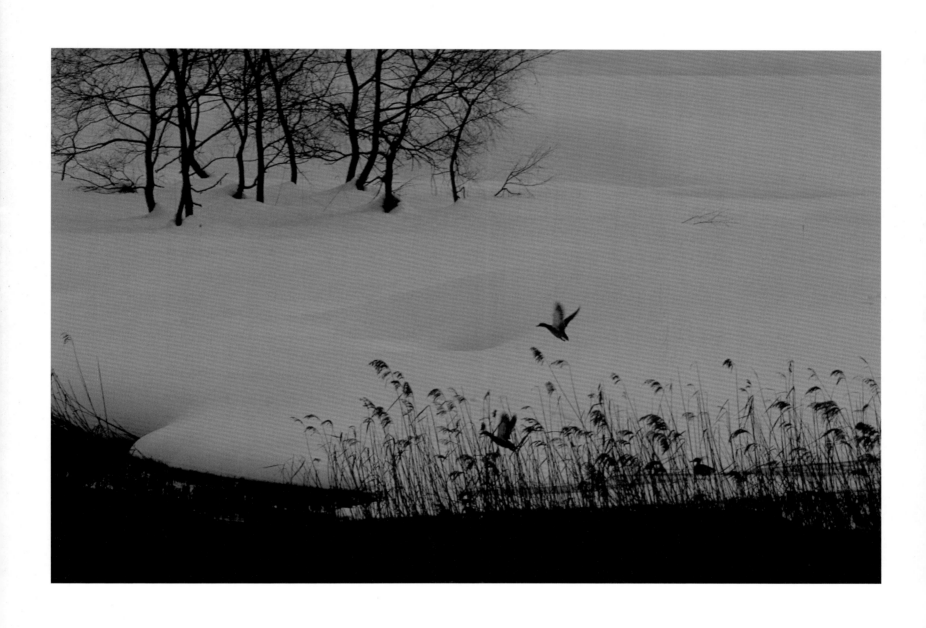

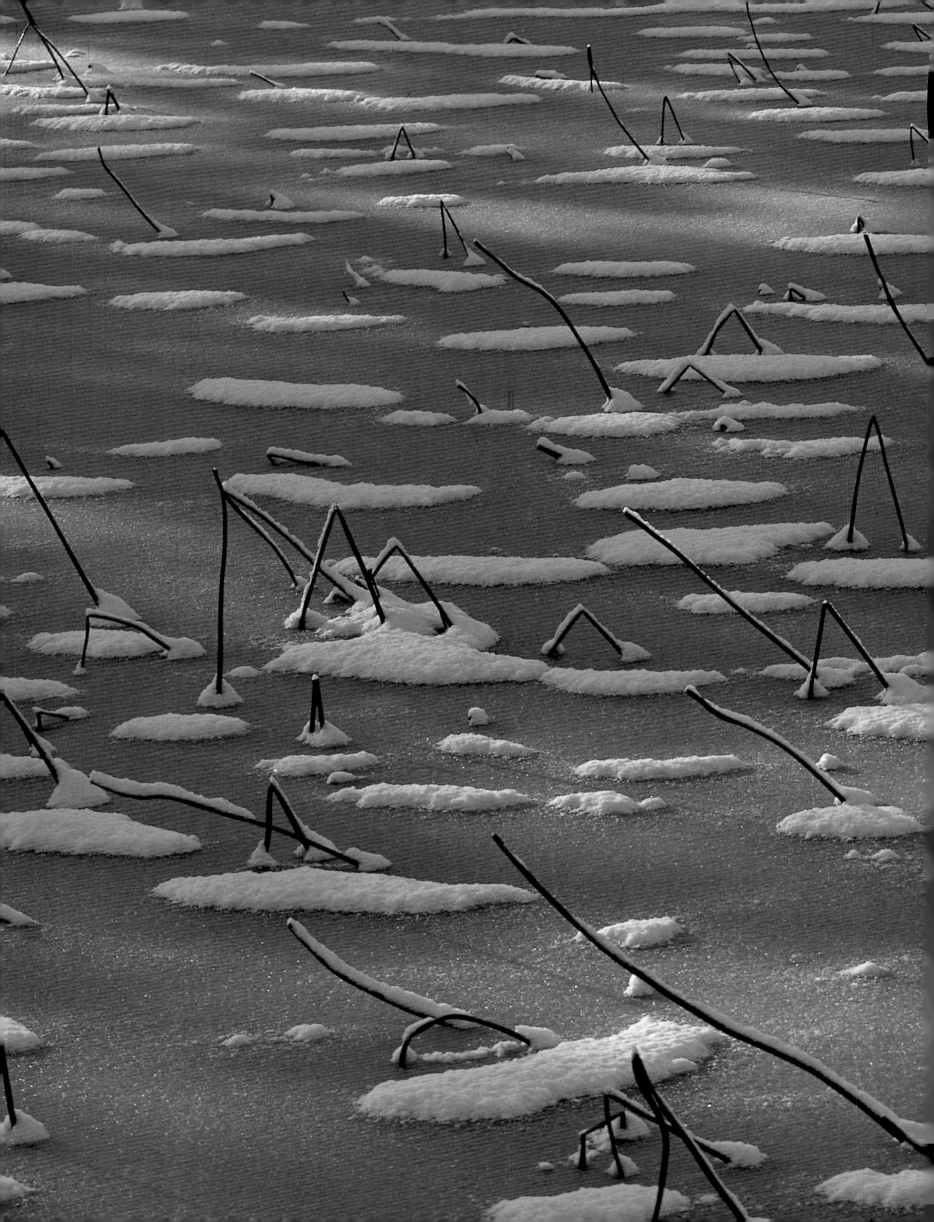

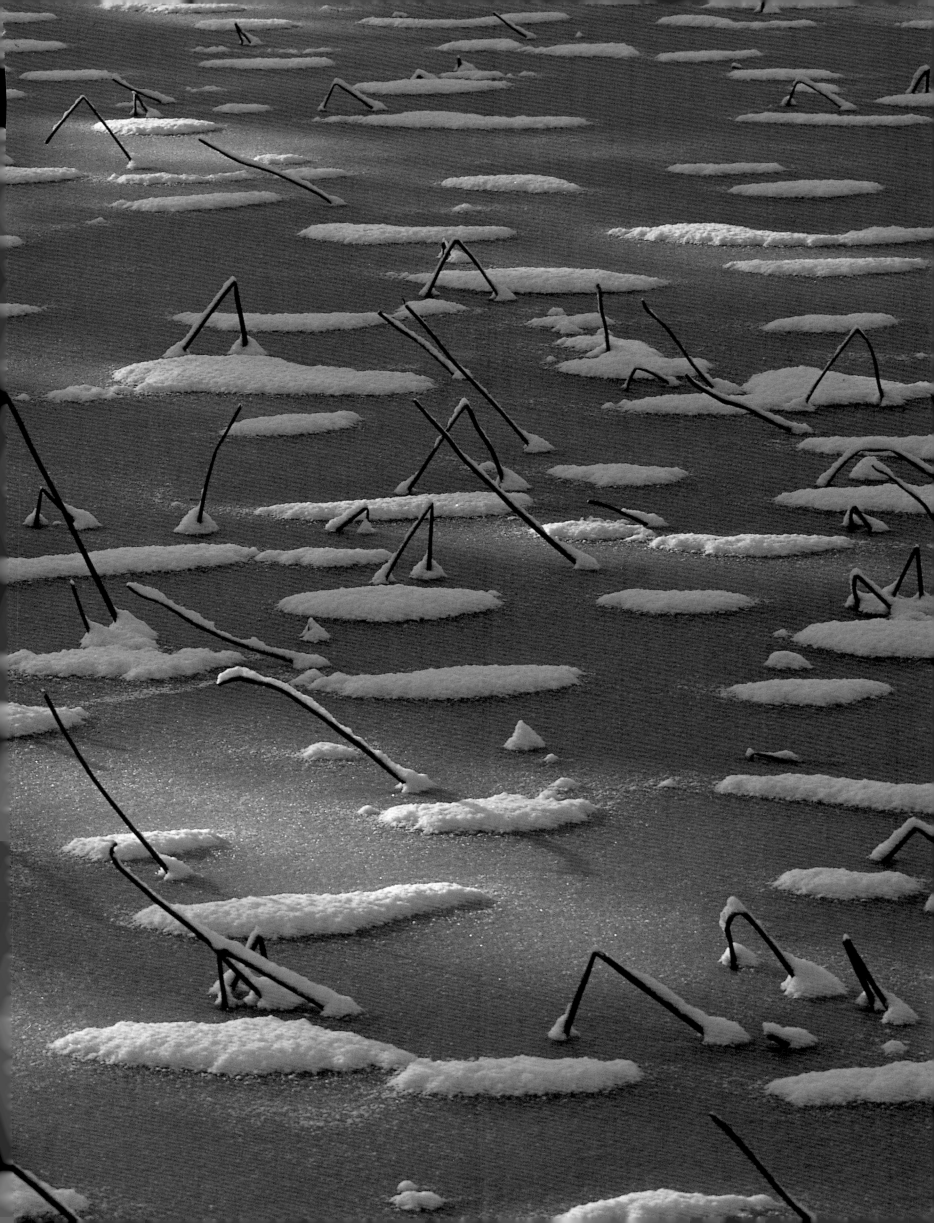

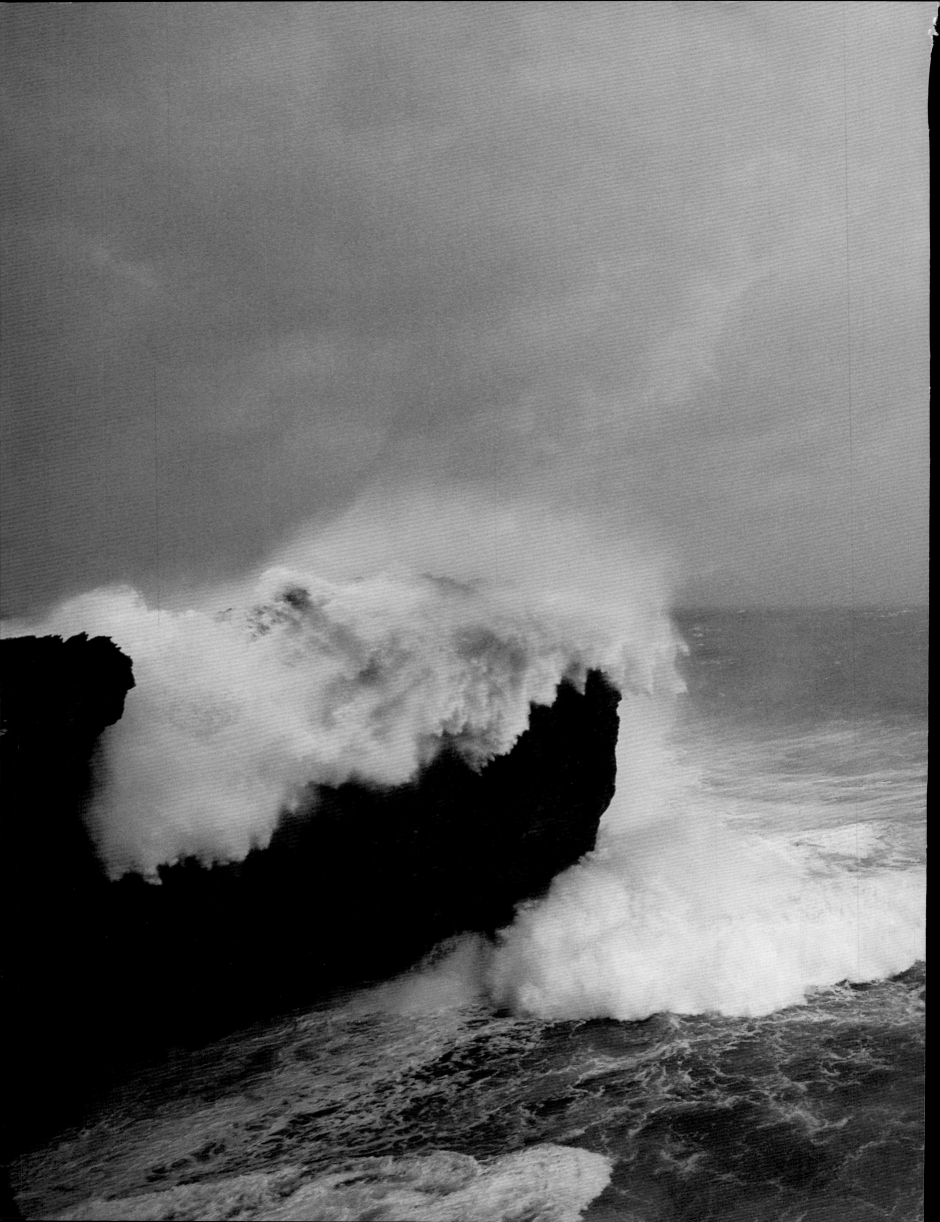

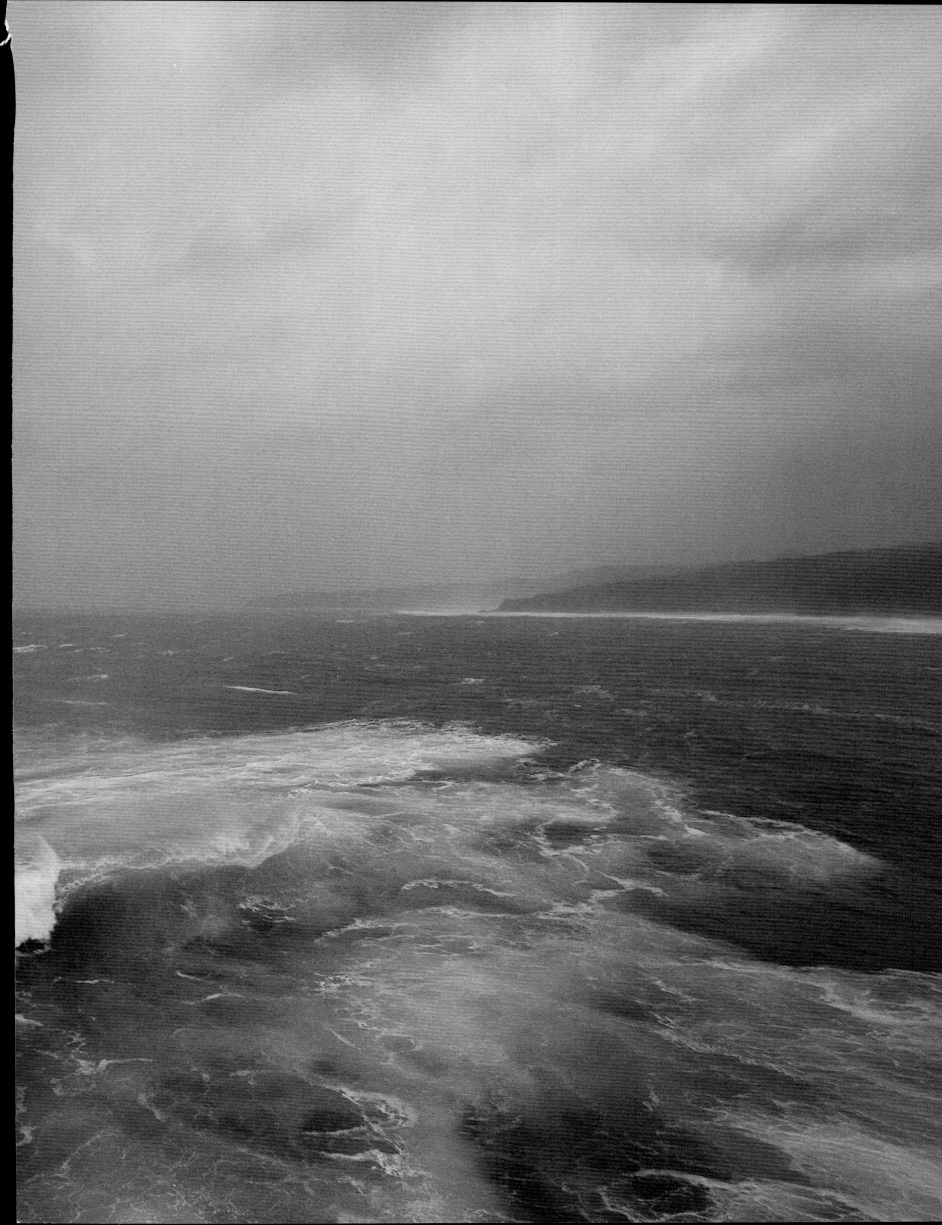

LIST OF ILLUSTRATIONS

Spring planting in Bhutan
Wangdi Phodrang, Bhutan

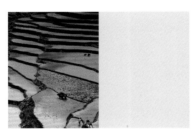

At the market in Kathmandu
Kathmandu, Nepal

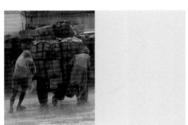

The rain cushions the pervasive poverty
and hardship
Srimangal, Bangladesh

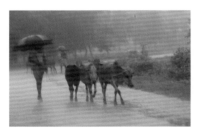

Flying under a full moon
Rameswaram, India

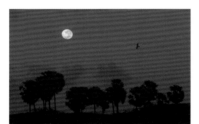

Midday squall
Trivandrum, India

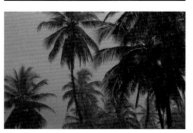

The sky's reflection on the waves
Bay of Bengal, India

Rough seas in the Bay
Bay of Bengal, India

Votive waters in this Hindu ceremony,
with the hibiscus in lieu of goat's blood
Calcutta, India

A blind Hindu devotee huddles in a cave
Bhubaneswar, India

Taking shelter from the rain
Puduchcheri, India

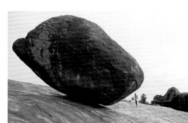

The butterball of Krishna—left by the
glaciers 200 million years ago
Mamallapuram, India

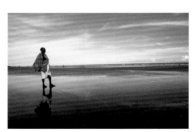

By the Bay of Bengal
Digha, India

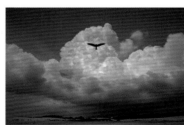

Skies above the holy land
Rameswaram, India

Purifying the heart under
the sacred waterfall
Courtallam, India

Bathing cattle in the Bay of Bengal
Madras, India

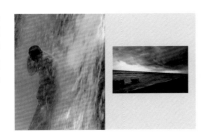

The monsoon arrives
Pulicat, India

Morning prayers in the ocean
Rameswaram, India

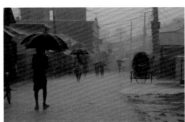

Rice planting
Shantiniketan, India

Only women may plant the rice
Shantiniketan, India

Gazing out at the ocean,
his head shaved and turmericked
to mark his father's death
Rameswaram, India

On a raft of water hyacinths
Dhaka, Bangladesh

The rainy season
Sylhet, Bangladesh

Flooded fields
Sylhet, Bangladesh

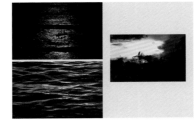

Fishing on a golden sea
Kanniyakumari, India

The evening sun reflected
on placid waters
Bay of Bengal, India

Dusk
Bhubaneswar, India

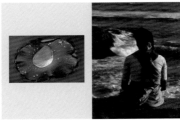

The northwester brings a sudden
thunderstorm that seems to wash
away the centuries
Lama, Bangladesh

Like jewelry on the lake
Mamallapuram, India

Cape Comorin on India's
southernmost tip
Kanniyakumari, India

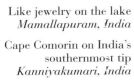

Walking toward the horizon
Noakhali, Bangladesh

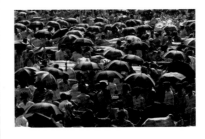

Fishermen by the Bay of Bengal
Digha, India

Outshining the sun
Courtallam, India

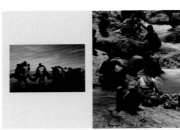

Activity at the cattle market
Dhaka, Bangladesh

As Ramadan ends, the port is filled
with people returning home
Dhaka, Bangladesh

Dawn breaks
Hatia Island, Bangladesh

Children aboard banana rafts
make fun of even the flooding
Sylhet, Bangladesh

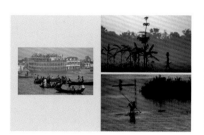

Strong rains and high winds
Teknaf, Bangladesh

Fishing for shrimp in the Bay of Bengal
Cox's Bazar, Bangladesh

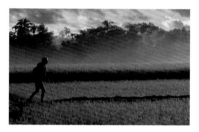

Morning mist
Hatia Island, Bangladesh

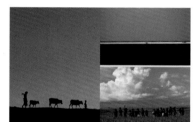

Fishing the life-giving Ganges
Sundarbans, Bangladesh

Catching a Bengal breeze
Aricha, Bangladesh

Going home
Hatia Island, Bangladesh

Come high tide, this field will again be
underwater
Noakhali, Bangladesh

Island boys
Hatia Island, Bangladesh

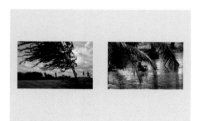

Coming home from the sea
Hatia Island, Bangladesh

The perfect umbrella
for a tropical shower
Cox's Bazar, Bangladesh

Bengalese woman
Sylhet, Bangladesh

Running with the wind
Sundarbans, Bangladesh

Water for every need
Khulna, Bangladesh

Season of the black clouds
Sylhet, Bangladesh

The rainy season comes
to the Bengal plain
Tangail, Bangladesh

Lined up at the weighing station with
their harvests of tea leaves
Srimangal, Bangladesh

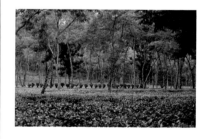

Soaring the vermilion skies
Kandy, Sri Lanka

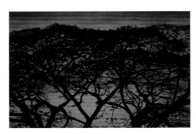

The Ayeyarwady flows on
Ayeyarwady River, Myanmar

The summer monsoon brings winds
and rain from the distant Indian Ocean
Matara, Sri Lanka

The forest at dusk
Mahaweli, Sri Lanka

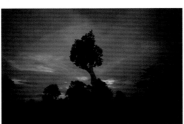

Fields of buckwheat
Jharkot, Nepal

The rain's poem
Avukana, Sri Lanka

A welcome rain
Mahaweli, Sri Lanka

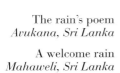

Going to school through paddies of green
Dhampus, Nepal

Mt. Nilgiri sparkles in the sun
Jomosom, Nepal

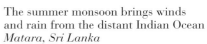

The infinite love of Buddha
Avukana, Sri Lanka

Stairway to Buddha
Mihintale, Sri Lanka

The Buddha's feet
Dambulla, Sri Lanka

The Mustang people descend
the Kaligandaki river
Kagbeni, Nepal

Villagers gather at the shrine
before dawn
Dhampus, Nepal

Girl harvesting buckwheat
Simikot, Nepal

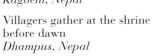

Men work the rice fields until dark
Nuwara Eliya, Sri Lanka

Ammonite-rich mountain village
Jharkot, Nepal

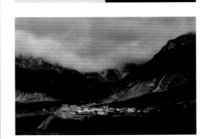

Girl carrying kindling
Gedu, Bhutan

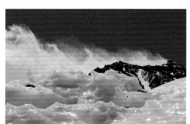

The forest of the gods
Dochhula, Bhutan

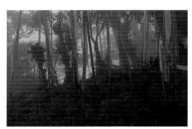

Prayer banners by a mountain
monastery
Taktshang, Bhutan

Monastery on the mountainside
Taktshang, Bhutan

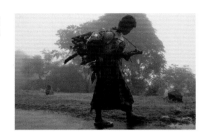

Monsoon-borne banner clouds
over the summit
Mt. Everest, Tibet

Ice at 6,500 meters above sea level
Mt. Everest, Tibet

Sandstorm
Lhasa, Tibet

Wheat field in the Tibetan highlands
Xigatse, Tibet

September rapeseed
Gyantse, Tibet

Crows on a glacier trail
Mt. Everest, Tibet

Yaks returning across the glacier
to base camp
Mt. Everest, Tibet

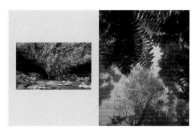

Smoke from cooking stoves
envelopes the town
Kunming, Yunnan, China

To market, to market
Dali, Yunnan, China

Mt. Yulongxue towers above the clouds
Mt. Yulongxue, Yunnan, China

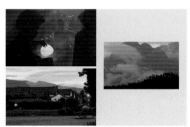

Birthplace of the Ganges
Gaumukh, India

The forest at dawn
Sikkim, India

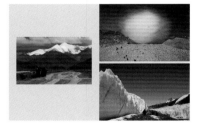
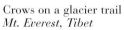

Holy tree sheltered
by the Himalayan mist
Sikkim, India

Butterfly on a prayer banner
Sikkim, India

Woman praying
Dharamsala, India

Independence Day (August 15)
in polyethnic India
Sikkim, India

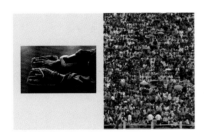

Lama walking
in the early morning mist
Sikkim, India

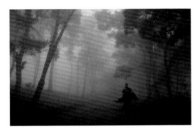

Lama at Thiksay Monastery
Ladakh, India

Sun breaks through the clouds
over the Rohtang Pass
Rohtang, India

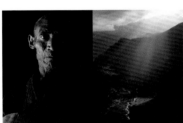

Girl guarding pre-harvest rice
from the monkeys
Sikkim, India

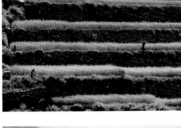

Pure water and clear skies
make this Tea Valley
Darjeeling, India

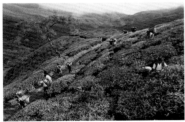

Brilliant foliage
Bangkok, Thailand

Brilliant plumage
Huahin, Thailand

The riverbank at dawn
Chiangrai, Thailand

Water lilies in the morning mist
Sukhotai, Thailand

Heading home from the rice harvest
Phitsanulok, Thailand

Out at daybreak to keep the birds
off the rice fields
Phitsanulok, Thailand

A bomb-pocked land
Plain of Jars, Laos

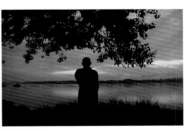

The soothing Mekong
Vientiane, Laos

Apprentice priest on the banks
of the Mekong
Paklay, Laos

Going begging after the rain
Pakse, Laos

Land and river in the post-rain glitter
Mekong River, Laos

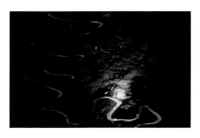

The Khmer smile
Siemreap, Taprohm, Cambodia

Lotus and rice
Thanhhoa, Vietnam

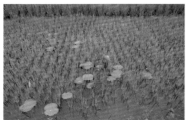

Going to sell the soldiers rolls
Angkor Wat, Siemreap, Cambodia

Boy under an azure sky
Siemreap, Cambodia

Dry season
Quinhon, Vietnam

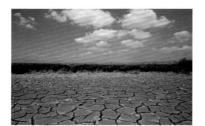

Paddy ready for planting
Compong Chhnang, Cambodia

The road to the temple
Phnom Penh, Cambodia

Pedicured up for the market at Tet
Hanoi, Vietnam

No school today
Hanoi, Vietnam

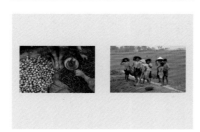

And still the rain falls
Kompong Cham, Cambodia

Boy tending the nets
Samson, Vietnam

Salt fields
Nhatrang, Vietnam

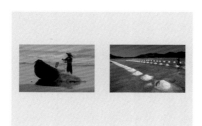

Working in the rain
Kudat, Sabah, Malaysia

Bats come out in the evening to feed
(reflection in water)
Deer Cave, Sarawak, Malaysia

In the tropical forest
Sepilok, Sabah, Malaysia

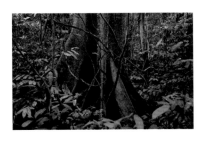

Morning in Borneo
Melak, Kalimantan, Indonesia

Pitcher plant
Mt. Kinabalu, Sabah, Malaysia

Tropical forest leaf
Sepilok, Sabah, Malaysia

Spring in the wetlands
Palembang, Sumatra, Indonesia

A placid morning on Lake Tawar
Takengon, Sumatra, Indonesia

Harvesting swallow nests
Gomantong Cave, Sabah, Malaysia

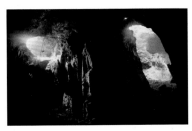

Dawn breaks over Borobudur
Borobudur, Java, Indonesia

Squall
Tapak Tuan, Sumatra, Indonesia

One day at a time
Solok, Sumatra, Indonesia

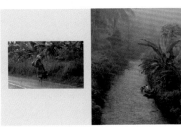

Terraced paddies in the tropical forest
Kian Gan, Luzon Island, Philippines

Farm women out at the break of day
Blitar, Java, Indonesia

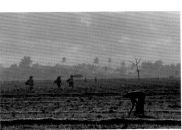

Housing stilts in the sea
Bohol Island, Philippines

Plague of grasshoppers
Pinatubo, Luzon Island, Philippines

Funeral procession by the sea
Batan Island, Philippines

Terraced paddies in autumn
Banaue, Luzon Island, Philippines

Crop-devastating swarm
of grasshoppers
Pinatubo, Luzon Island, Philippines

Girl collecting harvest
leavings in the rain
Negros Island, Philippines

Dew in the forest
Huang Long, Sichuan, China

Colors exposed by wind and waves
Chilung, Taiwan

Lotus pond in early summer
Taichung, Taiwan

The rainy season approaches
Jiuzhaigou, Sichuan, China

After the squall
Yangshuo, Guilin, China

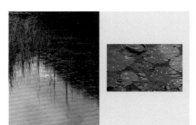

Swallow flying along
the mangrove coast
Chinmen Island, Taiwan

Sculpture by the sea
Chilung, Taiwan

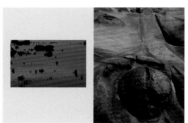

Snowfield at dusk
Huang Long, Sichuan, China

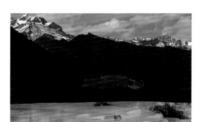

The tobacco harvest
Yuli, Taiwan

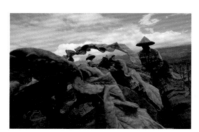

The holy site rests silent
Huang Long, Sichuan, China

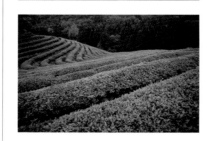

Stairway to the heavens
Longsheng, Guangxi, China

Flowering bamboo
Yangshuo, Guilin, China

A tea field pungent in green
Posong, Korea

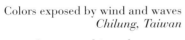

Indomitable
Kurye, Korea

The acacia season
Kwangju, Korea

Autumn rain on the rice field
Onoda, Miyagi, Japan

Wheatfield in spring breezes
Cheju Island, Korea

The winter monsoon
Matsunoyama, Niigata, Japan

Calm by the river
Tsunan, Niigata, Japan

Nets set in the Yellow Sea
Puan, Korea

Ice on the lotus pond
Takada, Niigata, Japan

Time and space of the gods
Ise Shrine, Japan

Shrine priests in the rain
Ise Shrine, Japan

The typhoon rages
Okinawa, Japan

Revered rock
Ise Shrine, Japan

Rain ripples
Shirakawa, Gifu, Japan

Lotus pond in late summer
Izunuma, Miyagi, Japan

MOTOI ICHIHARA

Born in December 1948 in Tokushima Prefecture, Japan.
Currently resides in Nerima, Tokyo.

EDUCATIONAL BACKGROUND

1974 Graduated from Nihon University, Tokyo, with BA, major in photography.

1971 Graduated from Nihon University with BA, major in cinematography.

PROFESSIONAL TRAVELS

1998 July: Ise Shrine and Shirakawa village, Japan.
April–June: South-Korea.

1997 February: Nagano and Niigata, Japan.
July–September: Ogasawara, Okinawa, and Yaeyama Islands, Japan.

1996 April–June: Hong Kong and China.
October–November: Northern Japan.

1995 October: Izu Islands.
April–September: Taiwan and the Philippines.
January–June: Sumatra, Borneo, and Brunei.

1994 July–October: Indonesia and Malaysia.

1993 April–September: Vietnam, Laos, Cambodia, and Yunnan.

1992 Took part in Japan-Kazakhstan Friendly Mountaineering Party Himalayan expedition.

1991 Awarded a Japan Arts Fund grant by the Agency for Cultural Affairs.
July–September: Northern India and Ladakh.

1990 March–September: Nepal and Bhutan.
Thirty-three works purchased by the Taiji Whale Museum (Wakayama, Japan).

1989 March–September: Sri Lanka and Southern India.
Attended the UNESCO Oman meeting on the Ocean Silk Road.

1988 March–September: Bangladesh, Myanmar, and India.

1987 March–September: Bangladesh and Myanmar.
Started shooting for Monsoon.

1986 Appointed by the Fisheries Agency to take part in whale research off the coast of Japan.
Photographed whaling at Taiji, Wakayama, Japan.

1983/84 Six months photographing with the International Whale Research Boat in Antarctica.

1983 Photographed whaling off Ogasawara Island, Japan.
Attended the International Whale Committee Conference in Brighton, U.K.

1982/83 Photographed Japanese whaling in the Antarctic Ocean.

1979 Started photographing whaling.

1973 Photographed Inuit in Alaska and Greenland.

PUBLICATIONS

1998 *Tokyo Islands*
Izu and Ogasawara photographs, published to commemorate the 120th anniversary of the islands' transfer to Tokyo (Gyosei Corp., Tokyo).

1996 Provided photos for Japan International Volunteer Center 1997 calendar.

1993 *Asia Monsoon*
from Asahi Shinbun Press, Tokyo.

1992 *Asia Monsoon*
photographs and essay serialized in *Asahi Weekly* magazine for one year (Tokyo).

1990 Antarctic photographs published in *National Geographic*, Washington, D.C.

1987 Reported monthly for *Voice* magazine, published by PHP Publishers, Tokyo.
Provided photographs for National (Panasonic) calendar.

1986 *The Antarctic Ocean*
from Iwanami Shoten Publishers, Tokyo.
The Sea of Whales, the Sea of Man
from Gyosei Corp., Tokyo.

SELECTED EXHIBITIONS

1997 *Modern Visual Angles by 24 Photographers*
at the Tokyo Metropolitan Photography Museum

1996 *What Can a Photograph Say to Us*
at Canon Salons throughout Japan
The Productive Sea, the Asian Sea
at the Toba Marine Museum, Mie Prefecture, Japan

1995 *The World of Motoi Ichihara*
in Jakarta, sponsored by the governments of Indonesia and Japan to commemorate Indonesia's 50th anniversary of independence.

1994 *Asian Mind and Form*
in Hiroshima, Japan, sponsored by the Hiroshima-Asian Conference Committee, Ministry of Foreign Affairs, and Cultural Affairs Agency.
Asia Monsoon
at Fuji Photo Salons in Tokyo, Osaka, Fukuoka, and Nagoya, Japan

1990/92 Antarctic photographs exhibited at Shirase Museum in Akita, Japan

1986 *The Sea of Whales, the Sea of Man*
at Fuji Photo Salons in Tokyo, Osaka, and Fukuoka, Japan

PROFESSIONAL MEMBERSHIPS

Japan Professional Photographers Society
Japan Travel Writers Organization

Reproductions copyright by Motoi Ichihara, Tokyo
Texts copyright by Motoi Ichihara, Tokyo
Author Liaison by Midori Ichihara

Translation from the Japanese by Frederick M. Uleman
Editorial direction by Sara Schindler
Jacket Design by Guido Widmer, Zurich, Switzerland
Layout by TypoRenn, Niederteufen, Switzerland; Giorgio Chiappa
Lithography by CopyDesign AG, St. Gall, Switzerland
Printed and bound by Basler Druck + Verlag AG, Basel, Switzerland

ISBN 3-908163-03-X